Becoming Edvard Munch

Influence, Anxiety, and Myth

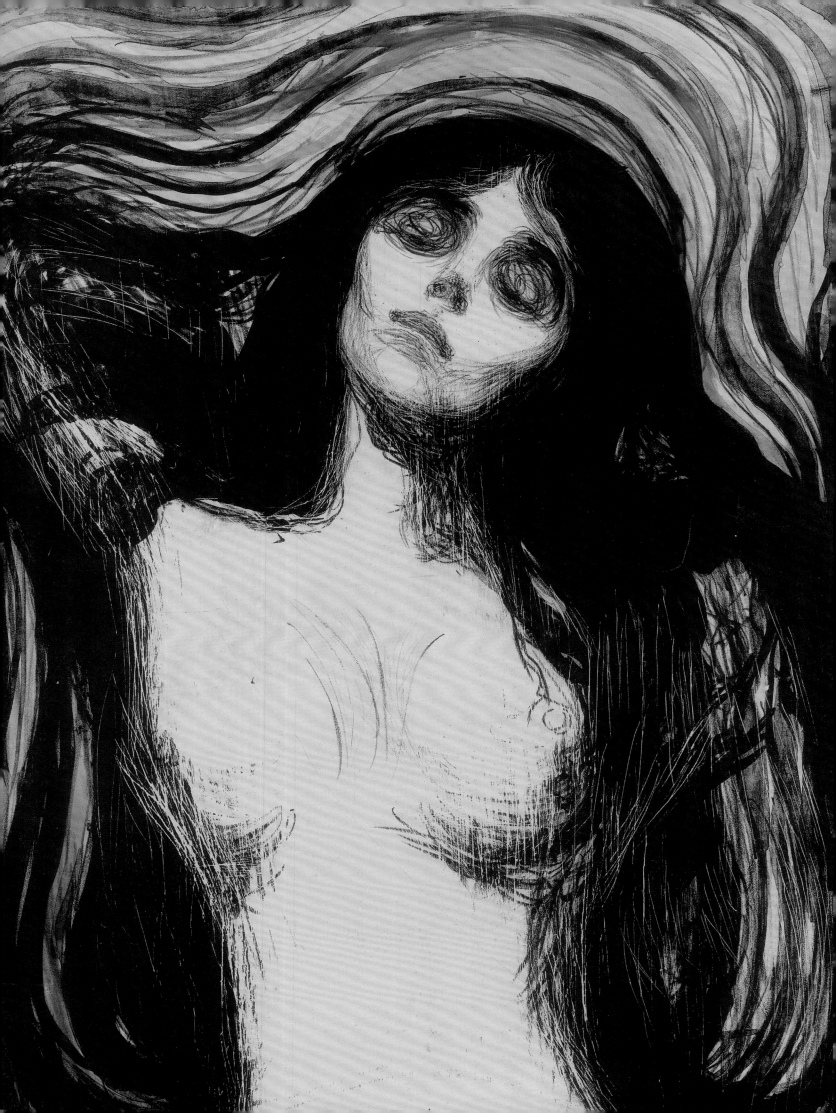

Becoming Edvard Munch

Influence, Anxiety, and Myth

JAY A. CLARKE

The Art Institute of Chicago
Yale University Press, New Haven and London

CONTENTS

 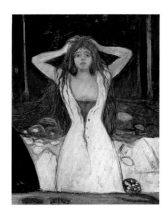 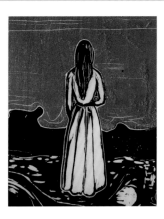

EXHIBITION SPONSOR

Bank of America

Bank of America is honored to serve as the national sponsor of
Becoming Edvard Munch: Influence, Anxiety, and Myth at the
Art Institute of Chicago, a unique exhibition that presents one
of Modernism's most enduring icons in a new and different
light. Some 150 paintings, prints, and drawings feature the artist's
work in relation to that of his pan-European contemporaries,
offering a perspective that challenges prevailing myths.

Becoming Edvard Munch: Influence, Anxiety and Myth is the
latest in a series of exhibitions that Bank of America has sup-
ported at some of our nation's greatest museums. Most recently,
Bank of America served as the national sponsor for *Pompeii
and the Roman Villa: Art and Culture around the Bay of Naples*
in Washington, D.C., and Los Angeles; *Monet to Dalí* in Detroit;
J. M. W. Turner in Washington, D.C., Dallas, and New York;
Frida Kahlo in Minneapolis, Philadelphia, and San Francisco;
and *El Greco to Velázquez* in Boston and Durham.

There are many important reasons we have chosen to be
a leading supporter of arts and culture in the United States.
Through our programs that support the arts in our communi-
ties, we provide access to cultural treasures across the country.
When we support arts education, we hope to provide young
people with experiences that will serve them all their lives. When
we lend to museums from our art collection, we expand cul-
tural resources for the public. And when we make grants to
help institutions grow, we support the economy, our communi-
ties, and all those served by these institutions.

At Bank of America, we recognize that cultural resources
are part of the foundation on which healthy communities
are built. We hope you enjoy *Becoming Edvard Munch* and that
you continue to share our passion and enthusiasm for the
important role art plays in all our lives.

Kenneth D. Lewis
Chairman and Chief Executive Officer
Bank of America

DIRECTOR'S FOREWORD

Perhaps surprisingly, the first time Chicago audiences would have encountered Edvard Munch's art was at the *Exhibition of Contemporary Scandinavian Art*, an impressive display organized by the American Scandinavian Society and supported by the kings of Denmark, Norway, and Sweden. The gathering of 165 pictures, six of them by Munch, traveled to several American museums, including the Art Institute, between 1912 and 1913. In his biographical note on Munch, the eminent collector, critic, and curator Christian Brinton claimed, "You will find in these beseechingly beautiful or feverishly troubled canvases, now the most exalted and sensitive response to human suffering, now the scarlet trail of the serpent." As did Brinton, Munch's early critics in America, like many in Europe, focused on his representations of death, sin, and suffering—an approach that has characterized both scholarly and popular attitudes ever since. However, while many of us are familiar with the iconic image of *The Scream*, there are many other sides to Munch that have been eclipsed by the traditional emphasis on his supposed emotional imbalance and artistic isolation. In addition to his depictions of death and sexuality are moody, relatively calm landscapes and pictures of bathers that celebrate the vitality of the human form in nature.

Almost a century after the *Exhibition of Contemporary Scandinavian Art*, the Art Institute has mounted this exhibition—*Becoming Edvard Munch: Influence, Anxiety, and Myth*—which is designed to consider the artist's relation to his peers and question the very myths that Brinton and other early critics and scholars helped establish. One effect of the traditional approach to Munch's art has been to present his work in a monographic way. He rarely admitted the influence of other artists, and exhibitions of his work have tended to take his word at face value. The Art Institute, however, has been able to draw on its rich permanent collection of fin-de-siècle paintings, prints, and drawings, and then expand its search outward in order to consider the complex web of visual sources that Munch may have brought to bear on his art. This exhibition features specific works by a range of artists—among them Harriet Backer, Gustave Caillebotte, James Ensor, Akseli Gallen-Kallela, Vincent van Gogh, Christian Krohg, Claude Monet, Auguste Rodin, and Frits Thaulow—not only because they resonate with Munch's art visually or thematically, but also because he could actually have seen them in his various travels. Many of these artists are like old friends to American audiences, whereas others are virtually unknown.

Over one-third of this exhibition derives from the museum's own, outstanding permanent collection, which boasts 110 works on paper by Munch and a stunning painting, *The Girl by the Window*, acquired in 2000. Among the richest caches of prints by Munch in the United States, these works came to the Art Institute through an interesting episode in the history of collecting. The main group of 85 prints was initially formed by the respected dealer J. B. Neumann, who sold them in 1955 to the famed architect Ludwig Mies van der Rohe, a fellow German émigré who came to Chicago in 1938 to direct the School of Architecture at the Armour Institute of Technology. In 1963, after the Guggenheim Museum in New York turned them down, they were purchased by the Art Institute.

The thesis of this exhibition and catalogue was conceived by Jay A. Clarke with the guidance of Douglas Druick, and we are grateful for their efforts. Without the generosity of the many lenders from throughout Scandinavia, Europe, and the United States, we would never have been able to evoke the complex, interconnected web of influences that Munch brought to bear on his art. Finally, we are grateful to our generous exhibition supporters: Bank of America, exclusive corporate sponsor; the Harris Family Foundation in memory of Bette and Neison Harris; the National Endowment for the Arts, which believes a great nation deserves great art; and an indemnity granted by the Federal Council on the Arts and the Humanities. We hope you enjoy both the wonder and complexity of Munch's work and this visual journey into the art of his time.

James Cuno
President and Eloise W. Martin Director
The Art Institute of Chicago

PREFACE AND ACKNOWLEDGMENTS

Edvard Munch's goal of capturing the totality of life, from the uncertainties of adolescence to the sureness of death, arose from his fascination with the vast range of human experience. His works, which bear titles such as *The Kiss, Anxiety, Vampire, and Dance of Life*, show our earthly existence as an inextricable mix of love and destruction, self-persecution and regeneration. This tendency makes it all the more puzzling that critics and viewers have long placed the artist in an interpretive strait-jacket, regarding him solely as a figure of existential angst and leaving out many of the nuances that make his work compel-ling. The text that follows draws heavily on Munch's letters and diaries, on the writings of contemporary cultural commenta-tors, and on the formal and thematic aspects of the paintings, prints, and drawings he created. Taken together, these reveal and resuscitate forgotten conversations about Munch and his art. How, they help us ask, can we understand his complex and ambivalent body of work, which contains images, on the one hand, of anxiety and sexual torment, and on the other, of serene fjords at sunset? Or make sense of his desire to be perceived as truly independent and original even as he worked to absorb the influences of his European and Scandinavian contempo-raries? As we shall see, it is within, and from, these seeming contradictions that Munch created his mythic art and persona.

Edvard Munch: Influence, Anxiety, and Myth came into being as the result of a grand collaboration. First, I would like to acknowl-edge our sponsors, without whose generosity this exhibition and publication would not have been possible. We are grateful to Bank of America, exclusive corporate sponsor; the Harris Family Foundation in memory of Bette and Neison Harris; the National Endowment for the Arts, which believes a great nation deserves great art; and the Federal Council on the Arts and the Humanities. We extend particular thanks to our lenders: the Ateneum Art Museum, Helsinki; the Baltimore Museum of Art; the Bergen Art Museum; Mr. Nelson Blitz, Jr., and Ms. Catherine Woodard; the Cleveland Museum of Art; at the Drammens Museum, Einar Sørensen; the Epstein Family Collection, espe-cially Sarah G. Epstein and Vivi Spicer; at the Fogg Art Museum, Susan Dackerman; the Frances Lehman Loeb Art Center; at the Galerie Katharina Büttiker, Katharina Büttiker and Susanne Weber; Mrs. Martin L. Gecht; Göteborg Art Museum; at the Jane Voorhees Zimmerli Art Museum, Christine Giviskos and Marilyn Symmes; at the Lillehammer Art Museum, Svein Olav Hoff; Mr. and Mrs. James Mabie; the Mildred Lane Kemper Art Museum; at the Minneapolis Institute of Arts, Patrick Noon; the Munch Museum, Oslo; at the Musée d'Orsay, Guy Cogeval; the Musée Marmottan Monet; the Museo Thyssen-Bornemisza; at the Museum of Fine Arts, Boston, Patrick Murphy; the Museum of Modern Art, New York; the National Gallery of Art, Washington, D.C.; the National Museum, Stockholm; the National Museum of Art, Architecture and Design, Oslo; the Nelson-Atkins Museum of Art; the New York Public Library; at the Philadelphia Museum of Art, Shelley Langdale; Smithsonian American Art Museum; Statens Museum for Kunst, Copenhagen; at the Stiftung Stadtmuseum, Berlin, Angelika Reimer; Tate, London; Von der Heydt Museum, Wuppertal; Yale Center for British Art; and the private collectors who wish to remain anonymous.

I am also very grateful to my Norwegian colleagues, whose kind collaboration has truly allowed us to tell the story of Munch in his native land. They have made me feel welcome on each and every visit, and aided me in countless research inquiries. At the Bergen Art Museum, thanks go to Audun Eckhoff, Knut Ormhaug, and Anniken Thue; at the National Museum of Art, Architecture and Design, Oslo, to Trond Aslaskby, Nils Messel, Bodil Sørensen, Øystein Ustvedt, and especially Frode Ernst Haverkamp, Sidsel Helliesen, and for-mer curator Marit Lange, who helped make Oslo my second home and offered unflagging encouragement and support; at the Munch Museum, Oslo, to Inger Egan, Mai Britt Guleng, Lasse Jacobsen, Petra Pettersen, former director Gunnar Sørensen, Ingebjørg Ydstie; and at the Galleri Kaare Berntsen, to Kaare Berntsen, Ann Falahat, and especially Ina Johannesen, who went above and beyond the call of duty to help secure particu-larly difficult loans, giving welcome advice along the way.

I have had the opportunity to spend several weeks in the archives of the Munch Museum under the generous sponsorship of two granting agencies, the American Scandinavian Foundation and the Norwegian Marshall Fund. An exhibition planning gift from Dr. Lilo Closs offered crucial assistance at the outset of the project. Many scholars have provided invaluable advice and support, among them Jolanta Akre-Johansson, Vivian Endicott Barnett, Mary Weaver Chapin, Hollis Clayson, Marion Deshmukh, David Getsy, Reinhold Heller, Lucy Hunt, Frank Høifødt, Frauke Josenhans, Maud Lavin, Antoinette Le Normand-Romain, Dominique Lobstein, Margaret MacNamidhe, Maria Makela, Ana Martinez, Allison Morehead, Mary Morton, Christopher Riopelle, Anne Roquebert, Tom Sloan, and Maryanne Stevens.

Edvard Munch: Influence, Anxiety, and Myth was initially encouraged by the Art Institute's former director and president, James N. Wood, and later embraced by his successor, James Cuno. I owe them a great debt, as I do Dorothy Schroeder, who has carefully managed all budgetary aspects of the exhibition in concert with Dawn Koster, Jeanne Ladd, and Meredith Mack. For their help in securing important loans, thanks also go to Dieter Buchhart, Christopher Eykyn, Janne Gallen-Kallela-Sirén, Holtermann Fine Art, and Tor Petter Mygland. Frederick Mulder and David Nash provided invaluable assistance with the indemnity application.

My colleagues in the Department of Prints and Drawings, especially Jason Foumberg, Barbara Hinde, Elliot Layda, Suzanne Folds McCullagh, Mark Pascale, Mardy Sears, Matt Stolle, Harriet Stratis, Martha Tedeschi, Peter Zegers, and Emily Vokt Ziemba, have been exceptionally supportive of this project and understanding about the time it has taken away from my regular duties. I also received help from a host of able interns: Perri Blitz, Jessie Feiman, Nore Hugendubel, Caitlin Rubin, Rebecca Ruderman, Anastasia Standa, and Kathryn Sullivan. I am especially grateful to conservator Kimberly Nichols, who painstakingly documented the inks, papers, and technical processes that Munch used for his prints, and to Christine Conniff-O'Shea, who helped determine how to present these works to best effect.

I also extend my heartfelt thanks to the following Art Institute staff, who have helped bring this project to fruition: In the Department of Conservation, Allison Langley, Kristin Lister, and Frank Zuccari; in Contemporary Art, James Rondeau; in Design and Construction, Bernice Chu and Yaumu Huang, designer of the elegant exhibition installation; in Development, Warren Davis, Mary Jane Drews, Kimberly Masius, and Amy Radick; in the General Counsel's office, Troy Klyber and Maria Simon; in Graphic Design, Marine Bouvier, Lyn DelliQuadri, and Jeff Wonderland; in Imaging, Jennifer Anderson, Susan Carlson, Christopher Gallagher, Robert Lifson, Loren McDonald, and Amy Zavaleta; in Marketing and Public Affairs, Yael Eytan, Carrie Heinonen, Erin Hogan, Chai Lee, and Gary Stoppelman; in Medieval through Modern European Painting and Sculpture, Geri Banik, Darren Burge, Robert Burnier, Rachel Drescher, Karen Huang, Adrienne Jeske, Jill Shaw, and especially Stephanie D'Alessandro; in Museum Education, Margaret Farr and David Stark; in Museum Registration, Darrell Green, John Molini, all of the art packers and handlers, former registrars Mary Solt and Tamra Yost, and especially Pat Loiko and Angie Morrow, who coordinated the many complex travel and shipment arrangements with grace and good humor; in Physical Plant, Thomas Barnes and his crew; and in the Ryerson Library, Amy Ballmer, Jack Brown, Melanie Emerson, and Christine Fabian.

The job of creating this catalogue was as complex as that of the exhibition itself. In the museum's Publications Department, Kate Kotan, Joseph Mohan, Amy Peltz, and Susan Rossen were all instrumental to the book's success, while Carolyn Heidrich Ziebarth oversaw the production and printing with exemplary professionalism, making a daunting task seem effortless. Designer Daphne Geismar responded to the complexities of Munch's art with intelligence and sensitivity. The text itself benefited greatly from the careful comments of three scholars whose work I truly admire: Patricia G. Berman, Marcia Brennan, and Gerd Woll. Gloria Groom and Jenny Anger also shared many helpful suggestions. I was also fortunate to work with research assistant Britany Salsbury, who contributed greatly through her tireless efforts; it was a pleasure to coauthor the individual object entries with her.

Douglas Druick helped to realize this exhibition more than anyone, and had faith in my abilities. Jennifer Paoletti, the talented exhibition coordinator, moved it forward in countless ways. She kept me on task and was, most importantly, an exceptional colleague. This book would not be nearly half what it has become without the insight, patience, and intelligence of its gifted editor, Greg Nosan, who asked tough questions and offered welcome guidance when I could not see the forest for the trees.

Finally, my immediate family: my husband, John F. K. Bradley, and our two beautiful children, Liam and Cora, have been extremely supportive, even traveling with me to Norway and putting up with ridiculous hours and a host of challenges, as have my close friends Jennifer Bernardi, Sylwia Kolodziej, Louisa Kunzler, and my loving parents and siblings. John, above all, understood the importance of this project and encouraged me beyond measure.

It has been an honor and a pleasure to work on this publication and exhibition for the Art Institute of Chicago, and I hope this book will serve in some small way to acknowledge all that the museum has given to me, and to the many visitors who share in the wonder of the works in our care.

Jay A. Clarke
Associate Curator of Prints and Drawings
The Art Institute of Chicago

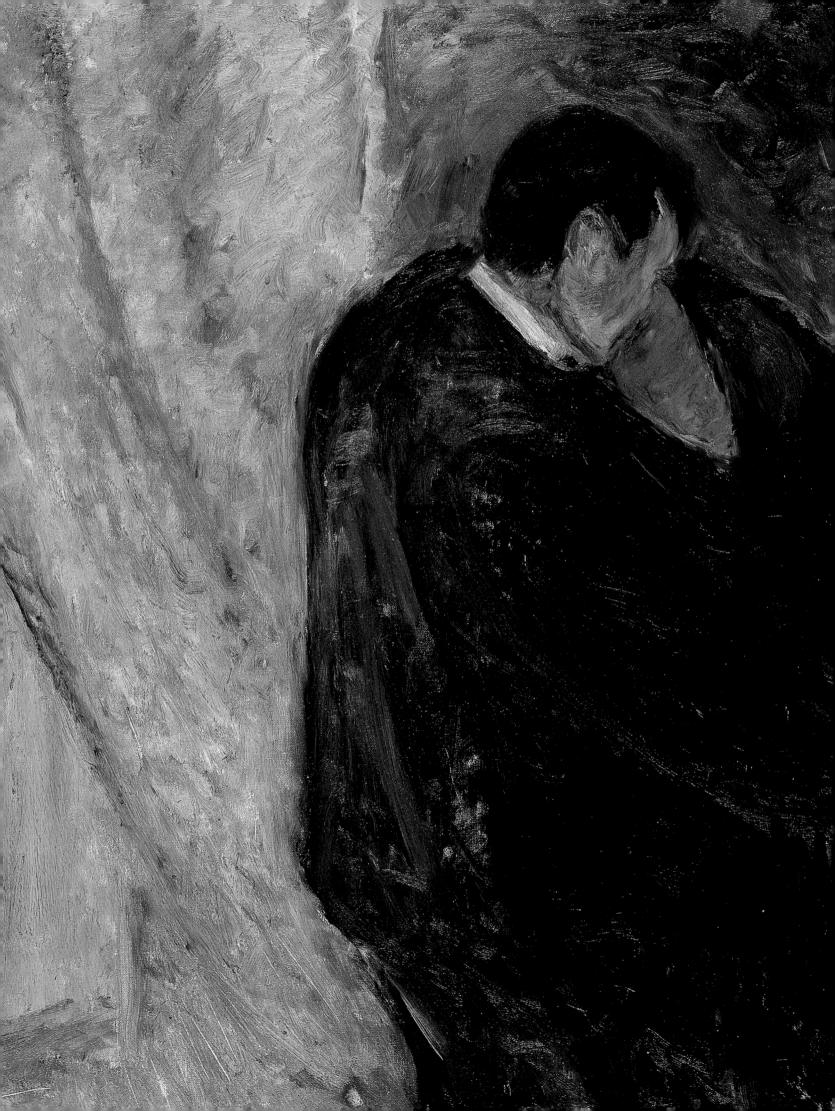

MUNCH'S ANXIETY OF INFLUENCE

The myth of the artist we know as Edvard Munch was constructed during his lifetime by art historians, critics, and the artist himself; since then, it has been reinforced by our collective fascination with his representations of self-torment. But Munch did not spring fully formed into the world, screaming toward us as an angst-ridden, isolated figure. A product of his time, he was saturated with ambivalence, striving for originality even as he worked at reinterpreting a wide variety of sources. The artist largely denied that he was influenced by others but happily claimed credit for his work's effect on the German Expressionists, who designated him their spiritual godfather. During his lifetime, he wrote diaries and planned exhibitions with a careful eye to both his place in the market and his posthumous reputation. He was perpetually considering his legacy and, wanting to be perceived as a true original, did his best to expunge suggestions that he might have had artistic models of his own. Munch's anxiety of influence reaches at once back in time and into the future, on him as the center and from him to the margins, manifesting itself in ways political, psychological, social, and most of all visual.

As we shall see, however, Munch was like a sponge, soaking up motifs, painting styles, technical tricks, marketing strategies, and aesthetic postures from a wide variety of sources. As the Norwegian Symbolist poet Sigbjørn Obstfelder astutely remarked in 1896, "[Munch] does not have the type of imagination that, out of itself, creates new worlds, new combinations, or epics. He possesses a reproductive imagination. He is receptive. His merit lies in that he is able to feel intense passion under the impact of life. He does not recreate it."[1] Obstfelder's remarks by no means signify that Munch lacked imagination, but rather that he used his creative force to transform, through his own experience, the subjects he encountered. The same is true for Munch's absorption of other artists' styles and motifs. He recast epics and existing mythic vocabularies in his own idiom, and while these sources are not always obvious, they are a subtle visual presence.

This chapter will focus on Munch's early production and travels up until 1893, by which point he had arguably become a mature artist in his own right. As we take a close look at Munch's training and early career, we will follow him from Norway to France and back again twice, exploring the artistic

environments he inhabited and the ways in which he drew from them in his own process of self-creation and self-definition. Munch was an inveterate and at times obsessive traveler, and his journeys to other countries allowed him to step away from his hometown of Kristiania (now Oslo), and, as an expatriate of sorts, experiment freely.[2] The shuttling back and forth between Kristiania, Copenhagen, Paris, Berlin, and his summer refuge in rural Åsgårdstrand offered Munch the opportunity to pick and choose from motifs and styles that suited him. He likewise experimented with a range of commercial, political, and technical approaches, carefully noting their advantages and disadvantages, and gauging the critics' reactions.

Naturalism, Impressionism, and Symbolism, the dominant artistic styles most discussed by contemporaries during this fraught period, held divergent political and aesthetic associations in different countries. For example, in Berlin, Munch's temporary home during the 1890s, Impressionism was considered radical and even socially degenerate. Yet in his homeland, these interconnected yet formally distinct styles meant something different due to the political and educational alliances between France and Norway. Unlike Germany, which had just won the Franco-Prussian War and saw France as its enemy, Norway regarded France as a model of constitutional freedom that it hoped to emulate as it attempted to dissolve its union with Sweden. In fact, these strong political ties stretched back to the early nineteenth century, when King Karl Johan, after whom Kristiania's main thoroughfare was named, served as a general in Napoleon's army.

Indeed, in the 1880s and early 1890s, Naturalism, a style that Norwegians associated with raw representations of the working classes, was closely connected to—and even interchangeable with—Impressionism, with its emphasis on truth in vision, freedom of expression through facture, and the formation of alternative exhibition societies. Naturalism flowered in France in the 1860s, and Impressionism gained prominence in the 1870s. Because Norwegian artists of Munch's generation first began traveling to France for training in the early 1880s, they conflated the two styles politically and formally, later adapting them when they returned to Scandinavia. Symbolism, however, was more amorphously defined at this point, and associated with emotive states, psychological intensity, and an evocative, more vibrant color palette. As he forged his way amid this shifting climate,

Munch moved from style to style until he returned home to foster a distinct form of Symbolism that we will consider further in chapter two. He explained the stylistic dilemma of this period years later: "I began as an impressionist but under the violent confusions of soul and life in the bohemian days impressionism did not give me enough expression, I had to seek expression for what moved my mind."[3]

I. Anxiety of Influence

Anxieties of influence, as Harold Bloom argued in his foundational text of 1973, are multifaceted: they can be considered homages or crutches, Oedipal dilemmas that can be either overcome or invisibly internalized. For Bloom, the term itself is a metaphor that suggests how individual artists misread and creatively reinterpret the work of their predecessors.[4] The essence of any avant-garde movement is to exist on the cutting edge, which explains Munch's keen desire to be viewed as innovative and independent at every turn. However, as Bloom argued with regard to poetry, each of Munch's images "implicates a matrix of relationships."[5] As we attempt to trace these relationships, the goal will not be to find the ultimate context, origin, or source for a particular image, but to suggest several potential ones, opening the artist's works up to a new, more complex range of interpretations.[6]

The anxiety of influence from which I maintain Munch suffered has been largely sidestepped by art historians from his time to our own. On the contrary, most twentieth-century scholars perpetuated his status as a rebel and original by focusing on psychobiography as the key to understanding his work; emphasizing the importance of vanguard visual models, especially the French Impressionists and Symbolists; and ignoring other, seemingly more pedestrian influences, especially the artists of his native Norway. Munch himself added to this mythology of independence by remaining largely silent about his visual models. (When he did discuss artistic sources, it was generally in terms of personality, national character, or technique, and he rarely addressed specific works.) Despite the ample journaling with which he recorded his emotional life—and the artworks that, he argued, emanated from his deep need to chronicle himself—his published perceptions about other artists are few and far between. It is no surprise that scholars have relied so strongly on psychobiography, as it

was this that Munch himself used as a way to both explain his art and market it.[7] It is more helpful, perhaps, to examine—as we will here—his private correspondence with other artists, collectors, exhibition organizers, family, and friends. Seeking to communicate rather than dramatize, Munch used these unpublished letters to make appointments, plan travel, sell work, and negotiate the stuff of everyday life. When we encounter these writings, we meet a different man than we have come to expect: one who had a firm grasp on his career and knew how to charm collectors, take a kind and nurturing approach to his family, and pay keen attention to strategies of display.

Traditionally, descriptions of his education and early exhibitions have focused on the details of his life, assiduously forwarding the perception that, from the start, he was greatly maligned. As has often been the case with other supposedly insane artists such as Vincent van Gogh, critics have created a one-to-one correspondence between Munch's art and his emotional life. For example, in the seminal work *Night in St. Cloud* (p. 38, fig. 34) the seated, melancholy male figure has often been described as Munch's alter ego, forlorn following news of his father's death. Other, more nuanced readings of this and many other of the artist's compositions have been occluded by this need to equate art and life.[8]

In 1888 and 1889 Munch created *Evening* [1] and *Summer Night: Inger on the Beach* [2], two paintings of seated women seen in profile, contemplating nature. *Evening* represents his sister Laura in a traditional country dress, white apron, and straw hat, staring fixedly to the right at the landscape or out onto the Vrengen Fjord, where the work was painted; a couple appears in the background, possibly attending to a recent catch the man is dragging in by net. Sadness veils the sitter's face, perhaps in relation to the figures in the distance.[9] She is surrounded by a lush landscape made up of brushy marks of varied greens and pinks, indicating the abundance of life in this summer setting. *Summer Night* depicts the artist's other sister on the shore at Åsgårdstrand, where the family vacationed beginning in 1889. Inger's face is placid, nearly devoid of expression; she is utterly engrossed in the view and appears almost as a part of the rocky shoreline itself. Indeed, she wears a virginal white dress that reflects the blues, browns, and yellows around her. The pale hues suggest the long

1 **EDVARD MUNCH** (Norwegian, 1863–1944). *Evening*, 1888. Oil on canvas; 75 × 100.5 cm (29 1/2 × 39 5/8 in.). Museo Thyssen-Bornemisza, Madrid, 1967.7 (689). Cat. 2.

2 **EDVARD MUNCH** *Summer Night: Inger on the Beach*, 1889. Oil on canvas; 126.5 × 161.7 cm (49 3/4 × 63 5/8 in.). The Rasmus Meyer Collection, The Bergen Art Museum, RMS.M.240. Cat. 4.

3 **JOHAN CHRISTIAN DAHL** (Norwegian, 1788–1857). *Larvik in Moonlight*, 1839. Oil on canvas; 98 × 155 cm (38 5/8 × 61 in.). The National Museum of Art, Architecture and Design, Oslo, 34.

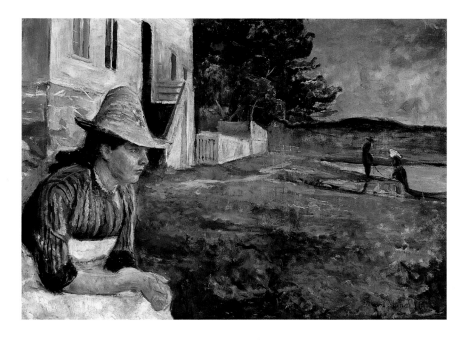

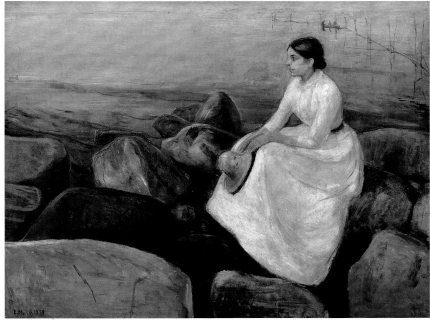

Norwegian summer nights and, in this case, echo the sitter's cool mood in a work that has been interpreted as a representation of purity—calm, controlled, and drained of the tension suggested in *Evening*.[10]

These two pictures, like so many others, have been frequently explained as episodes in the artist's psychobiographical narrative: *Evening* depicts his mentally unstable sister Laura—frequently described as an alter ego for the painter—and *Summer Night* shows his emotionally untainted sister.[11] But if we move beyond biography and mental illness, we can see that the motif Munch used in both pictures has another story to tell. In Munch's time, images such as these, of men and women by the shore or reflecting on a landscape, emerged from a strong cultural current that equated contemplation with nature, Neo-Romantic subject matter, the powerful draw of Norway's land, and the modern practice of open-air painting. At this critical moment in his career, as the artist attempted to make a name for himself within Kristiania's art community while simultaneously projecting an image of radical independence, he tried many different approaches that had very little to do with his sitters' emotional states.

The spirit of Romanticism that had flowered in Norway under the talents of Johann Christian Dahl in the early nineteenth century was being revived in the 1880s, as Norwegians trained abroad returned home in the hopes of fostering an art to call their own. Paintings such as *Larvik in Moonlight* [3], which were themselves influenced by the works of Dahl's German mentor Caspar David Friedrich, were reconsidered with a modern twist. In Munch's paintings, for instance, the figures and settings, the open Impressionist brushwork, the pastel or blue-hued palette, and the palpable sense of moody introspection all exemplify what was then coined as a new artistic term: *Neo-Romanticism*.[12] Later, when he had come to decry Impressionism and move toward a more radical style of expression, the artist used his journals to reinterpret *Evening* and *Summer Night (Inger on the Beach)*, arguing that they expressed psychic interiority and inventiveness, and were connected to his unique way of life, not to the work of other practitioners.

If we consider a prototypical French Impressionist picture that portrays a similar subject, it is revealing to see how differently it has been interpreted. Claude Monet's pathbreaking *On the Bank of the Seine, Bennecourt* [4], which Munch could well have seen in 1889 at the Galerie Georges Petit, Paris, represents the artist's mistress, Camille Doncieux, seated by the river on a sunny spring day. Due to Monet's iconic stature as the father of Impressionism, most scholars have approached this canvas in terms of painting technique or the site's proximity to Paris—not necessarily in relation to biography.[13] In other words, although the motifs used by Munch and Monet are connected, critical approaches to them have remained disconnected. Munch's typecasting as an unbalanced genius has encouraged historians to consider his work as emotional autobiography, whereas that of the more "stable" Monet has been viewed formally, as so many layers of paint.

In 1884, sixteen years after *On the Bank of the Seine, Bennecourt*, Munch's Norwegian contemporary Eilif Petersen painted *Summer Evening at Sandø* [5], which is similar thematically to all three of the works we have seen. Shown in three-quarter view, the subject ignores the late summer sunset behind her and waits by a country road for someone to approach. The meadow nearly swallows her up as she merges with the tall grass. This evocative evening scene may at first appear worlds away from Monet's more objective canvas, but like his, and Munch's, it exists as a modernization of the classical forest idyll, a motif in which the countryside is deliberately portrayed as a setting of peace and contemplation in contrast to the encroaching realities of the Industrial Revolution.[14] Petersen depicts the sitter in the act of thinking, just as Munch did; she is not simply staffage, as was the case with Monet. To turn away from biography and suggest that both Monet's and Petersen's paintings are potential visual sources for Munch's work in no way takes away from his originality. Instead, it serves as a way to challenge our own sense of who Munch was and what his work means, and to move us past any sense we might have that he was an isolated, historically amputated figure.[15]

As Petersen's painting indicates, part of reconnecting Munch to history involves looking at his work in relation to that of contemporary Scandinavian and Continental artists who were not necessarily members of the French avant-garde. To some extent, the impulse of twentieth-century critics to connect Munch with Impressionism and Symbolism is understandable: bringing Munch closer to the center of the art world allowed them to elevate his status and distance him from

4 CLAUDE MONET (French, 1840–1926). *On the Bank of the Seine, Bennecourt*, 1868. Oil on canvas; 81.5 × 100.7 cm (32 1/16 × 39 5/8 in.). The Art Institute of Chicago, Potter Palmer Collection, 1922.427. Cat. 126.

5 EILIF PETERSSEN (Norwegian, 1852–1928). *Summer Evening at Sandø*, 1884/94. Oil on canvas; 129 × 160 cm (50 3/4 × 63 in.). Private collection, courtesy Galleri Kaare Berntsen, Oslo. Cat. 130.

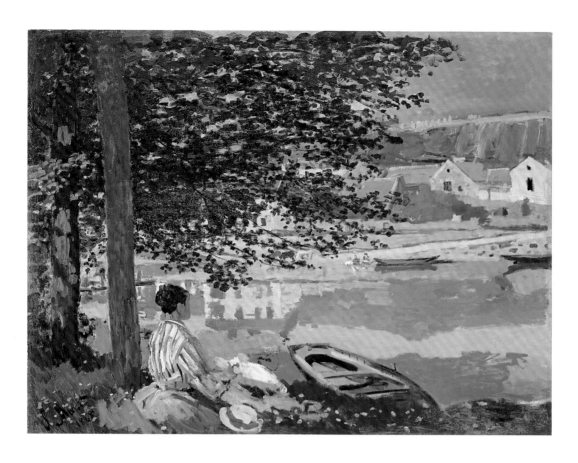

the peripheral, supposedly backward aesthetic traditions of his home country. In order to be a true innovator, so the story goes, Munch must have taken inspiration first and foremost from artists such as Monet, Paul Gauguin, and Vincent van Gogh.[16]

Works such as *Melancholy* [6], for example, have been connected primarily to Gauguin. According to lore, Munch's canvas represents his friend Jappe Nilssen sitting on the shore, jealously ruminating over the couple in the background, who prepare to row out to an island for a romantic tryst. Not surprisingly, the figure has also been interpreted as an alter ego for the depressed, isolated painter. But determining precisely which of Gauguin's (or another artist's) pictures Munch might actually have seen is crucial to making any argument about influence, and works that seem visually similar need to be carefully mapped onto the complex chronology of Munch's travels. For instance, one source that has been suggested for *Melancholy* is *Christ in the Garden of Olives* [7], which depicts a despondent Christ who looks strikingly like Gauguin.[17] While the conceit of the tortured artist as modern-day martyr resonates strongly with Munch's own self-image, the known exhibition history and provenance of Gauguin's picture offers little clue as to where Munch could have seen it, even if the two pictures do superficially and thematically resemble one another. Unfortunately, the painting was at the Parisian dealer Boussod and Valadon for less than one day in March of 1891 (Munch was in Nice at the time) when Theo van Gogh sold it to the French journalist and writer Octave Mirbeau; it was not publicly exhibited until 1910 in London.[18] There is no doubt, however, that Gauguin's broad application of paint and compartmentalization of bright colors into discrete outlined areas influenced Munch when he encountered the artist's pictures in Paris and Copenhagen beginning in 1888. In fact, his cousin, the painter Ludvig Ravensberg, recorded his thoughts on Gauguin in 1909: "[Munch] would admit that regarding the flat areas and deep colors, he was not only influenced but found strong support in Gauguin's example."[19]

As early as 1888, Munch may also have seen Vincent van Gogh's images of sorrowful men and women in lithographs, paintings, and monumental drawings such as *Weeping Woman* [8].[20] In this powerful sheet, a woman holds her head in her rough-hewn hands. Van Gogh often aimed for social commentary in his use of this motif, but his work, like Munch's,

also shares the iconic quality of Albrecht Dürer's engraving *Melencolia I* [9]. Although Munch's *Melancholy* lacks the social pathos of Van Gogh's sheet and has been discussed as a certain man depicted at a certain time, the Dürer reminds us that it also conveys a timeless sense of powerful human emotion.

The imagery of *Melancholy*, though, also reveals Munch's debt to peers such as Petersson, with whom he had frequent contact in Kristiania. As previously discussed, the subject of the lone figure in nature looking pensively outward had become a signature trope for modern Norwegian painting. It is important to recognize, however, that Norwegian artists of the 1880s and 1890s—and Munch specifically—admired and were fascinated by numerous other French artists whose work was just as important as that of Gauguin, for example, is to us today. In fact, artists such as Jean Charles Cazin, Jules Bastien-Lepage, and Pierre Puvis de Chavannes were far more visible and widely respected than vanguard figures, and Munch's teachers and mentors would have prepared him to appreciate them before he ever stepped foot in France.[21] Moreover, in the age of the international exposition and the explosion of the European art market, the young Munch could have seen paintings, prints, and sculptures by artists from many countries, including Belgium, Britain, Finland, Germany, Holland, and the United States.

The artist may also have drawn inspiration from lesser-known French works such as Cazin's *Ulysses after the Shipwreck* [10], whose composition *Melancholy* directly references.[22] In the late 1880s, Cazin was more admired than Gauguin and had more exposure in public Salon exhibitions, dealers' shops, and pan-European expositions. In this picture, he offered an updated depiction of the ancient hero, placing the contemplative, dejected man in the rocky region of Pas-de-Calais in northern France.[23] Perhaps even closer to Munch's *Melancholy* is Max Klinger's etching *Night* [11] from his series *On Death, Part I*. This print represents a lone figure—the artist himself—seated beside the open water, contemplating a single lily. As Marit Lange has convincingly argued, Munch was introduced to Klinger's prints by his mentor Christian Krohg, who shared rooms with the German artist in the late 1880s.[24] Klinger and Munch, like Cazin and his close friend Puvis de Chavannes, adopted historical, mythic, and biblical subject matter, revivifying it for contem-

6 EDVARD MUNCH *Melancholy*, 1894/96. Oil on canvas; 81 × 100.5 cm (31 7/8 × 39 5/8 in.). The Rasmus Meyer Collection, The Bergen Art Museum, RMS.M.249. Cat. 28.

7 PAUL GAUGUIN (French, 1848–1903). *Christ in the Garden of Olives*, 1889. Oil on canvas; 73 × 92 cm (28 1/2 × 35 7/8 in.). Norton Museum of Art, West Palm Beach, Fla., gift of Elizabeth Norton.

8 VINCENT VAN GOGH (Dutch, 1853–1890). *Weeping Woman*, 1883. Black and white chalk with brush and stumping, brush and black and gray wash, and traces of graphite over a brush and brown ink underdrawing on ivory wove paper; 50.2 × 31.4 cm (19 3/4 × 12 3/8 in.). The Art Institute of Chicago, gift of Mrs. G. T. Langhorne and the Mary Kirk Waller Fund in memory of Tiffany Blake and Anonymous Fund, 1947.23. Cat. 107.

9 ALBRECHT DÜRER (German, 1471–1528). *Melencolia I*, 1514. Engraving in black ink on ivory laid paper; image: 24 × 18.6 cm (9 7/16 × 7 5/16 in.). The Art Institute of Chicago, Clarence Buckingham Collection, 1938.1452.

10 JEAN CHARLES CAZIN (French, 1841–1901). *Ulysses after the Shipwreck*, 1880/84. Oil on canvas; 73.3 × 59.7 cm (28 7/8 × 23 1/2 in.). Tate: Presented by Arthur R. Anderson, 1927, L694. Cat. 93.

11 MAX KLINGER (German, 1857–1920). *Night*, plate 1 from the series *On Death, Part I*, 1889. Etching, aquatint, and burnishing in black ink on ivory wove paper; plate: 31.5 × 31.5 cm (12 3/8 × 12 3/8 in.); sheet: 36 × 36 cm (14 1/2 × 14 1/2 in.). The Art Institute of Chicago, restricted gift of Thomas Baron, 2008.148. Cat. 120.

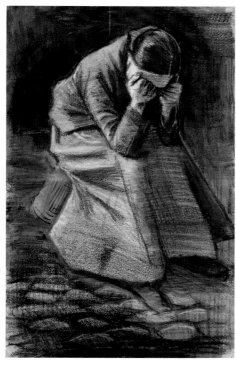

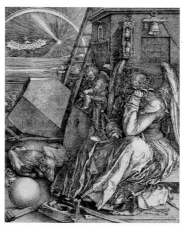

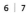

porary audiences. So, in fact, did Gauguin and Van Gogh, which suggests the presence of overlapping aims and motifs that would have been clear to viewers in Munch's day, but which art historians, in their urge to distinguish vanguard painters from their more conservative colleagues, often forget to see.

II. Creating a Norwegian Art

A century ago, as today, critics rarely related Munch to his Norwegian contemporaries; instead, they tended to describe him as an anomaly in his own land.[25] Sometimes, however, viewers familiar with Norwegian painting—and in France and Germany, these were few—looked at his work and saw clear examples of its influence. The Berlin journalist Theodor Wolff, for instance, suggested that Munch surpassed French painters because he looked at life through his own decidedly Nordic sensibility. To demonstrate this, Wolff singled out *Mystery on the Shore* [12]. Unlike the pastel hues of French Impressionist landscapes, he argued, the blue-violet *Mystery on the Shore* contained "wild passages of color."[26] This magnificent painting, which depicts a summer sunset, also includes folk-inspired anthropomorphic elements such as a smiling, troll-like rock and a tree stump that resembles a woman's flowing hair. In his diaries, Munch later noted the living character of the landscape itself: "The stones protruded above the water, mystically like sea people ... the dark blue sea rose and fell—sighed among the stones."[27] Wolff emphasized Munch's avowedly Norwegian characteristics both pictorial and physical, praising his use of raw color and his intimate connection to the land.[28]

At the same time, though, the critic failed to see that this early work clearly emerged from the distinctly Norwegian tradition of blue mood paintings, which included Peterssen's *Nocturne* [13] and Frits Thaulow's quintessentially Nordic *Melting Snow* [14]. Both works, in different ways, demonstrate how blue-violet—which critics had recently singled out as a uniquely Norwegian color, evocative of light and water on long summer nights—was employed as a key ingredient. As Leif Østby described it, the use of "the emotional color" peaked around 1890 with the work of Munch, Peterssen, Thaulow, and others.[29] Peterssen's painting depicts a nymph-like figure on the banks of a reflective pool, and Thaulow's pastel represents the gently flowing Lysaker River in the spring

of 1887. In *Mystery on the Shore*, Munch embraced this indigenous color, the folkish tradition of fantastic creatures such as mermaids and trolls, and the representation of the Norwegian fjord. Later, as we shall see, he transformed this aesthetic in his brooding, sexually suggestive interiors.

It is to Munch's early life and education in the art community of Kristiania that we must turn if we are to gain a sense of where he came from and how his own aesthetic experiments were informed by artists such as Peterssen and Thaulow. Many of his mentors hoped to create an internationally inflected native art by adapting foreign influences—including Naturalism, Impressionism, and Symbolism—into something uniquely and identifiably Norwegian. The nationalist project and the images that accompanied it were not restricted to Norway, but in fact existed throughout Europe and America before and around the turn of the nineteenth century. These modern nations, or "imagined communities," as Benedict Anderson has called them, were formed with the goal of creating political, social, and cultural oneness, a sense of unity amidst the reality of heterogeneity.[30]

The broader project of constructing a Norwegian cultural identity was one to which Munch's family was already closely connected. The artist's paternal uncle was the revered historian and professor Peter Andreas Munch, and excerpts from his famous eight-volume *Det norske folks historie* (1852–63) were read frequently in his childhood home. This text worked to establish the indigenous history of the Norwegian people as opposed to their Swedish rulers, and to resuscitate folk culture alongside high culture. As Patricia Berman has noted, this new approach greatly influenced future generations of artists, literary figures, and scholars such as Bjørnstjerne Bjørnson, Henrik Ibsen, and Munch himself, who likewise hoped to reestablish "a coherent, homogenous Norwegian culture distinct from the cultures of its Scandinavian neighbours."[31] Still famous today, P. A. Munch is commemorated in a statue at the University of Oslo that stands in the main courtyard facing Karl Johan Street, where Munch set his anxious urban landscapes. Other well-known members of the once aristocratic Munch family were the painter Thaulow, his paternal cousin, and his uncle, the painter Carl Friedrich Diriks.

Munch's home life, however, was more hardscrabble and volatile than these elevated connections would seem to suggest.

12 EDVARD MUNCH *Mystery on the Shore*, 1892. Oil on canvas; 86.5 × 124.5 cm (34 × 49 in.). Private collection.

13 EILIF PETERSSEN *Nocturne*, 1887. Oil on canvas; 81.5 × 81.5 cm (32 1/8 × 32 1/8 in.). The National Museum of Art, Architecture and Design, Oslo, NG.M.00848. Cat. 132.

14 FRITS THAULOW (Norwegian, 1847–1906). *Melting Snow*, 1887. Pastel on tan wove paper, laid down on canvas and wrapped around a strainer; 54.6 × 94.6 cm (21 1/2 × 37 1/4 in.). The Art Institute of Chicago, Margaret Day Blake Collection, 2004.86. Cat. 140.

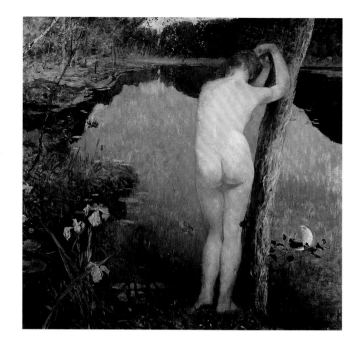

14

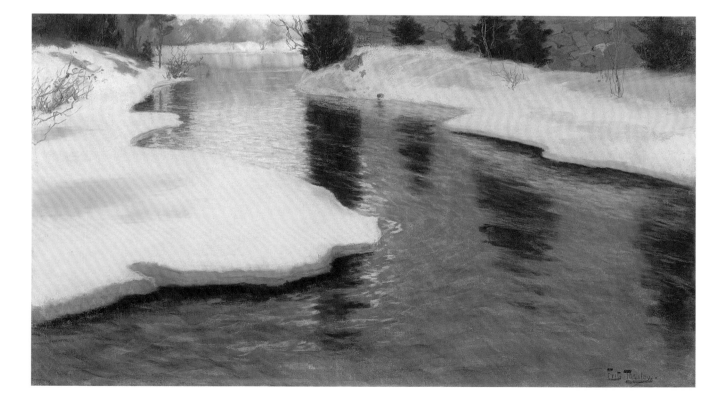

Psychobiographers have found plenty of material in Munch's immediate family, which was characterized by bodily illness, mental imbalance, religious fervor, and at times precarious financial circumstances. When he was only a small child, Edvard's physical frailties manifested themselves in the sort of frequent sicknesses that seemed to plague the entire family [see 15]. As a military doctor and general practitioner, his father, Christian, was modestly paid and worked hard to keep his family fed and modestly housed. When his wife, Laura, died from tuberculosis several months after giving birth to their fifth child, Inger, he became obsessively religious and depressed. His sister-in-law, Karen Bjølstad, took over the day-to-day responsibilities of running the household. But all was not grim: Dr. Munch enjoyed reading novels and poetry aloud in the evenings, which no doubt fired Edvard's creative imagination.[32]

Young Edvard did not spring onto Kristiania's art scene a rebellious firebrand. Interested in drawing even as a child, he moved from novice to professional tentatively and respectfully. As a boy, he often did watercolor-and-ink drawings of interiors on paper and executed simple landscape oil studies on cardboard. The former were somewhat awkward, as one would expect of a thirteen year old documenting his surroundings, and show an untrained eye and hand. In one example [see 16], Munch depicted the family drawing room in a detailed, colorful scene that displays some proficiency in perspective; his father's body, however, seems to melt into the chair without convincing anatomy. Landscapes such as *From Hakloa in Maridalen* [17] exhibit a more sophisticated handling of both space and the paintbrush, but likewise indicate a crude understanding of the human form. Tellingly, Munch the novice did not aspire to realism: in fact, such early oil sketches indicate that he was drawn to open brushwork and atmospheric, Impressionistic light effects from the start.

Besides the practice that these works afforded him, Munch received some instruction in art history and aesthetics from his extended family. His frequent illnesses and his father's lack of funds meant that he could not stay in a proper school and was mostly given lessons at home from his aunts Karen, who made collages and small sculptures from wood and paper for the tourist trade, and Jette, who was married to Diriks. Through his uncle, the young Munch was given illustrated books and

newspapers, a luxury in those days, and invited to the annual exhibitions of the Art Association. He was able to view original works there and at local art galleries such as Blomqvist, which opened in 1870. As he revealed in a daybook entry of 1880, he also gleaned both images and knowledge from the art history books in the university library.[33]

As he soaked up visual information from all these sources, Munch frequently drew copies of paintings such as Hans Gude and Adolf Tidemand's *Bridal Voyage on the Hardangerfjord* [18], an icon of the period. Later, he recalled, "There were many beautiful paintings but none made such an impression on me as the marvelous *Bridal Voyage on the Hardangerfjord* ... In the smooth fjord the great mountains gaze at their own reflections and the birch trees dip their green crowns; a bridal party is rowing out towards the stave church."[34] The sense of reverence the young artist felt for Gude and Tidemand's self-conscious combination of genre and landscape undoubtedly inspired his later affection for genre scenes set in prototypically Norwegian environments. At first glance, the emotional intensity of works such as *Melancholy* may seem worlds away from the rather stiff merriment of *Bridal Voyage*, but Munch likewise attempted to fuse narrative, contemporary myths, and the beauty of the mountains and fjords, as did many Neo-Romantic landscape painters of his generation.

Artists like Munch, who have been branded emotionally unbalanced geniuses, are often described as self-taught outsiders whose works spring from a pure emotional drive that has been untamed by the civilizing function of an organized academy. Similarly, artists who have no teachers are supposedly under the sway of less influence and therefore more original. Not surprisingly, then, Munch has been treated as an autodidact, his artistic instruction most often described as short-lived, stunted, or informal.[35] Indeed, as early as 1889, Christian Krohg wrote in an exhibition review, "It is sad that Munch has not had the advantages of a thorough academic training ... but Munch is so independent that this did not scar him, as it has so many others."[36]

The artist's education may not have been conventional and academic, but it was thorough in its own way. In fact, he had many mentors—Krohg included—who instructed him both formally and informally from 1881 to around 1892. Before Munch decided to make art his career, he received nearly a year of

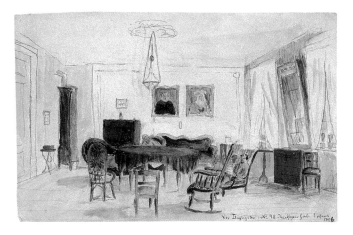

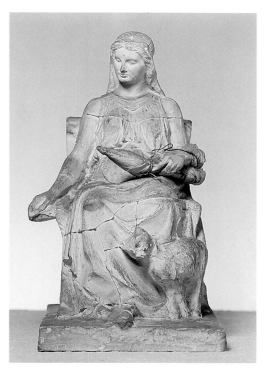

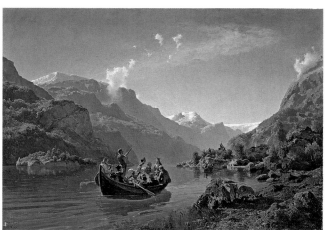

training as an engineer, a course of study his father felt would bring both prestige and much-needed income. But due to his poor health and perhaps a genuine lack of interest, he wrote in his diary entry for November 8, 1880, "I have again signed off from technical school. I have decided to become an artist."[37]

At the time, however, opportunities for formal artistic training within Norway were extremely limited, due in part to the fact that the largely agrarian economy offered little economic stability for artists. The country had no government-sponsored art schools, as did other European nations, so artists eventually traveled abroad for advanced education, most often to Munich and Düsseldorf. First, though, the majority cut their teeth at the state-supported Royal School of Art and Design. Founded in 1818 by another ancestor, Jacob Munch, a pupil of the French Neoclassical painter Jacques-Louis David, this establishment aimed to enrich craft and architecture first and the fine arts second. It was not until the 1870s that art education proper was advocated, and only in 1909 were these efforts realized with the foundation of Norway's Academy of Art.[38]

Munch's first teacher at the school, the sculptor Julius Middelthun, was the head of the drawing program from 1869 until his death in 1886. Middelthun's portraits, done in the classicized manner of the Danish sculptor Bertel Thorvaldsen, are seemingly antithetical to Munch's expressive work, and the teacher has often been cast as the conservative foil to his student's rebellious, antiestablishment persona. But Middelthun's example was exceedingly important to the younger artist's formative education, and his letters to Munch show that he was strongly supportive.[39] Middelthun was also a key contributor to Norway's emerging nationalist style. His best-known pieces were highly realistic representations of famous men that were executed in gleaming marble. Less remembered are his sculptures—many of them in matte clay—of figures such as mermaids, Norwegian literary heroes, and Freyja, the Norse goddess of love and fertility [19], which reveal his fascination with indigenous history and legend.

Middelthun's narrative approach, however superficially opposed to those of his students, profoundly shaped their developing sense that they might build a modern Norwegian art by combining subjects and styles borrowed from other cultures with those very much their own.[40] For example, his teacher's brand of national mythology may have been one of the influences that inspired Munch to create his first mermaid painting (p. 76, fig. 74), with its native landscape and modernized themes of mythic love and sexuality. Despite Middelthun's staid reputation, he was among the few of his generation to admire the "new" Naturalist direction in French art, which he had encountered at the 1878 Exposition Universelle in Paris.

Enrolling at the school, Munch was able to proceed directly to drawing the body, skipping over the tedious practice of first rendering ornaments and plaster casts. Given the prominence of the human figure in his oeuvre, his early difficulties in composing it, and the later critique his contemporaries leveled against his "poor" mastery of the human form, this ability was of the utmost importance. He attended evening classes with Middelthun from spring 1881 through summer 1883, drawing nude models. Munch's compositions were posed, academic, and far from original, but the aim was to render the body with anatomical correctness and master the use of light and shadow.

One noted scholar described Munch's experience with Middelthun as fostering an "antagonistic attitude towards all art other than his own."[41] Most historians and biographers have argued that Middelthun was a strident and inflexible teacher. However, there is no evidence in Munch's letters that he disliked Middelthun's approach, and, even though his attendance was sporadic, he continued his studies for a full two years. Indeed, Munch later wrote fondly and respectfully of his elder, remarking on his impressive ability to judge works of art and suggesting that his praise came at a critical juncture.[42] The admiration seems to have been mutual, as the sculptor praised his student's drawings despite their often summary character.

Soon after he began studying with Middlethun, Munch rented a studio space that he shared with several other young artists in a building nicknamed *Pultosten*, or the Cream Cheese, which was characterized by an atmosphere of bohemian collaboration (see p. 213). Pultosten was affiliated with some of the most progressive figures in Norway's art world; among these was Christian Krohg, who had returned home from his education and Wanderjahr in Berlin, Karlsruhe, and Paris to establish himself and, together with Frits Thaulow and Erik Werenskiold, foster a Norwegian national aesthetic. Krohg agreed to be the informal teacher of the young artists

in the building, correcting and critiquing their works and offering guidance. He thus became Munch's first real painting teacher in a relationship characterized by closeness and a lack of formality. True to form, Munch later claimed that Krohg had never been his teacher, since his first exhibited painting was done without the older artist's direction. But this disavowal came after their estrangement in 1910.[43] Krohg's tight brushwork, Naturalist subject matter, and calm, amiable personality were all directly opposed to the image that Munch would later adopt for himself, so it should come as no surprise that he distanced himself from his former mentor.

Early on in Munch's career, literary and artistic Naturalism reigned, but as members of the Kristiania vanguard gained a foothold, the aesthetic and political ramifications of late Impressionism and the early subjective currents of Symbolism were being felt simultaneously. As Kirk Varnedoe remarked, this somewhat paradoxical combination of Naturalism's moral tone, Impressionism's bold spatial arrangements, and Symbolism's focus on psychological imagination came together at this explosive moment in Norwegian art.[44] One interesting product of this environment was the journal *Impressionisten*. Edited by Krohg, it survived for five years, focusing not on art but on literature, social issues, and brief "impressions" of life in Kristiania. One frequent contributor was Hans Jaeger, the leader of the city's bohemian circle, which Munch joined in the mid-1880s. Jaeger advocated atheism, free love, and socialism, and was decidedly opposed to what he judged the false morality of bourgeois society. He also encouraged his acolytes to write their own biographies, something Munch did in his own poetic fashion for the rest of his life. Krohg was likewise a literary figure whose novel *Albertine* (1885), based on the life of one of his models, told of a young woman drawn into prostitution by corrupt police officials.[45] The book was banned for obscenity, but the artist nevertheless transformed one of its scenes into a painting. The clamor and outrage surrounding Jaeger and Krohg's writings served to set them at the apex of Kristiania's vanguard. This would have made them all the more attractive to Munch, as he was attempting to antagonize his conservative father, who staunchly opposed his new circle of freethinking friends.[46]

These political and artistic currents affected not only Munch's personal life but also the direction of his art. In *Girl Kindling a Stove* [20], for instance, he depicted a household servant—hardly a progressive subject to our eyes. At the time, however, such themes were indicative of Naturalism's desire to break class barriers and reveal the lives of the downtrodden. The most vocal Norwegian advocate of portraying the poor was Krohg himself, as *Sleeping Mother* [21] attests. Here, he took a well-loved, often sentimentalized scene and used it as a means of social commentary: the mother is so exhausted from work that she falls asleep at an uncomfortable angle, sharing the crowded space with her baby and a host of flies. Neither Munch's nor Krohg's imagery exaggerated the truth, but rather sought to present it unvarnished by the bourgeois conventions of maternal and domestic bliss.

Between 1881 and 1882, precisely the moment when Munch shared his studio in Pultosten, an artist's strike erupted in the Kristiania art community that would come to define the members of its budding avant-garde; bring to the foreground issues of style and nation; and stake a claim for modern art in a tradition-oriented country. The conflict pitted the Modernists (Hans Heyerdahl, Krohg, Thaulow, and Werenskiold) against the more conservative Kristiania Art Society, which held a virtual monopoly over exhibitions in the city since its founding in 1836. Run by nonartists, this private group staged annual displays that dictated the tastes of the middle class, promoting work that was realistic and aesthetically beautiful but free of political commentary. The strike precipitated a boycott of the Art Society's exhibitions because the Modernists felt their professional concerns were being ignored. The leaders of the strike had all recently returned home from Paris and, possibly emulating the democratic Impressionist exhibitions, called on Norwegians to embrace new, forward-thinking, French-inflected art.[47]

As Kerry Herman suggested, this fracas in fact sprang from the unfortunate reality of Norway's political situation. Since 1814, the country had been under Swedish rule, struggling for national independence. In their own way, Kristiania's striking artists were promoting a form of national Romanticism as they campaigned for a native art that depicted Norwegian landscapes and people, an art that was informed by European examples but not beholden to them. The leaders of the strike, more than anything, argued in favor of a French model for modernism, one that stressed a radical break from bourgeois

realism yet continued to operate within Norwegian traditions. Although their secessionist stance might seem to imply a vanguard aesthetic approach, what they in fact fought for was a strongly national subject matter wrapped in French Naturalist and Impressionist clothing.

In 1882 and 1883, following the first two independent exhibitions precipitated by the strike, the label Impressionism, rather than Naturalism, began to be associated more and more with vanguard Norwegian painting. The need to define the style both politically and aesthetically soon reached its

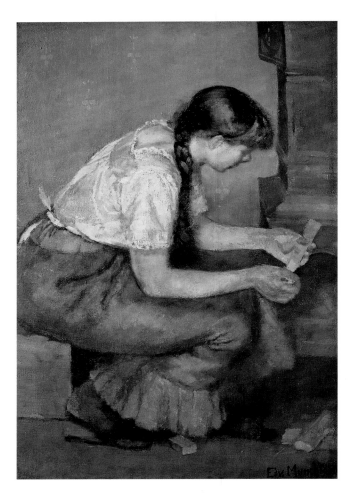

peak, leading to a debate that encapsulated the entrenched positions of several opposing voices and illustrated the vehemence of Norwegian cultural politics. In 1882, Munch's teacher and Pultosten colleague Werenskiold published an article entitled "The Impressionists," in which he embraced enthusiastically the French painting he had seen in Paris and explained its makers' aesthetic project. "Impressionism is easily understood," he reported, "as nothing more than developed naturalism, a better view of nature.... They seek to repeat the impression—*l'impression*—the spontaneous, momentous impression that nature makes on us ... not in any way that we *know* they are but, but what they *look* like."[48] Eschewing "academic rules and prescriptions," Impressionists were instead "lead exclusively by their common sense and artistic sense." For Werenskiold, the Impressionist practice of spontaneous, individual perception held political value, too, connoting a free, antiestablishment stance and echoing the issues raised by the strike. In his terms, Impressionists were born of opposition, and it was this spirit of independence that led to their technical and chromatic experimentation.

Werenskiold's work itself offers an excellent idea of his vision of Norwegian Impressionism. *In Familiar Surroundings* [22], for instance, features his fiancée, Sophie Thomesen, strolling through her family's garden. Her fashionable clothing and umbrella, the outdoor setting, and the open application of paint certainly recall French Impressionist art; indeed, in its subject, this resembles Monet's *Study of a Figure Outdoors (Facing Right)* (p. 48, fig. 48), painted four years later. Begun in Norway but completed in Paris, the canvas intersects both worlds. As was his style, Werenskiold focused on prototypically Norwegian sites and scenes, here representing a farm near Kragerø on the country's southeast coast. But he also experimented with a new, slightly vertiginous vantage point from below, one that Munch later emulated in works such as *Woman in Blue against Blue Water* (p. 49, fig. 49). While Werenskiold's Norwegian audiences would have valued this combination of French style and recognizable, indigenous imagery, French audiences evidently responded to it as well, receiving the work with praise at the Salon of 1882.[49]

Werenskiold's main detractor was Lorentz Dietrichson, Norway's sole professional art historian, who admired his

20 EDVARD MUNCH *Girl Kindling a Stove*, 1883. Oil on canvas; 96.5 × 66 cm (38 × 26 in.). Private collection.

21 CHRISTIAN KROHG (Norwegian, 1852–1925). *Sleeping Mother*, 1883. Oil on canvas; 107.5 × 142 cm (42 3/8 × 55 7/8 in.). The Rasmus Meyer Collection, The Bergen Art Museum.

22 ERIK WERENSKIOLD (Norwegian, 1855–1938). *In Familiar Surroundings*, 1882. Oil on canvas; 46 × 56 cm (18 1/8 × 22 in.). Lillehammer Art Museum, LKM 337. Cat. 143.

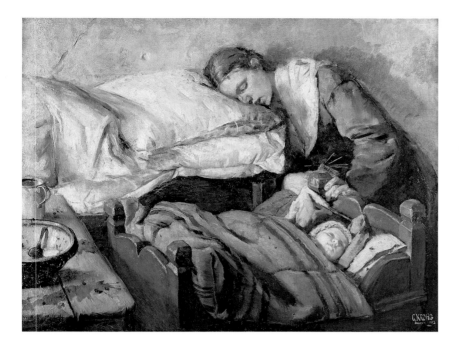

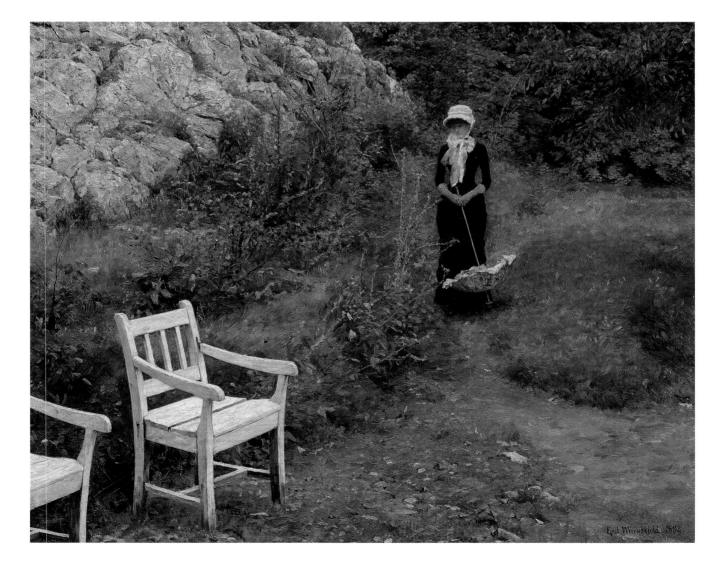

paintings yet disparaged his critical writings, pointedly remarking, "What a big difference there is in being a richly endowed artist and [being able to] express opinions about art."[50] Dietrichson felt that Werenskiold and his supporters should embrace all art, even non-Impressionist art; this included Naturalism, which he associated with Norwegian aesthetic traditions. The difference between the two styles, Dietrichson claimed, was that Naturalism aimed to "bring out a *complete* impression, and only the *complete* impression is the *true* impression," whereas Impressionism only represented nature as an abstraction. Ultimately, he feared that for "young unfinished talents, that do not yet know how to draw," Impressionism would "bring forth a damaging contempt for drawing—an aberration." It is precisely this vocabulary that was to be used against Munch in the coming years, as he was charged with a disregard for the basics, a desire to side with the unconventional for the sake of rebellion, and a lack of respect for his own national tradition. One work from this period that exemplifies Munch's open disavowal of Naturalism and embrace of bohemian life is his *Tête-à-tête* [23]. The smoky café; the ample serving of whiskey on the table; the sexually charged tension between the two figures; and, most importantly, the smudged and nearly abstract nature of the forms that emerge from the haze are all precisely what Dietrichson and later Munch detractors loathed.

III. Learning at Home and Abroad: Appropriation, Ambition, and Conflict

During these heady days of the debates around the strike, when Munch decided to become an artist, took classes with Middelthun, and maintained his studio at Pultosten, he also made his first visits to an artists' colony. In the summers of 1883 and 1884, he traveled to Thaulow's Open-Air Academy, which was located in the rural area of Modum, north of Kristiania. The playwright and journalist Gunnar Heiberg referred jokingly to the group's "French complexion," probably because of Thaulow's recent studies in Paris.[51] It was at Modum that Munch created his first major exhibition piece, *Morning*, which bears witness to a new monumentality in his work, a bold physical presence that focuses the viewer's attention directly on a human form in the act of contemplation.

Morning [24], with its silvery blue hues and introspective aura, shows the artist moving away from the more descriptive form of Naturalism then used by Krohg and toward an increasingly subjective tonality and mood. The earthy hues of *Girl Kindling a Stove*, replete with an awkward handling of the body, suggest that Munch was trying to follow the Germanic training of his mentor, which favored the brown tones he would later disparage. With *Morning*, he took a great leap forward not only in anatomic assurance but in the dappled play of light on the model's face and surroundings, which suggest the influence of French Impressionism by way of Thaulow. And yet this is not an Impressionistic picture per se, but rather one in which Munch was experimenting with several visual modes at once, including that of the budding interest in blue mood painting advocated by Thaulow. The critics of the Autumn Exhibition of 1884 criticized the work as "tasteless" in its lack of finish and representation of an unelevated subject.[52]

Prepared to appreciate contemporary French art and no doubt curious about it, Munch left for Paris in 1885 on a three-week study trip paid for with a scholarship from Thaulow. Lodging in the Ninth Arrondissement, he positioned himself at the heart of the bohemian world and wrote to his aunt Karen of visiting cafés, the theater, the Salon, and the Louvre, and of the many Norwegians he encountered.[53] Judging from the works then on display in the city, and Munch's later absorption of some of their visual codes, there is every indication that this trip was tremendously important to his artistic development. At this point, it is likely that he would have paid equal attention to the paintings of vanguard artists such as Monet and Manet, and to those of artists who are today considered lesser lights. Among these would have been Jules Bastien-Lepage, a giant in the world of French art who made his name with large-scale paintings that fused rural imagery and historical heroism; he had long been popular with Scandinavian artists. Bastien-Lepage died the previous year, and in 1885 there was a major memorial retrospective exhibition being held at the Hôtel Chimay, in addition to many works included in that year's Salon. These pictures must have impressed Munch considerably, as there exists a similarity of subject matter and even painterly handling between Bastien-Lepage's *Village Love* [25] and Munch's *Summer Evening* (p. 35, fig. 33), made four years later. While his earlier work is

23 EDVARD MUNCH *Tête-à-tête*, c. 1885. Oil on canvas; 65.5 × 75.5 cm (25 3/4 × 2 3/4 in.). Munch Museum, Oslo, M 340.

24 EDVARD MUNCH *Morning*, 1884. Oil on canvas; 96.5 × 103.5 cm (38 × 40 3/4 in.). The Rasmus Meyer Collection, The Bergen Art Museum.

25 JULES BASTIEN-LEPAGE (French, 1848–1884). *Village Love*, 1882. Oil on canvas; 181 × 199 cm (71 1/4 × 78 3/8 in.). State Pushkin Museum of Fine Arts, Moscow.

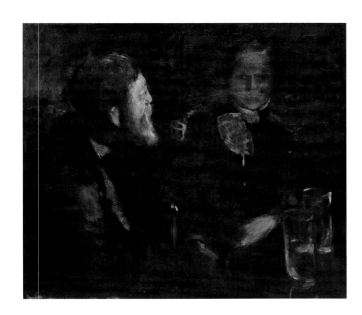

more romantic and physically massive than Munch's more suave, psychologically evocative easel picture, both artists utilized a tempered realist style with broad brushstrokes, revealing their knowledge of Impressionist facture.

Other works on display at the Salon and in private galleries such as that of Georges Petit indicated the dizzyingly wide range of artists then in fashion. The scope of style, genre, and geographical origin was extensive; as the market boomed, artists from Berlin, Kristiania, London, Munich, and elsewhere were flocking to Paris, where a plethora of galleries offered them hope of publicity and sales that were much greater than in their home countries, where private dealers were scarce. The Salon featured paintings that included the realist, academic *Adoration of the Magi* by William Adolphe Bouguereau, Henri Fantin-Latour's more experimental *At the Piano*, Michael Ancher's *Sick Girl*, Puvis de Chavannes's arcadian *Autumn*, Heyerdahl's *Norwegian Landscape*, and the down-to-earth Naturalism of Fritz von Uhde's *Let the Children Come unto Me*. The Galerie Georges Petit displayed an equally diverse if more forward-looking array of canvases by artists such as Albert Besnard, Jean Charles Cazin, Max Liebermann, and Monet.

Perhaps the most relevant image in these divergent exhibitions was Eugène Carrière's *Sick Child* [**26**]. A large canvas that exemplifies the artist's high realist phase, *The Sick Child*

represents a seemingly robust baby in the arms of his mother while her other children look on with concerned expressions. This painting, which was awarded a gold medal, was certainly one Munch would have taken account of, since his Paris visit directly coincided with his work on his own groundbreaking canvas entitled *The Sick Child* [**27**].

Upon his return to Kristiania, the artist continued to exhibit, and his works received increased attention in the popular press that stressed his fresh approach. The most telling of these critical reactions are the famous responses to *The Sick Child*, which was shown at the Autumn Exhibition of 1886. Although painted from a model, the work recalls Munch's older sister Sophie, who succumbed to tuberculosis when she was fifteen. Dying, she looks serenely out the window at right while an older woman holds her hand, bowing her head in despair. While creating the picture, Munch used both brush and palette knife, scoring the paint repeatedly in order to produce a highly energized surface that contrasts with the stasis of the figures. In fact, the work was painted, scratched out, and repainted several times over the course of a year. Throughout the next four decades, the artist finished six different painted versions of *The Sick Child* in a process of repetition that has typically been explained as resulting from the obsessive preoccupations of a man unable to let go of his sister's death. However, the 1896 version illustrated here was in fact commissioned by the Norwegian collector and factory owner Olaf Shou, which suggests that, rather than being controlled by his creative urges, Munch actually chose to channel them for his own profit.[54]

When it was first exhibited in 1886 under the title *Study*, *The Sick Child* became an immediate succès de scandale.[55] Most scholars have characterized the critical reaction as one of ridicule, as conservatives and liberals alike railed against its scratchy, unfinished state. The esteemed critic and historian Andreas Aubert even referred to it as a "castrated half-finished drawing" and an "abortion." Such judgments are often repeated in standard Munch biographies, where they have served to present him as a rebel who fights against society for the sake of his art, misunderstood by everyone. But in fact there was a strong chorus of admirers, including Aubert himself, who was quite positive on the whole. "I am not blind to the beauty," he continued; "had I found it thrown away in a dark attic . . .

26 **EUGÈNE CARRIÈRE** (French, 1849–1906). *The Sick Child*, 1885. Oil on canvas; 82 × 101 cm (32 1/4 × 39 3/4 in.). Musée d'Orsay, Paris.

27 **EDVARD MUNCH** *The Sick Child*, 1896. Oil on canvas; 121.5 × 118.5 cm (47 7/8 × 46 5/8 in.). Göteborg Museum of Art, Sweden, GKM 975. Cat. 54.

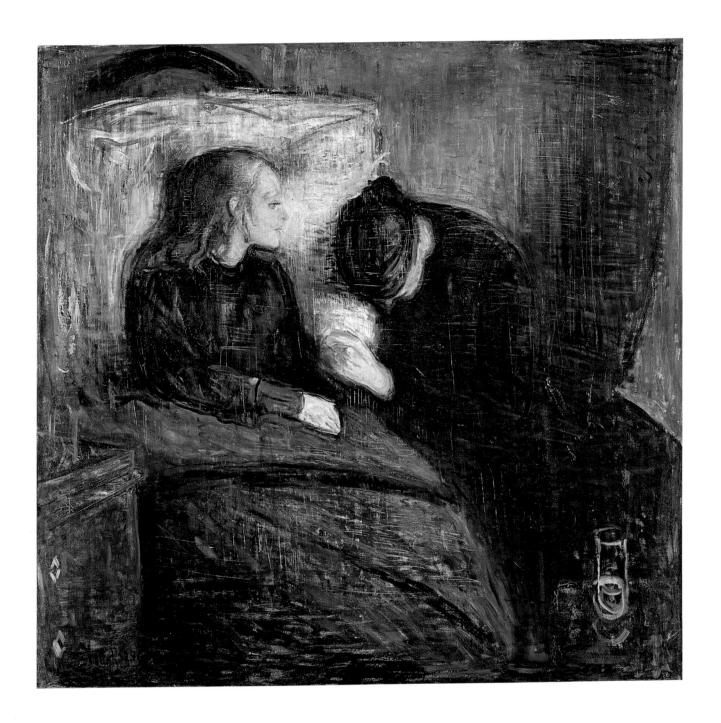

[I would have been] surprised by the fineness of its colors and ecstatic about its soulful expression."[56] For Aubert, the bold hues and expressive force of the painting were more important than its level of finish. Despite his estimation that Munch's "genius" was in danger of "going astray," he argued that the artist was a figure of great talent.[57]

However sensational, *The Sick Child* must also be understood as the latest of many images of tubercular children that Norwegian artists produced at this time. Although the causes, rates of infection, and death statistics are still a matter of some debate, it is generally accepted that Scandinavian countries suffered more than others—and they certainly represented the disease in visual culture to a greater extent.[58] Chief among the chroniclers were Munch's mentors Krohg and Heyerdahl. Three years before Munch's own *Sick Child*, Krohg completed the arrestingly confrontational *Sick Girl* [28], which, like Munch's image, represented the memory of his sister's death. The child is pushed into our space, confronting us with her pale skin, sunken eyes, and the very fragility of life itself, as symbolized by the wilting rose in her lap. Krohg's extreme cropping of the image shocked many of his contemporaries but appears to have had a strong impact on Munch, inspiring him—as did Krohg's other works—to employ unusual angles and vertiginous spaces.

In 1881, *The Dying Child* [29] was completed by Heyerdahl, who was a spiritual and technical inspiration to Munch although never one of his formal instructors. Trained in Kristiania, Munich, and Paris, Heyerdahl moved from religious imagery to domestic genre scenes and then on to landscapes of Åsgårdstrand (see p. 171, fig. 189), all depicted with a startling and evocative use of color. *The Dying Child* also represents a childhood memory: like Munch, Heyerdahl was haunted by witnessing the death of a sibling.[59] The boy in the foreground is perhaps the artist himself, weeping in his nightshirt; his mother's hands are clasped as if praying for a miracle, and his father seems to implore the baby boy to return to health. The heart-wrenching scene must have affected Munch with its humble interior, depth of emotion, and loose brushwork.

Munch may have been even more inspired, however, by the work's success. *The Dying Child*, which was awarded the Grand Prix de Florence at the Salon of 1882, was acquired by the French state, and Heyerdahl capitalized on the eager

market for the picture, painting several versions for sale in Norway. In 1884, Munch wrote to his friend and fellow painter Bjarne Falk in what was a rare mention of another artist's work, lamenting, "Did you read in the newspapers about the praise he received for his *Dying Child* and how he sold it to a museum in Paris? It is truly sad that it could not be purchased for our national museum. Such paintings—and not those painted in a brown sauce of which [the National Gallery] is so full—would be refreshing and educational for young artists."[60] No doubt Munch's own desire to tackle this theme was in part out of homage to his elders, but it also sprang from a self-conscious desire to better them and to build upon a market seemingly hungry for such imagery. He later wrote to his biographer Jens Thiis, dismissing the genre as "the days of pillows, of sick beds, of feather quilts," suggesting that he improved upon a stale theme and modernized it.[61] Munch's choice of this motif was in some sense a challenge, and the furor it caused was in every way a success in that it drew the attention he desired.

Equally important to his formal artistic education, however, were developments closer to home that fostered artistic unity and the forceful promotion of a Norwegian avant-garde. In the Autumn Exhibition of 1885, Thaulow and Heyerdahl were represented with eight and sixteen works, respectively; this gathering must have inspired Munch to emulate and surpass their growing popularity by doing something altogether different. Following these exhibitions and the momentum they created, a group of six painters—Werenskiold and Peterssen, plus Harriet Backer, Kitty Kielland, Gerhard Munthe, and Christian Skredsvig—spent the summer working and living at a farm called Fleskum in Bærum, close to Kristiania (see p. 213). All had been trained in Munich and, eschewing the brown tones of the German school, went to study in Paris, returning to Kristiania in the early 1880s to found their own movement. The Fleskum Summer, as it came to be called, was in many ways a model for Munch in that these artists worked in a manner that absorbed foreign influences while creating what they felt was a prototypically Norwegian mode of painting. While the communal environment of their project would be anathema to his more independent mode of working, the combination of styles, imagery, and national undertones in their landscape scenes constituted an important precedent.

28 CHRISTIAN KROHG *Sick Girl*, 1880–81. Oil on canvas; 102 × 58 cm (46⁷/₈ × 22⁷/₈ in.). The National Museum of Art, Architecture and Design, Oslo, NG 805.

29 HANS HEYERDAHL (Norwegian, 1857–1913). *The Dying Child*, 1889. Oil on canvas; 24.5 × 25.5 cm (9⁵/₈ × 10 in.). The National Museum of Art, Architecture and Design, Oslo, NG.M.00349. Cat. 114.

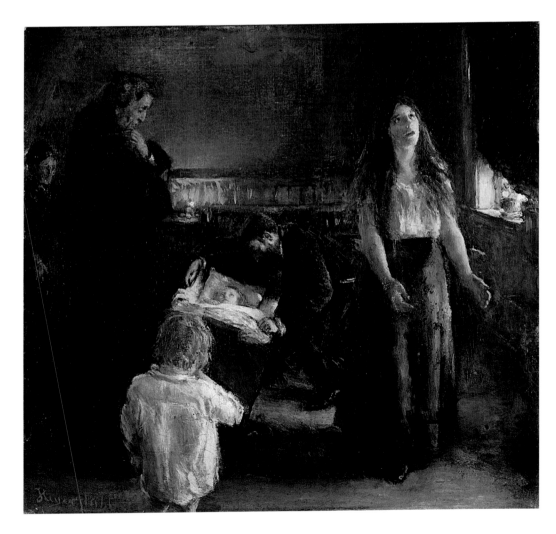

One of the central figures in the Fleskum group was Peterssen, whose *Afternoon at Dælivannet* and *Nocturne* epitomized the tenor of the summer's goals. Peterssen had recently been in Paris, where he had been enraptured by Puvis de Chavannes's *Sacred Grove, Beloved of the Arts and the Muses* [30], remarking of the work, "There is something muted and dreamy, a certain sacred evening stillness."[62] We can see clearly how the muted colors, dreamlike quality, and spiritual mood affected his *Afternoon at Dælivannet* [31], with its quarter moon reflected in the calm, green-blue water. In *Nocturne* (p. 19, fig. 13), created the next year, the artist used this very same setting but inserted a wood nymph resting on a tree. Enhancing the soft-focus landscape with this imaginary addition, Peterssen also made the name more evocative, borrowing the musical title used frequently by James McNeill Whistler, who was living in Paris at the time.

Following the Fleskum Summer, critics and artists began to use the term *Norwegian mood painting* as a way to characterize the works of the group and its followers, who concerned themselves with indigenous landscape and also with mood and subjectivity. Considering works such as Munch's *Summer Night's Dream: The Voice* (p. 75, fig. 73) and *Moonlight* (p. 97, fig. 98), in which he conjured up magical evening landscapes that depict specifically Norwegian settings, enables us to recognize him as a product of his time rather than set apart from it, or somehow beyond the nationalistic concerns of his artist colleagues. Once Munch reached his stride, he seems to have been able to draw from a variety of images and styles, obliged to follow no one approach in particular. His art was neither French nor Norwegian, neither Impressionist nor Symbolist—the autonomous stance he took was calculated, defiant but very much of the moment. Indeed, Kitty Kielland captured it inadvertently when she wrote about the perceived Norwegian dependence on foreign art: "What was learned abroad was well digested, it entered the Norwegian bloodstream, and strengthened rather than weakened national feeling."[63] Her words come to the very heart of the matter, suggesting that "pure" Norwegian art was not tainted by outside influence but rather emboldened by it. For Kielland and her Fleskum cohorts, foreign aesthetics were made indigenous through the act of returning home, something that Munch also made a point of doing each and every summer.

Adding to the sense of a developing movement was the mammoth *Nordic Exhibition of Industry, Agriculture, and Art*, staged at Copenhagen's Tivoli Gardens in 1888. Munch showed two works, which have been identified as *Christian Munch on the Couch* (1881; Munch Museum, Oslo) and a now-lost painted version of *Bohemians*.[64] Similar to the earlier *Tête-à-tête*, the destroyed *Bohemians*, later reprised in the etching *Kristiania Bohemians I* (1895), publicized Munch's connection to the Norwegian vanguard in a very powerful way. In addition to a rich selection of Danish, Norwegian, and Swedish paintings by influential contemporaries such as Anna Ancher and Ernst Josephsen, the exhibition also included a separate, large-scale display of French art. This component included a remarkable range of work, from Eugene Delacroix's Romanticism to Gustave Courbet and Henri Fantin-Latour's Realism, from academic painters such as William Adolphe Bouguereau to the Impressionist Alfred Sisley. Unlike the divided zones of the Salon and even the more daring dealers' shops Munch saw in Paris three years earlier, this exhibition argued for an embrace of divergent styles, of all that could be referred to and championed as French. The event not only showed Munch a broader range of production than ever before, but perhaps encouraged him to experiment even further with stylistic fusion.[65]

Following his trip to Denmark, Munch created the genre picture *At the General Store in Vrengen* [32], which contains undertones of the Impressionist and nascent Neo-Impressionist paint handling that he could have encountered in Copenhagen. The artist offset the cool blues with complementary pinks and browns, and combined long, broad brushstrokes in the floorboards with smaller, shorter ones laid down in a bricklike manner above the head of the child at the counter. Painted in a country town on the Kristiania Fjord, the work depicts shoppers and clerks who are absorbed in their own thoughts and actions. The most striking figure is the small girl at left; wearing a hat and carrying a small basket, she stares at the viewer in an unsettling manner that is devoid of emotion. While not overtly disturbing, the painting conveys a sense of psychological tension and isolation that would become increasingly prominent in the coming years.

The artist rendered this tension in a more explicitly sexual and emotional way in the powerful *Summer Evening* [33]. Here,

30 PIERRE PUVIS DE CHAVANNES (French, 1824–1898). *The Sacred Grove, Beloved of the Arts and the Muses*, 1884–89. Oil on canvas; 93 × 231 cm (36⁷/₁₆ × 90¹⁵/₁₆ in.). The Art Institute of Chicago, Potter Palmer Collection, 1922.445.

31 EILIF PETERSSEN *Afternoon at Dælivannet*, 1886. Oil on canvas; 64 × 91 cm (25¹/₄ × 35⁷/₈ in.). Private collection, courtesy Galleri Kaare Berntsen, Oslo. Cat. 131.

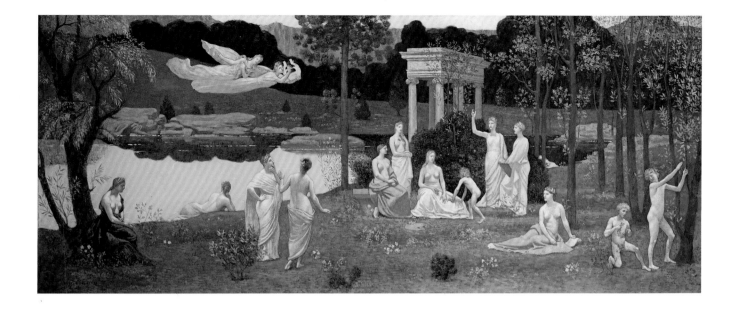

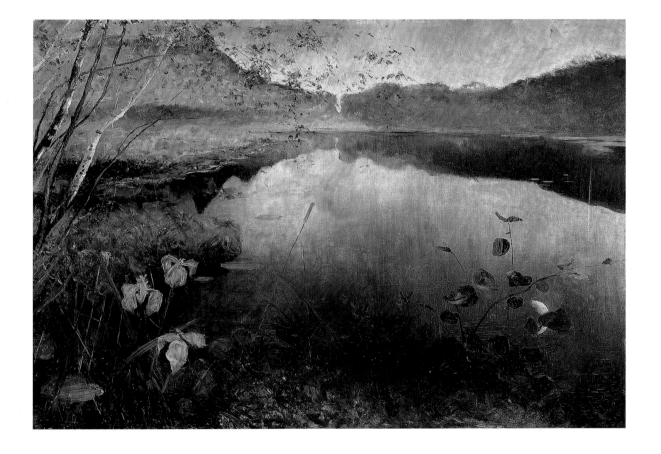

the theater critic Sigurd Bødtker appears to step closer to Inger Munch even as she draws more fully into herself. He is dressed in tones of brown that tie him to the house, just as Inger's blue skirt and shawl resonate with the brightly colored seascape behind her. Between the pair is a tree that suggests what later became one of Munch's recurrent motifs, Adam and Eve beside the Tree of Knowledge. For the first time, the artist depicted a dizzying space that is effectively divided between figure and landscape. His long, loose, painterly strokes indicate that he shifted from his heavily impastoed, Impressionist-influenced brushwork to one that is more fluid, rounded, and diluted—to such an extent that in areas the canvas is stained. In *Summer Evening*, Munch modernized the heroic rural imagery favored by contemporaries such as Werenskiold, fusing it with biblical undertones. His daring use of facture and staining, spatial recession, and sexualized myth suggests that this major but relatively overlooked painting marked a watershed moment in which he attempted to create a truly new form of art.

Trying to promote himself as Norway's artist of the future, and also to generate sales and win a coveted state grant to study in Paris, Munch made a bold move in the spring of 1889. At the young age of twenty-five, he organized a retrospective exhibition of his work, which would be the first of many attempts at self-promotion. Comprising 110 paintings and drawings and shown in the Student's Organization on University Street, just off Kristiania's main thoroughfare, the display elicited a great deal of commentary. As one negative critic astutely argued, "A young, immature artist must possess great impudence and a total lack of modesty to appear like this ... especially when he is obviously not at all finished with his training."[66] Indeed, it did take a great deal of confidence for Munch to launch what has been called the first solo exhibition in modern Norway, and to charge an entry fee, since he had dedicated himself to painting only a few years earlier. Moreover, given that the separate Autumn Exhibitions had recently taken hold as alternative avenues in their own right, his decision to step beyond them and stage his own display was indeed a radical statement. The majority of the works in the exhibition were immature efforts, and Munch perhaps included them to suggest that, while talented, he would be a suitable candidate for formal study abroad.[67]

Munch's artist colleagues and his small coterie of critical supporters, despite their mixed reviews, concluded that his work showed promise. Krohg, who wrote a highly complimentary article, argued that the exhibition confirmed Munch as the sole embodiment of what he called the Third Generation of Norwegian artists. The first included Tidemand and Gude, and the second comprised Heyerdahl, Krohg, Peterssen, Thaulow, and others who favored blue mood paintings. But Munch, Krohg insisted, moved beyond them in terms of his daring imagery and brushwork, existing as the figure "on whom the biggest hopes are tied."[68] He considered it a badge of honor that his student's draftsmanship was poor, that the public did not like his work, and that he was pilloried in the press, because "Munch does not resemble anyone else ... he *sees* in a different way than other artists. He sees only the important things and paints only that." For Krohg, Munch saw and told the truth, not in a polished and complete sense but rather in an evocative one. Despite views to the contrary, Krohg suggested that art is finished when the artist declares it so, going on to maintain that a lack of finish helps viewers become a part of the canvas because they in turn complete the work in their imagination.

For his part, Andreas Aubert praised aspects of Munch's production, although with some notable reservations: "I find the genius in his talent and admire its fineness, quantity, and strength," he wrote, "but this talent ... has not ripened into something."[69] The critic complimented Munch's use of color and his "deeper poetic mind and unique nervous compassion," which compensated for his works' "slovenly and raw" execution. Aubert perceived that Munch's art showed signs of genius but found it hard to move beyond the feeling that it lacked "finish" and a vital sense of "self-critique." Despite his concerns, however, he recommended, "Munch ought to be one of the first to receive one of our two-year stipends, but with the expressed condition that he find an excellent teacher in life drawing.... it will be to Munch's own best interest." In the end, Munch accomplished one of his main goals for the exhibition: he was awarded the prestigious grant from a committee that included Peterssen and Diriks, with a strong letter of support from Werenskiold.

In the summer of 1889, Munch created *Summer Night: Inger on the Beach* (p. 13, fig. 2). Among his most powerful

32 EDVARD MUNCH *At the General Store in Vrengen*, 1888. Oil on cardboard; 45 × 69 cm (17 3/4 × 27 1/8 in.). Lillehammer Art Museum, LBM M. 199. Cat. 1.

33 EDVARD MUNCH *Summer Evening*, 1889. Oil on canvas; 150.2 × 195.3 cm (59 1/8 × 76 7/8 in.). Statens Museum for Kunst, Copenhagen, KMS 2070. Cat. 3.

works to date, this painting showed him to be moving beyond his contemporaries. As Krohg had astutely remarked, the younger painters of Munch's generation did not break with the recipe of blue mood painting—they simply painted more shades of blue.[70] As we have already seen, in some ways *Summer Night* was just that, a blue mood painting akin to those of his mentors and elders. But it was also more. The pale gray and blue tonality, and the dark, silvery stones that populate the Åsgårdstrand beach add a psychological element that goes beyond the transcription of Norwegian landscapes and a celebration of their characteristic colors. Here, the barren rocks are not a backdrop: they have become Inger's company, alive with the tension of her cold, resolute presence. By introducing a new kind of emotion into such a scene, Munch was indeed surpassing his peers. He was doing so, however, from the familiar place of blue mood painting. Over the next three years, he would move from the known, the borrowed, to the truly inventive.

IV: Moving Away: Formal and Subjective Dislocations

In the thematic, technical, theoretical, and stylistic watershed that occurred between 1889 and 1893, Munch's subject matter and style became increasingly experimental and idiosyncratic. By the end of this seminal period, he arguably became the mature artist we now celebrate, having moved toward the images of anxiety and isolation for which he is most remembered. However, the transition from Neo-Romantic Naturalism and Impressionism to the quasi-Symbolist subject matter and facture of *Evening on Karl Johan* (p. 57, fig. 58), *Anxiety* (p. 90, fig. 90), *The Scream* (p. 92, fig. 93), and *Death in the Sickroom* (p. 105, fig. 104) was by no means seamless. During this time, Munch shifted back and forth between the various styles in his repertoire. For example, he created bustling street scenes such as *Rue de Rivoli* (p. 47, fig. 47) with regular, earthy-hued strokes of orange and yellow at the same moment that he painted strident blue, violet, and white interiors like *The Girl by the Window* (p. 52, fig. 50), with its tilting perspective and slashing brushstrokes. Between spring and summer 1889 alone, he created two startlingly different canvases, *Summer Night: Inger on the Beach* (p. 13, fig. 2) and *Music on Karl Johan* (p. 42, fig. 40), which likewise exemplify his desire to create mood, adopt imagery from other artists, and invent new images of his own within a Norwegian context.

The first few months of Munch's scholarship stay in Paris were eventful, to say the least. Arriving in early October 1889, he lodged with two Norwegian artists and began to take life drawing classes at the atelier of the revered artist Léon Bonnat, who taught many Scandinavian painters, including Heyerdahl and Werenskiold (see p. 214).[71] Perhaps as important, however, were Munch's visits to the immense Exposition Universelle of 1889 and all of its important satellite shows, which were undertaken to mark the centenary of the French Revolution. The art component of the fair comprised the regular Salon; national displays such as the Norwegian section, which featured Munch's *Morning* (p. 27, fig. 24); a retrospective section covering French art since 1789; and the exhibition *Impressionists and Synthetists*, which was held at Volpini's Café des Arts just outside the exposition's gates. Organized by Gauguin, Emile Bernard, and others, the latter would have afforded Munch the opportunity to see their work.

Because of his many disruptions in lodging, which were likely due to a lack of funds, the letters telling Munch of his father's death remained unopened, and he received the news the day after the burial had taken place. This event had profound emotional effects for many years to come and also faced Munch with the responsibility of providing for his sisters and maiden aunt, who were left destitute. Soon thereafter, he moved from Paris, where the bustling atmosphere and influenza epidemic had set his nerves on edge, to the calmer atmosphere of St. Cloud, which was located on the Seine about six miles west of the city. From the relative quiet of his new quarters (see p. 215), he painted and wrote a series of diaries, letters, and artistic credos, perhaps as a way to relieve himself of guilt over his misunderstandings with his father and chart his future career.[72]

During this watershed moment, Munch spent a great deal of time with the Danish poet Emanuel Goldstein, whose writing style and personal philosophy were shifting toward Symbolism, as were Munch's. Copious letters between the two friends attest to their shared interests in forging a new path. In his "St. Cloud Manifesto," Munch formulated his radically shifting ideas about emotive expression and its relation to subject matter, framing them as reminiscences of a night in a music hall filled with dancers and sexual interludes:

There was love and hate, longing and atonement, and beautiful dreams —and the mellow music fused with the colors. All of the colors … in that blue gray haze. The music and the colors captured my thoughts. They followed the light clouds and were borne by the sweet melodies into a world of happy bright dreams. I should paint something—I felt it would go so easily—it would form itself under my hands as if by magic,—Then they would see…. She closes her eyes and listens with an open, quivering mouth to the words he whispers in her long flowing hair. I would depict it just as I saw it in the blue haze…. People would understand the sacredness, the mightiness of it and they would remove their hats as if in a church … one would no longer paint interiors, people who read and women who knit. They should be living people who breathe and feel, suffer and love.[73]

Munch's poetic description of the visual and aural majesty of the café experience is filled with the hues and subjects of his subsequent creations. Recording his perceptions, he imagines how he might render them in paint, grandiosely suggesting that viewers would then be able to "see" his unique vision of existence—and perhaps his artistic power and ability as well. His desire to represent love, hate, longing, despair, and dreamy erotic connections as if they were sacred subjects suggests what would become his larger strategy of transforming the profane into the divine. By creating his own carnal mythology, Munch hoped to break free completely from Naturalism's documentary emphasis. He would no longer paint "interiors, people who read and women who knit," but rather "living people who breathe and feel, suffer and love."

This was a pivotal moment in the formulation of Symbolist theory in France, and the "St. Cloud Manifesto" clearly emerged from Munch's desire to connect with his contemporaries through both literary and visual texts. He was no doubt aware of writings by figures such as G.-Albert Aurier, who stressed the importance of an artist's national heritage, psychological make-up, and ability to manipulate color and depict subjective, mystical experience. Describing a painting by Van Gogh in 1890, Aurier employed lofty language that prefigured Munch's and reveals their shared attraction to explosive color and emotion: "Squatting houses contort themselves like beings in a passion of physical delight or suffering, or like beings who simply think…. Here is the universal, mad, blinding glitter of things … color becomes flame, lava, and precious stones, light becomes a consuming fire; life, a high fever."[74] Like his canvases, it seems, Munch's lyrical writings were at once indebted to works by other artists and very much connected to the intellectual currents of his place and time.

Night in St. Cloud, which Munch first executed in 1890 (see p. 63, fig. 61), repeated in pastel on canvas in 1892/93, and reprised again in a luminous oil of 1893 [34], was in many ways a realization of the theories he set out in his manifesto. Here, a top-hatted man sits in a dark, hazy interior; resting head on hand, he stares dejectedly out the window. The figure has been described both as Goldstein and as Munch himself, sitting in his hotel and looking out over the Seine, which was lit with gas lamps. Given Christian Munch's recent death, it is tempting to read the work simply as his son's autobiographical essay on his own despair and increasingly self-imposed isolation. Indeed, the picture, as his manifesto proclaimed, showed "through a blue haze" someone who certainly breathed and felt.[75]

This combination of a decidedly open, loose style of brushwork and a dark, cocoonlike interior space marked a new and highly experimental phase for the artist. Rather than an act of artistic isolation, however, these choices actually served to connect his work to that of contemporaries such as Harriet Backer, whose luminous *By Lamplight* [35] depicts a woman seated by a window. The shadowy space, distorted and slightly ominous perspective, and overwhelmingly blue tonalities relate directly to Munch's picture despite Backer's more overtly Naturalist, rural subject. Letters between Munch and his family also attest to his frequent social interactions in St. Cloud and his travels back and forth to Paris. There is no doubt that Munch was depressed and continued to drink heavily, but the relationship between *Night in St. Cloud* and his own frame of mind has long been exaggerated. Perhaps hoping for a purgative effect, Munch wrote in his diaries more than usual at this time, and it is these poetic documents that have been used to explicate his imagery.

Another painting created during this moment is the gemlike *The Seine at St. Cloud* [37]. Here, Munch divided his composition into three bands: the foreground, in which he used open, squiggly strokes; the middle ground of the water and bridge, which recalls Monet in its assured, sketchy application; and the sky, in which the brushwork is far more

34 EDVARD MUNCH *Night in St. Cloud*, 1893. Oil on canvas; 70 × 56.5 cm (27¹/₂ × 22¹/₄ in.). Private collection. Cat. 15.

35 HARRIET BACKER (Norwegian, 1845–1932). *By Lamplight*, 1890. Oil on canvas; 64.7 × 66.5 cm (25¹/₂ × 26¹/₈ in.). The Rasmus Meyer Collection, The Bergen Art Museum, RMS.M.20. Cat. 89.

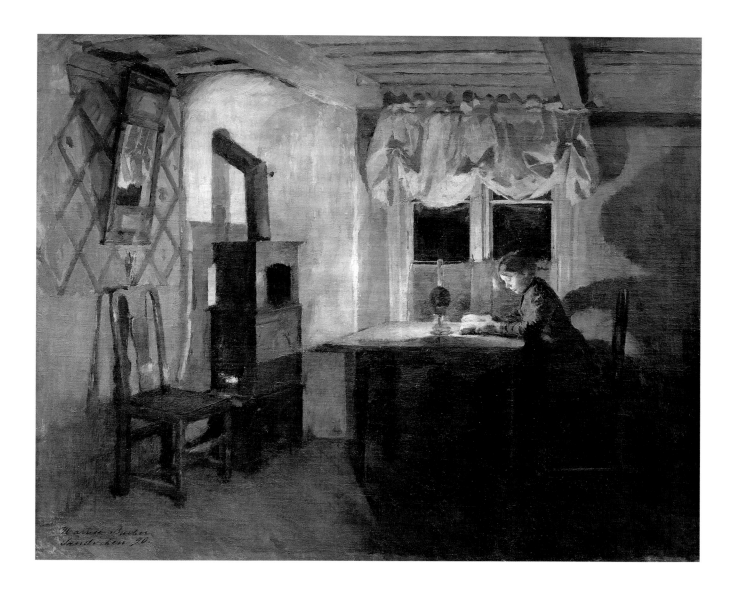

expressive and rounded. A man, perhaps a police officer, who once walked in the foreground was partially painted over, although the prominent shadow at lower left suggests a lurking presence. As in *Night in St. Cloud*, the artist used white underpainting in order to add light and clarity to the surface of the image.

Like James McNeill Whistler's *Valparaiso Harbor* [**36**], which Munch would likely have seen at the 1890 Salon or in the showrooms of Paris dealers, *The Seine at St. Cloud*, with its long boardwalk and high vantage point, suggests the majesty and glittering effects of the night sky. Munch also adopted Whistler's use of the term *nocturne* in his manifesto when he sought to describe the fusion of music and color he was attempting in the "blue haze." Whistler's atmospheric *Nocturne* paintings and lithographs, and works such as Henri Charles Guérard's blue-toned etching and aquatint *The Basin at Dieppe* [**38**], with its twinkling lights and reflective boats, would also have been on view, and may have stimulated Munch's increasing fascination with the symbolic and technical effects of night.

There is no question that Munch's experience of French vanguard painting in Paris and elsewhere had a transforming effect on his subject matter, palette, handling of paint, and theoretical approach to subjectivity. One major source of inspiration was the wide array of street images produced by the Impressionists. Before his Parisian trips of 1885 and 1889–91, the artist had created only a few urban views, which were relatively rare in Kristiania. However, between 1889 and 1892, he made significantly more pictures that focused on the bustling avenues of Paris and Kristiania, experimenting with a variety of painting styles, chromatic effects, and perspectival views, as if trying each one on for size.

The city street as a subject for modern art was almost without precedent in Norway, in part because dense urban centers were few but also because Norwegians, with their agrarian roots, favored representations of peasants and landscapes; so did tourists, whose trade supported many painters.[76] In France, however, the street and the crowd were popular Impressionist themes, occupying a place in the public consciousness as a space of sexual titillation and the home of Charles Baudelaire's flaneur, or gentleman stroller. To a great extent, this new fascination with public places was spurred by Baron Georges-Eugène

36 JAMES MCNEILL WHISTLER (American, 1834–1903). *Valparaiso Harbor*, 1866. Oil on canvas; 76.6 × 51.1 cm (30 1/8 × 20 1/8 in.). Smithsonian American Art Museum, gift of John Gellatly, 1926.6.159. Cat. 144.

37 EDVARD MUNCH *The Seine at St. Cloud*, 1890. Oil on canvas; 61 × 50 cm (24 × 19 5/8 in.). Frances Lehman Loeb Art Center, Vassar College, Poughkeepsie, N.Y., gift of Mrs. Morris Hadley (Katherine Blodgett, class of 1920), 1962.1. Cat. 5.

38 HENRI CHARLES GUÉRARD (French, 1846–1897). *The Basin at Dieppe*, 1883/89. Etching and aquatint with burnishing in black and blue-gray ink on ivory laid paper. Image: 29.5 × 47.5 cm (11 5/8 × 18 3/4 in.); sheet: 45.5 × 62.1 cm (17 7/8 × 24 1/2 in.). The Art Institute of Chicago, Mary S. Adams Endowment, 2003.259. Cat. 110.

Haussmann's ambitious urban renovation of Paris at mid-century, which created the long, wide boulevards, regular facades, and mansard roofs that shape our experience of the modern city. The open streets and the panoramic views they made possible no doubt effected Munch's perception of urban spaces.

Although Munch in many ways introduced the Impressionist cityscape to Norway, his mentor Krohg before him had frequently represented the economic and political tensions of urban life. Like his English contemporary George Clausen, whose *Schoolgirls, Haverstock Hill* [42] combines social realism, exaggerated perspective, and sexual allure, Krohg used the grim realities of everyday life as his inspiration.[77] In *Village Street in Grez* [39], for example, he depicted a group of exhausted French workers in blue smocks and caps, using gray and pale blue tones that are seemingly at odds with the bright blossoms on the trees at right. The dark umbrella in the central figure's hand acts like a somber void at the bottom of the composition. This jarring effect, when combined with the tilted perspective of the street, recalls the radical treatment of space in Japanese prints, which were then being imported to Paris in large quantities. The young woman who walks toward the viewer seems as if she will collide with the central worker, although their gazes do not meet.

It was no doubt his encounters with Caillebotte's work on his frequent trips to Paris that encouraged Krohg to adopt this exaggerated, unnerving approach to perspective even while remaining faithful to the bold, brushy realism that was his signature style. Indeed, he could have seen Caillebotte's iconic *Paris Street, Rainy Day* [see 41] during his 1877 visit, when it was on view in the Second Impressionist Exhibition. Krohg's and Caillebotte's paintings were superb examples for Munch to consider before he left Kristiania, but it was not until he actually visited the French capitol that he attempted major compositions that were self-consciously modeled on Impressionist street scenes.[78] One major painting he created in the summer of 1889, *Music on Karl Johan* [40], suggests that he was paying close attention to Caillebotte's and Krohg's unsettling representations of individuality amid the crowd. Here, a military band marches down the center of Kristiania's main thoroughfare while pedestrians stroll down either side. As in *Paris Street, Rainy Day*, these city dwellers are caught up largely in their own isolated worlds, and, like both that work and

39 CHRISTIAN KROHG *Village Street in Grez*, 1882. Oil on canvas; 102 × 70 cm (40 1/8 × 27 1/2 in.). The Rasmus Meyer Collection, The Bergen Art Museum, RMS.M.214. Cat. 122.

40 EDVARD MUNCH *Music on Karl Johan*, c. 1889. Oil on canvas; 102 × 141.5 cm (40 × 55 3/4 in.). Kunsthaus, Zurich.

41 GUSTAVE CAILLEBOTTE (French, 1848–1894). *Paris Street, Rainy Day, sketch*, 1877. Oil on canvas; 54 × 65 cm (21 1/4 × 25 5/8 in.). Musée Marmottan Monet, Paris, 5062. Cat. 92.

42 GEORGE CLAUSEN (English, 1852–1944). *Schoolgirls, Haverstock Hill*, 1880. Oil on canvas; 52.1 × 77.2 cm (20 1/2 × 30 3/8 in.). Yale Center for British Art, Paul Mellon Collection, B1885.10.1. Cat. 96.

Village Street in Grez, an umbrella acts as a major compositional element, drawing the viewer's eye to the foreground. In his poetic descriptive text for this imposing painting, Munch evoked the combination of aural, temporal, and visual sensations that may have inspired him: "One clear, sunny day I heard the music coming down Karl Johan—it filled my soul with celebration. The spring—the light—the music—melted together into a quivering happiness.... I painted the picture and let the colors quiver in time to the rhythm of the music."[79]

After spending the summer of 1890 in Norway, Munch was awarded a second state scholarship and returned to France the following November. After stays in La Havre and Nice, he shifted to Paris, living for a few weeks at 49 Rue Lafayette, where he wrote to his aunt of a "fairly nice room with a balcony."[80] He also mentioned that he was "racing from one exhibition to another," and while there were any number he might have seen, it is revealing that in no surviving letter does he mention one, or refer to any of the French artists whose canvases he would have studied, from those featured at Galerie Durand-Ruel to the Salon des Indépendants.

The painting by Munch that resonates most vividly with French Impressionism in general, and with Caillebotte specifically, is the luminous *Rue Lafayette* [43], which directly quotes the French artist's *A Balcony, Boulevard Haussmann* [45], a view from an apartment only blocks away from Munch's lodgings. Although clearly indebted to both *A Balcony* and Krohg's earlier *Karl Nordström* [44], *Rue Lafayette* contains all the hallmarks of Munch's emerging style, but infused with a dose of French experimentation. Whereas Caillebotte executed his canvas in tighter brushstrokes and obscured the street with towering trees, Munch used a combination of looser arabesques, dots, and slashes to assemble a work that is more about urban velocity and rushing perspective than about the voyeurism that inflects Caillebotte's picture. Munch's top-hatted subject is faceless—we cannot read his expression—but his laconic stance and the casual manner in which he rests his arms upon the balcony convey the mastery he feels over his domain. The artist rendered the swirling design of the wrought-iron balustrade in long, curving strokes of blue, dark red, green, and ocher paint, and the shadows in bright pastel shades of light blue and yellow. The buildings, people, and street below are constructed of rectangular dashes of paint,

with some areas in shadow composed of freely zigzagging marks. In true Impressionist fashion, the colors are largely unmodulated, and the white, unprimed canvas activates the shimmering painted surface. The strokes themselves, though, are not modeled on those of any one painter; in fact, they became a hallmark of Munch's mature style in the 1890s, as his technique became more independent and his imagery more personal.

Another street scene executed at this time was *Rue de Rivoli* [47], a work whose depiction of movement and sheer physical speed prefigured Futurism by nearly three decades. Although again using a high vantage point, Munch did not focus on the viewer but on the frantic forward motion of the pedestrians and carriages, and on the modernity of the buildings themselves. The balcony at left, where he presumably stood, is abstracted to the point of being almost unrecognizable and is pushed up against the picture plane, emphasizing with its own solidity the frenzied action below. Here, the artist did not attempt to capture a recognizable place, but rather to portray the bustle of a Parisian street. His approach to the subject certainly resembles that of Monet's *Boulevard des Capucines* [46], which he could have seen at Galerie Georges Petit in 1889. The bird's-eye perspective, the style of rendering pedestrians, and the Parisian site are clearly connected, however different the use of color may be. The other great difference is Munch's rushing perspective, which prefigures his later *Scream* imagery.

Besides these prototypically modern street scenes, Munch created a handful of Impressionistic paintings of women and men by the ocean. In some ways these bridged the gap between Norway and France, combining the Northern motif of isolated seaside figures with a marginally Impressionist facture and the practice of placing subjects within natural settings. Munch's *Woman in Blue against Blue Water* [49], probably created after his return to Norway, is clearly connected to Monet's *Study of a Figure Outdoors (Facing Right)* [48], which the younger artist may have seen at Galerie Durand-Ruel in 1891. The same distinct bands of bold green and yellow appear in both works, and the women's bodies serve to divide the spaces in half, the shade of their dresses picking up elements of sky, water, and grass. However, Monet's light, plein-air work is far less intense and expressive than Munch's canvas, which confronts us with the figure's direct gaze. The latter work also possesses

43 EDVARD MUNCH *Rue Lafayette,* 1891. Oil on canvas; 92 × 73 cm (36 1/4 × 28 3/4 in.). The National Museum of Art, Architecture and Design, Oslo, NG.M.01725. Cat. 8.

44 CHRISTIAN KROHG *Karl Nordström,* 1882. Oil on canvas; 61 × 46.5 cm (24 × 18 1/4 in.). The National Museum of Art, Architecture and Design, Oslo, NG 1223.

45 GUSTAVE CAILLEBOTTE *A Balcony, Boulevard Haussmann,* c. 1880. Oil on canvas; 69 × 62 cm (27 1/8 × 24 3/8 in.). Private collection.

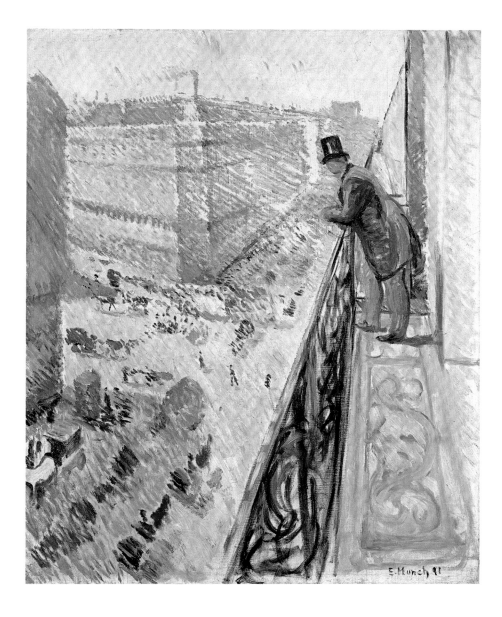

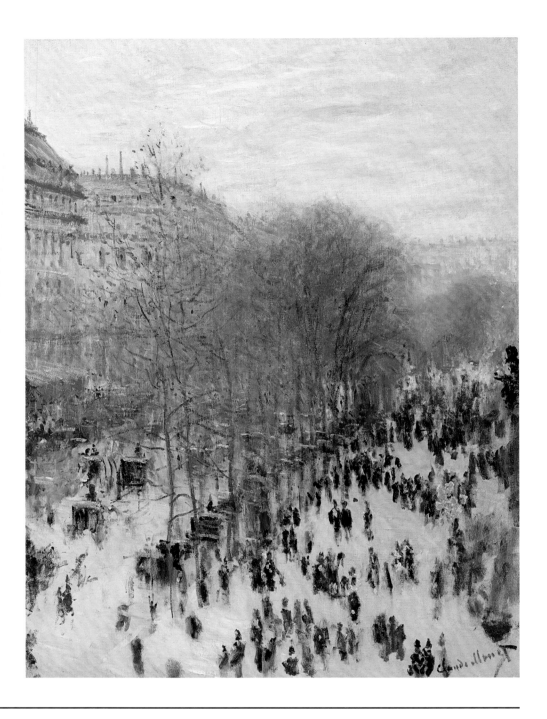

46 CLAUDE MONET *The Boulevard des Capucines*, 1873. Oil on canvas; 80.3 × 60.3 cm (31 ⁵/₈ × 23 ³/₄ in.). Nelson-Atkins Museum of Art, Kansas City, Missouri, purchase, The Kenneth A. and Helen F. Spencer Foundation Acquisition Fund, F72-35. Cat. 127.

47 EDVARD MUNCH *Rue de Rivoli*, 1891. Oil on canvas; 81 × 65.1 cm (31 ⁷/₈ × 25 ⁵/₈ in.). Harvard Art Museum, Fogg Art Museum, gift of Rudolf Serkin, 1936.153. Cat. 7.

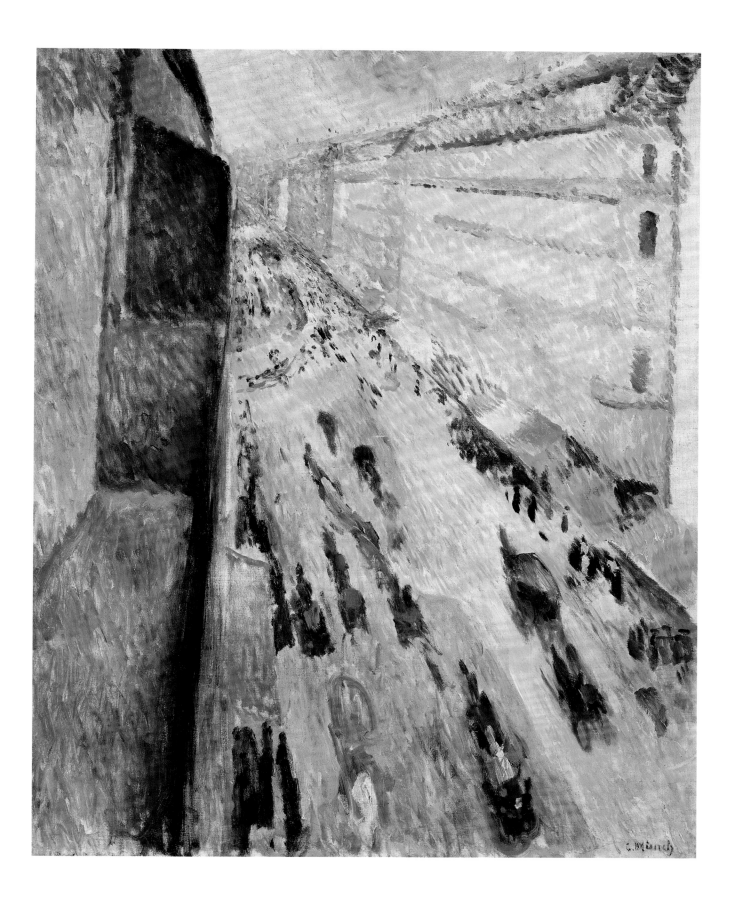

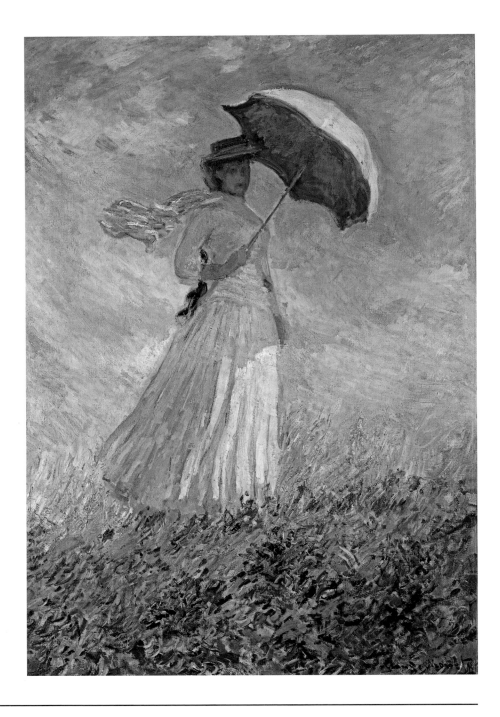

48 CLAUDE MONET *Study of a Figure Outdoors (Facing Right)*, 1886. Oil on canvas; 130.5 × 89.3 cm (51 3/8 × 35 1/8 in.). Musée d'Orsay, Paris, gift of Michel Monet, 1927, R.F. 2620. Cat. 129.

49 EDVARD MUNCH *Woman in Blue against Blue Water*, 1891. Oil on canvas; 99 × 65.5 cm (39 × 25 3/4 in.). Private collection. Cat. 9.

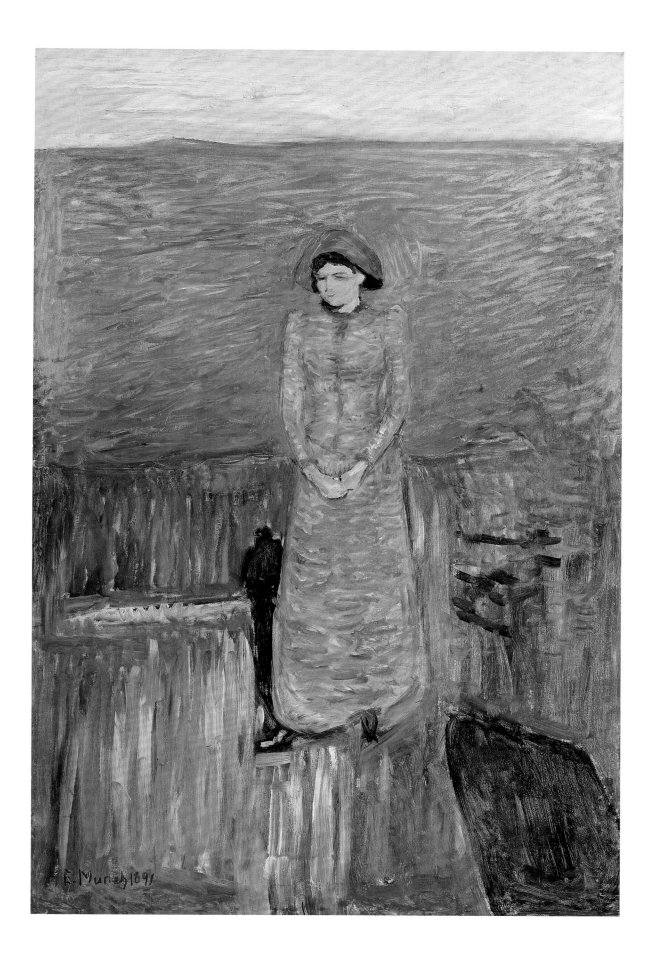

an architectonic quality that is produced by vertical bands of paint in the foreground, controlled horizontal strokes in the body of the dress, and curved, dynamic marks in the sea. In Monet's picture, the woman appears as an object of visual delectation, whereas Munch presents her in a more vulnerable position, her hands clasped in a protective gesture and a dark shadow looming before her. The red of her hat serves as the kind of halo that Munch later repeated in *Anxiety* (p. 90, fig. 90) and *Madonna* (p. 83, fig. 82) to more openly sexual effect. In *Woman in Blue against Blue Water*, Munch was not trying on a style, as he was in his street scenes, but inhabiting it: the figure's awkward body, clutching hands, and uneasy step forward suggests a kind of voyeurism and emotional electricity that differentiates itself from Monet's essay in color and wind.

Even as Munch worked to integrate French and Norwegian themes, the critical conversations about such blending appeared to be coming to a head. In the insightful comments mentioned earlier, Kitty Kielland outlined the issue of national identity and foreign influence in a way that provides a helpful context for understanding Munch's 1890–91 experimentation and the future directions he would take. Kielland (see p. 213) began by inquiring rhetorically where Norwegian painters were headed in their aesthetic development, answering that they—and presumably she—wanted a "new, fresh view, torn away from foreign suggestions, they want to see our nature and our life, with an eye for what is Norwegian."[81] Speaking of the past, she argued that some of the country's best artists sought their subjects from home but "have taken them out abroad, brought them under foreign influence … modified them through foreign understanding, and the pictures have gotten a cosmopolitan order, which do not give the country the cleanest, finest character." The understandable need to leave Norway for advanced instruction, she argued, has caused even great artists to get "their natural taste and discovery twisted." Although it may appear reactionary, this attitude in fact reflected that of Kristiania's vanguard, who had come to place greater emphasis on Norwegian identity as a key to their larger goal of overthrowing Swedish rule. The aim now was for artists to learn abroad so they might direct their knowledge into the budding national style soon to be dubbed Neo-Romanticism.

This growing tension between what was adopted and what was indigenous faced Munch when he arrived home from his extended French stay in the spring of 1892, no doubt conflicted about his place in Norway's artistic community. He would not revisit Paris for three years; instead, he traveled to Germany, where he immersed himself in Berlin's art scene. Soon after his return from Paris, however, he began to explore a new series of motifs, creating works that would come to define his art in perpetuity. Four striking, thematically diverse paintings characterize this brief and powerfully productive moment: *The Girl by the Window*, *Kiss by the Window*, and *Mystery on the Shore*—all painted in varying shades of blue and purple—and the magisterial *Evening on Karl Johan*. These canvases exemplify Munch coming into his own, focusing on images of interior reflection, suggestive sexuality, mystical seascapes, and anxiety-ridden street scenes that are worlds away from the fleeting brushstrokes and bright palette of *Rue Lafayette*.[82]

In the wake of the "St. Cloud Manifesto" and *Night in St. Cloud*, Munch continued to create scenes of contemplation and sexual passion acted out in tight, even claustrophobic architectural settings. In fact, dark, moonlit spaces silhouetted by a cruciform window frame became one of his signature motifs in the early 1890s. *The Girl by the Window* [50], for instance, takes up a theme beloved by German Romantics such as Caspar David Friedrich [see 51] yet inserts a clear note of sexual tension. At the same time, Munch used a slightly elevated perspective to give the clear impression that the subject is also being watched. Whereas the viewer looks down on her vulnerable form from a position of empowerment and control, there also exists a shadowy figure to her immediate right; vaguely resembling a top-hatted man, he is perhaps her evening visitor or even the shadowy trace seen in *Night in St. Cloud*. The rounded tabletop at bottom right is tipped against the picture plane, as is the floor, which seems to tilt under the woman's ill-defined feet. The strange perspective is only heightened by the voyeuristic pose of the woman herself, who glides open the sash to peer outside, perhaps across to the neighboring apartment buildings or below to the street. In this haunting picture, an eerie feeling of expectation converges with the sense of looking and being looked at: this is no quiet retreat, but an interior imbued with precisely the emotional frisson that Munch was aiming for.

At the same time, however, interiors such as this were not solely an outgrowth of the "St. Cloud Manifesto"—in fact, they were prevalent in Scandinavian painting just prior to Munch's adoption of the woman-at-the-window motif. In *Interior, Frederiksberg Allé* [52], for instance, Vilhelm Hammershøi offered up a cooler, less sexualized treatment of the theme in which a woman tentatively approaches the window frame. The picture's silent black, brown, gray, and white tones are markedly different from Munch's electric blues, violets, and earthy browns, but the general motif of an entrapped woman, looking out to a world she cannot fully and freely inhabit, is similar.[83] The window motif was not the sole property of the Romantics but was likewise adopted by the Impressionists, who were attracted to its compositional possibilities and to the way in which it allowed them to explore the play of indoor and outdoor spaces and the subject of vision itself. Monet's *The Red Kerchief, Portrait of Madame Monet* [53] depicts the painter's wife Camille, the same woman featured in his earlier *On the Bank of the Seine, Bennecourt* (p. 15, fig. 4). She passes by a set of French doors, through which the viewer catches sight of her penetrating gaze and striking attire. The gray tones of the walls, window frame, and fluttering curtains stand in stark contrast to her bright red cape and the green, snow-covered garden outside.[84] While the forward motion of her body and the shifting position of her face suggest an intimate, domestic encounter that is more direct than Munch's and Hammershøi's later, rather symbolic treatments, Munch could well have absorbed Monet's use of the window and the parted curtains as well as the complex overlapping of gazes between the female subject, the male artist, and the viewer.

In 1892, the artist also began to work with what would become another repeated image over the next several years, a lover's embrace in front of or next to a window. Unlike the full-length, isolated figure in *The Girl by the Window*, the embracing couple in *Kiss by the Window* [54] is seen from the knees up, pushed off to the side, away from the prying eyes of the pedestrians below and the neighbors whose windows are visible across the street. While surreptitious, their embrace is all-consuming: the formally dressed male seems to devour his companion's entire face in a ferocious act of passion. While the painted version could also be a self-portrait, since Munch often represented himself as a black-haired man from just this angle, the subject might just as easily be an everyman.[85] The artist's agitated brushwork adds to the emotional nervousness that the physical connection seems to produce. Munch combined small, directional strokes with longer, curved ones, depending on the object being rendered. He painted the upright bar of the window frame in hatched vertical lines and the curving curtain in zigzagging marks, creating the figures with heavier applications of long marks to give the bodies an added sense of weight.

Not surprisingly, images such as this one were also popular in late-1880s Europe, and included Max Klinger's *In the Park* [55] and Albert Besnard's *Love* [56]. Like Munch's couple, the pair in *Love* is close to an open window, but their rushed abandon, which seems mirrored by the wind whipping in from the balcony, stands in contrast to the closeted, oppressive space of *Kiss by the Window*. Both Besnard's and Klinger's individual prints were part of larger narrative series in which a woman is seduced, becomes pregnant, turns to prostitution, and dies from syphilis (Besnard) or in childbirth (Klinger). Soon after he finished *Kiss by the Window*, Munch likewise included it in a series called *Love*, which moved from virginity to love, jealousy to anxiety. Another related work is Auguste Rodin's iconic *Kiss* [57], a sculpture that was initially titled *Paolo and Francesca* in reference to the doomed lovers in Dante's *Inferno*, cousins who were consigned to hell for their illicit passion.

At the same moment he was creating these interiors, Munch made *Mystery on the Shore* (p. 19, fig. 12), an unusual painting that continued his recent interest in moody, evocative evening land- and seascapes. When the work was first exhibited, a critic from the conservative *Aftenposten* newspaper remarked, "There are giant octopuses with long tentacles spread-eagled on the field, which are supposed to represent tree stumps and roots, and there is a moon that can reflect itself in four mirror images ... over the extraordinary stone configurations" that were identified as trolls.[86] Indeed, this anthropomorphic imagery brings the canvas to life, from the tree stump and the smiling white rock to the oddly shaped stones that appear to be rowers moving across the surface of the water. In this symbolic approach to nature, the artist exceeded his goal of depicting "men who breathe and feel," producing seascapes that did the same.

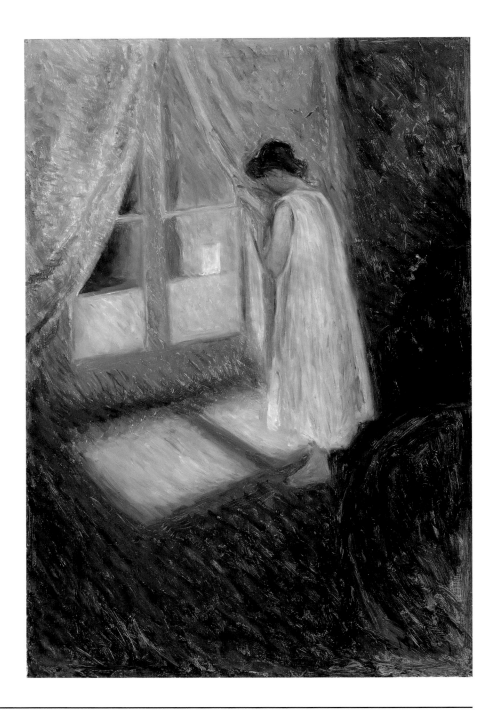

50 EDVARD MUNCH *The Girl by the Window*, 1893. Oil on canvas; 96.5 × 65.4 cm (38 × 25 3/4 in.). The Art Institute of Chicago, Searle Family Trust and Goldabelle McComb Finn endowments; Charles H. and Mary F. S. Worcester Collection, 2000.50. Cat. 14.

51 CASPAR DAVID FRIEDRICH (German, 1774–1840). *Woman at the Window*, 1822. Oil on canvas; 44 × 37 cm (17 3/8 × 14 9/16 in.). Nationalgalerie, Berlin, NG 906.

52 VILHELM HAMMERSHØI (Danish, 1864–1916). *Interior, Frederiksberg Allé*, 1900. Oil on canvas; 56 × 44.5 cm (22 × 17 1/2 in.). Private collection. Cat. 111.

53 CLAUDE MONET *The Red Kerchief, Portrait of Madame Monet*, 1873. Oil on canvas; 99 × 79.8 cm (39 × 31 3/8 in.). Cleveland Museum of Art, bequest of Leonard C. Hanna, Jr., 1958.39. Cat. 128.

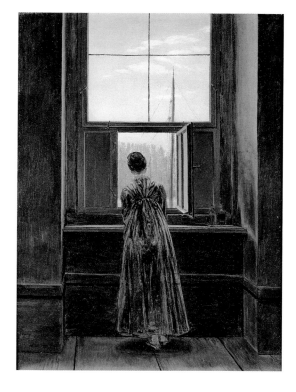

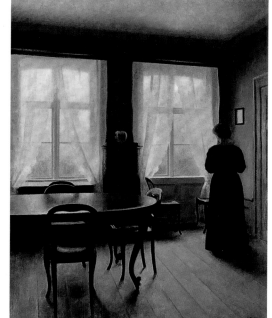

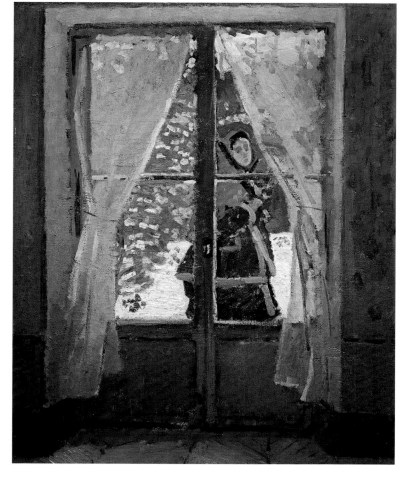

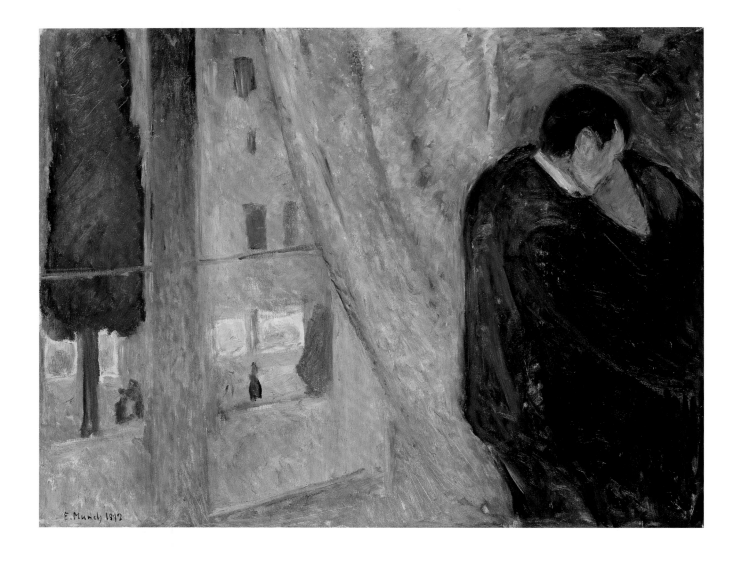

54 EDVARD MUNCH *Kiss by the Window*, 1892. Oil on canvas; 73 × 92 cm (28 3/4 × 36 1/4 in.). The National Museum of Art, Architecture and Design, Oslo, NG.M.02812. Cat. 11.

55 MAX KLINGER *In the Park*, plate 4 from the series *A Love*, 1887. Etching in black ink on cream Japanese paper; plate: 45.5 × 27.3 cm (17 15/16 × 10 3/4 in.); sheet: 60 × 44.8 cm (23 5/8 × 17 5/8 in.). National Gallery of Art, Washington, D.C., gift of the Epstein Family Collection, 2001, 2001.132.19. Cat. 118.

56 ALBERT BESNARD (French, 1849–1934). *Love*, c. 1886. Etching and drypoint in black ink on cream Japanese paper; image: 31.7 × 24.8 cm (12 1/2 × 9 3/4 in.); sheet: 39.5 × 31 cm (15 1/2 × 12 1/4 in.). The Art Institute of Chicago, Albert H. Wolf Memorial Collection, 1926.164. Cat. 90.

57 AUGUSTE RODIN (French, 1840–1917). *The Kiss*, 1886. Bronze; 86.4 × 34 cm (34 × 13 3/8 in.). The Baltimore Museum of Art, the Jacob Epstein Collection, BMA.1951.128. Cat. 135.

These living, breathing elements began to populate Munch's urban landscapes as well. In *Evening on Karl Johan* [**58**], which is among the most iconic and powerful works of his career, he continued to explore the confrontational, staring faces that he had begun with the young girl in *At the General Store in Vrengen* (p. 35, fig. 32). In this work, he married the Impressionist city-scape with a Norwegian subject—Kristiania's main prome-nade—but did so in an entirely different manner than he had with *Music on Karl Johan* (p. 42, fig. 40). The strident blue he had adopted since 1890 covers almost the entire right side of the canvas, emphasizing both the claustrophobic crush of figures on the sidewalk and the rushing perspective that stretches into the distance. Wide eyes stare out of ghostly faces, adding a nightmarish element of anxiety.

Like so many others we have encountered, this picture has often been explained in terms of the artist's psychobiography. In 1885, Munch had carried on a fraught affair with a married woman, Milly Thaulow, sister-in-law of the painter Frits. The art-ist referred to her frequently in his literary diaries, and this canvas has been connected with his nocturnal prowls in search of her. This link surely arose from one of Munch's autobio-graphical prose poems, in which he recalled the shame of find-ing Milly Thaulow only to be disregarded: "And then she came at last.... she smiled softly and moved on.... He was full of ecstasy. Then everything became silent ... everybody who passed looked so strange and alien, and he felt that they looked at him, stared at him, all these faces, pale in the evening light."[87] This evocative text does indeed connect the anxious feeling of the painting to Munch's very real feelings of disappointment and dismay, but it bears remembering that the event described occurred in 1885 while the text and image were produced in 1892, seven years after the affair had ended. Perhaps he sought to associate the image with his affair as a way to make it more titillating to his viewers, a recurring strategy from this time forward.

In fact, the picture reveals more about itself than Munch's literary reminiscences do. Its jarring perspective powerfully recalls the views he made of Paris two years earlier. But those brightly colored, daytime streets have been reimagined and transformed into a nightmare of yellow windows and pallid faces. Just prior to creating this canvas, Munch traveled through Brussels, where he could have seen the first version of James

Ensor's *Intrigue* [see **59**].[88] The carnivalesque masks in that haunting work would, as they did for Ensor, have presented Munch with an ideal means of registering his distaste for false bourgeois morality. In *Evening on Karl Johan*, the artist stained the canvas and used long strokes, broadly applying blue, black, purple, and red paints. For Munch, this new technique, along with the intense colors and inventive subject, mark a decisive turn away from his Impressionist experiments and toward a world—and a modern mythology—all his own.

It can be argued that the artist had attained a certain level of artistic maturity by the time he completed *Evening on Karl Johan*—that he had indeed become "Munch." But this slow transformation into the artist we know was not a solitary path, but rather a journey marked by educational, geographic, and visual influences and a complex critical reception, all elements that combined, historically speaking, to create a particular kind of figure. If we recall Obstfelder's insightful observation—"[Munch] does not have the type of imagination that, out of itself, creates new worlds, new combinations, or epics.... He is receptive"—it is now clear that this openness in no way detracted from his revolutionary inventiveness. But Munch's anxiety of influence prevented him from showing his hand, from revealing the wealth of sources that inspired him. This reluctance turned Munch into a seemingly isolated figure, which was precisely his intention. Munch was not only becom-ing a great artist, but also a savvy marketer of his own increas-ingly mythic personality. As we will see, Munch's anxiety of influence taught him to emphasize the influence of anxiety—to foreground his supposed mental illness and overwrought, angst-ridden images. To a great extent, his contemporaries embraced this persona, as we still often do to this day.

58 EDVARD MUNCH *Evening on Karl Johan*, 1892. Oil on canvas; 84.5 × 121 cm (33 1/4 × 47 5/8 in.). The Rasmus Meyer Collection, The Bergen Art Museum, RMS.M.245. Cat. 10.

59 JAMES ENSOR (Belgian, 1860–1949). *The Intrigue*, 1911. Oil on canvas; 94.6 × 112.4 cm (37 1/4 × 44 1/4 in.). Lent by The Minneapolis Institute of Arts, gift of Mrs. John S. Pillsbury, Sr., 70.38. Cat. 102.

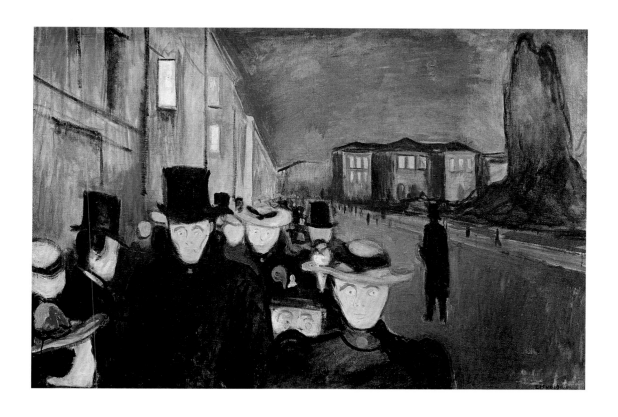

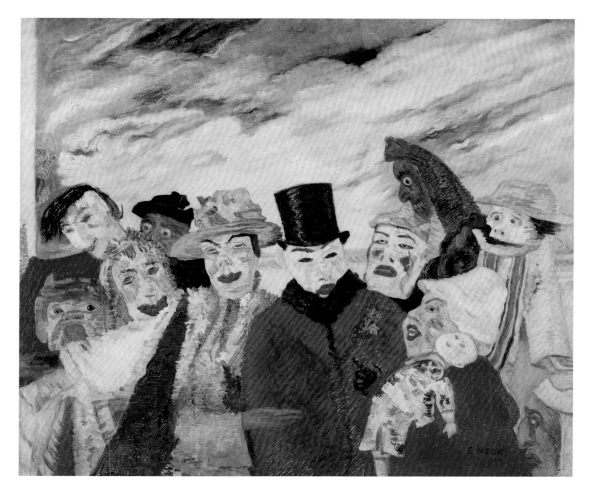

NOTES

1

As quoted in Bjerke 1995, p. 26.

2

See Edward Said, "No Reconciliation Allowed," in *Letters of Transit: Reflections on Exile, Identity, Language, and Loss*, ed. André Aciman (New Press, 1999), pp. 87–114; and Linda Nochlin, "Art and the Conditions of Exile: Men/Women, Emigration/Expatriation," *Poetics Today* 17 (1996), pp. 317–37.

3

Munch 2005, p. 183.

4

Harold Bloom, *The Anxiety of Influence: A Theory of Poetry*, 2nd ed. (Oxford University Press, 1997), pp. xxii–xxiii.

5

Ibid., p. xxiii.

6

For more on this issue of expanding, potentially never-ending contexts, see Mieke Bal and Norman Bryson, "Semiotics and Art History," *Art Bulletin* 73, 2 (1991), pp. 174–208. Regarding the potential risks of suggesting artistic influences, see James Elkins, "Review: *Modern Art in Eastern Europe: From the Baltic to the Balkans, ca. 1890–1939* by S. A. Mansbach," *Art Bulletin* 82, 4 (Dec. 2000), pp. 781–85.

7

Two foundational texts that challenge avant-garde myths of originality are Rosalind Krauss, *The Originality of the Avant-Garde and Other Modernist Myths* (MIT Press, 1985); and Peter Burger, *Theory of the Avant-Garde*, trans. Michael Shaw (University of Minnesota Press, 1984). One example of the psychobiographical interpretive approach to Munch is Reinhold Heller's seminal monograph *Munch: His Life and Work* (Heller 1984). Heller has modified this perspective, however, in recent articles such as Heller 2006. Other works that have critiqued the extensive use of psychobiography are Berman 1994; Yarborough 1995; and Herman 1999. Ingrid Langaard considered Munch's visual sources extensively in Langaard 1960, while two exhibition catalogues—Rapetti and Eggum 1991 and Schneede and Hansen 1994—focused on Munch's influence from and on French and German artists, respectively.

8

Two superb, if opposing, readings of this work are Heller 1978 and Lange 2003.

9

A standing female figure at center was somewhat awkwardly over-painted by Munch but remains a vague, shadowy form; for an infrared reflectograph of this detail, see Peter Vergo, *Twentieth-Century German Painting* (Sotheby's Publications, 1992), p. 288.

10

For one such reading of this work, see Heller 1984, p. 41.

11

See, for example, ibid., p. 168.

12

For more on this term and its historiography, see Lange 1988; and Bjerke 1995, pp. 81–98.

13

Even Monet himself obliterated a crucial autobiographical element, his baby son Jean, whom he painted out of Camille's lap in a rather abrupt, even hasty fashion; see Gloria Groom, "On the Bank of the Seine, Bennecourt," in Douglas W. Druick and Gloria Groom, *The Age of Impressionism at the Art Institute of Chicago* (Art Institute of Chicago/Yale University Press, 2008), p. 49.

14

For other examples of the modernization of mythology, see Jennifer L. Shaw, *Dream States: Puvis de Chavannes, Modernism, and the Fantasy of France* (Yale University Press, 2002); and Michelle Facos and Sharon L. Hirsh, eds., *Art, Culture, and National Identity in Fin-de-Siècle Europe* (Cambridge University Press, 2003).

15

Regarding the myths of Munch's originality, see Clarke 2006.

16

For more on the Francocentric paradigm for modernism, see, for instance, Jenny Anger, "Courbet, the Decorative, and the Canon: Rewriting and Rereading Meier-Graefe's 'Modern Art,'" in *Partisan Canons*, ed. Anna Brzyski (Duke University Press, 2007), pp. 157–77.

17

Debora Silverman, *Van Gogh and Gauguin: The Search for Sacred Art* (Farrar, Straus and Giroux, 2000), p. 295.

18

Georges Wildenstein, *Gauguin* (Les beaux-arts, 1964), no. 326, pp. 124–125.

19

Ludwig Ravensberg, diary entry, Dec. 31, 1909, Munch Museum Archives. My thanks to Patricia Berman, who suggested I look at these diaries. In Copenhagen, Munch could have encountered Gauguin's work through the artist and exhibition organizer Johan Rohde, a friend of Gauguin's estranged wife, Mette Gauguin. The Bergen Art Museum's version of *Melancholy* suggests this connection most strongly, painted as it was following Munch's 1893 trip to the Danish capital, where he could have seen the major Free Exhibition featuring twenty-nine works by Van Gogh and fifty by Gauguin. See Gertrud Oelsner, "Den store organisator," *Johan Rohde: ARS UNA* (Odense, 2006), pp. 13–35; Flemming Friborg, *Gauguin: An Essay* (Ny Carlsberg Glyptotek, 2005); Merete Bodelsen, *Gauguin og van Gogh i København i 1893* (Ordrupgaard, 1984); and Henri Dorra, "Munch, Gauguin, and Norwegian Painters in Paris," *Gazette des Beaux-Arts* 29 (1976), pp. 175–80.

20

Munch could have encountered these works either through his friend Rohde in Copenhagen or Theo van Gogh in Paris. An impression of the lithograph was also in the collection of his friend Georg Brandes. Regarding the male and female versions of this motif, see Colta Ives et al., *Vincent van Gogh: The Drawings*, exh. cat. (Metropolitan Museum of Art / Yale University Press, 2005), pp. 80–82; and Carol Zemel, "Sorrowing Women, Rescuing Men: Van Gogh's Images of Women and Family," *Art History* 10, 3 (Sept. 1987), pp. 351–68.

21

See Jensen 1994, chap. 5. For a wide-ranging view of this theme, see Jean Clair et al., *Mélancholie: génie et folie en Occident*, exh. cat. (Réunion des Musées Nationaux/Gallimard, 2005).

22

Munch could have seen Cazin's work around 1889, when it was exhibited in Paris at the Cercle des Mirlitons or through Cazin's dealer, Georges Petit; see letter from Jean-Charles Cazin to Georges Petit (acc. no. 850806), Research Library, Getty Research Institute, Los Angeles. Many thanks to Mary Morton for her assistance finding this information.

23

Many thanks to Gabriel Weisberg for generously sharing his expertise on Cazin.

24

See Lange 1994.

25

Three recent attempts—all from Scandinavian scholars—are Lange 1988; Messel 1994; and Bjerke 1995. See also Varnedoe 1982b; Herman 1999; and Kent 2000.

26

Theodor Wolff, "Bitte um's Wort: Die 'Affaire Munch,'" *Berliner Tageblatt*, 1892, n.pag., newsclipping, Munch Museum Archives.

27

As quoted in Woll 1978, p. 243. According to Woll, these diary notes were written about 1915.

28

Wolff (note 26).

29

Leif Østby, *Fra naturalisme til nyromantik: en studie i norsk malerkunst i tiden ca. 1888–1895* (Gyldendal Norsk Forlag, 1934).

30

Benedict Anderson, *Imagined Communities: Reflections on the Origin and Spread of Nationalism*, revised ed. (Verso, 1991).

31

Berman 1993b, p. 159. P. A. Munch also authored many other texts, among them *Norse Mythology* (1840), which played a major role in the renaissance of Norwegian culture in the nineteenth century and are still in use today.

32
For a thorough discussion of Munch's childhood, see Bøe 1989, pp. 12–30; Heller 1984, chap. 1; and Naess 2004, pp. 15–56. For more on Munch's early education, see Mørstad 2008.

33
Edvard Munch, daybook entry, Dec. 8, 1880, in Munch 1949, p. 47. On Bjølstad's artistic practice, see Heller 1984, p. 18.

34
As quoted in Lande 1992, p. 61.

35
For more on this issue, see Herman 1999, pp. 219–21.

36
As quoted in ibid., p. 219.

37
Munch 1949, p. 47.

38
See Torunns Borthen, Jan Michl, and Astrid Skjerven, "Igår-idag-imorgen? 'Glimt fra Tegneskolens historie,'" in Dag Mathiesen et al., SKHS: kunst og design i 175 År (SKHS, 1993), pp. 9–40; and Messel 2002, p. 219.

39
Julius Middlethun to Edvard Munch, Apr. 25, June 16, and July 31, 1884. Munch Museum Archives.

40
For examples of Middelthun's sculpture, see Mai Britt Guleng and Marit Lange, eds., Norsk skulptur katalog (National Museum of Art, Architecture and Design, 1997), pp. 129–42. See also Norsk kunstner leksikon, vol. 2 (Universitetsforlaget, 2001), pp. 926–27.

41
Heller 1984, p. 23.

42
Bøe 1989, pp. 60–61.

43
Høifødt 2006, p. 16.

44
For more on this, see Varnedoe 1982a.

45
Varnedoe 1979, p. 89.

46
Heller 1984, pp. 31–32.

47
Herman 1999, pp. 12–14. See also Marit Werenskiold, "Werenskiold og Thaulow som kampfeller: kunstnerrevolusjonen 1881–1884," in Frits Thaulow og Erik Werenskiold (Lillehammer Art Museum, 1998), pp. 5–31; and Messel 2002.

48
Erik Werenskiold, "Impressionisterne," Nyt Tidskrift (1882); repr. in Kunst, kamp, kultur: gjennem 40 aar i tekst og billeder (Cammermeyers, 1917), p. 64. Emphasis in original. For more on the term Impressionism in Norwegian art of this period, see Messel 2002. Thanks to Kari Diesen-Dahl for her assistance with the Norwegian translations in this chapter.

49
Marit Werenskiold, "Yndlings Promenaden (På gamle tomter)," in Malerier Lillehammer Kunstmuseum, ed. Svein Olav Hoff (Lillehammer Art Museum, 2002), pp. 44–46.

50
Lorentz Dietrichson, "Impressionisme," Norsk Maanedsskrift (1883); repr. in Fra kunstens verden, foredrag og studier (Gyldendalske Boghandles Forlag, 1885), pp. 170, 181, 197. Emphasis in original.

51
Einar Østvedt, Frits Thaulow: Mannen og verket (Dreyers, 1952), p. 58.

52
Bøe 1989, p. 80.

53
Munch 1949, p. 59.

54
For more on Munch's repetition of the sick child motif, see Clarke 2006.

55
For a discussion of The Sick Child's reception, see Eggum 1978, pp. 143–47; and Heller 1984, pp. 31–37.

56
Andreas Aubert, "Kunstnernes 5te Hostudstilling," Morgenbladet, Nov. 9, 1886, newsclipping, Munch Museum Archives. For negative reviews, see Heller 1984, pp. 35–37; and Bøe 1989, pp. 111–12.

57
See Bjerke 2006b, p. 72.

58
Thomas Dormandy, The White Death: A History of Tuberculosis (New York University Press, 2000), p. 96. See also David Barnes, The Making of a Social Disease: Tuberculosis in Nineteenth-Century France (University of California Press, 1995); and Teemu Ryymin, "Civilizing the 'Uncivilized': The Fight against Tuberculosis in Northern Norway at the Beginning of the Twentieth Century," Acta Borealia 24 (2007), pp. 143–61.

59
Messel 1994, p. 221.

60
Munch 1949, p. 55. The Prix de Florence carried with it 5,000 francs and two years of study in Italy.

61
As quoted in Varnedoe 1982a, p. 164, cat. 52.

62
As quoted in Johannesen 2002, p. 107. See also Lange 2002a, p. 271.

63
Kitty Kielland, "Lidt om norsk kunst," Samtiden 1 (1890), p. 224.

64
Illustreret Katalog over Kunstafdelingen ved den Nordiske Industri-, Landbrugs- og Kunstudstilling (August Bangs Forlag, 1888), p. 42, cats. 742–43.

65
For more on the French section and its importance, see Emil Hannover, "Nogle billeder paa den franske udstilling," Tilskueren (1888), pp. 561–75. Thanks to Inger Engan of the Munch Museum, Oslo, for helping me locate the exhibition catalogue and related materials for the 1888 exhibition. Also included were canvases by Bastien-Lepage, Besnard, Bougeureau, Cazin, Courbet, Delacroix, Fantin-Latour, Gervex, Manet, Monet, Puvis de Chavannes, and Raffaëlli; prints by Buhot and Tissott; and sculptures by Rodin.

66
As quoted in Heller 1984, p. 43.

67
Among the sixty-three paintings listed in the catalogue were At the General Store in Vrengen (p. 35, fig. 32), Puberty (p. 86, fig. 87), and The Sick Child (p. 29, fig. 27). See Katalog over Edv. Munchs maleriudstilling, Munch Museum Archives.

68
Christian Krohg, "Tredje Generation," Verdens Gang, Mar. 27, 1889; repr. in Kampen for tilværelsen, vol. 1 (Gyldendalske Boghandel Nordiskforlag, 1920), pp. 189–91. Emphasis in original. Munch's drawings in the exhibition were not listed by name.

69
Andreas Aubert, "I Anledning af Edvard Munchs Udstilling," Dagbladet, May 19, 1889, newsclipping, Munch Museum Archives.

70
Herman 1999, p. 206.

71
For more on Bonnat's studio, see Challons-Lipton 2001.

72
Heller 1984, p. 55.

73
As quoted and translated in Bøe 1989, pp. 122–23.

74
G.-Albert Aurier, "The Lonely Ones—Vincent van Gogh," originally published in Mercure de France (1890); as quoted in Symbolist Art Theories: A Critical Anthology, ed. Henri Dorra (University of California Press, 1994), p. 221.

75
For an extensive discussion of this picture and of Munch's relationship to Goldstein, see Heller 1978; and Nergaard 1975.

76
See Sheffield 1999.

77
Krohg self-consciously experimented with Impressionist styles and subjects in From Eisvold Square (Karl Johan Street, Impression) (1883; private collection) and Look Ahead! Bergen Harbor (1884; National Museum of Art, Architecture and Design, Oslo). His most notable use of urban landscape as social critique is Struggle for Life (1888–89; National Museum of Art, Architecture and Design, Oslo).

78
For more on the relationship between Krohg and Caillebotte, see Varnedoe 1979, p. 89. On Munch's street scenes, see Berman 2008b; for more on the Paris street, see Julia Sagraves, "The Street," in Anne Distel et al., Gustave Caillebotte: Urban Impressionist, exh. cat. (Art Institute of Chicago/Abbeville Press, 1995), pp. 87–140.

79
Quoted in Tøjner 2001, p. 96; see also Høifødt 2006.

80
Munch 1949, p. 113.

81
Kielland (note 63), p. 225.

82
Many of these works were featured in Munch's second major monographic exhibition, held at the Trostrups Building in Kristiania. Fifty paintings and ten drawings focused on his production between 1890 and 1892.

83
On Hammershøi's interiors, see Felix Krämer, "Vilhelm Hammershøi: The Poetry of Silence," in Sato, Fonsmark, and Krämer 2008, pp. 13–27. On late-nineteenth-century interior spaces, see Sharon Marcus, Apartment Stories: City and Home in Nineteenth-Century Paris and London (University of California Press, 1999); and Charles Rice, The Emergence of the Interior: Architecture, Modernity, Domesticity (Routledge, 2007).

84
For more on this painting and Monet's use of windows, see Kermit Swiler Champa, Studies in Early Impressionism (Yale University Press, 1973), pp. 28–29; and Steven Z. Levine, "The Window Metaphor and Monet's Windows," Arts Magazine 54, 3 (1979), pp. 98–104.

85
The first incarnation of this image, a self-consciously autobiographical drawing entitled Goodbye (1890/91; Munch Museum, Oslo), depicts the interior of an artist's studio and contains the narrative element of a departing embrace.

86
As quoted in Stang 1979, p. 95.

87
As quoted in Woll 1993, p. 32.

88
For more on the connections between Ensor and Munch, see Eggum 1980, p. 23.

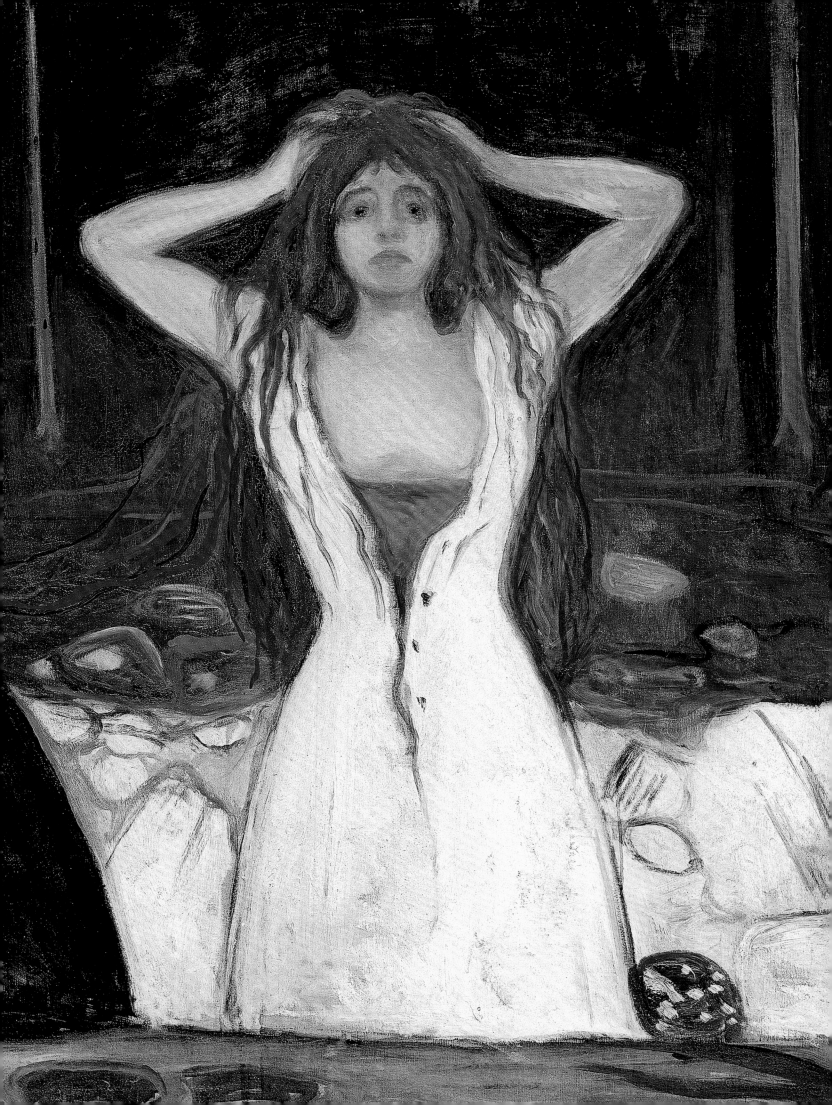

CREATING A REPUTATION, MAKING A MYTH

Historically explained as the neurotic products of Munch's disturbed mind, the recurring motifs of anxiety, death, and sorrow in his work have often been explained by quotations such as "My sufferings are.... indistinguishable from me, and their destruction would destroy my art," and "Sickness, insanity, and death were the black angels that guarded my cradle."[1] Such words, revealing as they are, are excerpted from diaries that the artist wrote with an eye to publication as literary works and are marked by a keen desire to shape his posthumous reputation. In 1929, Munch himself admitted that these texts were "partly true experiences, and partly produced by my imagination ... when I write these notes ... it is not to tell about my own life."[2] Indeed, while they possess poetic beauty and are clearly important, they exist as part of Munch's larger campaign of self-promotion and the careful crafting of a public persona. The "insane" Munch, as we shall see, was a product—one introduced both by hostile and friendly critics and later packaged and presented by the artist and his early biographers in a very deliberate way.

Recently, these quotes were marshalled again in newspaper reports of the violent theft (and later retrieval) of the Munch Museum's versions of *The Scream* and *Madonna*. In this way, the robbery was explained in terms as angst-ridden as *The Scream* itself.[3] This should come as little surprise, however, since the themes of artistic isolation, misogyny, and insanity were central to the artist's reputation almost from the very moment of its construction and have remained entrenched and reinforced for more than a century. During the 1890s, however, critics offered many alternate and equally compelling interpretations of Munch's work that have been largely forgotten today. Norwegian and German commentators, for example, explained them within the context of Neo-Romanticism, linking them to influences as unexpected, in our time, as Norwegian fairy tales.

In this chapter, we will explore, on the one hand, how Munch came to be regarded as—and, in a sense, collaborated in creating a persona of—the misunderstood, neurotic misogynist we still perceive him to be. On the other, we will attempt to recover the voices of commentators like Franz Servaes, who attempted to free the artist's work from its interpretive straitjacket and connect it with that of his contemporaries. In order to accomplish this, we will examine the reception of Munch's art in Norway, France, and Germany during the seminal six-

year period from 1890 to 1896, the time during which his first solo exhibitions were held and his reputation was initially formed. Drawing on reviews, on a book of essays written with Munch's approval, and on the artist's own diaries and letters, we will investigate how these interwoven and often contradictory biographical, national, and stylistic histories were told and untold. What such late-nineteenth- and early-twentieth-century documents reveal are cultural perceptions often strikingly at odds with the image of Munch and his art that we have come to know. By resuscitating these histories, we can also consider how and why some works have become Munch's signature pieces while others have been consistently pushed to the margins. Considering both categories from the perspective of the artist's own contemporaries helps us to see them with fresh eyes, and to appreciate their relationships in new ways.

Munch's strong self-mythologizing tendencies are emblematized in a powerful color woodcut entitled *Blossom of Pain* [60]. In 1898, the artist was commissioned to create drawings for a group of poems by the Swedish novelist, playwright, and poet August Strindberg. Later that year, perhaps sensing the popularity of the motif, he created this woodcut on the same subject. Here, we see a figure—with a face that resembles Munch's—wincing in pain as blood pours from his heart. At the base of the bloody stream sprouts a lily, a symbol of the artist's creative efforts. As in *Self-Portrait with Cigarette* (p. 109, fig. 109), the artist chose to focus on the blue-purple color that was so central to his art at the time: the body of the tortured man is printed in the same evocative hue, with only the blood and the lily inked in red. This motif was a recurring symbol for Munch, and he encouraged the perception that the anguish of his personal life fueled his art. But, as we know from private correspondence, he in fact negotiated a higher fee for his initial illustrations before agreeing to take on the project.[4] Hard economics and public perception were key ingredients in the genesis of this image—not simply the outpouring of raw creative fervor.

I. Neurasthenia, Decadence, Insanity

Munch did not begin to gain a reputation for mental illness after returning to Kristiania from Paris in 1892—he had earned it years before. In 1890 and 1891, he showed ten and six works, respectively, in Kristiania's alternative Autumn Exhibition, primarily landscapes. The responses balanced negativity, curiosity,

and praise. Some critics suggested that the artist heralded a new generation of Norwegian painters, and yet others claimed he was the ruination of the future. The Impressionist and Post-Impressionist facture of canvases such as *Night in St. Cloud* [61], *Spring Day on Karl Johan* [63], and an early version of *Evening: Melancholy* [62] stunned most viewers. Andreas Aubert, already mentioned as an earlier champion of Munch's abilities, was cautionary in his review of the 1890 show. A promoter of Neo-Romanticism, Aubert was disappointed that Munch did not embrace national revivalism, instead adopting subjects from contemporary French art. Seeking to explain this misstep, Aubert proposed that the artist

suffered from the psychological condition known as neurasthenia. Using the parlance of the day, he described Munch as:

Nervously sensitive, seeking stimulation to the very point of sickness; in his veins is the blood of an extraordinarily noble race.... Among our artists, Munch is the one whose entire temperament is formed by the neurasthenic.... He belongs to the generation of fine, sickly sensitive nerves that we encounter more and more frequently in the newest art. And not seldomly do they find personal satisfaction in calling themselves "Decadents," the children of a refined, overly civilized age.[5]

A medical term invented by the American physician George M. Beard in 1869, neurasthenia, otherwise known as nervous exhaustion, was said to be on the rise in metropolitan centers as chronic fatigue, depression, hysteria, and weakness attacked the emotionally compromised urban body. That women were supposedly more susceptible to this disease only made it more of a threat to male artists, who were commonly seen as feminized and emotionally unstable to begin with.[6] Beard's ideas were soon translated into several European languages and, by the early 1890s, had become part of the Norwegian intellectual vocabulary.[7] Adopted and adapted by social commentators, neurasthenia was elided with decadence and degeneration, and applied to the visual arts.

Aubert described Munch as having inherited his mental illness from "an extraordinarily noble race" as well as from the "sickly sensitive" generation around him. The artist's close relatives were indeed afflicted with emotional as well as physical diseases: as we saw in chapter one, his sister Laura suffered from schizophrenia or bipolar disorder, and his father endured severe bouts of depression accompanied by extreme religiosity.[8] The critic may have been aware of these difficulties, as he had known the artist since at least 1889, and may also have been referring to the prominent Munch family as representing the prevalent stereotype of Norwegians as a depressive people. In addition, Aubert's remarks resonate with then-current debates about the Danish-Norwegian nobility, from which the Munchs descended, and their deteriorating strength in comparison to heroic peasant farmers.[9]

If neurasthenia was a badge of instability, however, it also seemed to be a side effect of modern creativity, since Aubert went on to list a virtual who's who of contemporary artists whose work was considered emotive and aesthetically adventurous:

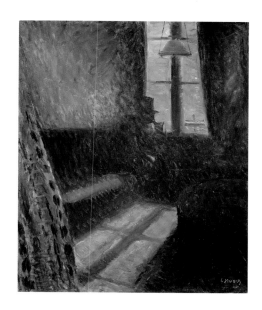 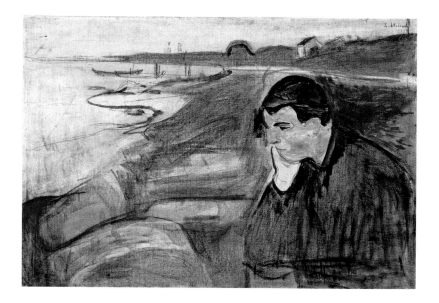

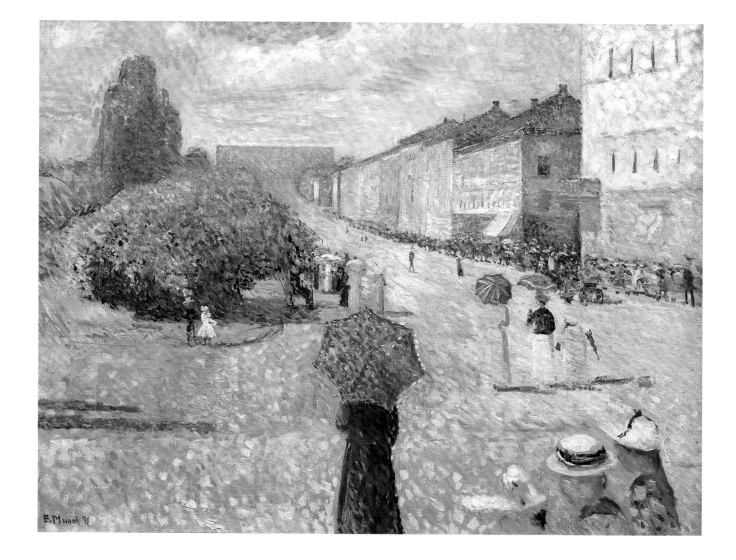

We find among these artists the most spiritual men, whose artistic gift I admire greatly, men like . . . Whistler in London, Hammershøi in Copenhagen. If you like to take into account also Puvis de Chavannes among them regarding this type . . . who likewise counts among the greatest ideal and monumental artists of this time. Also in German art, but in another form, one finds similar sickly characteristics in figures such as Gabriel Max, Böcklin, and Max Klinger.[10]

Aubert's grouping of these figures, regardless of their actual physiological or psychological states, reveals a perceived similarity that transcended geographic or stylistic differences. That the critic was able to make these connections attests not only to his knowledge of contemporary art—and, by extension, to his readers' and Munch's familiarity with it as well—but to a deep understanding of the form and content of art in a pan-European context.[11] The stylistic mixture he discussed was diverse, ranging from Whistler's moody, hazy nocturnes (see p. 40, fig. 36) to the gleaming finish of Böcklin's raucous sirens (see p. 77, fig. 76). But these artists' otherworldly, ideal subject matter and sensibilities are analogous. Significantly, Aubert did not refer to this group by the current catchall term *Symbolist*, but rather associated them through their apparent mental illness and emotional sensitivity.

However, other critics recognized Munch's debt to Symbolist art not in terms of emotional and cultural sickness, but in terms of Symbolism's own aesthetic aims. Christian Krohg approached Munch's art in just such a way when reviewing a version of *Evening* in 1891. The motif held many different titles, including *Jealousy, Melancholy,* and *The Yellow Boat,* all emphasizing different aspects of the psychology of the brooding figure in the foreground, his relationship to the landscape around him, and the actions of the two lovers in the background. In a laudatory article, Krohg discussed the canvas as a microcosm of Munch's work and took pains to address the vitriolic reactions against him:

Moving as a story of young love, it reminds one of something fine and sweet in one's own life. . . . It is related to symbolism, the latest tendency in French art. The latest slogan now is "resonance" in color . . . It is a fascinating picture, serious and severe—nearly religious. Be careful, take heed, it isn't without certain reasons that men speak and fight so much about Munch's pictures. . . . So we have then, for us, the great phenomenon of Munch, he that here at home has been reckoned as

the most incorrigible of all realists, as the most impudent and reckless of all horror painters, being the only, the first that has turned to idealism, that dares to subordinate nature, the model, etc. to the mood and change them in order to achieve more.[12]

Moving away from the labels Naturalism and Impressionism, yet still invoking Realism, Krohg emphasized colorism and interiority as characterizing Munch's—and therefore Norway's—initial foray into Symbolism. Indeed, he developed the notion of "resonance in color" as he described the painting further:

A long shoreline that moves inwards over the picture and becomes a delicious line, which is remarkably harmonic. This is music. . . . It may even be that this [canvas] is related most closely to music and not to painting, but in any case it is brilliant music. Munch should be given credit for being a composer.[13]

Munch's music on canvas is described in terms of color, line, and emotion. But the emotions he depicted, according to Krohg, were not horrific or the productions of a sick mind, but rather lyrical, spiritual, and sweet.

In fall 1892, Munch showed fifty (mostly new) paintings and several drawings at his second solo exhibition, which was held in the Tostrup Building. Kristiania's conservative press looked on his talents more favorably this time, although many remained puzzled. As a critic for *Aftenposten* put it after detailing the oddities of his canvases and their bold chromatic and narrative choices, "One has at this exhibition the best of opportunities to test the breadth of his powers of apprehension and . . . lively imagination."[14] He was somewhat befuddled, however, by the works themselves, especially their colors, commenting, "But when he approaches the color box—yea, then begins the misfortune, to say nothing of the mystification." Indeed, Munch in many ways promoted this "mystification" by changing the title of *The Artist's Sister Inger* (1892; National Museum of Art, Architecture, and Design, Oslo) to *Harmony in Black and Violet,* of *Summer Night: Two Human Beings* (1892/93; destroyed) to *Harmony in White and Blue,* and so on. These poetic names, which the artist later changed back, displayed his admiration for Whistler's evocative titles, emphasized the works' emotive sensations, and underscored the importance of moody, blue evening landscapes. One visitor to the exhibition, the painter

Adelsten Normann, was so struck by what he saw that he invited Munch to show his work in Berlin. This was a proposal that in many ways launched the artist's career.

In November 1892, Munch's exhibition opened at the Verein Berliner Künstler, a conservative, if egalitarian, art society funded by the state. The Verein was run by Anton von Werner, who was also president of the equally staid Berlin Academy. At this time, the German government supported only academic art executed in a photographic National Realist style and staunchly opposed all forms of French-inspired Naturalism and Impressionism, which were associated with the gritty, urban subjects of Émile Zola's novels and decidedly at odds with chancellor Otto von Bismarck's Anti-Socialist Laws, which aimed to suppress the working classes. Just over twenty years earlier, in 1871, Germany had defeated France in the Franco-Prussian War, and any art or artist thought to be influenced by its former enemy was still greeted with suspicion and censure.

Given the psychological anxiety, sexual innuendo, and open brushwork of Munch's paintings, which included *The Sick Child* (1885/86; National Museum of Art, Architecture, and Design, Oslo) and *Kiss by the Window* (p. 54, fig. 54), it is not entirely surprising that the exhibition was shut down by the Verein's board. Its closure was a cause célèbre, prompting significant debate in the popular press and a secession of sorts within the society itself. Both conservative and progressive critics weighed in, fanning the flames of the by then continent-wide scandal. As Reinhold Heller has outlined, the rift began just four days after the opening, when the artist Hermann Eschke organized a petition insisting that the show be closed "out of respect for art and for honest artistic striving."[15] In turn, the jury that had approved the exhibition was served another petition demanding their resignation. Von Werner called a special meeting to debate the matter, and artist members voted to close the exhibition seven days after its debut. Karl Köpping, a printmaker and respected professor, led a large group to secede from the Verein and found their own Union of Berlin Artists. Of all this, Munch wrote to his aunt, "Well, I never thought there would be so much commotion.... The whole uproar has been most amusing ... I could hardly have had better publicity."[16]

The pathologized language of the negative reviewers was hardly shocking, and in many cases they arrived at an assessment of Munch's mental state that was even more uncharitable than Aubert's. Commenting on the fracas surrounding Munch's work, an unidentified critic in Berlin's liberal *Freisinnige Zeitung* traced it to Max Nordau's recently published *Degeneration* (1892). In his book, Nordau, a Viennese physician and writer, railed against the emotionally hysterical and decadent forces present in "ugly" modern art, specifically Impressionist works, which he equated with sickness and moral degeneracy on the part of both their makers and urban viewers.[17] To Nordau's way of thinking, the hyperstimulated, diseased artist produced agitated canvases that in turn manifested symptoms of disease and exhaustion in the beholder.[18] The low subject matter associated with Impressionism in particular was seen to engender base, corrupt behavior.

The art critic Adolf Rosenberg, who approached the Verein exhibition by critiquing the formal aspects of Munch's painting, offered a similar diagnosis. A conservative proponent of National Realism, Rosenberg vehemently decried the artist's works. Indeed, the supposed formlessness of brushwork and rawness of subject matter in Impressionist art went against all that Rosenberg held dear—clarity, patriotism, pure narrative messages, and representational verisimilitude. As early as 1887, when defining Impressionism for the first time in one of Germany's mainstream art journals, the critic Friedrich Pecht characterized it as ugly, formless, and lacking in imagination.[19] Likewise, for Rosenberg, Munch's careless "smearing of paint" was "a grotesque sin" that had "nothing to do with art."[20] For Rosenberg, like Nordau, such visual offenses were equated with moral depravity and thereby had the potential to infect society.

As Rosenberg's review suggests, the primary focus of much Verein exhibition criticism was on the aesthetic battle underway within the society itself; only a few commentators attempted to define Munch's style, discuss his paintings in detail, or question how they related to contemporary Norwegian and European modernism. The most characteristic article of this sort, and one that was quoted and excerpted in many newspapers following the incident, was a favorable account written by Walter Leistikow (under the pseudonym Walter Selber) for the journal *Freie Bühne*. Entitled "The Munch Affair," the piece established the almost mythic dichotomy between the conservative, inhospitable von Werner and Munch, whose strong personality, individuality,

emotional depth, and representation of "truth" was so unjustifiably attacked and rejected.[21]

It must be noted that Munch and Leistikow knew and respected each other. Leistikow was not only an important exhibition organizer and sometime critic, but also an accomplished painter and printmaker whose evening landscapes must have attracted Munch's notice when he was in Berlin. The German artist's *Evening Mood at Schlachtensee* [64] exemplifies his luminous representations of the lakes on the outskirts of Berlin's Grünewald. The simplification and massing of forms, the use of shadow, the framing device of the trees, and the patterned reflections on the water prefigure *Moonlight* (p. 97, fig. 98), which Munch created at around the same time.

II. Mood, Myth, Norwegianness

Perhaps surprisingly, given Rosenberg's railings and Leistikow's influential portrait of Munch as a righteous victim, the overall critical reaction to the Verein exhibition was fairly balanced. Already, however, the temptation to sensationalize his art and experience had become irresistible. Munch himself noted this tendency when he wrote to his aunt, "It is too bad that the Norwegian newspapers only reprint the negative reviews . . . here [in Berlin] there are a lot of praiseworthy articles."[22] In fact, far from hiding in dismay, the artist was thriving in Berlin. When his aunt wrote asking if he was anxious about the furor, he replied, "All is going excellent, and I really like it here— I have plenty of company and am thinking of painting some pictures . . . I have gained six pounds and have never felt so good."[23] Clearly he was enjoying the publicity and the attention being paid to his art.

Unlike his defender Leistikow, however, other supportive reviewers suggested remarkable, context-based interpretations of Munch and his pictures that did not shape the myth we have come to know, and that need to be reactivated if we are to recover a sense of how Munch's work came to be what it was and understand what it meant in its own cultural moment. These men, most notably critic Georg Voss and journalist Theodor Wolff, explained Munch's art as emerging from nationally rooted, Northern-based approaches. They characterized the artist as a "poet," a "mood painter," and "down to earth"—which is to say literally close to the land and its people—and focused on his works' barren settings and bluish

hues, evocative of Norwegian summer nights. In this way, Munch's champions associated his art with a healthy, rural, Germanic tradition, one far less threatening than the decadent, distinctly urban French Impressionism of his Nordau-influenced detractors.

Rather than demonizing the Impressionist aspects of Munch's art, Voss and Wolff argued instead that he surpassed his French models, looking at life with his own Nordic sensibility. Voss, who was sympathetic to Naturalism and Impressionism and supported the artists who seceded from the Verein, took a measured approach to the objects in the Berlin exhibition. Exceedingly perceptive, he remarked on what was precisely Munch's gambit: to adopt certain aspects of Impressionist facture and poses and transform them into something inherently—or at least apparently—original. Like many in his generation of Scandinavian painters, the critic stressed, Munch subscribed to the tenets of French Impressionism, but only in part. Although such Northern painters came from a culture notably lacking in "truly important works of art," their pictures possessed uncultivated, uninhibited rawness and daring. Within this group, however, Munch stood out: rather than simply imitating or following the compositional recipes of the French, with their predictable subject matter and colors, Munch gravitated toward inventive content and colors that were bold and expressive. Lurking behind the seeming disharmony of his works was an "incredible beauty," one especially apparent in the indigenous blue and violet of the landscapes.[24]

Wolff, for his part, looked at the Verein show and questioned what all the fuss was about. He called for tolerance, claiming that Munch had the same right to exhibit his work as any other artist. Describing his viewing experience, Wolff wrote:

Between eccentric and truly hideous works, I seem to see fine and quite delicate mood paintings—in dark, moonlit rooms, on lonely country paths, during quiet Norwegian summer nights—I thought I heard the breathing of quiet, melancholic and strange people who sleepwalk and, without a word, hiding their struggles in their hearts, wander over deserted, stony beaches.[25]

Wolff used poetic language to characterize the works as Neo-Romantic mood pictures. He also argued for an appreciation of other cultures, suggesting that "nerves and temperaments are different in the northern border regions." Of course, Wolff

64 WALTER LEISTIKOW (German, 1865–1908). *Evening Mood at Schlachtensee*, c. 1895. Oil on canvas; 73 × 93 cm (28³/₄ × 36⁵/₈ in.). Stiftung Stadtmuseum, Berlin, GEM 68/1. Cat. 123.

was departing from one stereotype—decadence—only to embrace another, the common perception that Norwegians were grave, simple, moody folk who tended toward silence and melancholy.[26] Another approving critic, Wolfgang Kirschenbach, pushed the Northern connection even further when he reviewed Munch's show at its Dresden venue, a location he claimed was more sympathetic since that city's inhabitants were more culturally conscientious than the "dilettantish" Berlin viewers. He described the artist's "curious" and highly individual "nerve paintings" as distant from Impressionism, instead arguing they were reminiscent of fairy tales and inextricably bound to literature.[27]

Paintings such as the haunting *Storm* [65] exemplify the sense of otherness and difference that critics like Voss perceived as Munch continued to develop his own, decidedly personal idiom. The title, according to his later biographer Jens Thiis, derived from a storm the artist experienced at Åsgårdstrand, but the highly stylized grouping of the figures and the symbolic treatment of their gestures and coloration also indicates a storm of the imagination.[28] The five women at left, dressed in gowns of different shades, all clutch their heads in their hands, echoing the stance of the central figure in white. Like the figure in *The Scream*, these individuals serve as abbreviated signs for fear. The tilting tree at center and the dark, ominous night sky suggests the blowing wind, and the women's terrified gestures are reactions to the tempest they presumably see in the water before them. It is precisely on this connection with *The Scream*, and on the picture's general sense of distress and unease, that historians have tended to focus.

But it is incongruous that these women should stand outside in the midst of a wild storm; if they were truly so frightened, they would seek safety indoors. It is possible, however, that the figures represent a modern equivalent of the Furies, avenging goddesses who, according to Greek myth, were charged with keeping order through punishment. The German art critic Willy Pastor identified these maidens as such, comparing them favorably to similar images by the Swiss artist Arnold Böcklin, whose *Villa by the Sea* [66] represents a despairing woman who stands near a classical structure as waves press against the shore.[29] Perhaps quoting from this work, Munch removed obvious mythical elements and updated the theme by employing layers of thinned, streaked, and stained

paint, and incorporating artificial light, which glares through the windowpanes of the house. He greatly admired Böcklin, arguing in an 1893 letter that he "stands above all other painters of our time."[30]

The Storm also recalls the story of the Norse goddess Freyja, who waits for her beloved to return from the sea. Pastor, who knew Munch in Berlin, echoed this suggestion, asking his readers, "Is she a bride? Do the bright evening windows suggest a wedding feast? And does the bride anxiously await her groom?"[31] While Munch's visual suggestions are subtle, Pastor and others were able to interpret the painting as a modernization of an ancient tale precisely because they looked beyond the trope of degeneracy, which had already become standard.[32] Despite the fact that Munch was steeped in Nordic myths—he was raised in a household in which they were beloved—they may have been a source he wished to downplay, since mythology was the narrative domain of the Neoclassicists, not the Modernists. However, as we will see, a few years later he began to adopt Christian subject matter to tell the story of his own perceived suffering, gravitating toward content that served to reinforce the mythology of his status as a misunderstood outsider.

As the critics suggested, Munch did indeed display a number of "mood" paintings at the Verein exhibition, works that bore a clear resemblance to those of his Nordic contemporaries. Among the most stunning of these landscapes is *Starry Night* [68]. In this powerfully mystical and technically experimental work, the artist rendered the majestic Åsgårdstrand landscape in shadowy shades of blue, purple, and red, illuminating it with a star-studded sky and an unseen moon. The title and composition call to mind Vincent van Gogh's *Starry Night* [67], which Munch could have seen at the Salon des Indépendants in 1889. Below the night sky is the by now signature curving shore and a wall that serves to bisect the picture and direct the eye to the stars themselves; in real life, this structure demarcated the private property of the Kiøsterud family [see 69] and is more easily seen in the sunlit painting of the same setting, *Trees and Garden Wall in Åsgårdstrand* [70].[33] Also on the grounds was a substantial linden tree that is represented by the large bifurcated oval shape above the wall.

Munch created *Starry Night* in part by staining the canvas, painting in thin layers of oil paint that he diluted to the

65 **EDVARD MUNCH** *The Storm*, 1893. Oil on canvas; 91.8 × 130.8 cm (36 1/8 × 51 1/2 in.). The Museum of Modern Art, New York, gift of Mr. and Mrs. H. Ingrens Larsen and acquired through the Lillie P. Bliss and Abby Aldrich Rockefeller Funds, 1974, 1351.1974. Cat. 17.

66 **ARNOLD BÖCKLIN** (Swiss-German, 1827–1901). *Villa by the Sea*, 1866. Oil on canvas; 123.4 × 173.2 cm (48 5/8 × 68 1/4 in.). Schack-Galerie, Munich.

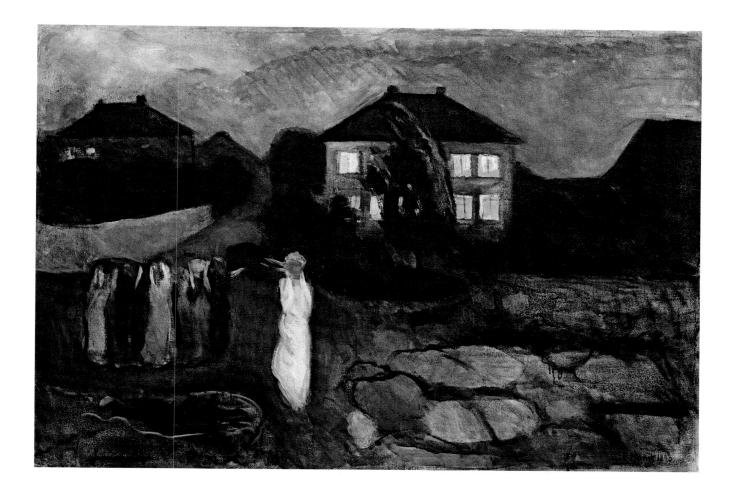

consistency of watercolor. Some areas, such as the red border around the tree, the space where the shore meets the land, and the strange, implied human presence at bottom center are delineated in thicker layers of paint as if to emphasize their physicality and differentiate the ephemeral effects of air, starlight, and moonlight. It was perhaps such attempts to capture the fluidity of water and sky that inspired Munch's future use of veil-like layers of paint. The shadowy shape at center may show one form or suggest a pair joined in an embrace, but its abstract quality makes it difficult to identify.

Although critics such as Voss praised landscapes like *Starry Night* as purely Norwegian, the painting in fact bridges the worlds of narrative evocation, indigenous setting, and scientific study. In 1896, Munch made a lithograph entitled *Attraction I* (p. 121, fig. 120) that depicted the same setting. But there, instead of the mysterious form in *Starry Night*, we see two lovers whose sexual bond is represented by strands of the woman's hair, which reach out to her male companion. While two stars are indeed visible, the focus has moved away from the landscape, which now serves as an emotive backdrop. Another important component of *Starry Night* is its connection to Munch's interest in celestography. One of his friends in Berlin was the Swedish playwright August Strindberg, an able painter and photographer who was fascinated with

capturing the fleeting aspects of nature, from the stormy sea of his expressive *The Vita Märrn Seamark II* [**71**] to his celestographs of the night sky [see **72**]. Munch admired Strindberg's celestographs, which were made with special photographic instruments and involved lengthy exposures.[34] More than meets the eye, *Starry Night* is an amalgam of the erotically narrative, technical, personal, and scientific aspects of Munch's work at this time, more than a simple Norwegian landscape or a component of his famous series *The Frieze of Life*, which was first shown in 1902.[35]

As we have seen, there were echoes of influence from elsewhere, but, more and more, Munch strove to transform these into a seemingly independent stance, to seamlessly absorb them into his personal vocabulary. This process is very much in evidence in *Summer Night's Dream: The Voice* [**73**], which has been imprisoned by interpretations that either treat it as part of *The Frieze of Life* or approach it biographically, as a reference to Munch's affair with the married Milly Thaulow. Indeed, the painting was the first of six pictures first gathered under the title *Love*, followed by *Kiss by the Window*, *Vampire*, *Madonna*, *Melancholy*, and *The Scream*. The series in many ways echoed Max Klinger's series *A Love*, in which an innocent woman is seduced, abandoned, and shamed, later dying in childbirth. But whereas Klinger's is strict in its chronological narrative and tightly etched style, Munch's is loose in both its story and painted facture.

The painting shares with *Moonlight* (p. 97, fig. 98) its setting of tree trunks, illuminated water, and the Åsgårdstrand shoreline. Like *The Storm*, however, this work also exists as a reworking of another already existing motif, that of a nymph in the forest, a common theme since the Renaissance. But again Munch dramatized and modernized it, titling the image in a way that does not suggest biographical connections but rather evokes the magic of this time of year and the blossoming desire of the young woman. Attired in a white dress that underscores her innocence, she stares directly out at the viewer with an air of anxiety and vulnerability, her face a mask-like tumult of fear and desire, her arms pinned behind her back. Indeed, she becomes part of the forest, her hieratic stance as upright as the trees. *Summer Night's Dream* represents the beginning of love; the virginal longing that we see in the figure's face is held back, as is conveyed by her stiff,

67 VINCENT VAN GOGH *Starry Night*, 1889. Oil on canvas; 73.7 × 92.1 cm (29 × 36 1/4 in.). The Museum of Modern Art, New York, acquired through the Lillie P. Bliss bequest.

68 EDVARD MUNCH *Starry Night*, 1893. Oil on canvas; 108.5 × 120.5 cm (42 3/4 × 47 1/2 in.). Von der Heydt Museum, Wuppertal, G 1179. Cat. 16.

69 View of the Kiøsterud property in Åsgårdstrand, showing the wall that appears in Munch's *Starry Night* (p. 71, fig. 68). Drawing by Arne Eide, published in Arne Eide, *Åsgårdstrand: om hvite hus og løvkroner spredt historikk* (J. W. Eides, 1946), p. 55.

70 **EDVARD MUNCH** *Trees and Garden Wall in Åsgårdstrand*, 1902/04. Oil on canvas; 99 × 103.5 cm (39 3/4 × 41 5/8 in.). Musée d'Orsay, Paris, 1986, R.F. 1986-58. Cat. 81.

71 **AUGUST STRINDBERG** (Swedish, 1849–1912). *The Vita Märrn Seamark II*, 1892. Oil on cardboard; 60 × 47 cm (23 5/8 × 18 1/2 in.). Nationalmuseum, Stockholm, NM 6980. Cat. 138.

72 **AUGUST STRINDBERG** *Celestograph*, 1893/94. Royal Library, Stockholm.

controlled posture.[36] As in *The Storm*, however, a hint of Nordic tradition seeps into the picture. As Patricia Berman and others have noted, the setting for *Summer Night's Dream* calls to mind Saint Hans's Night, the traditional Nordic celebration of summer's return. Like many saints' days, this festival often coincided with wild revelry, and lovers were said to meet on the wooded shores of the fjords, abandoning the constraints of everyday life.[37]

As we saw in chapter one, *Mystery on the Shore* (p. 19, fig. 12), with its anthropomorphic rock and tree stump, suggests Wolfgang Kirschenbach was correct in saying that Munch was inspired not just by myths, but by fairy tales as well. Such influences can also be seen in the two mermaid paintings the artist created in 1893 and 1896. The first, *Summer Night: Mermaid* [74] depicts a blonde mermaid in a rocky, Åsgårdstrand seascape with an echo of a moon shadow behind her. By placing a mythical figure within an identifiable Norwegian landscape, Munch underscored the relationship between Norway's present and its legendary past, and also suggested the continued relevance of these archetypes in the modern world. After all, the source of the mermaid's power was her ability to enchant sailors with her song, luring them to a watery death; in this sense, she operated as yet another powerful example of the femme fatale, a motif that Munch was to adopt, transform, and return to again and again. At some later point, he demythologized this picture by adding two other bathing women behind her.[38] Three years later, Munch was commissioned to create a similar painting, *The Mermaid* [75], for the home of Norwegian industrialist Axel Heiberg (see p. 216). Here we see a more traditionally red-haired mermaid transforming herself into a woman, appearing as a more forbidding version of the heroine in Hans Christian Andersen's 1836 folktale *The Little Mermaid*, who gives up her life in the sea for love in the world of humans.[39] The sunny disposition of the 1893 painting turns more brooding and sensual here, as Munch invests his folkloric character with a distinctly unsettling gaze.

Images such as these did not, however, leap out of Munch's imagination like a mermaid out of water. Rather, they were part and parcel of a resurgent interest in myth that accompanied the European national revivals of the 1880s and 1890s. Arnold Böcklin's images of centaurs, naiads, sirens, and lonely figures by the shore had a profound and lasting impact on Munch. His idiosyncratic variations on themes from antiquity, which include *In the Sea* [76], embody a witty exuberance. Here, a harp-playing sea-centaur is accompanied by four singing naiads while tritons pop their heads above the water in the background, ready to join the fun. Böcklin's own title for the work, *Café-Concert in the Sea*, captures the spirit of his attempt to modernize mythology and make it more relevant to contemporary society; café-concerts were popular urban entertainments. Indeed, the artist's immense following in Germany ushered in a style known as Neo-Idealism, a national variant of Symbolism.

Ernst Josephson's canvases also combined indigenous myth with decorative schemes for modern times, and were executed in a daring, open facture that was associated with vanguard currents. *The Water Spirit* [77] depicts a nude figure from Nordic folklore who passionately plays a violin as a torrent of water rains down upon him. Like Munch's mermaids, he used his music to lure passersby to their deaths. The final version of this work was purchased by the aristocratic painter Prince Eugen of Sweden, who had it installed directly into a wall. Painted in Paris, where the artist had become friends with Theo van Gogh, the painting displays an open brushwork that belies his knowledge of the French Impressionists.

Akseli Gallen-Kallella painted his *Aino Triptych* for a competition to create fresco designs based on the Kalevala, the Finnish national epic. The central panel, *Väinämöinen and Aino* [78], depicts the elderly Väinämöinen pursuing the young maiden Aino, who drowns herself rather than accept his proposal of marriage; in doing so, she turns into a water nymph. Like Munch's *Mermaid* and Josephson's *Water Spirit*, this work was first painted in Paris and capitalized on the loose brushwork of contemporary French art to describe the splashing water and expansive sky. The artist also made the carved wooden frame, which incorporates patterns from Finland's ancient pagan culture; these include a swastika-like motif that was considered a symbol of natural regeneration.[40]

III: Individuality, Sexuality, Misogyny

Despite all the disparaging reviews, the positive side of the "Munch Affair," as the artist revealed to his aunt, was that it taught him early on that controversy sells. Over the next nine

73 EDVARD MUNCH *Summer Night's Dream: The Voice*, 1893. Oil on canvas; 87.9 × 108 cm (34 5/8 × 42 1/2 in.). Museum of Fine Arts, Boston, Ernest Wadsworth Longfellow Fund, 59.301. Cat. 19.

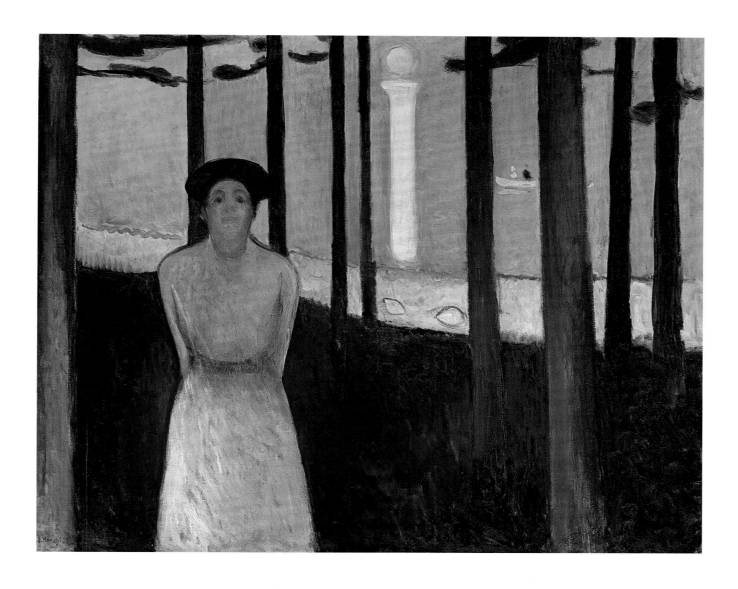

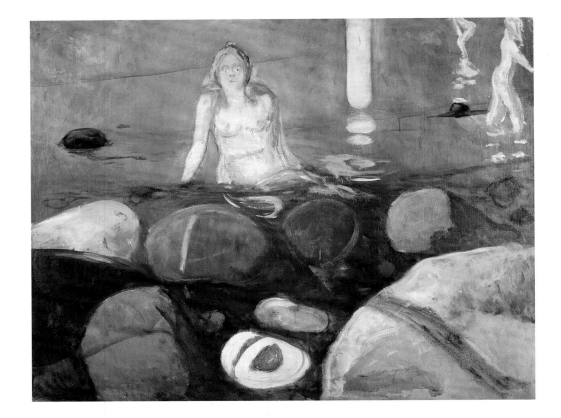

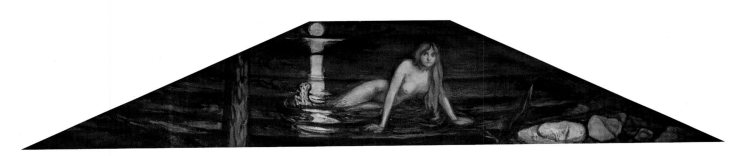

74 EDVARD MUNCH *Summer Night: Mermaid*, 1893. Oil on canvas; 93.2 × 117.5 cm (36⅝ × 46¼ in.). Munch Museum, Oslo, MMM 746. Cat. 18.

75 EDVARD MUNCH *The Mermaid*, 1896. Oil on burlap; 100.3 × 323.9 cm (39½ × 127½ in.). Philadelphia Museum of Art, gift of Barbara B. and Theodore R. Aronson, 2003, 2003-1-1. Cat. 51.

76 ARNOLD BÖCKLIN *In the Sea*, 1883. Oil on panel; 86.5 × 115 cm (34⅜ × 45¾ in.). The Art Institute of Chicago, the Joseph Winterbotham Collection, 1990.443. Cat. 91.

77 ERNST JOSEPHSON (Swedish, 1851–1906). *The Water Spirit*, 1884. Oil on canvas; 146.5 × 114 cm (57⅝ × 44⅞ in.). Göteborg Art Museum, F 215. Cat. 115.

78 AKSELI GALLEN-KALLELA (Finnish, 1865–1931). *Väinämöinen and Aino*, 1890. Oil on canvas; 117 × 117 cm (46⅛ × 46⅛ in.). Private collection. Cat. 103.

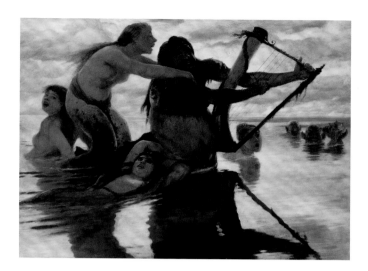

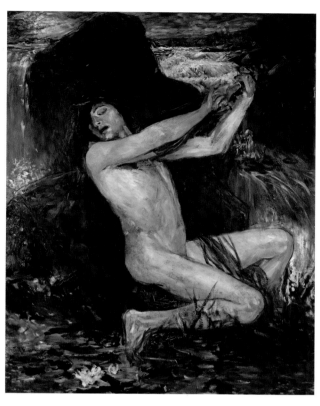

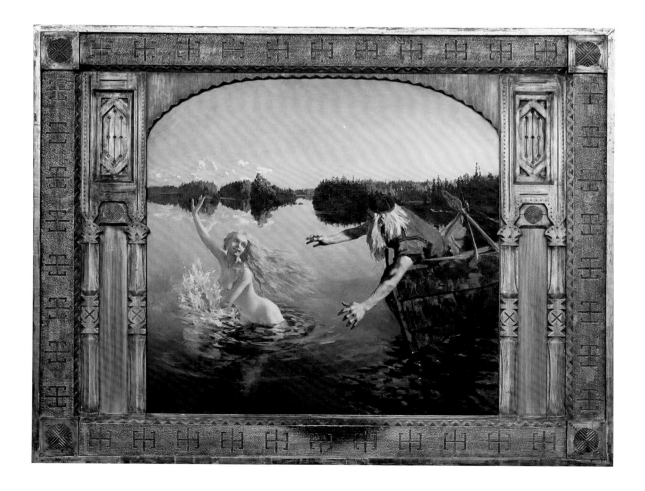

months, he proceeded to travel his exhibition to six other venues throughout Germany, organizing the tour with the German art galleries Eduard Schulte and Theodor Lichtenberg Kunstsalon.[41] Admission fees were charged in some of these locations and, as a result, Munch earned extra money in addition to securing a number of sales.[42] In some venues, Munch negotiated for entry fees, knowing that he would sell little but attract a large audience nonetheless. He also garnered unprecedented publicity. The artist learned that by positioning himself as a radical outsider, and by capitalizing on the popular press's portrayal of him as a tortured, mentally ill Impressionist, he could attract substantial and sensational attention. Writing again to his aunt about the furor in Berlin, he claimed to have made a tactical error by not showing his "scandal pictures" at a gallery immediately upon the closure of the initial exhibition, lamenting, "I could have earned several thousand kroners."[43] He had discovered that if he allied himself with forward-looking dealers and critics, he could elicit sales.[44] As the scandal played itself out, Munch wrote to his family and friends of the wonderful company he kept, the many friends he made, and the appreciation he felt for his work from the forward thinking among Berlin's art community. He was well aware of the bad press and, in some ways, appreciated its immediate effect: the entrance fees that kept him financially afloat.

Soon after his scandal tour was over, the artist opened an exhibition of his recent work in a rented space on Berlin's main thoroughfare, Unter den Linden (see p. 215), for which he again charged an entrance fee. Fully aware of the outcry these new images would engender, the artist wrote in a letter, "There will probably be awful screaming because of the show ... it is an excellent location and the paintings look well— but the Germans will most probably not understand it."[45] Clearly, he welcomed the potential uproar, no doubt hoping it would again bring substantial revenues, sales, and critical attention. Among the works he showed were *Death in the Sickroom* (p. 105, fig. 104), *Mystery on the Shore* (p. 19, fig. 12), and the newly conceived series *Love*, which included *Kiss by the Window*, *Madonna*, *Melancholy*, *The Scream*, *Summer Night's Dream*, and *Vampire*. He would soon enlarge *Love* and later retitle it *The Frieze of Life*.[46] Part of his evolving, lifelong project to tell the story of humankind through his pictures, he expanded the series to incorporate the themes of life and death.

In comparison to the Verein exhibition the previous year, the Unter der Linden display in general featured fewer of Munch's calm, moody Impressionist works of the late 1880s and early 1890s. On the contrary, his new canvases contained far more that was bizarre, macabre, openly sexual, and overtly disturbing. The artist no doubt wanted to display his recent work and capitalize on the sensation the earlier exhibitions had inspired. Far from quieting the tenor of his work to pander to conservative critics, he deliberately moved in the opposite direction, displaying recently created images of prostitutes, disturbing deathbed scenes, and shrieking, faceless creatures.

Critics immediately weighed in on this change in subject matter and style. One, writing for the *Berliner Tageblatt*, found himself "provoked" by the "hair-raising vulgarity" of the artist's new work.[47] Another, of the *Berliner Börsen-Courier*, reacted to the show with similar outrage and bewilderment. He claimed Munch's "symbolism is too deep for us to understand," arguing that the artist had learned nothing from earlier criticism and instead attempted to further shock and offend the public.[48] The anonymous author judged that Munch was severely lacking in self-esteem and self-discipline, and had stunted his own emotional, physical, and artistic development. Asking "Is this art or is this madness?" he concluded that the "mystical-demonic-symbolist-nonsensical art that he made" was sinful "trash." Equating Munch's imagery with his emotional state, the critic wondered openly if the art itself was crazy. Once again, the physical object had now come into question as insane and powerful, capable of precipitating moral decline in those that viewed it and even further degradation to its makers.

Such terminology was derived in part from Nordau's scientific and medical vocabulary, which, as we have seen, presumed that a sick body and mind created sinful, demonic art. Not coincidentally, the *Berliner Börsen-Courier* author used the term *Symbolism* to denote a style equated with psychic torment, degeneracy, and unhealthy mysticism. This is hardly unusual, since Symbolism was now entering the German critical vocabulary as a manifestation of decadence and a way to describe French art. In a more positive vein, progressive critics praised

the Symbolists' musicality, mystery, poetic sensibility, and use of sensationalism to draw an audience.[49] But it was in less praiseworthy articles such as the *Börsen-Courier*'s that the standard portrayal of Munch's insanity, decadence, and connection to French literary Symbolism took root in Germany just as it had in Norway.

Munch's life in Berlin did indeed involve heavy drinking, which undoubtedly affected his artistic and personal choices. But more than anything, it was the company he kept that contributed to his intensified focus on death, liminal states of being, the occult, and sexual abandon. Not unlike his circle of friends in Kristiania, the artist's Berlin milieu consisted of figures on the outer fringes of bohemia—people who, like himself, were temporary expatriates on German soil. Writing excitedly of his active social life, he evoked a routine that largely revolved around literary figures. These men, who met "at the corner table of The Black Piglet made up of Germans, Danes, Swedes, Finns, Norwegians, and Russians," included Strindberg, Richard Dehmal, and their ringleader, the Polish writer Stanislaw Przybyszewski [see **79**].[50]

The charismatic Przybyszewski was actively researching and writing about individuality, irrationality, free love, the subconscious, and Satanism. His group avidly discussed—and in some cases lived—their philosophical theories, and it could be argued that Munch, steeped in these Nietzschean notions, was moved to experiment visually with new states of consciousness and a heightened interest in visualizing sexuality and morbidity. The artist's association with the Berlin avant-garde served to reinforce his supposed aberrance from normative behavior and social mores.[51] As Munch's contemporary and supporter Erik Werenskiold commented in 1893, reassessing his shift in subject matter, "Now everything is German philosophy, vampires, women suckling men's blood, love and death, etc. And that sort of philosophy does not impress me."[52]

The association of Munch's art with just such themes was further reinforced in the first monographic study of his art, *The Work of Edvard Munch: Four Contributions*, published in Berlin in 1894. The text, which referred specifically to pieces displayed in the Unter den Linden show, contained essays written by the art critics Willy Pastor and Franz Servaes, the critic and dealer Julius Meier-Graefe, and Przybyszewski. Munch and Przybyszewski were close—even, as the latter

suggested, "inseparable"—friends, so it can be assumed that Munch had a hand in the text.[53] The four articles, while different in tone, shared a common focus on Munch's color, imagination, individuality, misogyny, Nordic sensibility, primitivism, psychological content, and reverence for nature.

As Przybyszewski stated in his editor's foreword, the aim of the book was to develop an understanding of the "solitary" and "richly individual" "greatness" of his friend's work, which he felt had been erroneously judged from the standpoint of Naturalism rather than from the perspective of psychic interiority.[54] Przybyszewski introduced individuality as a lens through which to read the artist's output, claiming that Munch's "naked individuality" revealed itself in his break with tradition and his turn inward. Munch focused on his imagination and, instead of seeing nature as exterior "truth" like the Naturalists, saw it through his inner psychology. Przybyszewski himself was keenly interested in psychic and hypnotic states of mind and described Munch's work as a product of the subconscious.[55]

Later accused of murdering his own wife and abandoning his children, Przybyszewski had a deep-seated hatred of women that permeated all of his work, including his writings on Munch. In his essay, for instance, he argued, "The tragedy of mankind is to be destroyed by women."[56] Indeed, misogyny has long been a specter hovering over Munch criticism, with some scholars arguing that he was a virulent woman-hater and others suggesting that he greatly admired many of his female patrons and friends.[57] Although the truth likely lies somewhere in between, it is important to recognize how many of the artist's images draw upon contemporary notions of the femme fatale.

Salome [**80**], a lithographic self-portrait of the artist and his friend, the gifted musician Eva Mudocci, illustrates the difficulty of accurately assessing the sexual anxieties embedded in Munch's work. This biblical story, in which Salome's allure is coupled with her desire for John the Baptist's death, was a frequent subject in turn-of-the-century Germany and France, as social fears surrounding women's strength and their power over men hit their peak. Here, the artist placed himself in the role of the saint, grimacing as he is enveloped in Mudocci's hair.[58] Any simplistic reading of this image is complicated, however, by Munch and Mudocci's long, stable friendship—and by the fact that Mudocci had for years been romantically

involved with a woman, the pianist Bella Edwards. While the traditional interpretation of this work as a misogynist gesture is certainly prompted by the title and nominal subject matter, it must also, however, be seen as originating with Przybyszewski's early interpretations of Munch's oeuvre.[59]

Perhaps predictably, Przybyszewski paid particular attention to the nascent *Frieze of Life* series, interpreting paintings such as *Vampire* [81] as revelations of Munch's psyche. Rendered in a gestural, Impressionistic facture, the work represents a woman bending over to kiss (or bite) the neck of a man whose head rests on her lap. The amorphous background serves to push the figures into the viewer's space as we witness their embrace, which is sexual, but potentially either tortured or tender. The dark, evocative background is enlivened by two strong blue-black lines that encircle the triangular shape of the figures like halos. This detail, combined with the woman's flowing red hair, heightens the painting's numinous, otherworldly tenor. Indeed, red hair has been a common attribute of sinful women from ancient times forward, from the well-known story of Mary Magdalene to the provocative Greek myth that red-haired women turn into vampires when they die.[60]

Przybyszewski described the scene as depicting "a broken man" whom a female figure renders helpless and who slumps over, resigned to his fate.[61] In the Unter den Linden exhibition, Munch had named the painting *Love and Pain*, and in 1918 titled another version of the work *A Woman Kissing the Back of a Man's Neck*. But beginning with the 1894 publication of *The Work of Edvard Munch*, it was widely known by the title Przybyszewski gave it: *Vampire*. His essay offered new interpretations of Munch's work, ones that to a large extent remain in place today: Munch the isolated individual who projects his disturbed psychology onto canvas, and Munch the woman-hater, victim of the femme fatale. Munch certainly embraced this role as part of his persona and, as we will see, encouraged it in his diaries.

Przybyszewski was also attracted to *Madonna* [82], another seminal work included in *The Frieze of Life* that exists in five painted and two printed versions.[62] The paintings vary significantly in color and technique, but all depict the same motif: a young, dark-haired woman, entirely nude, with a red halo above her head. One arm reaches back over her head and the other down behind her, rendering her body entirely available to her lover. The work has been most convincingly described as a woman who, in the act of lovemaking, tilts her head back in ecstasy; the viewer occupies the position of her male partner. Like *Vampire*, this work carried alternate titles, in this case *Woman Who Loves* and *The Face of a Madonna*; according to the Munch collector Rolf Stenersen, "The artist often asked critics or art dealers to choose names for his pictures. It pleased him when they were given literary titles."[63] These competing titles also suggest, however, the Madonna-whore complex from which it could be argued that Munch and many men of his time suffered.

Indeed, the seemingly opposed domains of the religious and the erotic were frequently merged in the Symbolist imagery of the 1880s and 1890s, and were by no means peculiar to Munch. The two had been combined in works by British Pre-Raphaelites such as Dante Gabriel Rosetti. *Beata Beatrix* [83], for example, commemorates poet Dante Alighieri's passion for the unattainable Beatrice, who sits transfixed while the Angel of Death hands her a poppy, symbol of sleep. The painting's altarpiece format and its union of passion and death—not to mention the figure's ecstatic posture—resonate with Munch's own aims for *Madonna*.[64] Likewise, the Munich artist Franz von Stuck created numerous versions of his extremely popular and provocative canvas *Sin* [84], in which a nude, curvaceous woman emerges from a dark background. While it may harbor its own sexual intentions, the snake slithering around her body also alludes to the serpent that tempted Eve in the Garden of Eden.

French artists, meanwhile, were flooding the market with prints that capitalized on the themes of love, religion, and death, frequently adapting their subjects from literary texts. Two such images are Odilon Redon's *Death: "My Irony Surpasses All Others"* [86] and Henri Martin's *Silence* [85]. In Redon's print, from a series based on Gustave Flaubert's novel *The Temptation of Saint Anthony* (1874), the artist uses the female body to marry youth and age, sacredness and profanity, creating an image of deadly allure. In a different but equally subtle manner, *Silence* unites the appealing gaze of a dark-haired young woman with the reminder of death symbolized by the crown of thorns encircling her head. All of these visual sources were available to Munch either through exhibitions or reproductions, and images such

79 EDVARD MUNCH *Stanislaw Przybyszewski*, 1895. Oil and/or tempera on cardboard; 62.5 × 55.5 cm (24 5/8 × 21 7/8 in.). Munch Museum, Oslo.

80 EDVARD MUNCH *Salome*, 1903. Lithograph in black ink on lightweight laid buff paper; image: 39.8 × 30.5 cm (15 5/8 × 12 1/8 in.); sheet: 59.8 × 43.5 cm (23 1/2 × 17 1/8 in.). Print Collection, Miriam and Ira D. Wallach Division of Art, Prints and Photographs, Photography Collection, The New York Public Library, Astor, Lenox, and Tilden Foundations. Cat. 82.

as *Madonna* and *Vampire* are best understood within the same context.

Given Przybyszewski's focus on sexualized imagery, he was also drawn outside *The Frieze of Life*, to *Puberty* [87]. Here, a young girl sits at the edge of her bed, her arms protectively covering her genital area and her face riddled with anxiety at the changes coursing through her body. The dark shadow that rises behind her has been read as a phallic symbol that she greatly fears. [65] Yet the merging of Eros and Thanatos we saw in *Madonna* and *Vampire* might also be present here as well, as the figure in *Puberty* has been said to represent Munch's sister Sophie, whose own maturation was cut short by her early death. [66] Regardless of the sitter's identity, the work bears a striking resemblance to Félicien Rops's *The Greatest Love of Don Juan* [88], right down to the pose of the figure and the shadow behind her. Rops's image depicts a young girl who believes she has been impregnated by the sperm left in a chair vacated by the narrator, a Don Juan character who looks on menacingly in the background. Although Munch denied having seen Rops's drawing and the later print, Przybyszewski preceded his discussion of *Puberty* with another print by Rops, which suggests that Munch would indeed have known of Rops's highly sexual and misogynist drawings, paintings, and prints.

He would also have been familiar with the many other representations of adolescent sexuality that were circulating in German and Scandinavian culture, as artists of all kinds investigated erotic worlds that the morally progressive avant-garde had thrown open to exploration. [67] The contemporary fascination with budding sexuality was not limited to the female gender, as Magnus Enckell's *Awakening* [89] demonstrates. Here, a young man literally and figuratively awakens from the pure, untroubled dreams of childhood into adult intellectual, spiritual, and sexual consciousness. His clenched fist, stern countenance, and the tentative movements of his legs suggest reluctance and fear. Hesitant to move into the realm of darkness and adulthood symbolized by the deep black void beneath him, he remains in the white, sunlit area of the bed. It is interesting to note that, historiographically, this representation of a young man has been read primarily as an intellectual awakening, whereas that of the girl in *Puberty* has been seen as sexual. In fact, the anxious

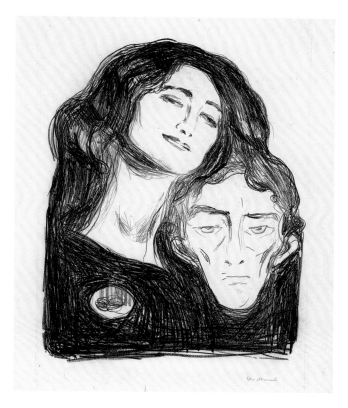

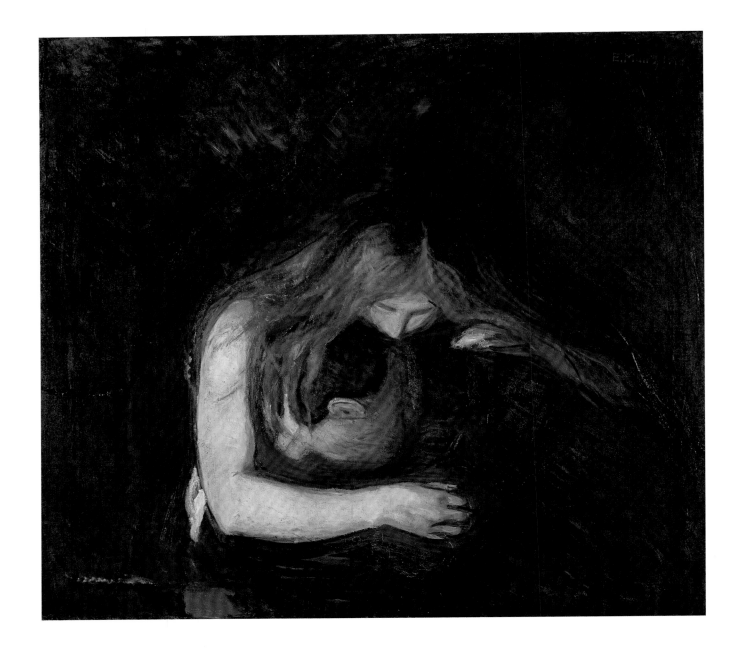

81 EDVARD MUNCH *Vampire*, 1894. Oil on canvas; 100 × 110 cm (39 3/8 × 43 1/4 in.). Private collection.

82 EDVARD MUNCH *Madonna*, 1895/97. Oil on canvas; 101 × 70.5 cm (39 3/4 × 27 3/4 in.). Collection of Catherine Woodard and Nelson Blitz, Jr. Cat. 41.

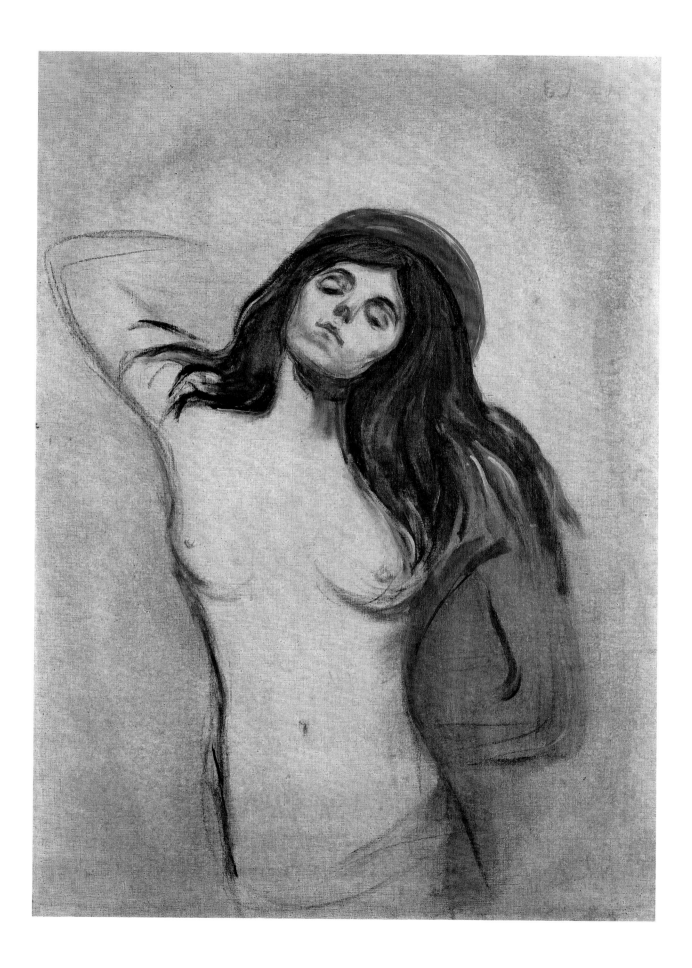

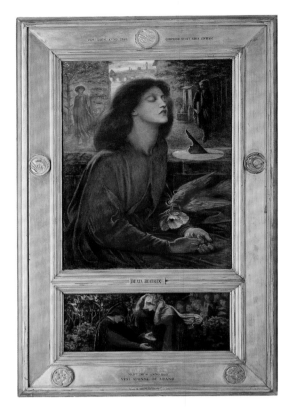

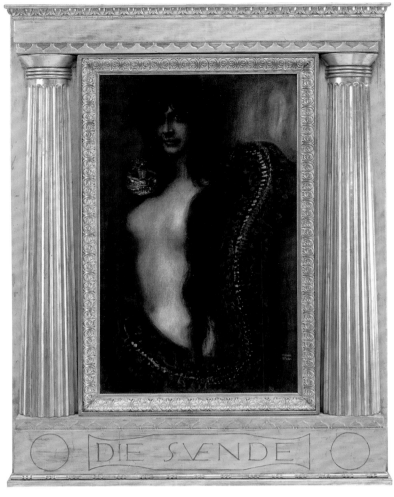

83 DANTE GABRIEL ROSSETTI (English, 1828–1882). *Beata Beatrix*, 1872. Oil on canvas; main canvas: 87.5 × 69.3 cm (34⁷⁄₁₆ × 27¹⁄₄ in.); predella: 26.5 × 69.2 cm (10³⁄₈ × 27¹⁄₄ in.). The Art Institute of Chicago, Charles L. Hutchinson Collection, 1925.722. Cat. 137.

84 FRANZ VON STUCK (German, 1863–1928). *Sin*, c. 1893. Oil on canvas; 88 × 53.3 cm (34⁵⁄₈ × 21 in.). Gallerie Katharina Büttiker, Art Nouveau-Art Deco, Zurich. Cat. 139.

85 HENRI JEAN GUILLAUME MARTIN (French, 1860–1943). *Silence*, 1894/97. Transfer lithograph printed from three stones in light blue, golden yellow, and black ink on grayish ivory China paper; image: 49.2 × 32.5 cm (19³⁄₈ × 12³⁄₄ in.); sheet: 57 × 43 cm (22¹⁄₂ × 16⁷⁄₈ in.). The Art Institute of Chicago, Print and Drawing Fund, 2008.149. Cat. 125.

86 ODILON REDON (French, 1840–1916). *Death: "My Irony Surpasses All Others,"* plate 3 from the series *To Gustave Flaubert*, 1888. Transfer lithograph in black ink on lightweight ivory wove paper, laid down on heavyweight ivory wove paper (chine collé); image; 26.1 × 19.7 cm (10¹⁄₄ × 7³⁄₄ in.); sheet: 34.7 × 45.2 cm (13⁵⁄₈ × 17³⁄₄ in.). The Art Institute of Chicago, the Stickney Collection, 1920.1651. Cat. 133.

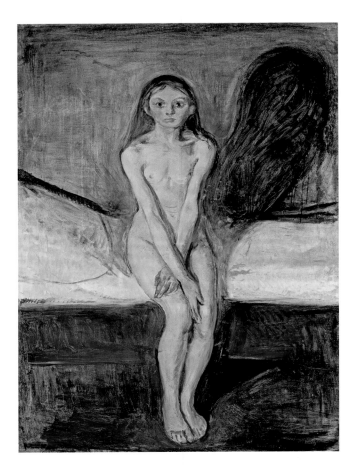

faces and bodies of both figures contain elements of physical and psychic arousal.[68]

IV. The Literary and the Primitive

As we have seen, Przybyszewski's rather tortured psychological approach to Munch's work, with its emphasis on isolation and individuality, is complicated by the images themselves, which suggest that the artist was drawing on and participating in a broader conversation taking place within literary and visual culture. Less remembered are the more measured remarks of his coauthor Franz Servaes, who addressed an issue that had been latent in the criticism of Munch's art from the start: his "raw," "childlike" primitivism. To make sense of this, he connected Munch to his immediate artistic predecessors. Servaes, a well-respected Berlin art critic, began by describing how Munch's antecedents had found their inspiration: Paul Gauguin fled civilization to find primitivism in Tahiti; Franz von Stuck searched for the "other side" in the centaurs of antiquity; and Max Liebermann left the city for the country to be inspired by peasant women. He continued:

In opposition to all these people, although in his inner core related, [is] Edvard Munch, the Norwegian. He does not need peasants or centaurs . . . and he does not need to go to Tahiti in order to discover and experience the primitive nature of mankind. He carries his own Tahiti within him.[69]

Servaes chose his comparisons astutely. At the time, Gauguin was seen as the torchbearer of French Symbolism; Stuck and Klinger as proponents of German Neo-Idealism; and Liebermann as the father of German Impressionism. By invoking these figures, Servaes strove at once to connect Munch to and differentiate him from them. Indeed, his comments suggest that he recognized the common impulses that linked artists as diverse as these, despite the fact that, in contemporary Scandinavian circles, the term *Primitivism* suggested indigenous folk revivalism and individuality, whereas in France it indicated an interest in colonialism and the "other."[70] Not surprisingly, the critic described Munch's primitivism as both personal and national: because he was "through and through Nordic-Germanic," he enjoyed a heightened connection to nature that manifested itself in his choice of the nationally charged color blue-violet, which illuminated "the dream-filled poetry of a northern moonlight."

87 EDVARD MUNCH *Puberty*, 1894/95. Oil on canvas; 151.5 × 110 cm (59 5/8 × 43 1/4 in.). The National Museum of Art, Architecture and Design, Oslo, NG.M.00807. Cat. 27.

88 FÉLICIEN ROPS (Belgian, 1833–1898). *The Greatest Love of Don Juan*, 1882/83. Graphite with stumping, scratching, and eraser on off-white wove paper, prepared with a white gouache ground (scratchboard); 26.1 × 19 cm (10 1/4 × 7 1/2 in.). The Art Institute of Chicago, Margaret Day Blake Collection, 1998.75. Cat. 136.

89 MAGNUS ENCKELL (Finnish, 1870–1925). *The Awakening*, 1894. Oil on canvas; 113 × 85.5 cm (44 1/2 × 33 5/8 in.). Ateneum Art Museum, Finnish National Gallery, Helsinki, Antell Collection, A II 787. Cat. 99.

By this point, the critical tide had shifted, perhaps in reaction to Przybyszewski's book. Instead of reading Munch's works as Impressionist, critics described them as childlike, primitive, musical, literary, and expressive of the artist's inner feelings—all Symbolist characteristics that focused on subjectivity and psychology rather than realistic colors or fuzzy brushstrokes. At the same time, however, they continued to describe his art as "sick" and "pathological."[77] Friedrich Fuchs, for example, argued that his readers must judge Munch's artwork "as a paleontologist, as a psychiatrist, as a psychopathologist," recognizing it "not as a fetus, a healthy sprouting being ... but as a rudimentary, sick, and emotionally stunted being."[78] Again, this strong, condemnatory language imagined paintings as living beings, capable of harboring their own emotional illnesses. As well, Fuchs connected the childlike imagery to the artist's supposedly "stunted" mental health.

At the same time, an unknown critic for Berlin's weekly society and entertainment paper, *Adels- und Salonblatt*, wrote an insightful piece on the show that judged Munch's strategy to be literary in nature and calculated to achieve critical acclaim. He indeed sensed Munch's self-promotional bent, arguing that the shock value of his works was part of his overall marketing strategy. What was puzzling was intended to be so—a hook to entice viewers to take a closer look. The critic observed that what made Munch so misunderstood by the general public was his relationship to literature, and suggested that most of his works began as poetry and only later took on visual form. The most important composition in this regard, he maintained, was *The Scream* [93]:

It is a color scream in lines of agate—and a crazy boy—the associative thought—marches forward. In this work lies self-irony ... some [of the image] will of course be understood by no one. Munch's subject matter is easier to understand from the point of view of poetry than as painting.[79]

In other words, *The Scream* reflects Munch's sense of self-irony because the main figure—the "crazy boy"—parodies what viewers thought of the artist himself. As was the case with musical interpretations of the work, this critic stressed its connection to literature and associative thoughts, drawing upon notions of Romantic self-reflexivity and synesthesia, as in the evocation of a sound when seeing an image.[80]

An icon, *The Scream* has become so associated with modern anxiety and personal torment that it is indeed difficult to see the work for what it is or to imagine what viewers would have experienced in the 1890s. Representing the same fjord landscape as he did in *Anxiety*, Munch pushes the sense of extreme perspective and vertiginous space further, abstracting the background figures and causing the abyss below the bridge to fall away drastically. As the artist later described it in his diaries, "A steep precipice on one side, it is ... a deep bottomless in depth.... I am walking and staggering along the precipice."[81] It is almost as if the central figure is headed to his death as the blue, blood red, orange, and yellow sky curves sinuously above; the cavernous space into which he is in danger of falling appears endless. The site has been identified as Ljabroveien, a street on a hill east of Oslo.[82]

To a great extent, the *Adels- und Salonblatt* critic was right to suggest Munch's relationship to literature: by this point, the artist had directly associated at least three versions of *The Scream* with published texts. Although there are as many versions of his *Scream* quotation as there are versions of the work (four paintings and pastels, several drawings, and one lithograph), one text from his literary diaries explains the content of the image in this way:

I was walking along the path with two friends
the sun was setting
I felt a breath of melancholy
Suddenly the sky turned blood-red
I stopped and leant against the railing,
deathly tired
looking out across flaming clouds that hung
like—blood and a sword over the
deep blue fjord and town
My friends walked on—I stood there trembling with anxiety
and I felt a great, infinite scream pass through nature.[83]

In 1895, Munch shortened this passage to the phrase "I felt the great scream go through nature," which he used to caption the work in exhibition catalogues and also incorporated directly into his lithographic version [94]. As the reviewer claimed, text and image become intertwined, not only figuratively, as Munch used his literary creations to complement his visual

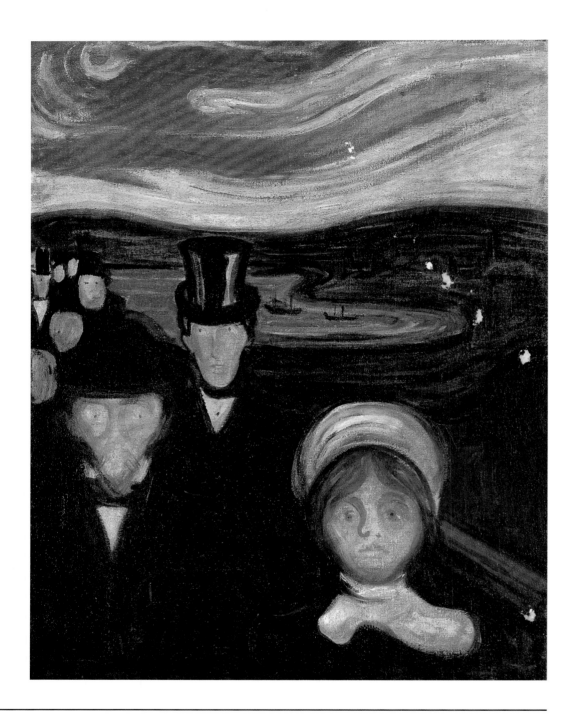

90 EDVARD MUNCH *Anxiety*, 1894. Oil on canvas; 94 × 73 cm (37 × 28 ³/₄ in.).
Munch Museum, Oslo, MMM 515. Cat. 20.

91 VINCENT VAN GOGH *The Bridge at Trinquetaille*, 1888. Oil on canvas;
65 × 81 cm (25 ¹/₂ × 31 ⁷/₈ in.). Hackmey Family, Israel. Cat. 108.

92 PAUL GAUGUIN *The Arlésiennes (Mistral)*, 1888. Oil on canvas; 73 × 92 cm
(28 ³/₄ × 36 ³/₁₆ in.). The Art Institute of Chicago, Mr. and Mrs. Lewis Larned
Coburn Memorial Collection, 1934.391. Cat. 104.

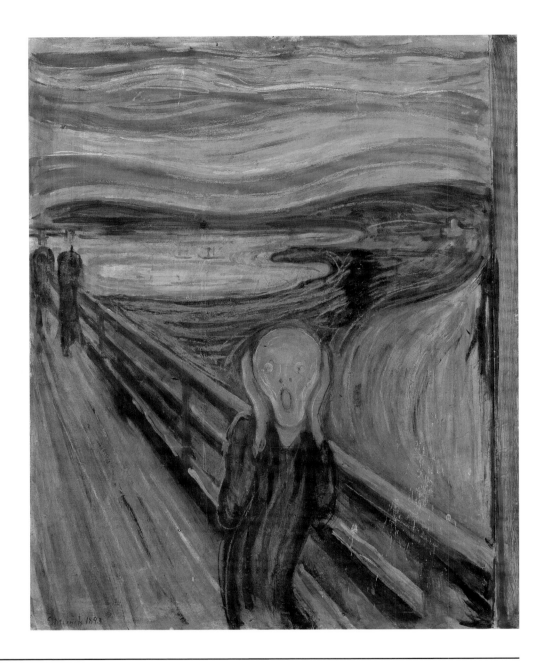

93 **EDVARD MUNCH** *The Scream*, 1893. Tempera and crayon on unprimed cardboard; 91 × 73.5 cm (35 3/4 × 28 7/8 in.). The National Museum of Art, Architecture and Design, Oslo.

94 **EDVARD MUNCH** *The Scream*, 1895. Lithograph in black ink on cream card; image: 35.5 × 25.3 cm (14 × 10 in.); sheet: 51 × 38.5 cm (20 × 15 1/8 in.). The Art Institute of Chicago, Clarence Buckingham Collection, 1963.282. Cat. 36.

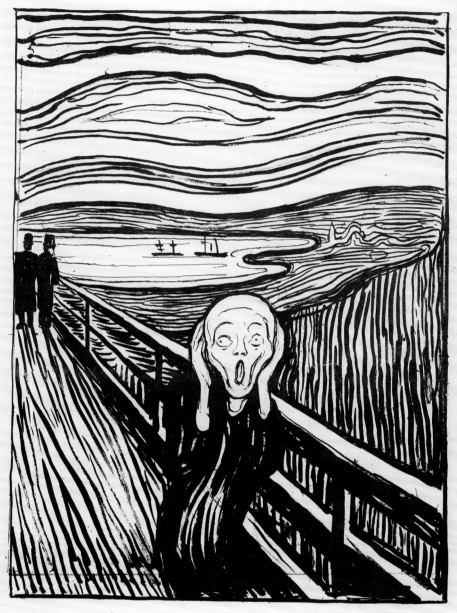

Geschrei

Ich fühlte das grosse Geschrei
durch die Natur

ones, but literally, as he combined image and text on the lithographic stone. By 1895, the artist regarded his diaries as poetic, ironic, and self-revelatory, but nonetheless explanatory of his work. As stated previously, these diaries should not be considered biographical source material—they are in fact literary works that parallel his painted, drawn, and printed oeuvre as creative explorations.

When he referred to Munch's work as literary, however, the reviewer was speaking not about its relationship to any written text, but rather about its imaginative qualities. Whereas in days past, he argued, "eternal" rules of art had insisted on "correct" representations of exterior reality, people had recently come to realize that there is, in fact, no objective visual "truth," but merely "sensory impressions" that "can only be understood with the help of our so-called imagination."[84] Munch, he went on to explain, represented things that at first sight cannot be understood, and in that respect he stood "closer to contemporary literature than to contemporary painting." According to the critic, a prime example of this literary, imaginary strain was At the Deathbed, or Fever [95], as Munch had listed the work in the exhibition catalogue. It depicts the artist and his family, presumably gathered around his sister Sophie as she lay dying. Like Death in the Sickroom (p. 105, fig. 104), the figures are not shown at their appropriate ages in 1877—the year Sophie died—but as they looked in 1895, a choice that underscores the event's status as a defining, continuing trauma.

The ghostly faces and flaming red color create the impression of a sweltering, claustrophobic space and evoke the stale scent of a sickroom. At the same time, the family's ghostly, masklike faces seem to prefigure the girl's death and the onset of their own despair. The critic felt this work was so "unbelievable, so naïvely painted, that one sees it as childish daubs of paint." But then, when looking closer and thinking carefully, he concluded that the artist had painted the feverish fantasies of a sick person. His interesting reading of the picture—made all the more believable by the viewer's perspective as the sick person—highlights Munch's imaginative qualities and suggests that his works take time to interpret. And the critic was quite right in noting the painting's hallucinatory aspects: an earlier drawing and a later lithograph [96] both emphasize what Munch omits

in this version: ghostly faces appearing above his sister's body. In the drawing, the spirit faces smile, as does a skeleton to the far right, displaying emotions that contrast starkly with the intensely mournful family. The viewer cannot see the sick child's face, but we share her space—perhaps at the moment of death, as she looks down on herself in the coffinlike bed, her family, and the ghosts who have come to welcome her into the next world.

Gathered around her are, from right, Munch; his father, whose hands are clasped in prayer; his sisters Laura and Inger; and his aunt Karen. The artist is the only figure whose body is nearly invisible, as if he is a floating head, a ghostly presence within his own family. Munch deeply associated himself with his sister's death, and it was understandably a touchpoint for him for the rest of his life. Around 1892, he wrote a heroic, partly fictionalized memoir of Sophie's death in which he detailed the close relationship between their alter egos, a sister and brother named Berta (or Maja) and Karleman [see 97]. One such text refers to the moment painted in At the Deathbed: "Maja lay red and burning hot in her bed, her eyes shone and traveled restlessly around the room—she was delirious— You dear sweet Karleman, take this away from me, it is so painful—won't you do that—she looked at him imploringly.... Do you see that head over there—it is Death."[85]

Munch's connection to primitivism and literature—as well as to insanity and offensiveness—were echoed in the writings of his own countrymen when the artist exhibited a similar group of works at Kristiania's Blomqvist Gallery in October 1895. Munch had been to Paris in September 1895 and, knowing that he needed to earn money to live and work there, arranged this exhibition to raise funds.[86] As had now become standard with the display of his recent works, conservative critics such as Henrik Grosch criticized them as the products of an abnormal brain bent on arousing sensation and shocking viewers.[87] Even the general public began to take action. A portrait of Ragnhild Juell, Przybyszewski's sister-in-law, hung in the exhibition and her father, Dr. Hans Lemmich Juell, wrote to Munch asking him to remove it from display. He pleaded, "I can't for the life of me understand how you could come to exhibit it [Madonna] publicly in Kristiania.... In the name of the friendship that I know exists between yourself and two of my daughters and their husbands, I beg you to do us the

95 **EDVARD MUNCH** At the Deathbed, 1895. Oil on canvas; 90 × 125.5 cm (35 1/2 × 49 3/8 in.). The Rasmus Meyer Collection, The Bergen Art Museum, RMS.M.251. Cat. 30.

96 **EDVARD MUNCH** By the Deathbed, 1896. Lithograph on paper; 39.4 × 50.6 cm (15 1/2 × 19 15/16 in.). Munch Museum, Oslo.

97 **EDVARD MUNCH** Berta and Karleman, c. 1890. Pen and ink on paper. Munch Museum, Oslo.

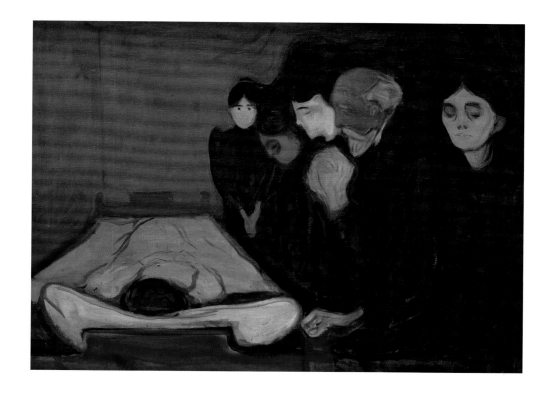

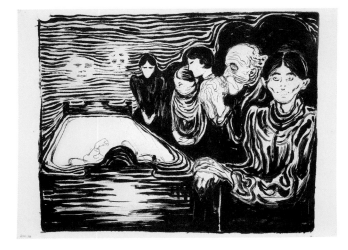

great favor of taking our daughter Ragnhild's picture out of the exhibition!"[88]

But this time, the debate about the insanity of Munch's art took on a surprisingly public dimension. Grosch, a museum director and critic, responded to the exhibition by commenting on Munch's ability to arouse a stir: "This need for sensation is an essential factor in [his] production. It is perhaps this sickly inclination . . . that makes it impossible . . . to regard Mr. Munch as a serious man with a normal brain."[89] Instead of arguing, as I have, that this rabble-rousing was calculated to great effect, Grosch was so outraged by paintings such as *Madonna* that he suggested these "repulsive" and "disgusting" works be removed by the police.

Grosch's argument was echoed at a highly vocal debate held at the University Student's Organization. Here, the poet Sigbjørn Obstfelder offered a positive assessment, focusing on Munch's advanced use of color, poetic conception of subject matter, and deep understanding of human emotion. His attempt to foster local support for Munch's talents was thwarted when an audience member vehemently challenged Munch's sanity. Johan Scharffenberg, a young medical student, stood up and, as Patricia Berman has noted, "established a direct link between Munch's radical images and the occurrences of mental and physical illness in the artist's family."[90] Munch, who was present in the audience, is said to have replied, "Well, now I know—I'm crazy, been crazy for five generations," jokingly accepting the badge of honor.[91] And yet later, upon more private reflection, he wrote in his diaries, "I am of the opinion . . . that my art is not sick, as Scharffenberg and many others believe. . . . When I paint sickness and suffering it is, on the contrary, a healthy release."[92] It would seem that the private and public Munchs were in conflict: while he wore his strangeness and insanity like a mantle in the wider world, he inhabited quite a different persona in private. As hundreds of private letters in the archives of the Munch Museum attest, he was far from crazy. Not unlike his experiments with certain subject matter or painting styles—such as Parisian streets and Post-Impressionist dots—the artist orchestrated his reactions, emotional postures, "sanity," and "insanity" at precise moments in order to achieve the outcomes he desired.

Even as Grosch and his cohorts derided Munch's style, the artist's supporters looked at his latest exhibition and saw evidence of a "raw unnaturalism" that was worthy of praise. The anarchist critic Rasmus Steinsvik, for instance, described Munch's pictures as infused with a musical, poetic, primitive, and folkish sensibility that was not offensive, but rather inspired national pride. He began his article by saying, "Munch is like a breath of fresh air from a known but hidden world."[93] The critic went on to explain that Munch painted thoughts and emotions as a means of national expression, one familiar but concealed in the realm of magic and the psyche.

Munch is more a painter that paints moods. He searches the soul. He digs into the most hidden corner, twists himself into the soul of a people like it is, with its desire, its struggle, its suffering. And what he sees with his poetic view, he wants to describe with colors, painting our thoughts, our soul, our desires, our fear, our sorrow and [despair].

Instead of seeing Munch's images as representations of the artist's own angst, Steinsvik understood his work as speaking to others in a profound manner. "It is not the view of the spiritual and the strange things he sees and describes. It is the common things, that which reaches everyone and meets everyone, and especially that which encompasses the big fundamental values." His was not a sick and unnatural way of seeing, but one that touched the very essence of Norwegian—and, indeed, human—sentiment.

One product of this vision is *Moonlight* [98], which represents the shore of Åsgårdstrand, a summer land- and seascape framed by trees and enlivened by the long, narrow reflection of the moon on the water. The canvas is connected to Munch's lifelong project to assemble a "series of decorative pictures which should as a whole give a picture of life."[94] This series, *The Frieze of Life*, was conceived and reconceived by the artist many times, and can serve to unite many of his disparate works. But it can also serve as a strait-jacket that limits interpretations, as he often took paintings out of the series, sold them, and exhibited them separately. If *Moonlight* is only seen as a backdrop for the love and anxiety enacted in the *Frieze* series, then other aspects are ignored. Munch did not only create sexually and emotionally provocative pictures at this moment, but also the sort of strikingly calm and atmospheric landscapes that appeared throughout every phase of his career. *Moonlight* attests to his enduring fascination with the Norwegian fjord landscape and to his attraction

98 EDVARD MUNCH *Moonlight*, 1895. Oil on canvas; 93 × 110 cm (36 5/8 × 43 1/4 in.). The National Museum of Art, Architecture and Design, Oslo, NG.M.02815. Cat. 35.

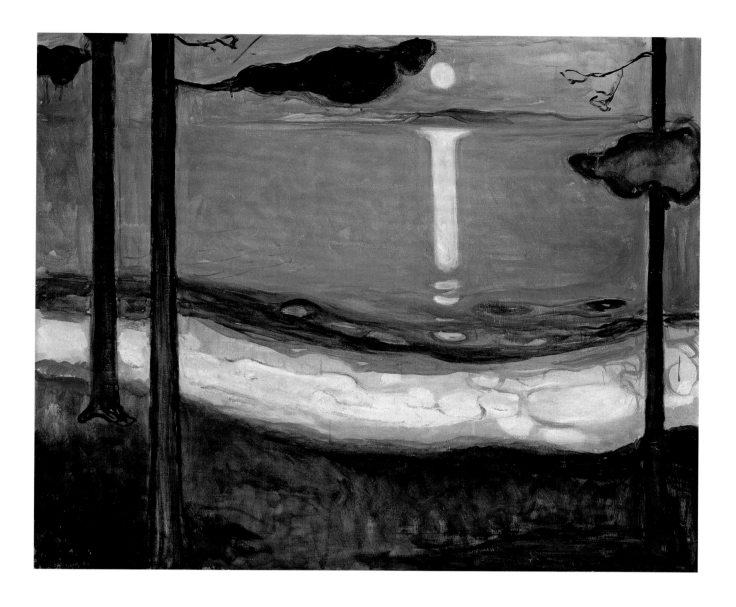

to the national, romantic blue mood paintings so prevalent in Norway in the 1890s.

In his review of the Blomqvist exhibition, Steinsvik also related Munch's work to Norwegian folktales, as had Kirschenbach in Germany two years before. He did so, however, in a far more potent and specific way—by comparing *The Scream* to Theodor Kittelsen's popular drawings of trolls and water sprites. Asking, "What does a [human] scream look like?" he replied that it looks the way we individually imagine it to. He then went on to claim his own vision of a troll: the figure in *The Scream*. Steinsvik's association was potent, as Kittlesen's and Erik Werenskiold's illustrations had gained an iconic status that parallels that of *The Scream* for Norwegians today [see **99**]. By associating

Munch's work with simple imagery and the poetic tradition of folk literature, Steinsvik diffused the artist's supposed insanity and foreignness by turning his creativity into a form of cultural nationalism.

Steinsvik saw works like *Ashes* [**100**] as evoking a universal sense of human suffering that, as he put it "reaches everyone and meets everyone." Set within a thick forest, the painting depicts a relationship in a state of disintegration. The woman, attired in a close-fitting dress that is unbuttoned to reveal her red undergarments and shapely breasts, puts her hands on her head in a gesture that seems to combine frustration and seductiveness. Some strands of her hair move as if by static electricity toward the disturbed man who cowers in the corner, his face a ghastly greenish blue. A large tree frames the left side of the canvas and crumbles into ashes beneath the figures.

The connection between the man and nature is even more explicit in the hand-colored lithograph *Ashes I* [**101**], created the following year. Here, the thin wash of blue watercolor adds pallor to the man's face, seeping out onto the ground and the ash heap, and up in smoke to a Medusa-like head that hovered above the figures before the image was divided in two and separated. Like *Blossom of Pain* (p. 62, fig. 60), the man's despair flows out of his body and into the earth. In this powerful hand-colored impression, the artist suggested this by blotting out the word *aske*, or ashes, which is barely visible along the bottom edge. Munch later wrote about the picture autobiographically in "The Tree of Knowledge," saying, "I felt our love lying on the ground like a heap of ashes."[95] The male figure could also be interpreted, as Steinsvik does, as everyman. Munch first exhibited the work, however, as *After the Fall*, its title invoking the sin of red-haired Eve, who put an end to humanity's earthly paradise.

Another related textual source for *Ashes* is God's condemnation as he casts Adam and Eve out of the Garden of Eden in the Book of Genesis: "In the sweat of thy face shalt thou eat bread, till thou return unto the ground; for out of it wast thou taken: for dust thou art, and unto dust shalt thou return." Indeed, the primal emotion represented in the work, the dense forest setting, and its association with one of the central literary texts of Western culture again complicate any easy or one-dimensional reading.

99 ERIK WERENSKIOLD *'Ugh!' Said the Troll*. Published in Peter Christen Asbjørnsen and Jørgen Moe, *Fairy Tales for Children: Norwegian Folktales* (Gyldendal, 1883–87), p. 25.

V. France and the Stereotype of Insanity

In 1896, Munch moved to Paris in the hope of securing French collectors and expanding his technical abilities by collaborating with the respected printers Auguste Clot and Alfred Léon Lemercier. Due to the influence of his friend Julius Meier-Graefe, at that time living in Paris and working as a critic and dealer, Munch was offered the chance to mount a solo exhibition at a gallery owned by Siegfried Bing. The previous year, Bing had decided to transform his space—which at that point featured Japanese objects—into a virtual temple of modern art and design. The establishment was renamed L'Art Nouveau, a moniker that immediately associated it with the latest currents in the Parisian art world. Bing described the project thus: "ART-NOUVEAU intends to group together all artistic manifestations that have ceased to be a reincarnation of the past—to offer, without excluding any categories and without preference for any school, a gathering place for all works marked by distinctly personal feeling."[96] Meier-Graefe, who was involved from the start, worked closely with Bing on his exhibition program.

In December 1895, Meier-Graefe wrote to Munch: "In eight days Bing's salon will open, and perhaps I can arrange to put up one or more of your paintings. Send me something, for example *The Scream* or something like it. Strong things!"[97] The fact that he asked for *The Scream* suggests that both he and Bing intended to make a splash with this new venture, as the picture would have been expected to cause a stir in Parisian art circles. Their choice of Munch also reflects the international aspirations of a firm that displayed Belgian, English, French, German, and Norwegian designs and objects side by side, among them works by Eugène Carrière, James Ensor, William Morris, and Henry van de Velde. Meier-Graefe's intervention worked and, in May 1896, a Munch exhibition of some sixty pieces opened at L'Art Nouveau, including twelve paintings, six drawings, and forty-two prints.[98]

Compared to the earlier sensations in Germany and Norway, Munch received very little attention in the French press, probably because he had not shown a significant amount of work in Paris before. The attention he did get, however, was mixed at best. The architect and critic Frantz Jourdain was among those who reacted to the Bing exhibition in scathing terms, taking Munch to task for his "false, very false naïveté and the resulting terrible, cerebral work." He was not finished: "His horror of the banal—although entirely praiseworthy—frequently pushes him to founder in bizarreness, and in a bizarreness that is even more painful as one feels it convoluted and vigorously spiced by literature."[99] As Jourdain described it, Edgar Allen Poe and Maurice Maeterlinck had already covered the territory of "the bizarre" and were followed by the painters Gustave Moreau, Odilon Redon, Henri de Toulouse-Lautrec, and Félix Vallotton. Like these predecessors, Jourdain claimed, Munch wanted to shock the public with his "newness" and with the "unexpected manner in which he composes his subject."

However, Munch's friend and fellow Scandinavian August Strindberg wrote a glowing and poetic, if highly idiosyncratic, review of the exhibition in the vanguard journal *La revue blanche*. Strindberg began his review by calling Munch "the esoteric painter of love, of jealousy, of death, and of sadness, [who] has often been the object of premeditated misunderstanding from the critic-hangman, who exercises his profession impersonally and at so much a head, like a hangman."[100] Perhaps predictably, given the themes of his own literary productions, the images he discussed focused on love and sexuality, and included *Jealousy*, *Kiss by the Window*, *Madonna*, *The Scream*, and *Vampire*. Strindberg's interpretations of the works were highly personal and resoundingly negative—not in their qualitative assessment but in their estimation of the emotional state of Munch's figures. He described *Kiss by the Window*, for example, in strikingly virulent terms: "The fusion of two beings, the smaller of which, shaped like a carp, seems on the point of devouring the larger, as is the habit of vermin, microbes, vampires, and women."

Munch's fourth version of this painting, *The Kiss* [103], resembles Strindberg's vulgar description to some degree. Worlds away from the first version of 1892 (p. 54, fig. 54), the figures in this smaller wood panel are painted in shades of pink, white, and yellow. The overwhelmingly blue tonality of the 1892 version is only present here in the blue light of the exterior, which is punctuated by the yellow of the windows across the street. Munch's broad, curving, paint-laden strokes correspond to the shifts in his palette and facture that occurred around 1895. The pink hues that describe the

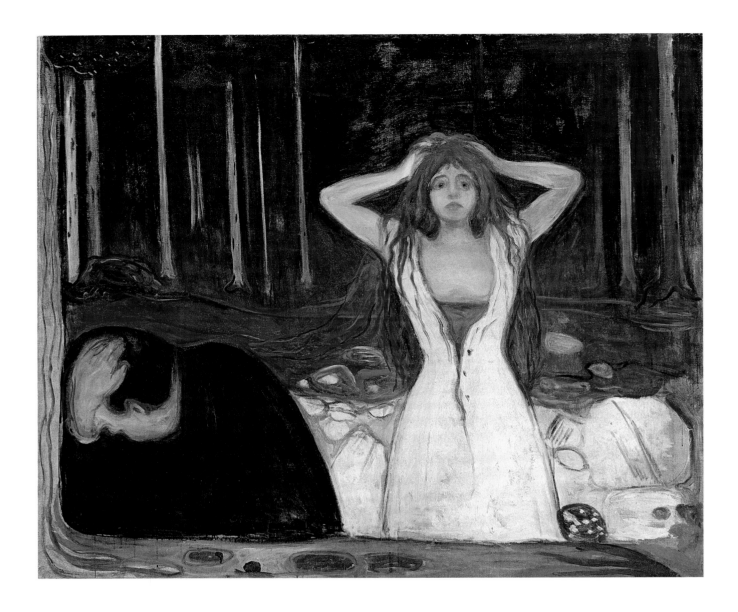

100 EDVARD MUNCH *Ashes*, 1895. Oil on canvas; 120.5 × 141 cm
(47 1/2 × 55 1/2 in.). The National Museum of Art, Architecture and Design,
Oslo, NG.M. 00809. Cat. 29.

101 EDVARD MUNCH *Ashes I*, 1896. Lithograph in black ink with additions
in brush and greenish blue, brownish orange, red, black, and blue water-
color on cream wove paper, laid down on off-white heavyweight wove paper;
image/sheet: 29.5 × 42.2 cm (11 5/8 × 16 5/8 in.). Collection of Catherine
Woodard and Nelson Blitz, Jr. Cat. 44.

lovers' bodies emphasize their raw nudity, while dark purple-blue outlines encircle the forms, shading musculature and breasts. The window seat bisects the figures at their genitals, further heightening the tension between the private interior and public exterior. Finally, the couple is placed in front of the open window, not surreptitiously to the side, as if exhibiting their passion for all to witness. Interestingly, Strindberg's misogynist reading argues that the woman, whom he associates with vermin, "devours" the man; in reality, however, it is the man whose face eclipses that of the woman, consuming her with passion.[101]

More like poems inspired by pictures, Strindberg's words nevertheless reinforced the dominant and still prevailing notion that Munch was a misogynist himself. That same year, Munch created a lithograph of the writer and gravely offended Strindberg by misspelling his name and including a nude woman in the symbolic border of the print [102]. This figure was likely intended as a comment on the sitter's alternately hateful and open-minded theories about women and free love. As Strindberg fell deeper into paranoia and insanity—in Berlin, he thought that Munch and Przybyszewski were trying to kill him with poison gas and invisible electric currents—he and Munch became a volatile pair. On various sittings for the portrait in Munch's studio, Strindberg maintained, the artist became hysterical and hopped into his bed, ignoring him altogether.[102]

In 1895, however, prior to Munch's exhibition at Bing's gallery, there appeared an in-depth article on his work by Thadée Natanson, a vanguard critic and editor sympathetic to Symbolism. That same year Natanson's journal, *La revue blanche*, featured the first published reproduction of *The Scream*. Even if Munch's later reception was somewhat cool, Natanson's text gave French audiences a preview of his macabre, emotionally intense themes. Natanson's was the first extensive investigation of Munch in the French press, and it is important to note how, in many ways, it subsequently solidified Munch's reputation as independent and ghoulish, and strove to differentiate him from his native Norway.

Natanson's review was written for *La revue blanche* as part of a series dubbed "Correspondence from Kristiania." The critic was in Norway on a belated honeymoon that doubled as a pilgrimage to meet Henrik Ibsen and see his plays performed.[103] Operating as both tourist and travel writer, Natanson discussed Munch's 1895 Blomqvist exhibition while giving a sense of the city's conservative art scene, rendering the affluent visitors' reactions in dramatic terms. "Most sneer or protest more noisily," he reported, rightly remarking that "the newspapers expressed the indignation of public morality, which they claim is offended."[104] Natanson, by contrast, revealed his sophistication, avant-gardism, and perhaps his superiority to the supposedly backward Norwegians by praising Munch's "evocative" prints and paintings, which he described in some detail. Complimenting the "lovely qualities in their

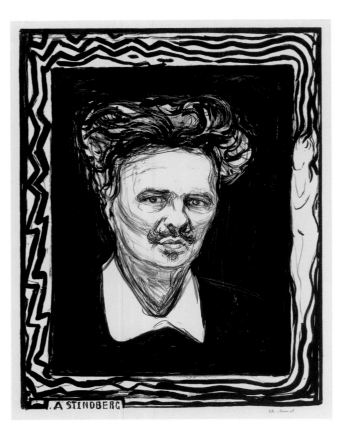

.A STRINDBERG

102 **EDVARD MUNCH** *Portrait of August Strindberg*, 1896. Lithograph in black ink on cream wove paper; image: 60.9 × 46.1 cm (24 × 18 1/8.); sheet: 66.3 × 49.4 cm (26 1/8 × 19 1/2 in.). The Art Institute of Chicago, Harold Joachim Purchase Fund and Prints and Drawings Purchase Fund, 1966.361.

103 **EDVARD MUNCH** The Kiss, 1896/97. Oil on panel; 38.5 × 31 cm (15 1/8 × 12 3/16 in.). Private collection, courtesy Galleri Kaare Berntsen, Oslo. Cat. 60.

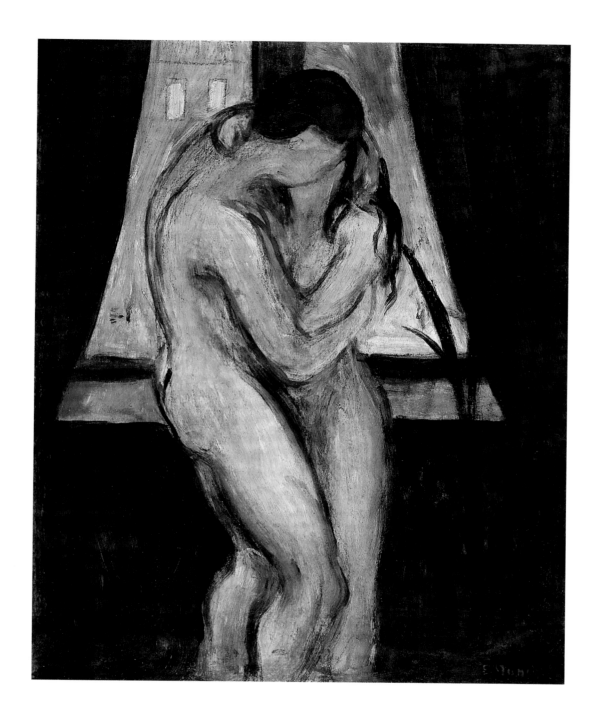

color," he argued, "It is above all the episodes of love and the episodes of death that have tempted his bitter verve most often."

Although these images made up only half of a display that included a number of portraits and landscapes, Natanson's main focus was the more incendiary works such as *Kiss by the Window*, *Madonna*, *The Scream*, and *Vampire*. He was particularly fascinated by Munch's images of death, a theme more common in Norway than in France, commenting, "The death episodes … [are] expressed by more violent scenes … where there remains even less tenderness or indulgence." This lack of compassion particularly struck the critic, and he poetically described the tension that existed in *Death in the Sickroom* [104]:

In the death chamber, the air of helplessness, the tears, the contorted features, a kind of intoxication among those present at the moment when the last breath is drawn; and then there are the visitors—ill-at-ease at the moment when they are about to approach the body whose stiffness pulls the sheets taut; other works precisely detail nuances of terror, of anguish.

Indeed, the array of human emotion combines with the drunken expectation of death and the terror of witnessing such a sobering event. Natanson comes closer than many to grasping the suspension of time and dreamlike quality of Munch's pictures. One constructive comparison in light of Natanson's comments is *A Funeral* [105], a moving canvas by Anna Ancher that Munch could have seen in Copenhagen in 1891. The artist may have admired the work's massing of forms; unsettling, slightly dizzying perspective; black and red-orange hues; and starkly isolated figures. In *Death in the Sickroom*, however, he energized the subject of mourning, introducing a palpable tension that is absent from Ancher's more subdued, documentary scene. Natanson concluded his piece by claiming it was impossible to adequately describe the force of Munch's pictures or their depth of expression.

The critic also referred to "other works" that dealt with emotions of terror and anguish; these included the terrifying, acid-green and yellow *Death and Spring* [106]. In this painting, Munch made a rare, self-conscious visual reference to an existing work of art: the etching *Dead Mother* [107], which Max Klinger conceived in 1889 and later included in the print portfolio *On Death, Part II*. As already noted, the German painter, sculptor, and etcher had a profound influence on

Munch's representations of sex and death, and shaped his approach to serial imagery. Klinger's print, although macabre, represents some hope for a future generation by depicting a deceased but youthful mother with daisies in her hair and an impish-looking baby on her chest. By contrast, Munch's stark, hieratic composition depicts the mother as old and decayed, and removes the child. Interestingly, in the 1901 etched interpretation of this work [108], Munch reinserted the child as a tormented young girl and removed any reference to the blooming outside world. In the painting, however, as in his canvas *Spring* (1889; National Museum of Art, Architecture, and Design, Oslo), he included a verdant landscape outside the window as a welcome contrast to the scene of death inside, which is relieved only by a few fern fronds.

Natanson concluded his review with a note on influence and geography, perhaps commenting on Munch's extensive stay in Berlin. He questioned the "Germanic" tenor of the artist's work, and recommended that he should come and see Parisian art:

For—if one can still speak of German art after what we have just read, right here, by Jules Laforgue—there is perhaps no influence seemingly more harmful than that of the too general and too genial theories in which he must bathe before getting—even a little—worked up, the painstaking metaphysical theories and the complicated, symmetrical cosmogonies … But is this not going too far in warning of a poetic turn in the mind of M. Munch and of the taste he has for literature?

In this passage, the critic associated Munch with prototypically German stereotypes by referring to the critic Jules Laforgue, whose own time in Berlin in the early 1880s gave Parisian journals their first taste of modern German art when he praised the "literary" and "imaginative" aspects of Klinger and Böcklin's work.[105] It was not that Natanson had severe criticisms of Munch's work; although he did have reservations about the artist's overly poetic sensibilities, he felt that his pictures lacked the literary, methodological, and theoretical underpinnings that ought to inform them. And these he believed Munch could garner in France better than anywhere. This cultural chauvinism is crucial to understanding the entrenched perceptions of Munch as seen through the eyes of his contemporaries. On the one hand, French critics like the influential Natanson saw him as exhibiting Germanic stereotypes, but

104 EDVARD MUNCH *Death in the Sickroom*, 1893. Oil on canvas; 134.5 × 160 cm (53 × 63 in.). Munch Museum, Oslo, MMM 418. Cat. 13.

105 ANNA ANCHER (Danish, 1859–1935). *A Funeral*, 1891. Oil on canvas; 103.5 × 124.5 cm (40³/₄ × 49 in.). Statens Museum for Kunst, Copenhagen, KMS 1433. Cat. 88.

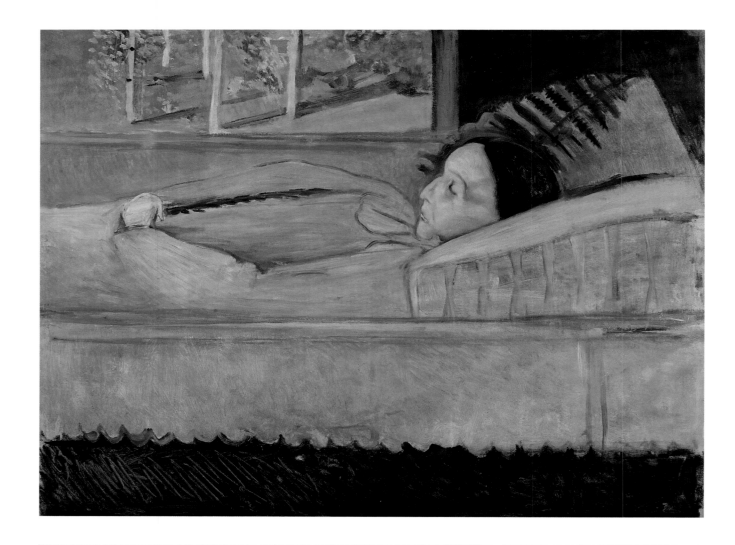

106 EDVARD MUNCH *Death and Spring*, 1893. Oil on canvas; 73 × 94.5 cm (28³/₄ × 37¹/₄ in.). Munch Museum, Oslo, MMM 516. Cat. 12.

107 MAX KLINGER *Dead Mother*, plate 10 from the series *On Death, Part II*, 1889. Etching in black ink on lightweight cream wove paper, laid down on cream wove paper (chine collé); plate: 45.6 × 34.7 cm (18 × 13⁵/₈ in.); sheet: 63.4 × 47.4 cm (25 × 18⁵/₈ in.). The Art Institute of Chicago, Joseph B. Fair Fund Income, 1977.303. Cat. 119.

108 EDVARD MUNCH *The Dead Mother and Her Child*, 1901. Etching with open bite and drypoint in black ink on heavyweight cream wove paper; plate: 32.3 × 49.4 cm (12³/₄ × 19¹/₂ in.); sheet: 42.1 × 58.6 cm (16⁵/₈ × 23¹/₈ in.). The Art Institute of Chicago, the William McCallin McKee Memorial Collection, 1944.591. Cat. 77.

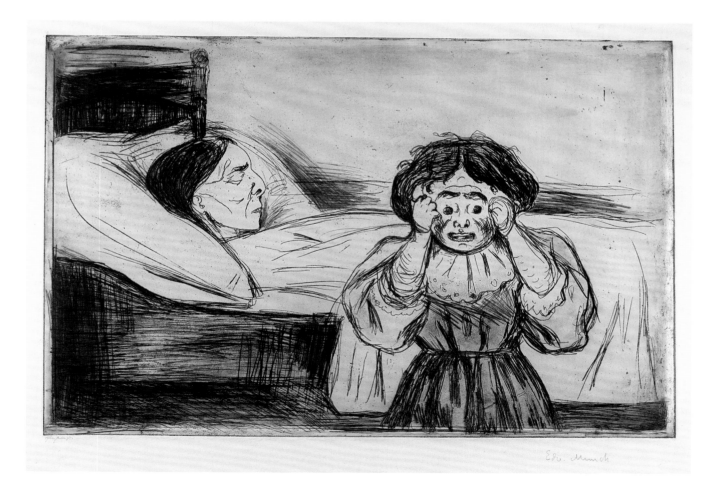

not necessarily Norwegian ones; on the other, admiring German reviewers saw his art as exhibiting both indigenous strains and French-inspired subject matter and paint-handling. Each national center held its own perceptions of the other, and, by extension, of Munch.

By the mid-1890s, however, certain aspects of Munch's critical reputation were solidified while others were being slowly eclipsed. To this day, most of us can envision canonical works such as *The Scream* and *Vampire*, but precious few would be able to recall *Mystery on the Shore* (p. 19, fig. 12) or *The Girl by the Window* (p. 52, fig. 50). Consistently, works read as "Norwegian" by critics have been virtually forgotten. The Northern characteristics of Munch's works touted by Norwegian and German critics were nowhere to be seen in French reviews such as Natanson's, which were remarkably insular in their approach. And yet, across borders, Munch's "insanity" and "independence" were given far more credence than they perhaps deserved.

One canvas that in many ways encapsulates the complex dilemma of the artist's reception and its relationship to his own persona is the powerful and mysterious *Self-Portrait with Cigarette* [109]. Here, we see a handsomely attired Munch emerging from a haze of blue smoke, surrounded by sketched, splattered, and stained streaks of black, blue, brown, and purple paint. The now-signature halo or shadow is visible on the shallow space of the wall behind him. Harshly lit, the artist's face, hand, and white shirt are the only points of illumination in an otherwise gloomy space. Munch's haughty, intense stare directly meets the viewer's; his extremely long arm holds a smoldering cigarette, badge of his bohemianism; and his bottom half is nearly enveloped in the blue haze he wrote about in his "St. Cloud Manifesto" of 1890.

As Patricia Berman and Erik Mørstad have thoughtfully argued, this work was immediately associated with the idea that Munch was physically and morally unstable, and thereby degenerate. Although the canvas was praised just as vociferously as it was denigrated, it became virtually an icon of the sick, socially aberrant artist. According to Munch's detractor Johan Scharffenberg, for example, the picture "seems to suggest he is not a normal person."[106] "But if the artist is abnormal," Scharffenberg continued, "a shadow is cast over all his art"—art that, he argued, was created for "degenerate people."

The young medical student went on to warn the public to steer clear of Munch's works, as if they could, by proximity, infect their viewers. However, the fact that the National Gallery of Norway bought this canvas directly from the exhibition—a purchase that precipitated a flurry of both criticism and defense in the popular press—only served to solidify the work's importance in Munch's oeuvre and subsequent historiography.[107]

Self-Portrait with Cigarette reminds us that, at this pivotal juncture in his career, Munch was a central participant in the process of critical mythmaking and reputation building that we have been exploring. The bohemian Przybyszewski attempted to frame the artist and his work as deeply individual, psychic, and misogynist; the German Wolff described Munch as a poetic, down-to-earth mood painter; and the French Natanson suggested the evocative, disturbing, and literary aspects of his production. Munch, for his part, responded by adopting most of this deeply conflicted, even contradictory discourse into his own sense of himself and his art, and the trajectory his career might take. On the one hand, his own ambivalence seemed to mirror—and perhaps spring from the same sources as—the cultural anxieties about pathology, form, iconography, individuality, and the market that swirled around him. On the other, he knew which of his images would promote controversy and which would associate him with a calmer, even indigenous landscape tradition, and he often balanced the two as he selected his works for public presentation. We can now understand the oft-quoted phrase with which we started this chapter—"Sickness, insanity, and death were the black angels that guarded my cradle"—not only as a biographical statement, but also as an attempt to give buyers and critics what they wanted.

109 EDVARD MUNCH *Self-Portrait with Cigarette*, 1895. Oil on canvas; 110.5 × 85.5 cm (43 1/2 × 33 5/8 in.). The National Museum of Art, Architecture and Design, Oslo, NG.M.00470. Cat. 38.

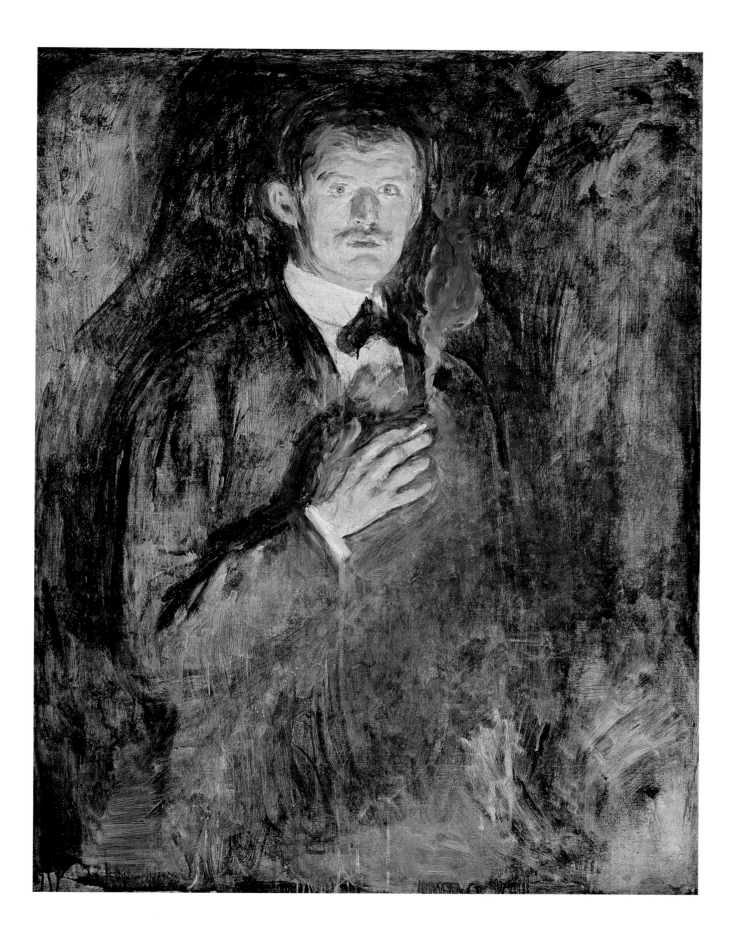

NOTES

1
As quoted in Epstein 1983, p. 11; and Berman 1994, p. 52, respectively.

2
As quoted in Tøjner 2001, p. 182.

3
For an example of this press coverage, see Walter Gibbs, "Museum Reopens Without Its *Scream*," *New York Times*, June 18, 2005.

4
Emil Schering to Edvard Munch, June 23, 1898. Munch Museum Archives. For a different interpretation of this motif, see Woll 2004, pp. 44–49.

5
Andreas Aubert, "Høstudstillingen: aarsarbeidet IV: Edvard Munch," *Dagbladet* 335, Nov. 5, 1890, pp. 2–3; as translated in Heller 1978, p. 81.

6
For more on the term's invention and dissemination in America and Europe, see Katherine Williams et al., *Women on the Verge: The Culture of Neurasthenia in Nineteenth-Century America*, exh. cat. (Iris and B. Gerald Cantor Center for the Visual Arts at Stanford University, 2004); and Barbara Spackman, *Decadent Geneologies: The Rhetoric of Sickness from Baudelaire to D'Annunzio* (Cornell University Press, 1989).

7
Berman 1993b, pp. 632–33.

8
Much has been written about Munch's mental illness by art historians, physicians, and psychiatrists. Among those written by the latter are Warick 1995; and Bowen 1988.

9
Munch and Aubert corresponded frequently from 1889 onward, as evidenced by letters in the Munch Museum Archives. See also Berman 1993b.

10
Aubert (note 5), p. 2.

11
Aubert traveled widely, writing perceptive reviews of exhibition reviews in Paris in 1889 and Copenhagen in 1888; for more on Aubert, see Messel 2002.

12
Christian Krohg, "Tak for den Gule Baaten," *Verdens Gang*, Nov. 27, 1891; as quoted in Boe 1971, pp. 141–42. Also reprinted as "Om Munchs Aften," *Dagbladet*, Nov. 27, 1891.

13
As quoted in Heller 1984, p. 82. See also Herman 1999, p. 216; and Oscar Thue, *Christian Krohg* (Aschehoug, 1991), p. 193.

14
Aftenposten, Oct. 9, 1892; as quoted in Bøe 1989, p. 162.

15
Heller 1993, p. 512.

16
Edvard Munch to Karen Bjølstad, Nov. 12, 1892; as quoted in Heller 1993, p. 512.

17
"Kunst und Wissenschaft," *Freisinnige Zeitung*, 1892, n.pag., news clipping, Munch Museum Archives. For more on Munch and Nordau, see Berman 1993b.

18
Jensen 1994, p. 206.

19
Friedrich Pecht, "Über den heutigen französischen Impressionismus," *Die Kunst für Alle* 2 (1887), p. 338.

20
Adolf Rosenberg, "Vereine und Gesellschaften," *Kunstchronik* 4, 5 (1992/93), p. 74.

21
Walter Selber [Walter Leistikow], "The Munch Affair," in *Freie Bühne* 3 (1893), pp. 1296–1300; repr. in Lovis Corinth, *Das Leben Walter Leistikows: Ein Stück Berliner Kulturgeschichte* (Paul Cassirer, 1910), pp. 42–48.

22
Edvard Munch to Karen Bjølstad, Nov. 26, 1892; as quoted in Schneede and Hansen 1994, p. 62.

23
Edvard Munch to Karen Bjølstad, Nov. 17, 1892; ibid.

24
Georg Voss, "Kunst, Wissenschaft, und Literatur," *National Zeitung*, Nov. 11, n.pag., news clipping, Munch Museum Archives.

25
Theodor Wolff, "Bitte um's Wort: Die 'Affaire Munch,'" *Berliner Tageblatt*, 1892, n.pag., news clipping, Munch Museum Archives.

26
Wolff's contemporary Richard Muther characterized the Norwegians in this manner in *Geschichte der Malerei in XIX. Jahrhundert* (G. Hirth, 1893/94), chap. 43.

27
W.[olfgang] K.[irschenbach], "Kunst und Wissenschaft," *Dresdner Nachrichten*, May 19, 1893, n.pag., news clipping, Munch Museum Archives.

28
Eggum 1978, p. 39.

29
Willy Pastor, in Przybyszewski 1894, pp. 69–71.

30
Edvard Munch to Johann Rohde, c. 1893; as quoted in Schneede and Hansen 1994, p. 63. For more on Munch's knowledge of Böcklin, see Mørstad 2004.

31
Pastor (note 29), p. 71.

32
For more on this myth, see Robert Luyster, "'The Wife's Lament' in the Context of Scandinavian Myth and Ritual," *Philological Quarterly* 77, 3 (1998), pp. 243–70.

33
Lippincott 1988, p. 46.

34
Ibid., p. 42; see also Eggum 1989.

35
Servaes referred to the motif as "holy and secret," and Pastor interpreted it as evoking Munch's "pantheistic spirit"; see Przybyszewski 1894, pp. 51, 72.

36
On the status of color, facture, and mood as shifting signifiers as Munch changed his style, see Bjerke 1995, pp. 28–41.

37
Emily Braun, Patricia G. Berman, and Alan Chong, "*Summer Night's Dream (The Voice)*," in Varnedoe 1982b, p. 192, cat. 66.

38
A 1906 photograph attests to this change, documenting an exhibition at the Galerie Commeter in Hamburg, which briefly represented Munch around this time. The image is in the Munch Museum Archives.

39
See Zarobell 2005. Regarding the commission, see letters from Axel Heiberg to Edvard Munch dated Aug. 15 and 28, and Sept. 7, 1896, Munch Museum Archives.

40
See Adriaan van der Hoeven, "The Aino Myth," in *Akseli Gallen-Kallela: The Spirit of Finland*, ed. David Jackson and Patty Wageman, exh. cat. (Groningen Museum/NAI, 2006), p. 144.

41
Although there were a few additions and deletions due to purchases, the same core of fifty-one to fifty-five paintings and drawings was featured in all six shows. The German venues included Düsseldorf, Cologne, Berlin (Equitable-Palast), Breslau, Dresden, and Munich. A seventh venue opened in Copenhagen in Feb. 1893.

42
The only income earned at Lichtenberg was from entry fees; otherwise, the exhibition lost money due to lack of sales; see Ferdinand Morawe to Edvard Munch, Sept. 12, 1893, Munch Museum Archives.

43
Edvard Munch to Karen Bjølstad (note 23).

44
On Munch's relationship with dealers, particularly Meier-Graefe, see Clarke 2003. For more on the "Munch Affair," see Heller 1993; and Peter Paret, *The Berlin Secession: Modernism and its Enemies in Imperial Germany* (Harvard University Press, 1980), pp. 50–54.

45
As quoted in Kneher 1994, p. 32.

46
For more on *The Frieze of Life*, see Heller 1969.

47
R. S., "Theater, Kunst, Wissenschaft," *Berliner Tageblatt*, Dec. 3, 1893, n.pag., news clipping, Munch Museum Archives.

48
L. U., "Neue Bilder," *Berliner Börsen-Courier*, Dec. 10, 1893, n.pag., news clipping, Munch Museum Archives.

49
Among the most positive early articles to appear about Symbolism was Franz Servaes's review of a show at Gurlitt's Kunstsalon in 1894; see idem, "Eine Symbolisten-Ausstellung," *Das Atelier* 4 (1894), p. 2.

50
Undated autobiographical text, c. 1893; as quoted in Schneede and Hansen 1994, p. 63.

51
For more on the Black Piglet, see Heller 1993.

52
Erik Werenskiold, 1895; as quoted in Gran 1951, p. 55.

53
Jaworska 1974, p. 314.

54
Przybyszewski 1894, n.pag. The author's own fascination with Nietzschean philosophy informed his remarks, leading him to argue that "individuality is eternal in mankind"; see ibid.

55
On Przybyszewski's work on Munch as part of his broader theories of psychic individuality and genius, see Irena Szwede, "The Works of Stanislaw Przybyszewski and their Reception in Russia at the Beginning of the Twentieth Century" (Ph.D. diss., Stanford University, 1970); and Lathe 1979.

56
Przybyszewski 1894, p. 15.

57
See, for example, Jayne 1989; and Van Nimmen 1997.

58
This print built upon motifs the artist had used since 1896 in images such as *Man's Head in Woman's Hair* (1896; Woll 88–89) and *Salome Paraphrase* (1898; Woll 125).

59
On the complexity of Munch's images of Mudocci and their relationship, see Berman and Van Nimmen 1997, pp. 196–201; Makela 2007; and Stabell 1973.

60
For more on this topic, see Marion Roach, *Roots of Desire: The Myth, Meaning, and Social Power of Red Hair* (Bloomsbury, 2005).

61
Przybyszewski 1894, pp. 19–21.

62
Of Munch's *Madonna*, Przybyszewski remarked, "Caught in the moment in which the private mysticism of the eternal intoxication of procreation, a sea of beauty from the face of the woman shines forth." See ibid., p. 19. On the many versions and interpretations of *Madonna*, see Høifødt 2008.

63
As quoted in Schröder and Hoerschelmann 2003, p. 137.

64
Munch could have seen a reproduction of the painting in Muther (note 26), vol. 3, p. 473.

65
See Eggum 1978, p. 50.

66
Tone Skedsmo and Ellen J. Lerberg, "*Puberty*," in Wood 1992, p. 105.

67
For an excellent discussion of *Puberty*, see David Ehrenpreis, "The Figure of the Backfisch: Representing Puberty in Wilhelmine Germany," *Zeitschrift für Kunstgeschichte* 67, 4 (2004), pp. 479–508.

68
An example of this tendency is Salme Sarajas-Korte, "*Awakening*," in Hayward Gallery 1986, pp. 92–93, cat. 14. On Enckell's representations of male subjects, see Aimo Reitala, "Magnus Enckellin varhaisten poika-kuvien lähtökohdista ja sisällöstä," *Taidehistoriallisia Tutkimuksia=Konsthistoriska Studier* 3 (1977), pp. 117–32.

69
Przybyszewski 1894, p. 37.

70
See Facos 1998, p. 73; Herman 1999, pp. 98–101; and Berman 1993c. On Gauguin's primitivist project, see Connelly 1995, chap. 3; and Douglas W. Druick and Peter Kort Zegers, *Van Gogh and Gauguin: The Studio of the South* (Art Institute of Chicago/Thames and Hudson, 2001). Regarding the nationalist issues surrounding German Neo-Idealism, see Clarke 2002.

71
Tøjner 2001, p. xx.

72
Ludvig Ravensberg, diary, Dec. 31, 1909. Munch Museum Archives.

73
Ibid.

74
Vincent van Gogh, *The Complete Letters of Vincent van Gogh*, vol. 2 (New York Graphic Society, 1958), p. 598.

75
For a more complete reading of Munch's early prints, see Clarke 2000; and Woll 1995.

76
Edvard Munch, draft of a letter to Jens Thiis, c. 1932; as quoted in Heller 1984, p. 103.

77
Friedrich Fuchs, "Die Ausstellung von Axel Gallén und Edvard Munch," *Das Atelier* 5 (1895), p. 5.

78
Ibid., p. 22.

79
S., "Munch und Gallén," *Adels- und Salonblatt* 3, May 10, 1895, p. 383.

80
For more on Munch and music, especially in regard to *The Scream*, see Prelinger 2000.

81
Munch 2005, p. 20.

82
See Heller 1973a; and Bjerke 2008.

83
Edvard Munch, c. 1891–93; as quoted in Tone Skedsmo and Ellen J. Lerberg, "*The Scream*," in Wood 1992, p. 96.

84
"Munch und Gallen" (note 79).

85
Munch 1949, p. 90; as translated in Eggum 1978, p. 172.

86
Boe 1971, p. 213.

87
Henrik A. Grosch, "Nye arbeider af Edv. Munch: udstillingen hos Blomqvist," *Aftenposten*, Oct. 5, 1895; as quoted in Boe 1971, pp. 216–17. Grosch described *The Kiss* and *The Scream* as "incomprehensible" and "repulsive," and *Death* and *The Moment of Death* as "caricaturelike" and "laughable." It is probable that the latter works correspond to versions of *The Smell of Death* and *Death in the Sickroom*.

88
Hans Lemmich Juell to Edvard Munch, Oct. 5, 1895; as quoted in Høifødt 2008, p. 31. It seems that the proximity of *Madonna* to Ragnhild Juell's portrait was too close for comfort.

89
Grosch (note 87), pp. 215–16.

90
Berman 1993b, p. 629. Scharffenberg's reaction is far better known than Obstfelder's remarks; this is indicative of Munch lore, as it was useful in securing the artist's reputation for insanity. For more on this debate, see Mørstad 2006b.

91
Ibid., n. 12. Høifødt 2006 explores the different versions and potential meanings of Munch's comment.

92
Tøjner 2001, p. 134.

93
R.[asmus] S.[teinsvik], "Edvard Munch," *Den 17 de Mai*, Nov. 12, 1895, news clipping, Munch Museum Archives.

94
Tone Skedsmo and Ellen J. Lerberg, "*Moonlight*," in Wood 1992, p. 61, cat. 12.

95
As quoted in Eggum 1979, p. 38.

96
Siegfried Bing, "Program for L'Art Nouveau"(1895); as quoted in Annette Leduc Beaulieu and Brooks Beaulieu, "The Thadée Natanson Panels: A Vuillard Decoration for S. Bing's Maison de l'Art Nouveau," *Nineteenth-Century Art Worldwide* 1, 2 (Autumn 2002), www.19thc-artworldwide.org/autumn_02/articles/beau.shtml. For more on Bing, see Gabriel P. Weisberg, *Art Nouveau Bing: Paris Style 1900* (Harry N. Abrams, 1986).

97
Julius Meier-Graefe to Edvard Munch, Dec. 12, 1895; as quoted in *Julius Meier-Graefe, Kunst ist nicht für Kunstgeschichte da: Briefe und Dokumente*, ed. Catherine Krahmer (Wallstein, 2001), p. 19. For a detailed account of this exhibition and the relationship between Meier-Graefe, Munch, and Bing, see Gabriel P. Weisberg, "S. Bing, Edvard Munch, and L'Art Nouveau," *Arts Magazine* 61 (1986), pp. 58–64; and Clarke 2003.

98
For a complete list of works in this exhibition, see Kneher 1994, pp. 92–94.

99
Frantz Jourdain, *La Patrie*, May 30, 1896, n.pag., newsclipping, Munch Museum Archives. My thanks to Jean Coyner for her help with the French translations.

100
August Strindberg, "L'exposition d'Edward Munch," *La revue blanche* (June 1896), p. 525; author's translation of the quote appearing in Messer 1985, p. 31.

101
In 1895, Munch created *The Kiss* (Woll 23), an etching that connects directly with *The Kiss* on panel. It was rare for Munch to work on panel at this point in his career.

102
Prelinger 1996, p. 147, cat. 32.

103
My thanks to Gloria Groom for sharing this information. For more on Munch's critical reception in Paris, see Rapetti 1991.

104
T.[hadee] N.[athanson], "M. Edvard Munch," *La revue blanche* 9 (1895), p. 477.

105
See Jules Laforgue, "Le Salon de Berlin," *Gazette des beaux-arts* 28 (1883), pp. 120–28; as excerpted in Elizabeth Gilmore Hoyt, *The Expanding World of Art, 1872–1902*, vol. 1 (Yale Unversity Press, 1988), pp. 293–301.

106
"Referat fra Lørdag 9.November," Det Norske Studentersamfund 1895; as quoted in Mørstad 2006a, p. 109.

107
For more on these debates in the press, see Kneher 1994, pp. 83–84.

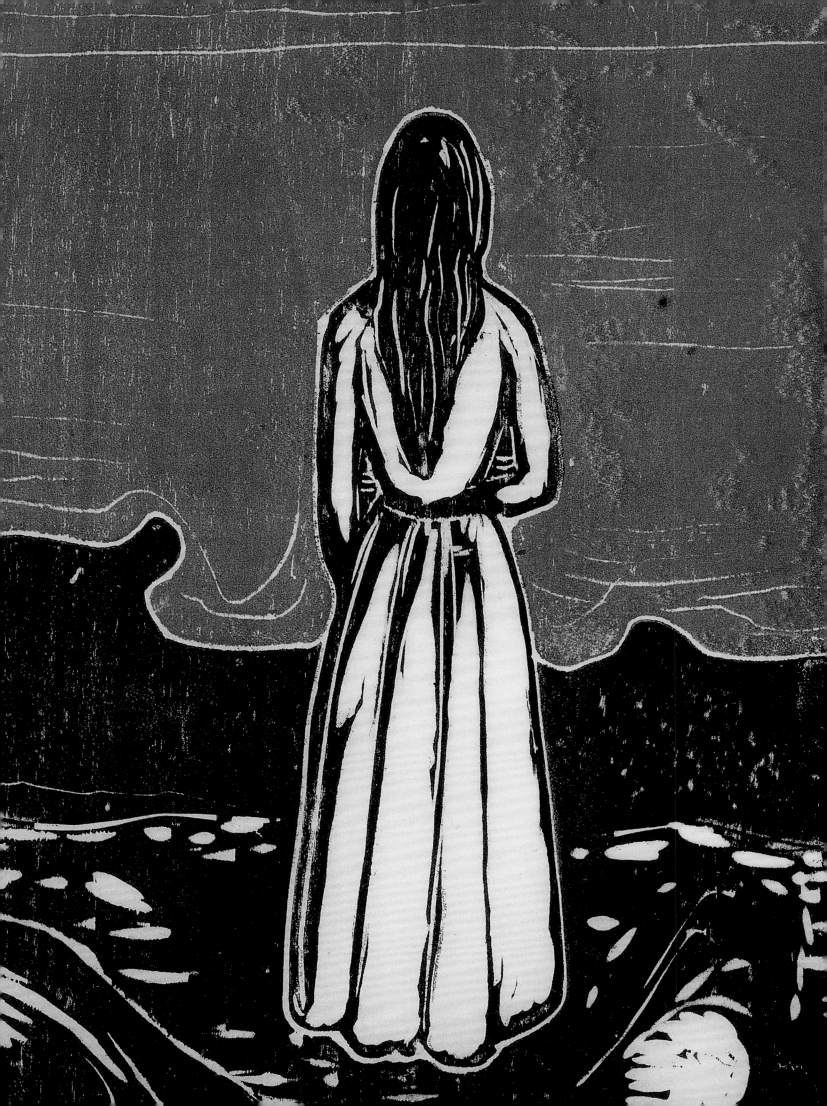

THE MATRIX AND THE MARKET: EXPLORING MUNCH'S PRINTS

The superb scholarly research that has been done on Munch's printed images and the inventive technical processes he used to create them has provided an exceptionally detailed entrée into his graphic work. Thanks to the efforts of Patricia Berman, Elizabeth Prelinger, Gerd Woll, and others, we know what many of these images mean from a sociohistorical perspective; when the artist worked and reworked certain plates; who printed the various editions of his copper plates and stones in Berlin, Kristiania, and Paris; and even what kinds of wood he used to make his woodblocks.[1] This chapter aims to build upon this impressive body of literature by investigating the connections between the matrix, the market, print history, artistic process, and subject matter. Central to our discussion will be the question of how Munch carefully and strategically anticipated market trends and absorbed other artists' technical tricks while simultaneously elaborating and expanding his own repertoire of images, inventing novel ways to explore his key motifs symbolically and creatively.

The artist did not begin printmaking until age thirty-one, in late 1894, while he was living in Berlin. By this point, he had achieved some notoriety by exhibiting his paintings throughout Germany, but his earnings came more from entrance fees than from sales. In a state of constant financial crisis, and feeling an increased need to support his family in the wake of his father's death four years earlier, Munch was likely lured to the medium as a way to earn additional income and publicize his images. He was already making copies of his paintings when commissioned by collectors, and also did so in order to show more than one version of a work while keeping the "original" for himself. So he no doubt anticipated the need—and the popularity—of printed versions as well.[2] In an 1893 letter to his aunt Karen, he offered an excited account of an experience in a paper shop in Copenhagen, where he offered the owners his paintings for photographic reproduction. In return, they gave him one hundred kroners for four paintings and one hundred more a month later. It was perhaps encounters such as this that encouraged Munch to think more strategically about making affordable images related to his painted work for collectors, dealers, and, in some cases, for his own documentation.

Munch created over 250 prints between 1894 and 1904—a prolific number for an artist who, at the same time, continued to paint, travel frequently, and organize numerous exhibitions. His embrace of printmaking was all the more remarkable,

however, given his relative ignorance of the field early in his career. In Norway, there was only a scant printmaking tradition on which to draw. Artists such as Heinrich August Grosch, who was trained in Copenhagen, created accomplished landscape etchings like *View of Tistedalen and Halden from the Veden Farm* [**110**], which represented Norway as his tourist-clients wished to see it: mountainous and rural, with pleasant dairy farmers in the foreground and fjords in the distance. Given the lack of painter-printmakers in Norway before Munch, there was probably little opportunity for instruction, and it is no surprise that he had to go elsewhere to learn the techniques he later mastered with such ability.

However, Munch did have a brief, if chance, introduction to printmaking as a young man. His uncle, the artist Carl Friedrich Diriks, created small, amusing books that gained some degree of popularity in Kristiania. In 1882, Munch followed suit and made a booklet of seven humorously captioned illustrations entitled *Pen Drawings* [see **111**]. As the title suggests, Munch's intention was to reproduce his drawings, not to experiment with transfer lithography, the medium in which the publication was printed.[3] However, the experience indicates that he was acquainted with such methods at an early age, even though thirteen years passed before he would experiment directly with a lithographic stone. This early practice at combining texts and images was something that the artist would fruitfully explore throughout his life in the books that gathered together his poetry, prints, and drawings. This narrativizing tendency was inherent to his conception of printed images and their relationship to one another, regardless of whether he described them with an explanatory text.

As we shall see, Munch's choice to use a particular matrix—whether a thin copper plate, a lithographer's stone, or a block of wood—to create an image was intimately connected to the kind of physical work he did on that plate, stone, or block. Each matrix has its own physical and chemical properties that add to the relative ease or complexity of making a work of art on it. For Munch, however, each of these materials and techniques also carried its own aesthetic, commercial, emotional, and historical associations, which influenced his decisions in a profound way. For example, in his ethereal *Summernight: The Voice* [**112**], he adopted means that were both linear and painterly. Here, he used drypoint to outline the woman's body, the trees, and the sunset reflecting on the

water. To render the interior spaces defined by the lines, he chose the open bite process, which produces effects resembling those of a wash drawing. In this technique, the artist masks off selected areas of the plate and then immerses it in an acid bath. The acid bites into the exposed areas, creating uneven peaks and valleys that hold ink when printed.

Through these choices, Munch strove to create in *Summernight: The Voice* a linear and tonal equivalent of his earlier canvas, a reproductive print—which is to say, a work on paper that "reproduces" a work in another medium, generally a painting—whose intent was mainly repetitive. While *The Voice* was certainly meant to stand on its own as a unique, powerful work of art, Munch's choice of drypoint and open bite suggest that this image's primary function was as an advertisement for its painted source.

I. Intaglio

It is not at all surprising that Munch adopted the technique of intaglio printmaking—and first experimented with reproductive processes in general—during his time in Berlin, since the city had experienced an etching revival beginning in the 1870s. Because the print could be used to advertise the Prussian government's ideology through affordable artworks, it was nurtured by the creation of special committees and supported by increased funding.[4] At the Berlin Academy of Art, the government also underwrote the instruction of legions of young artists whose work graced the pages of deluxe art journals and *Galeriewerke*, large-scale books that celebrated the riches of Prussia's museums by featuring reproductive prints of famous paintings.

By the mid-1880s, the figure of the painter-printmaker—a painter who practiced printmaking as an original means of expression rather than making reproductive works simply to earn a living—had gained increasing prominence. This was due in large part to contemporary histories that established the intaglio's connection to the Germanic past, focusing particularly on the greatness of artists such as Dürer and Rembrandt, who had brought printmaking to its highest creative potential in the sixteenth and seventeenth centuries. By the time Munch began making prints in earnest in the early 1890s, the painter-printmaker had emerged as the only true artistic practitioner of the intaglio print.

This ascent was accompanied by that of the reproductive etching. Etchings are made by spreading a thin layer of waxy ground on a copper plate; the artist then draws the design with a thin needle, which moves easily through the ground to expose the copper surface below. The plate is then immersed in an acid bath that eats away at the exposed areas while the waxy ground protects the rest of the plate. Afterward, ink is applied and the surface of the plate is wiped clean, so that the grooves are the only areas still holding ink. The paper is placed over the plate and run through a strong press that pushes the paper into the grooves to make the impression [see 113]. Printing was done either by specialty establishments or by artists themselves.

Fine art journals and museum publications created a strong market for etchings, and dealers such as Fritz Gurlitt changed public perceptions by selling them alongside paintings and sculptures, featuring the work of artists such as Käthe Kollwitz, Max Liebermann, and Anders Zorn. Artists and critics touted the etching process as a less laborious alternative to engraving, praising the results as "free," "painterly," "easy," "coloristic," and "improvisatory" compared to the more "serious" and "difficult" work necessary to create an engraving. These associations were class-based, inspired by the fact that engravers were often "professional" rather than "artistic" practitioners.[5] Drawing, incomplete and open, was thought to embody the artist's emotions, allowing for a similarly subjective experience on the viewer's part. Max Klinger, whose work Munch greatly admired, published *Painting and Drawing* (1891), a treatise that promoted etching as more suitable to the world of fantasy, imagination, and poetry.[6] Moreover, as the validity and function of the reproductive print was called into question by the encroachment of photography, the etching was touted as a potential savior, since its more painterly treatment differentiated it from the perceived mechanical impersonality of the photograph.

It was precisely this technical, theoretical, and commercial richness that attracted Munch to print media. The artist never revealed who his teachers were, but he likely learned etching and drypoint from his fellow artists and Berlin printers.[7] As mentioned earlier, another force that prompted Munch to create serial images in the first place was the need for additional income. Eberhard von Bodenhausen, a board member of the

110 HEINRICH AUGUST GROSCH (Norwegian, 1763–1843). *View of Tistedalen and Halden from the Veden Farm*, c. 1800. Etching on paper; 26 × 38.2 cm (10¼ × 15 in.). The National Museum of Art, Architecture and Design, Oslo, NG.K&H.A.19169.

111 EDVARD MUNCH *The Painter and the Farmer's Wife*, from *Pen Drawings*, 1882. Transfer lithograph in black ink on grayish white paper; 19 × 25.5 cm (7½ × 10¹/₁₆ in.). Munch Museum, Oslo.

112 EDVARD MUNCH *Summernight: The Voice*, 1894. Open bite etching and drypoint in black ink on heavyweight ivory wove plate paper; plate: 24.9 × 32.4 cm (9¾ × 12¾ in.); sheet: 44.9 × 62.8 cm (17⅝ × 24¾ in.). The Art Institute of Chicago, Clarence Buckingham Collection, 1963.280. Cat. 26.

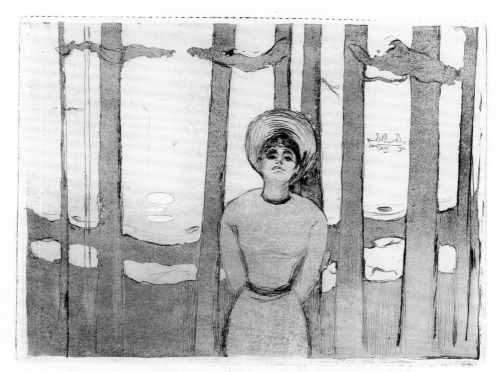

illustrated journal *Pan*, praised the artist's early etchings and suggested that he pursue the medium further, perhaps due to its growing popularity and the fact that etchings were more affordable than paintings, capable of increasing an artist's renown through their broad distribution.[8] In November 1894, Munch wrote to his family, "I am in good working humor—have begun to work with prints with the possibility of publishing a small collection—intaglio prints."[9] His letter suggests that he made these works for publication, but surely also did so because of the creative possibilities printmaking afforded.

Between 1894 and 1895, the artist made over thirty intaglio prints. *Harpy* [114], one of his first, was a pure drypoint. In this process, a sharp needle is drawn directly across the plate like a plough through a field, lifting small areas of copper, or burr, on the side, which creates a slightly fuzzy line when printed. However, the burr wears down quickly, so its effects are most visible in the earliest impressions pulled off the plate. For example, in this impression of *Harpy*—which Munch inscribed as the eighth—the furry quality of the figure's wings and the

dark shadow they cast only add to the gruesomeness of the scene. Here, a bird-woman sinks her talons into an emaciated man while the disembodied head of another figure, possibly the artist's mentor, Christian Krohg, sits beside the corpse. A skeletal artist sketches the hair-raising encounter casually in the background. Like so many of Munch's evocative yet enigmatic images, the work conveys a clear sense of gender anxiety: not only is the sexualized, hideous creature ready to devour the little meat left on the man's bones, but she symbolically rests her claws atop his genital area, threatening his potency.[10]

In 1895, Munch published his first print portfolio in Berlin with an introductory text by his friend Meier-Graefe. Although it has been considered of minor importance, the commercial and ideological strategies that Munch and Meier-Graefe employed to promote it are immensely revealing. Like the critics' responses, they epitomize the paradoxical relationship between originality and multiplicity in a decade when issues surrounding reproduction and illustration were highly conflicted.

Seven of the eight prints in the portfolio were executed in drypoint, which, as noted earlier, can only be printed a limited number of times before the furry quality of the line is lost. The first ten impressions were printed on thick Japanese paper and signed by the artist. Instead of capitalizing on this rarity, however, Munch and Meier-Graefe then decided to steel-face the plates, which entails encasing the entire printing surface in a thin layer of metal. Rarely used for early impressions or technical tours-de-force, this practice was more often employed for large, cheap printings after a plate had worn down, since it inevitably diminishes the feathery quality of the drypoint. The choice to steel-face indicates that the pair saw the portfolio as a predominantly commercial venture, and the fifty-five later impressions were printed on English copperplate paper and left unsigned.[11]

Despite the commercialism of their approach, Meier-Graefe and Munch attempted to add historical weight to the venture, using the strategy of scholarly explanation with an extensive introductory text. In his forward, Meier-Graefe focused on the prints' "decency," "respectability," "simplicity," and naturalism, stressing Munch's powers of observation. Interestingly, the one work he failed to discuss in the text, *The Day After* [116], was far from respectable, as it represented a woman

113

113 An etching of *The Sick Child* (p. 118, fig. 117) being pulled off a copper plate after printing.

114 EDVARD MUNCH *Harpy*, 1894. Drypoint in black ink on heavyweight off-white wove plate paper; plate: 29.8 × 22.9 cm (11 3/4 × 9 in.); sheet: 62 × 44.7 cm (24 3/8 × 17 5/8 in.). The Art Institute of Chicago, Clarence Buckingham Collection, 1963.275. Cat. 23.

115 EDVARD MUNCH *The Lonely Ones*, 1894. Drypoint with burnishing in black ink on cream wove paper; plate: 16.8 × 22.5 cm (6 5/8 × 8 7/8 in.); sheet: 34.3 × 48 cm (13 1/2 × 18 7/8 in.). The Art Institute of Chicago, Clarence Buckingham Collection, 1963.313.

116 EDVARD MUNCH *The Day After*. 1894. Drypoint and open bite etching in black ink on lightweight ivory wove paper, laid down on heavyweight off-white wove paper (chine collé); plate: 20.8 × 29.7 cm (8 1/4 × 11 in.); primary support: 20.2 × 29 cm (8 × 11 3/8 in.); secondary support: 44.3 × 62.9 cm (17 1/2 × 24 3/4 in.). The Art Institute of Chicago, Clarence Buckingham Collection, 1963.1143. Cat. 22.

sprawled on her bed after an evening of debauchery. According to Meier-Graefe, however, the elements in Munch's paintings that seemed to "shriek of glaring colors" and give rise to unhealthy imaginings, were, in his prints, "attained by means of very simple contrasts":

Take *The Lonely Ones*, for instance. There can be no clearer, more concise expression; there is an absolute minimum of extrinsic matter ... The relations—or rather nonrelations—of the individual to the universe cannot possibly be depicted more simply; it seems to me that it must have taken Munch several whole days to get it down on paper in all its terse significance.[12]

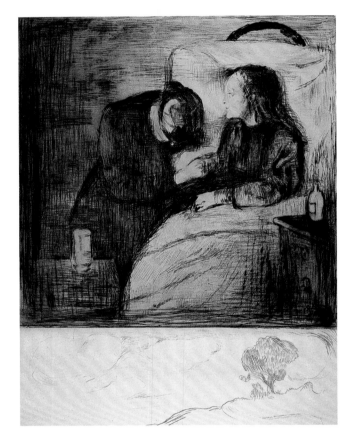

117

For Meier-Graefe, the subtlety of the black-and-white contrasts in *The Lonely Ones* **[115]** evokes the emotional contrasts between man and woman, humanity and nature. But he described their elemental simplicity as growing out of nature, not as contrary to it, as if he was attempting to redeem the urban decadence with which Munch was then associated. In the artist's prints, Meier-Graefe asserted, "The hand-writing is more correct ... everything is more decent, more respectable and sedate ... it is incredible that a man who normally paints with a broom-like brush now masters such delicacy not only technically but also in his subject matter."[13] This distinction is significant: as the critic explained in a later book, color—the domain of French painting—was materialistic and decorative, whereas line was associated with "primitives" such as Dürer. Munch's line, therefore, enabled him to express "elemental simplicity" in the manner of "the ancients."[14]

Although Meier-Graefe acknowledged that these prints had "the same subjects as exceptionally good paintings," when discussing *The Sick Child* **[117]**, he claimed, "It is strange that in the painting ... the artist achieved exactly the same effect with entirely different means."[15] The print's impression on the viewer, he suggested, was the same as the painting, even though it was made through a radically different process. Hans Rosenhagen, who reviewed Munch's prints when they were on display at Ugo Barroccio's Berlin gallery the same year (see p. 215), came to a similar conclusion. He remarked, "[Munch] has given a beautiful, delicate, and painterly effect with drypoint and aquatint, especially in the sheets *The Lonely Ones, Moonlight,* and *The Sick Child*," and went on to assert, "Most were etched after his paintings."[16] For Meier-Graefe and Rosenhagen, it was of little consequence that the prints were "after" the paintings, or that their subjects were the same; the prints were regarded as original interpretations, not reproductions. For both critics, the linear treatment transformed the work of art, rendering it "delicate" and "beautiful." Interestingly, to make their point, neither addressed the decidedly indelicate processes that Munch employed for his print *The Sick Child*. The artist created the initial design with drypoint but, as with the painted versions, energetically and even violently scored into the plate with additional drypoint and roulette, and then erased with a burnisher. He may have done this to replicate his similar attack on the canvas.

117 EDVARD MUNCH *The Sick Child*, 1894. Drypoint in black ink on heavyweight cream wove paper; plate: 38.6 × 29.2 cm (15 1/4 × 11 1/2 in.); sheet: 48.3 × 34.4 cm (19 × 13 1/2 in.). The Art Institute of Chicago, Clarence Buckingham Collection, 1963.318. Cat. 24.

Like Rosenhagen and Meier-Graefe, the critic Jaro Springer was a consistent supporter of modernism and, during the 1892 Munch scandal, of Munch himself. But he was far less enthusiastic about the new directions that Munch's art seemed to be taking in the Barroccio exhibition, calling him "more infamous than well-known."[17] Springer did not question the artist's immense talent, but feared that "tasteless" paintings such as *Madonna* (p. 83, fig. 82) would not win him any followers. He did see one ray of hope for this man who "could not be tamed," however, and that was printmaking. Springer argued: "In the etched sheets he is more moderate than in his paintings … and through etching Munch might be able to return to real art once again."[18] Although Springer characterized Munch's prints as more measured, etchings such as *Woman and Death*, *Harpy*, and *The Day After* display exactly the same provocative, sexualized imagery that Berlin critics (including Springer) pilloried in his paintings.

However, as Munch attempted to legitimize his intaglio prints, he did steer clear of some types of imagery. The artist chose not to display works like *Harpy* in his early graphic exhibitions, since they were more imaginative subjects unrelated to extant paintings—less like reproductive prints than, say, *The Sick Child*, and certainly more sexually provocative and disturbing. He printed *Harpy*, but in relatively few impressions, and the plate was never steel-faced, which suggests that he did not initially consider it saleable to a wide audience. After all, as we have seen, it was precisely their "moderation" that made etchings and drypoints like *The Lonely Ones* potentially attractive from a marketing perspective.

In the end, however, the portfolio was a commercial failure and appears to have put Meier-Graefe and Munch in dire financial straits. "Because of my generosity," the dealer told the artist, "I have gotten into the most dreadful predicament, and I do not know how I will get myself out of it. In Paris I will direct all my efforts at selling your paintings, I know no other way."[19] Munch's positive experience with the critics, however, appears to have encouraged him to continue making prints, and to move toward examples that resembled his paintings—and even repeated their popular imagery—in a way that was less reproductive, and more daring and unique.

Given that Munch first attempted printmaking in Berlin and no doubt encountered Impressionist practitioners in both

Berlin and Paris, it is important to note how very differently he handled the etching needle and exploited the processes at his disposal. Max Liebermann, Camille Pissarro, and many of his other contemporaries relied on subtle, carefully drawn lines and the light, atmospheric effects of aquatint. Yet if we consider Munch's hauntingly direct *Study of a Model* [118], we can see that such a polished approach is entirely absent from the plate, which is full of multidirectional, seemingly haphazard marks. The young woman's stiff pose and staid expression suggest that she may be merely a model posing, quite different from the anxiety-ridden, sexually imperiled subject of *Puberty* (p. 86, fig. 87), who she in some ways resembles. Yet her look of composure is profoundly at odds with Munch's highly energized mark making, which introduces a feeling of intense restlessness and unease. Here, the artist created tone not with carefully delineated areas of aquatint, but rather with the more haphazard open bite process, which he combined with drypoint. This approach shows him to be a printmaker moving on his own path, self-consciously rejecting the more refined intaglio prints of his contemporaries.

After several months of experimenting with various etching techniques, Munch began to embrace lithography, a medium in which he was able to break new ground and try novel approaches to familiar subjects.[20] For example, his lithograph *Attraction I* [120] contains different visual and symbolic information than his earlier intaglio *Attraction II* [119]. The intaglio's comparative rigidity suggests the separateness of the two figures, whereas the lithograph invokes a more mystical, enveloping sensation, with its curving top akin to an altarpiece and the woman's wavy hair serving to attract the man and draw him closer. One image is not necessarily more evocative than the other, but each reflects the characteristics of its medium—linearity on the one hand, fluidity and sensuality on the other.

II. Lithography

Between mid-July and early August 1895, Munch began to create his first lithographs.[21] Unlike intaglio and woodblock printmaking, in which an artist can theoretically prepare a matrix and print a sheet in a modest studio equipped with a small press, lithography involves complex, arduous chemical and printing processes. The basic principle is that oil and water

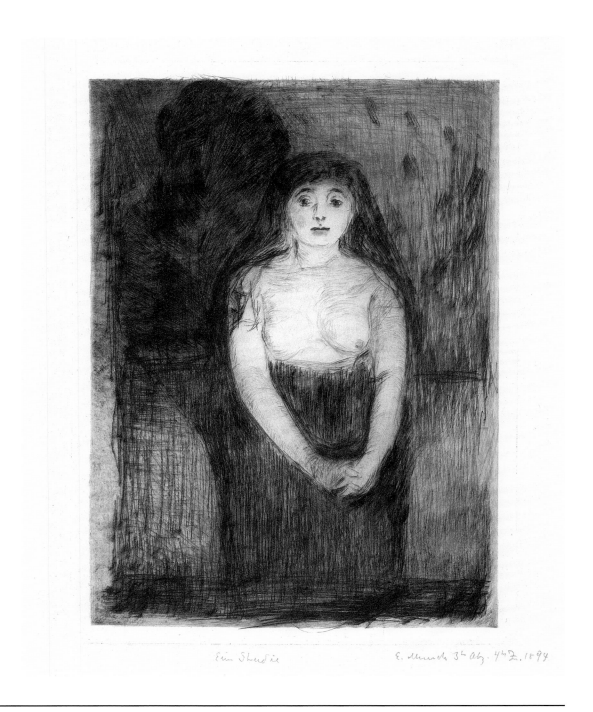

Ein Studie E. Munch 3ᵗ Abzg. 44Z. 1894

118 EDVARD MUNCH *Study of a Model*, 1894. Drypoint and open bite etching in black ink on heavyweight off-white wove plate paper; plate: 28.6 × 21 cm (11 1/4 × 8 1/4 in.); sheet: 42.9 × 34.2 cm (16 7/8 × 13 1/2 in.). The Art Institute of Chicago, Clarence Buckingham Collection, 1963.277. Cat. 25.

119 EDVARD MUNCH *Attraction II*, 1895. Etching with open bite and drypoint with burnishing in black ink on cream laid Arches paper; plate: 26.6 × 33.5 cm (10 1/2 × 13 1/4 in.); sheet: 30 × 43.4 cm (11 3/4 × 17 1/8 in.). The Art Institute of Chicago, Clarence Buckingham Collection, 1963.279. Cat. 31.

120 EDVARD MUNCH *Attraction I*, 1896. Lithograph in black ink on grayish ivory China paper; image: 47.4 × 36.1 cm (18 5/8 × 14 1/4 in.); sheet: 51.2 × 38.9 cm (20 1/8 × 15 3/8 in.). The Art Institute of Chicago, John H. Wrenn Memorial Collection, 1943.526. Cat. 45.

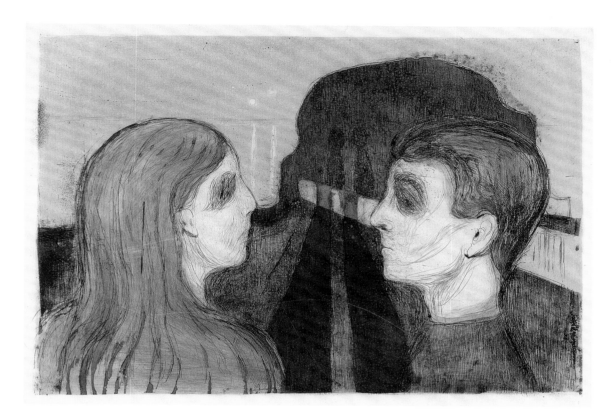

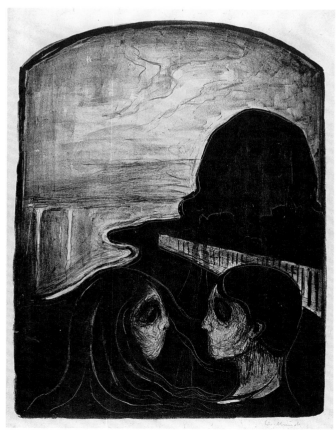

repel each other. To begin, the artist draws on a lithographic stone—a piece of heavy limestone—with a crayon or brush containing an oil-based medium. The surface is then treated with a liquid combination of nitric acid and gum arabic, which adheres itself selectively to the drawn and nondrawn areas. At this point, the drawn areas will attract greasy printing ink, while the porous limestone will repel it. Then the artist or printer removes the drawing material so that the stone appears to be—but is not, in fact—blank. Now the stone is ready to be printed. Continually wetted with water, the surface of the stone where the oily drawing was made repels the water and attracts only the greasy ink rolled onto it. Therefore, when run through a heavy press, the paper picks up only the images that the artist had originally drawn or painted [see **121**].

When Munch began experimenting with lithography, Germans had only just begun to resuscitate the process, which they had originated nearly a century before. The actor and playwright Alois Senefelder invented lithography in 1798 as a way to print sheet music cheaply, later espousing it as an artistic medium that flowered widely in France and Germany during the Romantic period. However, by mid-century, the process had fallen into disfavor and was associated more with commercial concerns and cheap advertising than with high art. This situation was slowly changing thanks to the support of curators and dealers, the efforts of individual practitioners, and collective ventures such as the deluxe art journal *Pan*, which featured artists' lithographs and thereby fostered increased public interest.[22]

Central to this revival was the promotion of lithography's close proximity to the artist's hand. Because the process so closely replicated the artist's direct drawing on the stone, it was thought to transcend etching, which relied upon tools to re-create linear or painterly effects.[23] In this way, lithography allowed Munch to make "original" drawings on the stone, ones that, unlike etchings, were not perceived as reproductive. Although Munch continued his intaglio practice of basing lithographs on his painted compositions, his frequent use of tusche, or lithographic ink, allowed for an expressiveness that recalled his practice of painting with oil on canvas, particularly his increasingly diluted use of oil in washes. Lithography permitted him to work on the stone as he would on a canvas and, in fact, his letters from 1895 reveal that he often placed the stone directly on an easel as he worked.[24]

Among Munch's first lithographs is *Self-Portrait* [**122**], in which he presents himself as carefully groomed, confidently directing his gaze at the viewer. His face is delicately and subtly rendered in lithographic crayon, whereas the background is almost entirely covered in a wash of black tusche, apparently in a haphazard manner. The skeletal arm and handwriting are even less expertly done: lines cross over into the upper and lower borders, and the two *D*s and one *N* in Munch's name appear backward (writing is reversed in the printing process). The first state of this print [**123**] shows the artist's face hovering in a mottled, hazy background that recalls the smoky blue atmosphere of his *Self-Portrait with Cigarette* of the same year (p. 109, fig. 109). His choice to blacken out the background in this version gives the work a deathly quality that is enhanced by the arm bone below and the handwriting above, which resembles that on a tombstone;

121

121 An impression of *The Scream* (p. 93, fig. 94) being pulled off a lithographic stone after printing.

122 EDVARD MUNCH *Self-Portrait*, 1895. Lithograph in black ink on ivory Japanese paper; image: 46.5 × 32.5 cm (18 1/4 × 12 3/4 in.); sheet: 59.7 × 44 cm (23 1/2 × 17 3/8 in.). The Art Institute of Chicago, Clarence Buckingham Collection, 1963.281. Cat. 37.

123 EDVARD MUNCH *Self-Portrait*, 1895. Lithograph in black ink on paper; sheet: 45.7 × 36.8 cm (18 × 14 1/2 in.). Munch Museum, Oslo.

indeed, Munch's choice of a lithographic stone on which to print this simulated tombstone was perhaps intentional. As Elizabeth Prelinger has noted, the floating, severed head was a common motif in Symbolist art, signifying the split between the spiritual and the physical.[25] It may also connect to his later self-representation in *Salome* (p. 81, fig. 80), suggesting martyrdom and a potential fear of lost male potency.[26] The stark image, with its sophisticated combination of broad areas of wash and the detailed section of crayon, is quite remarkable when we remember that the artist was just taking up the process.

Munch's early skill with lithography is also evidenced in *Vampire I* and *II*. As we saw in chapter two, the image depicts a man who kneels in front of woman, resting his head on her

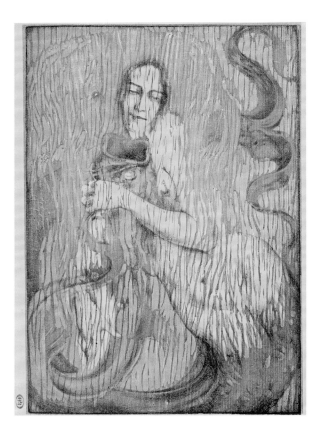

lap, as she kisses or bites his neck. In the painted version (p. 82, fig. 81), the couple is set in an amorphous space with a shadowy halo surrounding them. In *Vampire I* [125], however, Munch placed them before the same window frame that appears in his earlier paintings *Kiss by the Window* (p. 54, fig. 54) and *The Girl by the Window* (p. 52, fig. 50), suggesting the scene as a carnivorous denouement to the raw passion of the former. Indeed, in *The Frieze of Life* series, the artist positioned *Vampire* immediately after *Kiss by the Window*.

The tone of the *Vampire* lithographs is more ominous and predatory than that of the painting. This is especially true of *Vampire II* [126], in large part due to the presence of the woman's red, snakelike hair. While Munch produced black-and-white impressions such as *Vampire I*, he hand colored many of them, and in 1902 revisited the print considerably, using a dazzlingly complex array of woodblocks to print separate sections. In this impression, the main, or keystone, image is printed in black; the man's jacket is overprinted in a blue woodblock; the woman's hair in a red woodblock; and their faces and her arms in an ocher woodblock. This provocative combination of woodcut and lithography, which Munch mentioned in a letter that he had employed as early as 1897, was perhaps a trick learned in Paris from his friend Paul Herrmann, who not only mixed media but boldly exploited the grain of the wood in his own prints.[27] In Herrmann's *Playful Mermaid* [124], he used a lithographic stone for the blue underdrawing of the mermaid's body and that of her paramour the fish, overprinting it with three different wood blocks. The sensual use of the fish and the mermaid's wavy red hair, highly reminiscent of *Madonna* and hand-colored impressions of *Vampire*, suggests that Munch likely influenced Herrmann's work as well.

In *Vampire II*, the complexity of Munch's printing processes was matched by the intensity of visual information in the images themselves. Red hair, by now a familiar sign of erotic danger, commands the viewer's attention and seems to suggest blood itself, its snakelike form emphasizing the woman's emasculating power. As the artist once wrote about a lover's hair, "It had twisted itself around me like blood-red snakes—its finest threads had entangled themselves in my heart."[28] The insistent linearity of the crayon and tusche marks, which move frantically in different directions, make lithography the ideal vehicle for representing this sensually charged

124 PAUL HERRMANN (German, 1864–1940). *Playful Mermaid*, 1896. Woodcut from four blocks in blue, red, yellow, and light purple over lithograph in blue ink on heavyweight cream laid paper; image: 29.1 × 20.3 cm (11 1/2 × 8 in.); sheet: 36.2 × 28.1 cm (14 1/4 × 11 1/8 in.). Published in *Pan* 3 (1897), after page 252. Ryerson Library, The Art Institute of Chicago.

125 EDVARD MUNCH *Vampire I*, 1895. Lithograph in black ink with additions in graphite on heavyweight ivory wove paper; image: 36.3 × 46.9 cm (14 1/4 × 18 1/2 in.); sheet: 48 × 64 cm (18 7/8 × 25 1/4 in.). Munch Museum, Oslo, MMG 567-27. Cat. 40.

126 EDVARD MUNCH *Vampire II*, 1896. Lithograph printed from two stones in black and red-brown ink with woodcut printed from one block (sawn into four sections) in tan, blue, and blue-black ink on cream Japanese paper; image: 38.3 × 55 cm (15 1/8 × 21 11/16 in.); sheet: 40.6 × 57.2 cm (16 × 22 1/2 in.). Collection of Catherine Woodard and Nelson Blitz, Jr. Cat. 58.

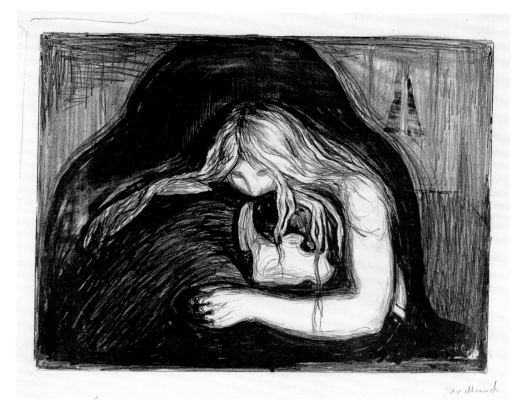

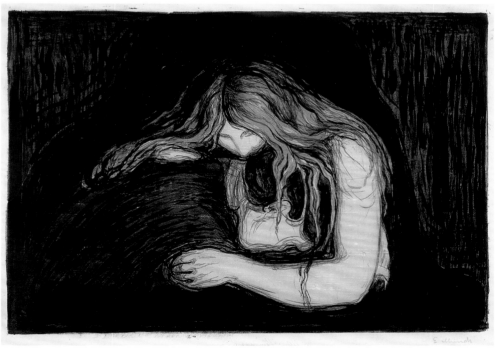

moment. The lines on the man's back move toward the woman like flowing water, her hair streams down to envelop him, and the background marks squirm and writhe, pressing her body against her victim's. Like the painting, the dark, haloed space that encloses the couple adds an otherworldly tenor to the scene.

Another lithographic monument of Munch's first year as a printmaker was *Madonna* [128–29], a print that went through numerous technical permutations from its first version in 1895 to a color version in 1902. Truncated impressions, in which the woman's body is cut off just below her breasts, date from the same year and were created from the same stone. Munch offered the following poetic description of the work in "The Tree of Knowledge" (c. 1916):

A pause when the whole word stops revolving. Your face encompasses the beauty of the whole earth. Your lips, as red as ripening fruit, gently part as if in pain. It is the smile of a corpse. Now the hand of death touches life. The chain is forged that links the thousand families that are dead to the thousand generations to come."[29]

As in the painting, Munch places the viewer in the role of the male lover and, as the text makes clear, connects the act of intercourse with both life and death. The former is expressed in the frame, which shows swimming sperm and, at lower left, a fetus who gazes strangely at its mother. Death, meanwhile, manifests itself in the terrible beauty of the woman herself, whose lips, here described in two subtle swipes of red watercolor, recall the world of the dead—of ancestors who have gone

before—that Munch suggests is connected, at this moment of conception, to that of children who have yet to be born.

On the one hand, such themes call to mind Munch's supposed anxiety about disseminating his own seed into the world, which sprang from his fear of women's potentially emasculating power and of his own family history. "Due to the seed of ill health that I inherited from my parents," he once remarked, "I decided at an early age that I would not marry."[30] On the other hand, they resonate with the work of contemporary French and German scientific journals. Due to advances in stereoscopic magnification, such publications were able to print pictures of biological phenomena such as sperm, which had never been observed with the naked eye. Munch was familiar, for example, with Ernst Haeckel's *Anthropogeny: Or the Evolutionary History of Man* (1891), which encouraged Darwin's theory of natural selection and was illustrated with different types of mammalian sperm [see 127].[31] As his later diaries reveal, Munch was fascinated with connections between the microscopic and the macroscopic, questioning how the blood cells that coursed through his body related to the universe: "A drop of blood is a world with a sun at its center, and planets and starry heavens are a drop of blood, a tiny part of a body."[32]

In *Madonna*, the theme of procreation is reinforced by the aqueous substance that surrounds the woman. In one of the painted versions (p. 83, fig. 82), the artist described this watery environment in soft, diaphanous shades of blue, red, and tan paint. Munch achieved the desired effect in an unusual way: after painting, he applied thinned oil paint and, while the canvas was still wet, sprayed it with a solvent. Then, over this background, he painted the woman's body and face. The sphere that encloses her, like the frame that may have originally enclosed another version of this painting, suggests the liquid realm of the sperm and the uterus.[33] In the first lithographic impression shown here [128], the frame is hand colored in red and green, which is reinforced by the green of the paper beneath. The blood red in which the sperm float perhaps signifies a broader life force. Munch may have adopted the practice of using the frame as a narrative element from Max Klinger, who employed it frequently. Indeed, prints such as *On the Tracks* [130] modernize traditional fifteenth- and sixteenth-century print cycles in which Death appears dancing

127

127 *Seed-Cells or Sperm-Cells from the Semen of Various Mammals.* Published in Ernst Haeckel, *Anthropogeny: Or the Evolutionary History of Man* (W. Engelmann, 1891), p. 134, fig. 19.

128 **EDVARD MUNCH** *Madonna*, 1895. Lithograph in black ink with additions in brush and red, green, blue, black, and yellow watercolor on mottled gray-blue wove paper (discolored to gray-green), laid down on heavyweight white wove paper; image: 60.3 × 44 cm (23³/₄ × 17³/₈ in.); sheet: 60.7 × 44.4 cm (23⁷/₈ × 17¹/₂ in.). The Art Institute of Chicago, Print and Drawing Department Purchase Fund, 1945.229. Cat. 33.

129 **EDVARD MUNCH** *Madonna*, 1895. Lithograph in black ink on gray-green wove paper; image: 59.6 × 44.2 cm (23¹/₂ × 17³/₈ in.); sheet (sight): 61.6 × 46 cm (24¹/₄ × 18¹/₈ in.). Mrs. Martin L. Gecht. Cat. 34.

130 **MAX KLINGER** *On the Tracks*, plate 8 from the series *On Death, Part I*, 1889. Etching and aquatint in black ink on cream wove paper; plate: 26.5 × 18.7 cm (10⁷/₁₆ × 7³/₈ in.); sheet: 55.5 × 31.1 cm (21⁷/₈ × 12¹/₃ in.). The Art Institute of Chicago, Gift of Jack Daulton, 2000.115.

131 **EUGÈNE GRASSET** (French, 1841–1917). *The Acid Thrower*, 1894. Gillotage with hand stenciling in blue, green, pink, orange, and brown ink on beige wove paper; image: 39.9 × 27.6 cm (15⁵/₈ × 10⁷/₈ in.); sheet: 59.7 × 43.8 cm (23¹/₂ × 17¹/₄ in.). Jane Voorhees Zimmerli Art Museum, Norma B. Bartman Purchase Fund, 1988.0138. Cat. 109.

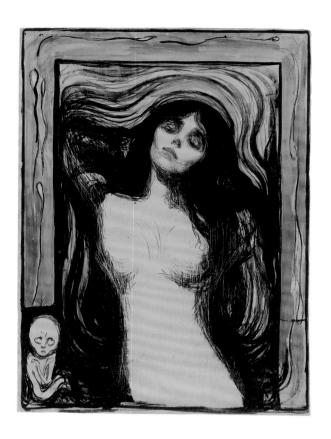

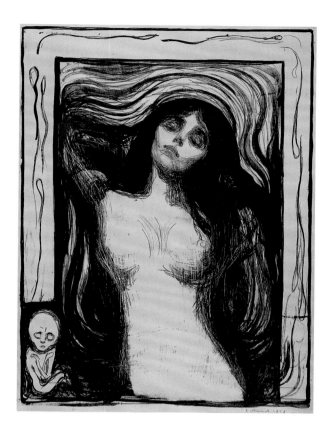

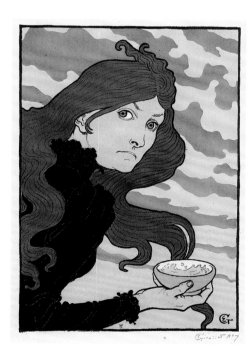

with the living as a symbol of their inevitable demise. The frame around it intertwines twisting tracks of steel with a fire-breathing snake topped by frightening masks and grimacing creatures.

Munch's decision to reproduce *Madonna* as a lithograph was perhaps consciously tied to the work's imagery: as described earlier, a lithographic stone must be wet before printing, so viscosity is integral to the very act of a lithograph's creation. His choice of mottled blue-gray paper for both of these impressions is likewise relevant.[34] The artist printed many of his earliest lithographs on this paper, but here it introduces a narrative element, suggesting the pallor of death and recalling the figure in Eugène Grasset's *Acid Thrower* [131], whose greenish blue skin tone adds to her ghoulish air. Although made with the photo-relief gillotage process, Grasset's image was made to look like a lithograph, and its popularity attests not only to the strong market for lithographs but also for images of demented femmes fatales.

Harry Kessler, one of the editors of *Pan*, wrote to the artist in 1896, suggesting prints for inclusion in the journal: "Maybe sometime you can submit a color lithographic portrait of a woman to us; here in Paris there are so many endlessly interesting female types. ... The most important thing ... is to use the most clear and simple technique ... and not too sketchy."[35] Like *Madonna*, which he created before he got this advice, Munch's lithographs of morally questionable female types did indeed exhibit a linear simplification.

In 1895, the same year Munch created the densely drawn *Vampire I*, he was experimenting with works such as *Tingel-Tangel* and *The Hands*, which he rendered in a much looser, gestural style of drawing. The first image [133] depicts a Berlin cabaret, known in German as a *Tingeltangel*, where women of ill repute dance for their male clientele; the central performer displays her undergarments to the crowd, while her seated companions spread their legs and lift their skirts.[36] Munch's hand coloring of this and many other impressions of *Tingel-Tangel* argues not only for his fascination with color lithography, a technique he would soon learn in Paris, but for his continued attraction to the color red as a sign of sexuality. *The Hands* [132], with its scene of relentless grabbing, is less documentary and far more haunting. Here, a sea of hands reach from all sides, and the woman's nude upper body and provocative gaze suggest that she is a willing object of their attentions.[37]

When prints such as these were first shown in Kristiania in 1895, the critic Henrik Grosch—who uncharitably argued that they could "be divided into two groups, the incomprehensible and the repulsive"—perceptively raised the issue of Munch's use of graphic caricature, an element of his style seldom accounted for in studies of his work.[38] Commonly regarded as a manifestation of the primitive and grotesque, caricature was an art form decidedly at odds with classical ideals of beauty. However, for French Romantics such as Charles Baudelaire and his inheritors, the Symbolists, it was considered a powerful means of expression.[39] Henri de Toulouse-Lautrec, for example, employed caricature in his rapidly executed lithograph of the Parisian café-concert performer Jane Avril [see 134], which highlights its subject's exaggerated gestures and nearly grotesque physiognomy.[40] Indeed, in lithographs such as *The Hands*, *The Scream*, and *Tingel-Tangel*, Munch built on Toulouse-Lautrec's example, using wavy, stark lines of thick black and white, and incorporating representations of common social types. In a compelling twist, one newspaper illustrator created an apt caricature of the most shocking works in his 1895 Blomqvist exhibition [135], which included the *Vampire, Self-Portrait with Cigarette*, and *Madonna* canvases. Here, the use of caricature to comment humorously on Munch's subject matter and painting technique unwittingly resembled his wavy, abstracted, and exaggerated lithographic images.

Modern painter-lithographers were still a relatively new phenomenon in Berlin, but in France they had enjoyed a longer period of favor. In that country, artists, printers, and publishers had sophisticated means of disseminating graphic images, and—as he did with Toulouse-Lautrec—Munch could have incorporated any number of their compositional devices, visual motifs, and technical tricks. One of these was the use of different-colored papers for expressive means. Paul Gauguin, for example, chose vibrant yellow paper for the suite of zincographs that was displayed at Volpini's Café des Arts in 1889, where Munch could have seen them. *Human Sorrow* [136], the fifth plate, suggests a sexual conflict in its depiction of a Breton girl who sits dejected while a boy looks on behind her. In this work and throughout the series, the color yellow can be understood as a nod to the influence of Japanese prints, a willful adoption of commercial poster paper, or, on a more symbolic level, to his turbulent

132 EDVARD MUNCH *The Hands*, 1895. Lithograph in black ink on cream card; image: 48.5 × 29.2 cm (19 × 11 1/2 in.); primary support: 51.4 × 38.9 cm (20 1/4 × 15 3/8 in.); secondary support: 59.5 × 49.7 cm (23 3/8 × 19 5/8 in.). The Art Institute of Chicago, Clarence Buckingham Collection, 1963.284. Cat. 32.

133 EDVARD MUNCH *Tingel-Tangel*, 1895. Lithograph in black ink with additions in brush and red, blue, yellow, green, orange-brown, and gray watercolor on ivory wove paper; image: 41.5 × 63.9 cm (16 3/8 × 25 1/8 in.); sheet: 48.7 × 69.8 cm (19 1/8 × 27 1/2 in.). The Art Institute of Chicago, Clarence Buckingham Collection, 1963.285. Cat. 39.

134 HENRI DE TOULOUSE-LAUTREC (French, 1864–1901). *Jane Avril,* 1893. Lithograph printed from five stones in olive green, yellow, orange, red, and black ink on tan wove paper; image: 124 × 91.5 cm (48 7/8 × 36 in.); sheet: 129 × 94 cm (50 3/4 × 37 in.). The Art Institute of Chicago, Mr. and Mrs. Carter H. Harrison Collection, 1949.1004. Cat. 141.

135 Caricatures of work by Munch exhibited at Blomqvist, Kristiania. Published in *Tyrihans,* Oct. 15, 1895, and *Vikingen,* Oct. 12, 1895.

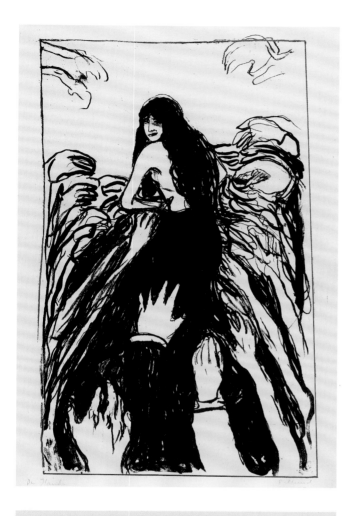

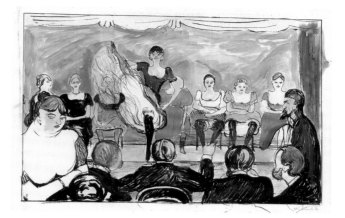

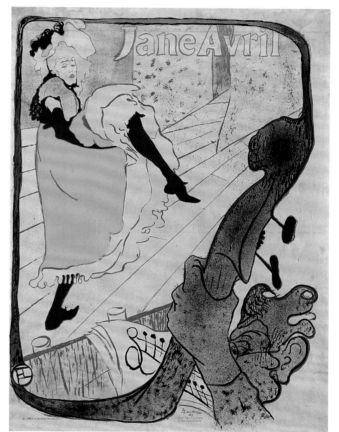

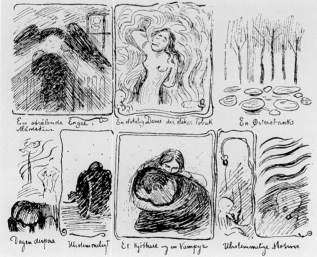

period with Van Gogh, to whom the color suggested sunlight and redemption.[41] The girl's gesture of despondence was perhaps a subtle influence on Munch's *Scream* and relates not only to the artist's paper choices but also to his angst-ridden motifs. In *The Fish* [137], the French Symbolist lithographer Charles Marie Dulac employed rushing perspective and subtly colored inks, tint stones, and papers in order to achieve ethereal and mysterious effects. Here, Dulac used a gray-black ink for the design; transferred the motif to the stone from a zinc plate; selected a brown ink for the tint stone; and printed on a thin, pale green paper laid down on a heavy-weight tan paper, evoking what he described as "fleeting emotions created by the diverse aspects of nature."[42] Perhaps in response, Munch printed versions of *The Scream* on vibrant red and purple papers [see 138], achieving the dramatically emotive effect he desired and establishing a direct chromatic connection to the blood-red sky he was said to have envisioned above the tormented figure (see p. 89). The paper color and grim subject matter of Félix Vallotton's *Funeral* [139] could have influenced Munch's lithograph of *Death in the Sickroom* [140] in a similar way. The stark contrast between the light sheet and black inks of Vallotton's woodcut combine with the somber theme to produce a powerful image of despair and mourning.

As these connections indicate, Munch's knowledge of French printmaking was already strong by spring 1896, when he moved to Paris in the hope of finding a market for his art and the opportunity to learn from renowned printers. Munch worked primarily with Auguste Clot, and the correspondence between the two attests to their artistic collaboration as well as their financial conflicts. Although printers are rarely given the credit they are due, Clot played a major role in creating Munch's lithographs—especially their ephemeral wash effects—during this fruitful period. But Clot was a businessman, and he required significant amounts of money in order to print a stone and retain the image for future printing. Munch was continually short of money and late on the rent he paid to keep the images on the stone from being ground down. As Gerd Woll has documented, between 1896 and 1898, he appealed to numerous friends and patrons to help him cover these costs; in order to live, he often mortgaged his canvases.[43]

Despite Clot's famed abilities as a printer, he appears to have joined Munch in a series of collaborative explorations. One of these is the lithograph *Jealousy II* [141], which depicts the staring face of a jealous man in the foreground while a couple flirt behind him. The familiar motifs include an apple tree that self-consciously alludes to the Garden of Eden; the woman's flowing hair, which enmeshes her male companion; and a "flower of pain" that reaches up the right side of the composition, introducing a sense of impending doom. The man has been identified as Munch's friend, the Polish writer Stanislaw Przybyszewski, and the couple as his wife, Dagny Juell, and one of her paramours. The look of this particular impression, however, is quite distinctive: one of very few in colored ink, it was printed on proofing paper. The gray-brown tonality of the ink and the uneven quality of its application result in a more ghostly, dreamlike space than the regular impressions, which show a high contrast between black and white.[44] Munch aimed for the latter look when he re-editioned the print around 1908 and 1916, which suggests that he recognized its greater appeal to his buying public.

The imagery of *Attraction II* and *Separation II*, both printed by Clot, seems almost to echo the basic principles of lithography—attraction and repulsion—in human terms. *Attraction II* [142] depicts the same setting seen in *Summer Night's Dream: The Voice* (p. 75, fig. 73) but, instead of a single figure, shows a facing couple about to embrace. Their eyes meet, and strands of the woman's hair reach out tenderly to encircle her mate. Blue watercolor, which infuses the landscape with shades of evening, adds an erotic tension to the scene. In *Separation II* [143], the woman moves away from the distraught man in the harsh light of day, but her hair remains drawn to him, as if not ready to part. Munch added crayon and graphic accents to this sheet, perhaps to fill in areas on the stone that did not print to his satisfaction. The coastal landscape recalls the motif of *Melancholy* (p. 17, fig. 6), as does the man's dejected, down-turned face. A decorative flourish in the woman's hair resembles a *lad*, a headband often worn by unmarried women. Another example of this type of headband is suggested in Erik Werenskiold's illustration of the Norwegian folktale "Soria Moria Castle," in which three princesses wait by a fjord landscape, one with her beloved's head resting on her lap.[45] In Munch's print, the woman's purity is further

136 PAUL GAUGUIN *Human Sorrow*, 1889. Zincograph in reddish brown ink on yellow wove paper; image: 28.7 × 23.7 cm (11 1/4 × 9 3/8 in.); sheet: 49.9 × 65 cm (19 5/8 × 25 5/8 in.). The Art Institute of Chicago, William McCallin McKee Memorial Endowment, 1943.1028. Cat. 105.

137 CHARLES MARIE DULAC (French, 1865–1898). *The Fish*, 1893. Lithograph in brown ink on pale green lightweight wove paper, laid down on tan wove paper (chine collé); image/sheet: 50.4 × 33.5 cm (19 7/8 × 13 1/4 in.); support: 64.5 × 49.5 cm (25 3/8 × 19 1/2 in.). S. P. Avery Collection, Print Collection, Miriam and Ira D. Wallach Division of Art, Prints and Photographs, the New York Public Library, Astor, Lenox and Tilden Foundations. Cat. 98.

138 EDVARD MUNCH *The Scream*, 1895. Lithograph in black ink on red wove paper; image: 35.5 × 25.4 cm (22 1/2 × 14 9/16 in.); sheet: 57.2 × 37 cm (22 1/2 × 14 9/16 in.). Museum of Fine Arts, Boston.

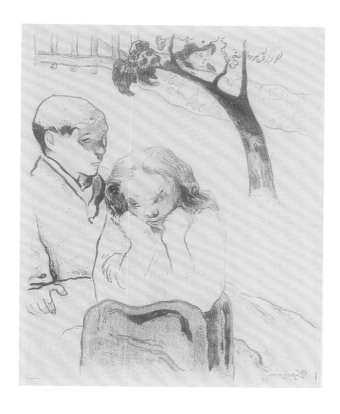

139 FÉLIX VALLOTTON (Swiss, 1865–1925). *The Funeral*, 1891. Woodcut in black ink on tan wove paper; image: 26 × 35.2 cm (10 1/4 × 13 7/8 in.); sheet: 32.4 × 42.2 cm (12 3/4 × 16 5/8 in.). The Art Institute of Chicago, gift of the Print and Drawing Club, 1956.1067. Cat. 142.

140 EDVARD MUNCH *Death in the Sickroom*, 1896. Lithograph in black ink on lightweight cream Japanese paper; image: 41.5 × 55.9 cm (16 3/8 × 22 in.); sheet: 54.4 × 66.7 cm (21 3/8 × 26 1/4 in.). The Art Institute of Chicago, gift of the Print and Drawing Club, 1954.268. Cat. 48.

141 EDVARD MUNCH *Jealousy II*, 1896. Lithograph in grayish brown ink on ivory China paper; image: 47.5 × 57.3 cm (18 3/4 × 22 1/2 in.); sheet: 48.7 × 68 cm (19 1/8 × 26 3/4 in.). The Art Institute of Chicago, Clarence Buckingham Collection, 1963.288. Cat. 50.

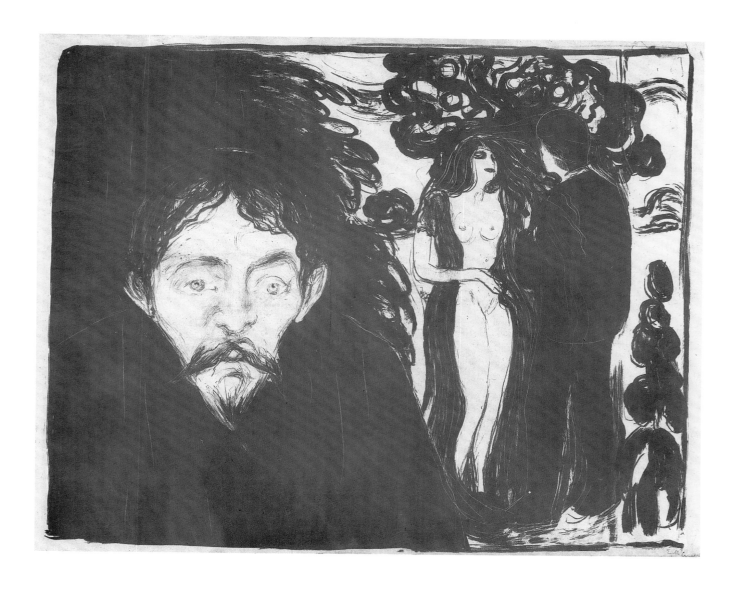

133

142 EDVARD MUNCH. *Attraction II*, 1896. Transfer lithograph in black ink with additions in brush and blue watercolor on off-white China paper; sheet trimmed to image: 38.3 × 60.4 cm (15 1/16 × 23 3/4 in.). Harvard Art Museum, Fogg Art Museum, purchase through the generosity of Lynn and Philip A. Straus, Class of 1937, M20223. Cat. 46.

143 EDVARD MUNCH *Separation II*, 1896. Transfer lithograph in black ink with additions in graphite on gray toned wove paper; sheet trimmed to image: 39.8 × 59.8 cm (15 11/16 × 23 3/8 in.). Harvard Art Museum, Fogg Art Museum, purchase through the generosity of Lynn and Philip A. Straus, Class of 1937, M20228. Cat. 53.

accentuated by her blonde tresses, which contrast with the man's darker, more controlled helmet of hair.[46]

In both of these works, the relationships between the couples are echoed by the hair that binds and divides them. Intimate yet resilient, hair lasts many decades after the body decomposes, and for this reason, popular magazines of Munch's time instructed women to create lockets of their loved ones' hair as tokens of remembrance. As we have seen, hair could be at once a sign for virtuous love and one for sin. Chaste women wore their hair up, like the prim matron pictured at left in *Anxiety* (p. 137, fig. 145), whereas long hair, if allowed to flow freely, signified loose morality. In 1896, Munch was commissioned to create illustrations for an edition of Baudelaire's *Flowers of Evil*. One of the poems in this volume, "Her Hair," rhapsodically describes a woman's scented locks: "A sun-drenched and reverberating port / Where I imbibe color and sound and scent. . . . I'll plunge my head, enamored of its pleasure / Into this black ocean where the other hides."[47] This intoxicating eroticism is suggested in Munch's images as well, although the hair he describes is just as often an agent of entrapment as an object of desire, infused with a static electricity and an almost gravitational force.

In 1897, Munch announced plans to publish a large print portfolio of lithographs and woodcuts entitled *The Mirror* that, as the poet Sigbjørn Obstfelder noted, wove together images of shorelines, water, hair, and other wavelike forms.[48] Although the wide production and circulation of this series was never realized, possibly due to a lack of funds, its very existence reveals the artist's continued fascination with continuous narrative structures—in this case, a graphic counterpart to his painted *Frieze of Life*.[49] The images in *The Mirror* capture the ebb and flow of life: earth, hair, and water are all represented in curving lines that suggest electrical currents and lines of force.[50]

III. Color Lithography

The hand-colored additions to impressions of *Attraction II* and *Ashes I* (p. 101, fig. 101), both printed in Paris by Clot, suggest that Munch was thinking about color lithography before he ever attempted it. As we have seen in the case of *Madonna* and *The Scream*, the artist's frequent use of colored paper demonstrates his fascination with its symbolic and visual effects

on his monochromatic lithographs. When Munch was making his first lithographs in Berlin, he used only black ink, but when he arrived in Paris, the abundance of color lithographs and printers no doubt enticed him to consider printing in color.[51] A few examples of his work include *Jealousy II*, with its gray-brown ink, and an evocative portrait of the French poet Stéphane Mallarmé in avocado green [144]. All of these colors had their symbolic meanings: the ink used in the latter work, for instance, may relate to a passage in Munch's diaries where he describes with rapture the "faded green" of Mallarmé's study and the "symphony of colors" that greeted the artist when he came to draw him from life.[52] As we have seen in his previous correspondence with Kessler, there were also perceived commercial incentives to creating color lithographs representing women.

One of Munch's first attempts to reconsider the process of printing in color was *Anxiety* [145]. This work is not a traditional color lithograph in the sense that each color is printed with a different stone; rather, it is a hybrid, a masterfully crude yet inventive transition between monochrome and multicolor printing. Here, the artist used one stone for both colors, inking the bottom half in black and the top half in red. The procedure is evident where the sky meets the mountains, and small portions of black ink were rolled onto the red section. This printed interpretation reverses the tonality of the painting (p. 90, fig. 90) and recalls the overtly linear quality of *The Scream* (p. 131, fig. 138), with its identical setting above the Kristiania Fjord. As in that work, the use of red was symbolic as well as formally arresting: on another impression of *Anxiety*, Munch wrote, "Nature was colored like blood and people passed like priests."[53] The multicolored version of *Anxiety* was included in the first issue of Ambroise Vollard's *Album des peintres-gravures*, a publication that the esteemed dealer hoped would encourage the collecting and appreciation of original prints, especially color lithographs.[54]

Munch fully embraced the practice of color lithography with his powerful, strikingly varied impressions of *The Sick Child I*, which were done with Clot's firm. These vary from those containing just one or two colors [see 147–48] to those containing six [see 149]. In color lithography, each hue is printed with a different stone, and therefore a sheet of paper that has already been printed with one color needs to be

144 EDVARD MUNCH *Stéphane Mallarmé*, 1897. Transfer lithograph with crayon and scraping in green ink on cream Japanese paper; image: 37.3 × 29.2 cm (14 3/4 in. × 11 1/2 in.); sheet: 63.7 × 43.8 cm (25 1/8 × 17 1/4 in.). The Art Institute of Chicago, Stanley Field Collection, 1961.343.

145 EDVARD MUNCH *Anxiety*, 1896. Lithograph printed from one stone in black and red ink on off-white wove paper; image: 41.4 × 39.1 cm (16 5/8 × 15 3/8 in.); sheet: 57.1 × 43.1 cm (22 1/2 × 16 15/16 in.). The Museum of Modern Art, New York, Abby Aldrich Rockefeller Fund, 1656.1940. Cat. 42.

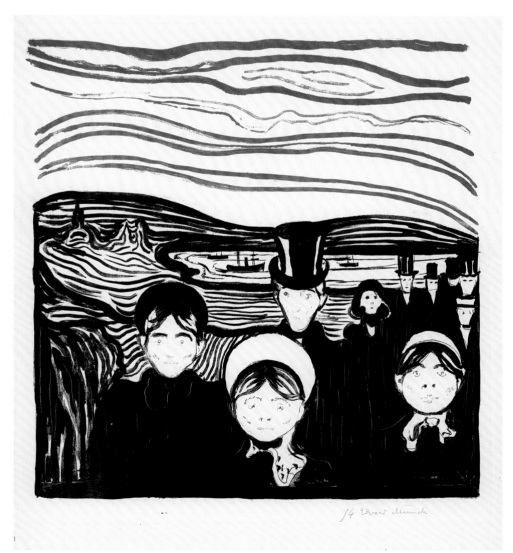

carefully positioned so that the next stone correctly aligns with the existing composition. Recalling the artist's supervision of the printing at Clot's shop, his friend Herrmann recounted a (possibly apocryphal) story that is clearly consistent with the myth of Munch the bohemian provocateur:

I wanted Clot to print for me, but I was told: "Can't be done, Mr. Munch has already reserved time." The lithographic stones with the large head were already lying side by side, arranged in a row and ready for printing. Munch arrived, stood in front of the row of stones, firmly closed his eyes, and conducted with one finger blindly in the air, "Print ... gray, green, blue, brown." Then he opened his eyes and said to me, "Come on, let's have a drink." So the printer went on printing until Munch returned and again blindly commanded, "Yellow, pink, red." And this went on a couple more times.[55]

Once he got up to speed, however, Munch likely narrowed his focus and oversaw the printing of several color combinations he felt to be particularly evocative. Unlike the painted version of 1896, whose commission may have encouraged Munch to recreate the work in another medium and reminded him of its marketability, the lithograph *Sick Child I* focuses on the girl's head. Like the painted and intaglio versions, however, the drawing is frenzied and rough, and the artist's scoring into the stone again replicates his attempt to paint, scratch out, and

then repaint the canvas. It is hard to tell whether this repetition constituted an attempt to revisit the emotional trauma of his sister's death or simply to create an affordable facsimile of the painting. Regardless, his many experiments with color reveal a broad array of chromatic effects. For instance, the first impression shown here **[147]** gives the girl a deathly pallor; the second **[148]** may suggest the blood Munch's sister Sophie spat up as she succumbed to tuberculosis; and the third **[149]**, with its somber black, gray-brown, pale yellow, and red palette, most closely approximates the look of the canvas.

Munch's interest in and aptitude for color lithography did not, however, convince him to adopt it exclusively. One reason may have been the technique's prohibitive cost. When he was making his lithograph *The Sick Child I*, he wrote a letter complaining of the cold and his perennial lack of funds: "I would dearly like to go to the warm rooms and beer halls of Germany, but I must stay here for a while in order to finish some lithographs.... Lithography is terribly expensive—it takes any amount of money—I hope I shall be able to produce something worthwhile."[56] He continued to make lithographs despite the expense, and in some cases funds were provided by publishers such as Ambroise Vollard or the production company Théâtre de l'Oeuvre, which commissioned lithographs to grace program covers for Ibsen's *Peer Gynt* and *John Gabriel Borkman* [see **146**].

This formative period of technical experimentation in Paris did not lead to a lifelong interest in color lithography. But Munch did continue to create monochrome lithographs for the remainder of his career, preferring to add color by hand or through his choice of paper. One of these works, printed in Norway, is *Ashes II* **[150]**. A mirror opposite of his previous hand-colored *Ashes I* (p. 101, fig. 101), it repeats almost exactly the composition of the painted version (p. 100, fig. 100). Although many elements of the two prints are similar—the man is seemingly buried in the earth, the woman brazenly available above it—in *Ashes II*, the forest grows over his decomposing body as she rises up, echoing the strong trees around her. As with the canvas, there is a gap between the trees where the woman emerges, phoenixlike, from the ashes of the relationship. Her dress is white, but a red flame appears to flare from her vulva, while her abundant orange-red tresses flow downward. The painting was favorably received by the press

146

146 EDVARD MUNCH Program for the Théâtre de l'Oeuvre production of Henrik Ibsen's *John Gabriel Borkman*, 1897. Lithograph in black ink on paper; 21 × 32 cm (8 1/4 × 12 9/16 in.). Munch Museum, Oslo.

147 EDVARD MUNCH *The Sick Child I*, 1896. Transfer lithograph printed from two stones in pale blue and black ink on ivory wove paper; image: 42 × 57.2 cm (16 1/2 × 22 1/2 in.); sheet: 48.3 × 63.5 cm (19 × 25 in.). The Art Institute of Chicago, Major Acquisitions Fund, 2003.1. Cat. 55.

148 EDVARD MUNCH *The Sick Child I*, 1896. Transfer lithograph in greenish blue and red ink on ivory wove paper; image/sheet: 43.2 × 57.1 cm (17 × 22 1/2 × in.). Munch Museum, Oslo, MMG 203-10. Cat. 56.

149 EDVARD MUNCH *The Sick Child I*, 1896. Transfer lithograph printed from four stones in black, dark gray, red, and light yellow ink on ivory China paper; image: 41 × 57 cm (16 9/16 × 22 7/16 in.); sheet: 44.5 × 58.4 cm (17 1/2 × 23 in.). Collection of Catherine Woodard and Nelson Blitz, Jr. Cat. 57.

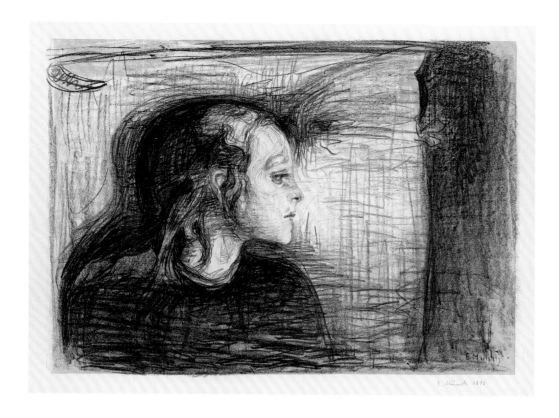

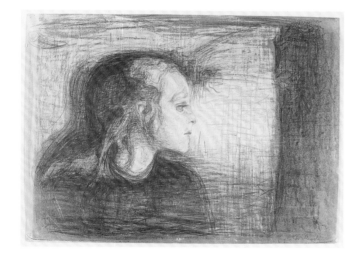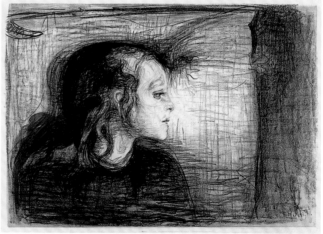

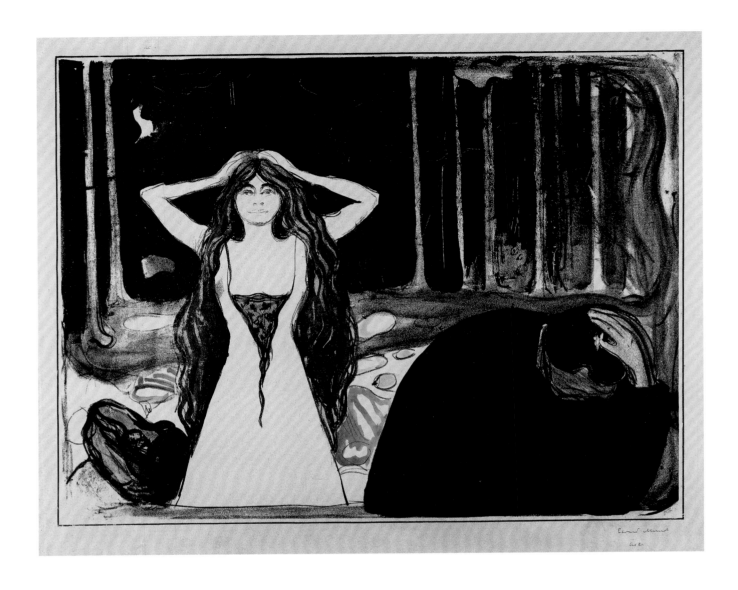

150 **EDVARD MUNCH** *Ashes II*, 1899. Lithograph in black ink with additions in brush and blue, red, yellow, purple, and orange watercolor on tan wove paper; image: 35.2 × 45.2 cm (13⁷/8 × 17³/4 in.); sheet: 42.3 × 52.8 cm (16⁵/8 × 20³/4 in.). Private collection. Cat. 68.

151 **EDVARD MUNCH** *Woman with Red Hair and Green Eyes: The Sin*, 1902. Transfer lithograph printed from two stones in yellow, reddish brown, and green ink on lightweight cream semitransparent wove paper; image: 70 × 40.3 cm (27¹/2 × 15⁷/8 in.); sheet: 77.8 × 48.1 cm (30⁵/8 × 18⁷/8 in.). The Art Institute of Chicago, Robert A. Waller Fund, 1950.1457. Cat. 80.

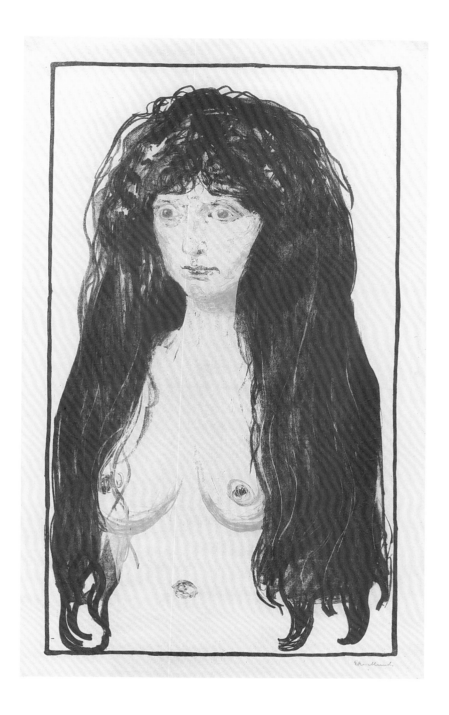

three years earlier, which no doubt explains Munch's desire to market yet another, closer printed version here.

An extraordinary exception to Munch's new practice, however, is the yellow, reddish brown, and green transfer lithograph *Woman with Red Hair and Green Eyes: The Sin* [151]. Here, the figure stares out as if in a hypnotic state; she is shown nude to the waist, her long red hair cascading around her full, sagging breasts. As in his *Madonna* lithograph, Munch pointedly framed his female subject, perhaps as a way to contain her powerful sexual allure.[57] He also added snaky lines in tusche, giving her hair increased prominence as a marker of menacing sensuality. Indeed, the title echoes that of Franz von Stuck's canvas *Sin* (p. 84, fig. 84), in which a woman stares out suggestively at the viewer while a snake slithers around her body. Most remarkable of all, however, was Munch's method of printing the work itself.[58] He began by recording the image on the stone with lithographic crayon, tusche, and incising; then, he masked off areas of the stone and took an impression of what remained. Finally, he transferred this partial image onto the reverse side of the same stone, where he used it to print different colors. The original lithographic stone, preserved in the Munch Museum, Oslo, attests to his ingenious method. Symbolically, the artist enhanced the image through his suggestive use of color; economically speaking, he tripled his money by employing one stone instead of three.

When Munch was in Paris, he also briefly experimented with another new, more affordable color process, burnished aquatint. In this intaglio technique, a dusty resin is scattered over a copper or zinc plate and then selectively affixed to the plate by heating, creating peaks and valleys on the surface.[59] However, Munch did not prepare the plates himself but rather purchased them already aquatinted; the work he did was to burnish, or scrape, the raised sections of plate to create a design. In Munch's aquatints, the raised areas hold ink, and the white areas correspond to those parts he burnished. To create the luminous *Young Woman on the Beach* [152], for example, the artist used a tool to burnish the dress and the roughly outlined landscape. He then added the colors by hand, applying them individually with a small rag so that each impression was unique. This process of hand inking was employed to great effect by Klinger, who created a similar atmosphere in his Neo-Romantic *Abandoned* [153],

which depicts a desperate, lone woman moving through a desolate landscape. Munch used burnished aquatint for a few more compositions, including *Boys Bathing* (p. 170, fig. 188), but ultimately, its rather delicate effects did not match his sensibilities, and he turned instead to the more raw, immediate technique of woodcut.

IV. Woodcut

In 1896, the same year Munch started to explore color lithography and burnished aquatint in Paris, he also began what would become a lifelong dedication to the woodcut. Whereas drypoint and etching involve printing areas that have been incised, woodcut works in the opposite way. Here, the artist uses a tool to cut or gouge into the block, leaving a raised design; the surface of this design is then inked and printed. Munch often chose to work with woods such as ash, oak, and beech, which have an open grain that is often visible in the images he printed. In fact, the artist frequently used this pattern as a visual or compositional device. Although Munch began his work in printmaking by learning orthodox practices such as intaglio, lithography, and aquatint, he quickly veered into highly experimental approaches in his work with the woodcut. This urge to bend the rules brought the artist to the forefront of exploratory work in this medium, suggesting a more creative and symbolic, less market-driven approach to the creation of repeatable images.

Even though the woodblock had been connected with fine art in both sculpture and printmaking since the time of Dürer around 1500, beginning in the nineteenth century, wood engraving was used widely as a cheap way to disseminate images in newspapers. As a physical substance, wood had profound psychic and national associations for Munch. Comparing the woodblock to the lithographic stone, he commented, "Wood is something that is alive.... a stone is dead."[60] Indeed, because of wood's cellular structure, its growth rings, and its tendency to expand and contract over time, Munch regarded the woodblock as a living entity. In the 1890s, Norwegians more generally were filled with a new historical and artistic appreciation for their homeland's traditional wood constructions, from medieval stave churches to richly painted rustic buildings and *kiste*, or wedding trunks. Munch's contemporary, the artist and theorist Gerhard Munthe,

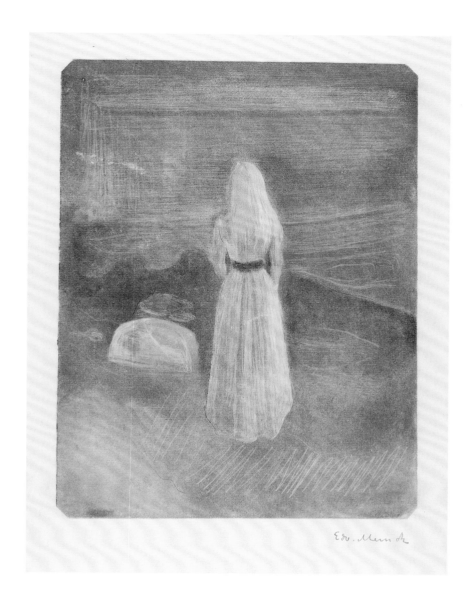

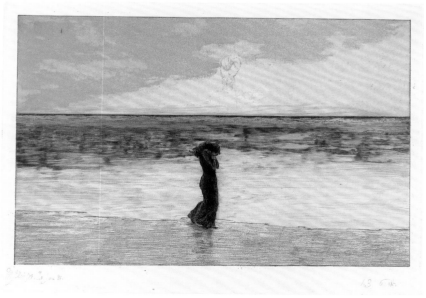

sought to renew indigenous craft traditions, changing the tastes of modern urbanites who favored internationalism.[61]

Closer to home, the artist's aunt Karen, we recall, was devoted to exploring craft traditions in her own wood sculptures and paper collages. Indeed, the print curator Eli Greve, who wrote a monograph on Munch's woodcuts in the 1940s and knew the artist personally, stressed the "primitive" and timeless craft traditions of the woodcut in his discussion of Munch's creative drive. While acknowledging his absorption of influences from abroad, Greve strove to differentiate his countryman from continental trends by stressing his down-to-earth connection to the woodcut.[62] The vast majority of Munch's woodcuts depict scenes of the human form in nature. These indigenous, national associations were, however, not always ones that critics wished to associate with Munch. In his 1917 monograph, Curt Glaser sought to distance Munch from the "decorative" Northern traditions, which he saw as retrograde. Whereas German "decorative artists" had adopted the color woodcut because of their reverence for Japanese examples, Glaser argued, Munch invented new means of printing with color that respected and challenged the material itself.[63]

Meanwhile, in both France and Germany, the woodcut was being revived as an artistic medium, even though the illustrations appearing in mass-circulation newspapers were considered popular, reproductive, and inartistic, tainting the entire medium by association. As early as the mid-1880s, German art historians were calling for a return to Dürer's fifteenth-century woodcuts, just as they were promoting his etchings. While this goal was not fully met in Germany until the work of the Expressionists after the turn of the century, in Munch's moment, efforts were well underway to remedy what was perceived to be a sad state of affairs.[64] In France, the artistic woodcut was being celebrated by critics, dealers, and printers, and by artists such as Félix Vallotton and Paul Gauguin, who sought to revivify the medium for a new generation of practitioners and collectors.[65]

This activity was underway at precisely the time Munch was living in Paris. Between 1894 and 1896, the writer Alfred Jarry, whom the artist could have known, published L'Ymagier, a luxury art journal that sought to raise the status of the woodcut by revealing its historical roots in the Renaissance and celebrat-

ing its use as a means of popular illustration. Tipped into the pages were original woodcuts by some of France's most daring and gifted practitioners. In his introduction to the first issue of this short-lived but influential publication, Jarry described the woodcut as "this material of the idols, this receptive matrix ... that contains for a century a series of emblematic dreams."[66] According to Jarry, the woodcut had the ability to hold new kinds of spiritual imagery for a broad, modern public.

Among Munch's first woodcuts in France were Anxiety and Moonlight I, in which he drastically reimagined works first made in other media. Anxiety [154] exemplifies the abstract effects that Munch was able to achieve when he used the side grain and capitalized on the materiality of the block. The raw, unpolished gouges that he removed from the block to create the staring faces, abbreviated sky, and geometric shapes of the men's hats calls to mind the words of Max Linde, an early Munch collector and interpreter. Linde argued that Munch's "eternal value" was most apparent in his woodblock prints, remarking, "The technique is of the highest simplicity, but of an even greater force."[67] Although various colored impressions of Anxiety exist, this monochromatic example constitutes a powerful artistic statement: the fearful, masklike faces were forcefully rendered in sharp, pared-down flicks of the tool, emerging from the dark black ink like hollow ghosts.

In Moonlight I [155], Munch capitalized on the uneven quality that resulted from hand printing the side grain of the wood and also relied upon color to infuse the image with a ghostly, emotive tenor. In this work, which offers a detail of his 1893 painting, a woman, dressed in black and wearing a broad hat, stands in front of a wooden house; to her right is an abstracted tree. The soft, spectral quality of the moonlight that falls on the figure's face and reflects in the windowpane, as well as her rigid body and wide-eyed expression, suggest an evocative, sensual, yet anxious moment, as if she is grappling with a decision that confronts her in the person of the artist-viewer. This unique impression was inked in black, green-blue, ocher, and hints of brown-orange, and the uneven hand printing contributed to its grainy quality. This last aspect enhances the haunting effect of the moonlight and suffuses the house and the tree, producing a marriage of content, matrix, and technique. Munch deliberately cut the block, using the

154 EDVARD MUNCH *Anxiety,* 1896. Woodcut in black ink on lightweight ivory laid proofing paper; image: 46.3 × 37.5 cm (18 1/4 × 14 3/4 in.); sheet: 49.1 × 39.2 cm (19 3/8 × 15 3/8 in.). The Art Institute of Chicago, gift of the Print and Drawing Club, 1953.177. Cat. 43.

155 EDVARD MUNCH *Moonlight I,* 1896. Woodcut printed from three blocks (one sawn into three sections) in black, green-blue, ocher, and brown-orange ink on tan wove paper; image: 39.7 × 45 cm (15 5/8 × 17 6/8 in.); sheet: 40.6 × 45.7 cm (16 × 18 in.). Collection of Catherine Woodard and Nelson Blitz, Jr. Cat. 52.

156 PAUL GAUGUIN *Auti te pape (Woman at the River),* 1893 / 94. Woodcut printed from one block in orange and black ink over yellow, pink, orange, blue, and green wax-based media on laminated cream Japanese paper; image/sheet: 20.3 × 35.3 cm (8 × 13 7/8 in.). The Art Institute of Chicago, Clarence Buckingham Collection, 1948.264. Cat. 106.

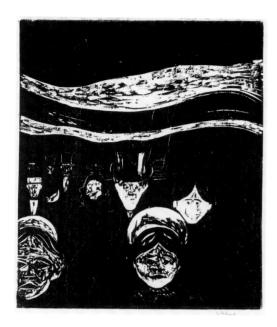 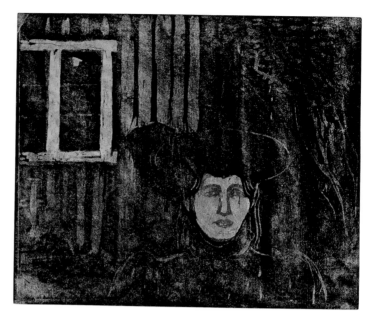

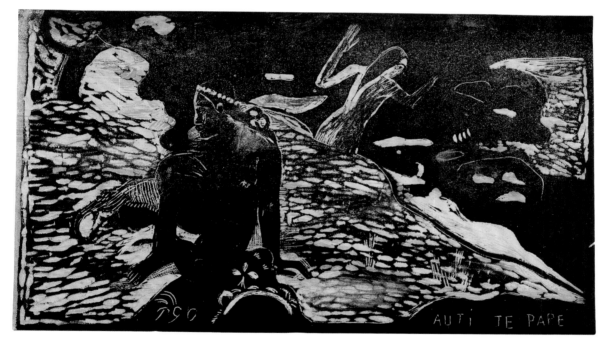

bands of the wood to emphasize the verticality of the slats on the house, the delicate branches of the tree, and the stiff, hieratic posture of the woman.

Impressions such as these have frequently been connected with the woodcuts of Paul Gauguin. It has been argued that Munch could have seen Gauguin's woodcuts through William Molard, a neighbor who stored the prints in his Paris apartment when Gauguin left for Tahiti. According to their correspondence, Munch visited Molard at the same moment he began to make woodcuts.[68] Although the two artists shared similar technical approaches, unorthodox printing methods, and interests in serial imagery, their matrices were markedly different. For example, Gauguin's mysterious color woodcut *Auti te pape (Woman at the River)* [156], which represents a seated, brooding Tahitian woman and another female figure bathing, was printed with a block made of hard boxwood, while Munch used a softer oak. But the varying densities of the blocks do not necessarily reveal themselves in the finished woodcuts. Both artists printed their sheets unevenly, creating a rough, unpolished feeling that accentuates the mystery of the scene. Munch produced his effect primarily by exploiting the open bands of the woodgrain itself, whereas Gauguin worked by applying less pressure to the block. Gauguin's embrace of raw printing and monotype inking no doubt influenced Munch as he took up the medium for the first time, striving for similarly unorthodox results.

Munch's woodcut *Evening: Melancholy I* [158], like the canvas *Melancholy* (p. 17, fig. 6), went through many technical and chronological permutations. As in the painting, which depicts him facing in the opposite direction, the male figure sits unhappily on the shore. But the couple pictured in the background, who are the apparent cause of his distress, are absent in the woodcut. In this and many of his subsequent woodcuts, Munch came up with an ingenious way to include color that involved neither the cumbersome and expensive use of lithographic stones nor the time-consuming effort of hand coloring each separate impression. Rather, he used one woodblock for the main image, or key block, here inked in light blue with a darker blue-green making up the hill above the man's head. Then, he cut another woodblock into pieces; inked them separately, in this case, in light green and red-brown; fit the block together like a jigsaw puzzle; and printed it on top of the key block. Brilliant as this process was, it was not invented by Munch. One of his contemporaries, the Danish artist Jens Ferdinand Willumsen, had used the same technique in the remarkable etching *Voting Day* [159]. This work was shown at Willumsen's 1892 solo exhibition in Kristiania, and the unusual process was described in the catalogue.[69]

Once Munch had adopted the jigsaw technique and discovered its uses, he began to employ it not only as a printing method, but also as a way of enhancing the symbolic content of his works. The majestically simple woodcut *Two Human Beings: The Lonely Ones* [160], which is connected to his earlier color aquatint *Young Woman on the Beach* (p. 143, fig. 152), evokes a feeling of dislocation through a clever technical maneuver. In Anders Zorn's *Fisherman at St. Ives* [161], which shares a similar theme, a man and woman look out to sea; although physically separate, they are technically joined through their similar treatment and the compositional device of the wall and road. In *Two Human Beings*, however, Munch separates them by sawing the blocks into several pieces. He cut the land and the sea into two separate blocks, printing the former in black and the latter in teal blue. The man, printed in black, is connected to the block with the land, while the woman exists as her own, separately inked and jigsawed block [see 157]. Dressed in pure white, she looks out on the expanse of water, physically and psychically divorced from the man; he, connected to the land and presumably to his

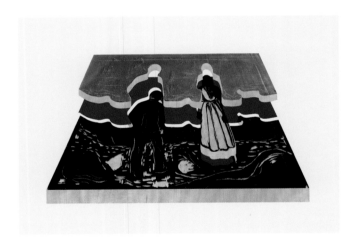

157 A re-creation of the jigsawed woodblock that Munch would have used to print *Two Human Beings: The Lonely Ones* (p. 149, fig. 160).

158 EDVARD MUNCH *Evening: Melancholy I*, 1896. Woodcut printed from two blocks (each sawn into two sections) in light blue, dark green, orange, and light green ink on Japanese paper; image: 37.6 × 45.5 cm (14 13/16 × 17 15/16 in.); sheet 45.4 × 57.8 cm (17 7/8 × 22 3/4 in.). Museum of Fine Arts, Boston, William Francis Warden Fund, 1957, 57.356. Cat. 49.

159 JENS FERDINAND WILLUMSEN (Danish, 1863–1958). *Voting Day*, 1890. Etching; 26.8 × 38 cm (10 1/2 × 15 in.). J. F. Willumsens Museum, Frederikssund.

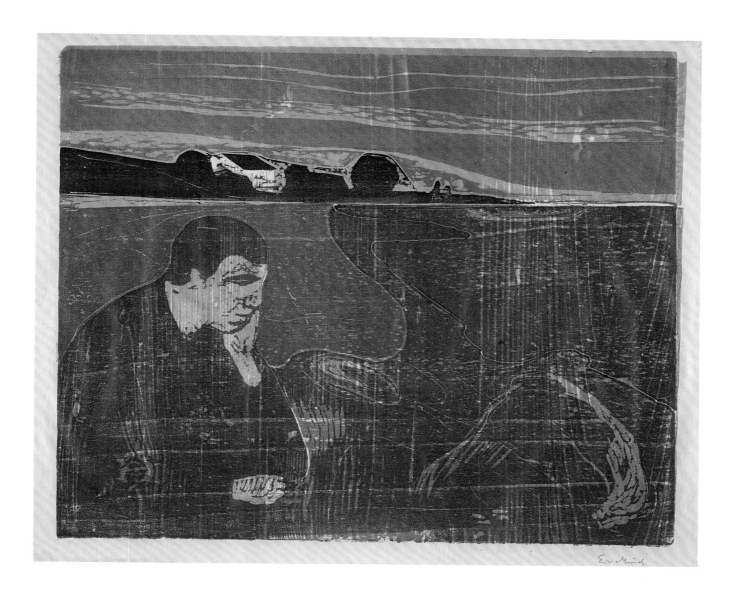

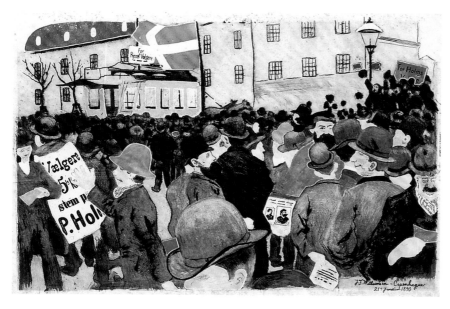

own emotions, is drawn toward her. In other impressions [see **162**], their feet exist in the same zone of the rocky shore, the land is inked in red, and the sky is colored an ethereal lilac. In this multicolored example, the man appears to move closer to the woman, while the ground, like molten lava, reflects the heat of their sensual encounter, its indented shape visually pressing them together. By contrast, the black and blue impression conveys a sense of cool separation.

Like *Moonlight I*, *Towards the Forest I* [**163**] strongly accentuates the grain of the wood; moreover, it suggests how this feature, when combined with the jigsaw method, conveys additional meanings. Here, a couple walks toward a dense wood, their arms wrapped around each other and their heads gently touching. The man is dressed in a suit and the woman is nude, although in other impressions she wears a long skirt; the motif itself relates to a series of drawings Munch made earlier, in which he explored variations on the theme of Eve walking into an ominous grove of trees. The striking teal blue, overprinted in black, permeates the image and is left in its pure form as a horizontal strip on top, suggesting an evening sky. The vertical strips of wood on each side, used to hold the jigsaw pieces together, appear almost as two wings of an altarpiece; their grain runs vertically, whereas in the interior image it runs horizontally.[70] Munch was very conscious of the visual and emotive effects of contrasting horizontals and verticals, writing in his diary, "In pine woods, one is very aware of those main lines living in nature—the perpendicular and the vertical. The branches form the explosive lines of movement—like soaring Gothic arches."[71] The same could be said for the effects of this woodcut: the cathedral of trees combines blocks with horizontal and vertical grains, adding a powerful tactile quality to the scene's elegiac and somber religiosity.

A year later, Munch created the majestic, stunningly printed landscape *Mystical Shore* [**164**], in which he used the device of a frame in a less symbolic and more insistently architectonic manner. As in the 1892 painting *Mystery on the Shore* (p. 19, fig. 12), we see a tree stump in the foreground whose roots resemble the arms of an octopus or the strands of a woman's hair. Yet the smiling rock that lent the canvas an eerie, fairy-tale sensibility has lost its human quality. The foreground is printed in green; the rock, setting sun and shadow, and tree stump in orange; and the water and sky in light blue. A darker blue serves as a key block printed over most of the other colors. Although Munch used the rough grain of the wood to articulate the horizontal, as he did in *Towards the Forest I*, he also employed another block with a visible vertical grain to suggest movement and reflections on the water. Unlike the religious undertones of *Towards the Forest I* or the scientific and sexual motifs present in *Madonna*, Munch's preoccupation here is with vision itself, with nature as seen through the artist's "inner eye," or interior imagination. As he wrote around 1907, "Nature is the vast eternal kingdom which nourishes art. Nature is not only that which is visible to the eye. It is also the inner images of the mind. The images upon the reverse of the eye."[72]

Two visually connected color woodcuts, *Woman's Head against the Shore* and *Two Women on the Shore*, exemplify other key aspects of Munch's work in the medium: his tendency to repeat certain motifs and his careful selection of papers for printing. Far more than his intaglios or lithographs, Munch's woodcuts exhibit the signature curve of the Åsgårdstrand shoreline, which operates as a dominant compositional and symbolic dividing line between humankind and nature, the familiar land and the mysterious sea. In his lithographs, Munch tended to present water motifs as waves, sinuous lines that were easily charted in tusche or crayon. Here, however, water is described as an endless, unknowable expanse. In *Woman's Head against the Shore* [**165**], the artist divided land and sea, cutting two blocks into two separate sections each. The woman, of course, belongs to the earthly domain, as solid as the rocks that anchor her form to the right.[73] *Two Women on the Shore* [**166**] similarly separates land, sea, and humanity, using three different blocks for each; here, however, the colors are symbolic: the sea is dark blue, the land green, the hair red-brown, and the old woman black. The theme of youth and old age is intensified by Munch's rendering of the old woman, who appears as if she is the figure of Death itself, reminding her companion of her own mortality.

At around the same time, Munch made *Melancholy II* [**167**], another striking woodcut of a woman on the shore. Here, he recasts his traditionally male figure of despair as a woman, setting her against the telltale Åsgårdstrand landscape. Her sense of despair is more palpable, abstracted, and physical than that of her counterpart in *Evening: Melancholy I* (p. 147, fig. 158):

160 EDVARD MUNCH *Two Human Beings: The Lonely Ones*, 1899. Woodcut printed from one block (sawn into three sections) in black and blue-gray ink on ivory Japanese paper; image: 39.3 × 54.6 cm (15 1/2 × 21 1/2 in.); sheet: 41.9 × 57.2 cm (16 1/2 × 22 1/2 in.). Collection of Catherine Woodard and Nelson Blitz, Jr. Cat. 71.

161 ANDERS LEONARD ZORN (Swedish, 1860–1920). *Fisherman at St. Ives*, 1891. Etching with burnishing in black ink on ivory laid Van Gelder paper; plate: 28 × 19.8 cm (11 × 7 3/4 in.); sheet: 47.2 × 30.7 cm (18 5/8 × 12 1/8 in.). The Art Institute of Chicago, Charles Deering Collection, 1927.1825. Cat. 145.

162 EDVARD MUNCH *Two Human Beings: The Lonely Ones*, 1899. Color woodcut printed from one block (sawn into three sections) on paper. Munch Museum, Oslo.

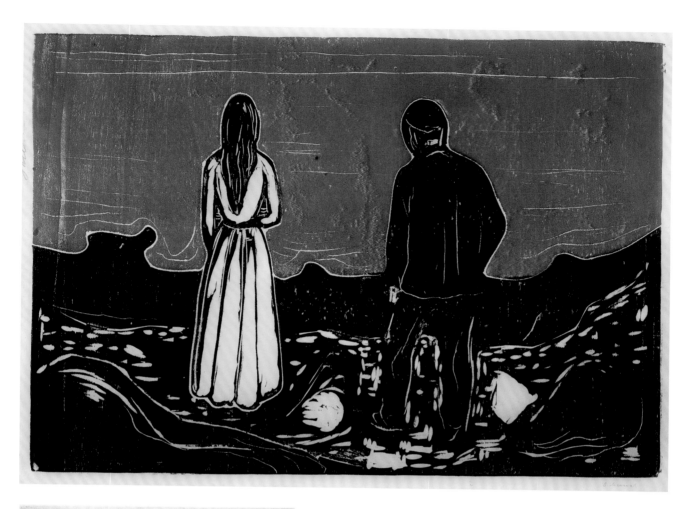

163 EDVARD MUNCH *Towards the Forest I*, 1897. Woodcut printed from two blocks (one sawn into three sections) in black, blue, and brownish orange ink on ivory Japanese paper; image: 52.3 × 64.4 cm (20 5/8 × 25 3/8 in.); sheet: 54.6 × 66 (21 1/2 × 26 in.). Collection of Catherine Woodard and Nelson Blitz, Jr. Cat. 64.

164 EDVARD MUNCH *Mystical Shore*, 1897. Woodcut printed from two blocks in dark blue, light blue, orange, and green ink on cream wove paper; image: 37.2 × 57 cm (14 5/8 × 22 7/16 in.); sheet: 37.9 × 58.3 cm (14 15/16 × 22 15/16 in.). Harvard Art Museum, Fogg Art Museum, Gray Collection of Engravings Fund, G8856. Cat. 63.

165 EDVARD MUNCH *Woman's Head against the Shore*, 1899. Woodcut printed from two blocks (each sawn into two sections) in light green, orange, blue-green, and red-brown ink on ivory Japanese paper; image: 46.5 × 41.1 cm (18 1/4 × 16 1/8 in.); sheet: 59.5 × 47 cm (23 3/8 × 18 1/2 in.). The Art Institute of Chicago, Clarence Buckingham Collection, 1962.84. Cat. 72.

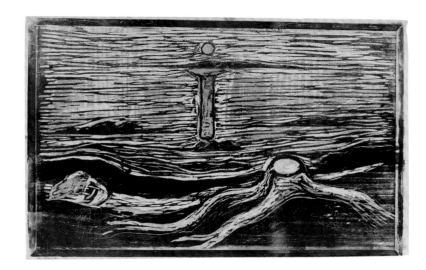

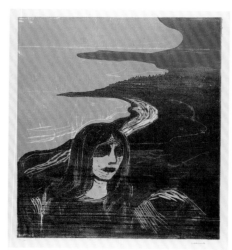

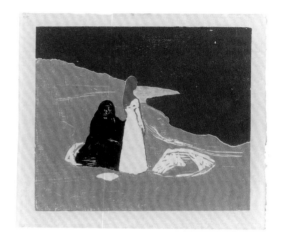

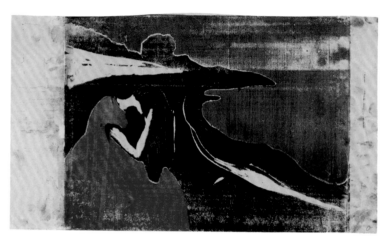

166 EDVARD MUNCH *Two Women on the Shore*, 1898. Woodcut printed from one block (sawn into three sections) in dark blue, green, black, and red-brown ink with additions in green crayon on cream Japanese paper; image: 45.6 × 51.4 cm (18 × 20 1/4 in.); sheet: 53.6 × 59.8 cm (21 1/8 × 23 1/2 in.). The Art Institute of Chicago, Clarence Buckingham Collection, 1963.293. Cat. 67.

167 EDVARD MUNCH *Melancholy II*, 1898. Woodcut printed from one block (sawn into three sections) in black, dark green, and red ink on cream wove paper; image: 33 × 42.2 cm (13 × 16 5/8 in.); sheet: 33.5 × 54 cm (13 1/4 × 21 1/4 in.). Epstein Family Collection. Cat. 66.

echoing the curve of the shore, her body bends into itself, and her head, which she holds in her hands, nearly vanishes beneath her flowing black hair. The stark color contrasts heighten the emotional intensity, with the vibrant red dress set off against the black shoreline and the dark green water and sky. This sheet—one of only a few known impressions—was pulled by hand, and the artist's fingerprints and printing ink are visible in the margins. The shape of the paper, however, retains that of a horizontal landscape, extending the image into the blank edges.

Among Munch's most celebrated woodcuts is his strikingly spare *The Kiss IV* [168–69], in which he emphasized the grain of the wood as much as the image of the embracing lovers. In a 1913 article on Munch's graphic art, Curt Glaser posed the rhetorical question of why scholars focus on the "what" rather than the "how" of the artist's prints, going on to question why their thematic content should be so much more fascinating than their formal qualities. Glaser suggested, as I have in this chapter, that the process Munch used to create an image shaped its meaning profoundly, even if it shared a motif with works in other media: "For Munch there is one art, and the differences lay in the means by which he produces them … the most varied of them is *The Kiss*, that in woodcut finds its purest solution."[74] Glaser is right: here, the motif is distilled to its most abstract, with the two figures literally fusing together; they are undifferentiated by color, and their physical separateness is only hinted at in their entwined arms and the suggestion of the man's leg against the woman's dress. In contrast to *Two Human Beings*, in *The Kiss IV*, the figures are formed with one block to signify their unity, while the background was printed with yet another block, articulated not by cutting into it but by simply inking and printing it, so that the natural wood grain created the pattern itself.[75] The two impressions seen here exemplify the startling differences that sometimes characterize various colorings and printings of one image: the grayish brown and black version [168] is more heavily inked and printed, while the cooler gray and black impression [169] was printed with far less pressure, allowing the couple to sink back into the block itself, with the more pronounced grain acting like a gauzy veil over the entire image.

As these impressions of *The Kiss IV* demonstrate, Munch extended the creative, symbolic, and technical boundaries of the woodcut medium—and the limits of his own motific repetition—into a new realm of expressiveness and experimentation. As we have seen, his early intaglio prints for Meier-Graefe's portfolio both adopted and transcended traditional perceptions of reproductive etchings, and the project's commercial failure served to catapult him in the direction of further innovation. Despite this early setback, the artist continued to embrace and capitalize on current trends such as lithography, mining the process in his own deeply ambivalent and complex manner. In works such as *Madonna* (p. 127, figs. 128–29) he seamlessly combined technical and symbolic elements, unifying the work he did on the stone with the motif itself. In images like *The Sick Child I* (p. 139, figs. 147–49), with its sumptuous color variations, Munch presented his viewers with a provocative sense of sameness and difference, one that he promoted when exhibiting several, differently colored variations simultaneously. The fluid boundaries between love and death, repetition and uniqueness, primitive and modern, formal and iconographic also suggest themselves in his powerful woodcuts. In *Towards the Forest I* (p. 150, fig. 163), for instance, the sexual and spiritual fuse in an image depicting the physical union of two beings within the symbolic space of a cathedral-like forest. Although the artist may have initially begun printmaking as a way to earn money, through his exploration of the various technical possibilities of each matrix, it became much more: an index of his larger approach to creativity. Indeed, Munch's prints reveal the ways in which his aesthetic, financial, and professional ambitions were intertwined as he pursued a set of motifs that were at once saleable, cutting-edge, and intensely personal.

168 **EDVARD MUNCH** *The Kiss IV*, 1902. Woodcut printed from two blocks (one sawn into two sections) in gray-brown and black ink on cream Japanese paper; image: 47.1 × 47.2 cm (18 1/2 × 18 1/2 in.); sheet: 52.5 × 49.4 cm (20 5/8 × 19 1/2 in.). The Art Institute of Chicago, Clarence Buckingham Collection, 1963.292. Cat. 78.

169 **EDVARD MUNCH** *The Kiss IV*, 1902. Woodcut printed from two blocks (one sawn into two sections) in gray and black ink on heavyweight cream wove paper; image: 46.7 × 48.2 cm (18 3/8 × 19 in.); sheet: 57.4 × 54.7 cm (22 5/8 × 21 1/2 in.). Jim and Kay Mabie. Cat. 79.

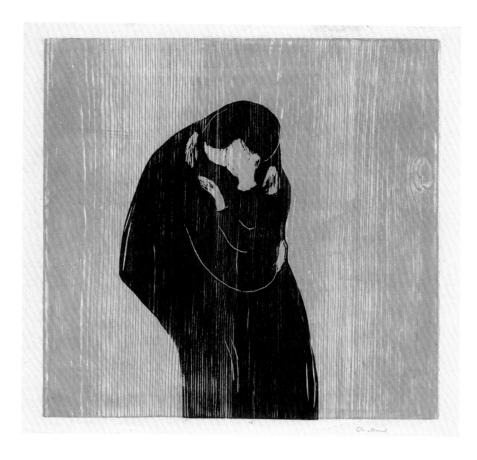

NOTES

Many thanks to Mark Pascale and Kimberly Nichols for their suggestions on this chapter.

1
This chapter builds upon the definitive studies of Munch's graphic work, which include Berman and Van Nimmen 1997; Prelinger 1996 and 2006; and Woll 1991, 1995, 1996, and 2001.

2
For more on these issues, see Woll 2008b.

3
Three of these sheets are reproduced in Woll 2001, pp. 438–39. See also Bruteig 2008, pp. 64–65. On printmaking in Norway before 1900, see Sidsel Helliesen, *Norsk grafikk: gjennom 100 år* (Aschehoug, 2000), pp. 17–30.

4
For a fuller treatment of German print culture, see Clarke 1999; and Lewis 2003.

5
As early as 1872, the eminent museum director Max Jordan used these terms to differentiate etching from engraving. M.[ax] J.[ordan], "Neue Kunstblätter," *Im neuen Reich* 2 (1872), p. 80. For more on this issue, see Clarke 1999, introduction.

6
See Max Klinger, *Malerei und Zeichnung* (Insel, 1891). For more on this fascinating text, see Marsha Morton, "'Malerei und Zeichnung': The History and Context of Klinger's Guide to the Arts," *Zeitschrift für Kunstgeschichte* 58 (1995), pp. 542–69.

7
For more on these beginnings, see Woll 2001, pp. 10–112. Although Munch eventually had his own press on which he printed small editions, he went to these firms during his early years, no doubt to pick up the tricks of the trade. The city's premier printer, Otto Felsing, was so well-known that he or an associate signed a print to the left of the plate while the artist signed it to the right, thus signifying the importance of his role as co-creator of the image. As an example of this practice, see Prelinger 1996, p. 81, cat. 9.

8
See Eberhard von Bodenhausen to Edvard Munch, Dec. 12, 1894. Munch Museum Archives.

9
Edvard Munch to Karen Bjølstad, Nov. 14, 1894; as quoted in Woll 1995, p. 9.

10
Trygve Nergaard convincingly argued that *Harpy* is an allegory of artistic creativity, while Patricia Berman has connected a similar print to a short story by Strindberg; see Nergaard 1978, pp. 134–35; and Berman and Van Nimmen 1997, p. 111, cat. 15.

11
The portfolio's price was very reasonable: the early, signed impressions sold for one hundred marks and the later, steel-faced ones for fifty marks. For dealers, the prices were even less: sixty and thirty marks, respectively. Kneher 1994, p. 78 and n. 135. By 1903, the print *The Sick Child* (Woll 7) had significantly appreciated, as it sold to Dr. Max Linde for forty marks; see Munch 1954, p. 12.

12
Julius Meier-Graefe, *Edvard Munch: Acht Radierungen* (self-published, 1895), p. 17. For images of all the works in the Meier-Graefe portfolio, see Prelinger 1996, pp. 65–79, cats. 1–8.

13
Meier-Graefe (note 12), p. 13.

14
Julius Meier-Graefe, *Félix Vallotton* (J. A. Stagardt/Edmond Sagot, 1898), pp. 3–4. For more on the issue of Munch and color, see Herman 1999, chap. 5.

15
Meier-Graefe (note 12), p. 14.

16
Hans Rosenhagen, "Munch-Gallén Ausstellung bei Ugo Barroccio," *Tägliche Rundschau* 15 (Mar. 10, 1895), pp. 3–4.

17
J.[aro] S.[pringer], "Ausstellung und Sammlungen," *Die Kunst für Alle* 10 (1895), p. 222.

18
Ibid.

19
Julius Meier-Graefe to Edvard Munch, Oct. 13, 1895. Munch Museum Archives.

20
This time frame assumes that Munch began making intaglios in Oct. or Nov. 1894 and, in Apr. 1895, was working on a lithographic portrait of Kessler; see Woll 1995, pp. 15–16.

21
We can date this new activity to these three weeks with receipts sent to the artist by the lithographic printers M. W. Lassally (Jul. 19) and A. Liebmann (Aug. 8). Munch Museum Archives.

22
See, for example, Max Lehrs, "Neue Lithographieen," *Die graphischen Künste* 16 (1893), pp. 85–86.

23
For more on the issue of lithography as a simulacrum of drawing, see Marjorie B. Cohn, "The Artist's Touch," in *Touchstone: 200 Years of Artists' Lithographs* (Harvard University Art Museums, 1998), pp. 15–35. For an important treatise on the technique, see Edouard Dûchatel, *Traité de lithographie artistique* (self-published, 1893).

24
Woll 1995, pp. 15–16.

25
Prelinger 1996, p. 93.

26
For Odilon Redon's frequent treatment of the theme, see Douglas W. Druick et al., *Odilon Redon: Prince of Dreams, 1840–1916*, exh. cat. (Art Institute of Chicago/Harry N. Abrams), pp. 94–103.

27
For more on the use of this combined process in France and England, see Jacquelynn Baas and Richard S. Field, *The Artistic Revival of the Woodcut in France, 1850–1900*, exh. cat. (University of Michigan Museum of Art, 1984), pp. 97, 128.

28
Woll 1978, p. 243.

29
As quoted in Stang 1979, p. 136. For a thorough technical description of the states of this print, see Prelinger 1996, pp. 99–105, cats. 16–17; and Woll 2001, pp. 69–72.

30
As quoted in Tøjner 2001, p. 208.

31
The first German edition was *Anthropogenie: oder, Entwickelungsgeschichte des Menschen* (W. Engelmann, 1874). Fig. 127 was taken from the fourth German edition, published in 1891. On Haeckel's theories and his profound influence on a generation of European intellectuals, see Robert J. Richards, *The Tragic Sense of Life: Ernst Haeckel and the Struggle over Evolutionary Thought* (University of Chicago Press, 2008).

32
Tøjner 2001, p. 104. My thanks to Jenny Anger for her suggestion.

33
We know from caricatures such as fig. 135 that a painted version of *Madonna* was surrounded by a frame that, like the lithographic version, featured both sperm and a small fetus; Høifødt 2008, p. 25.

34
The paper has since faded, taking on a green-gray tone. For more on Munch's paper choices, see Woll 2003.

35
Harry Kessler to Edvard Munch, Sept. 30, 1896. Munch Museum Archives. For more on the popularity and ubiquity of such images, see Bram Dijkstra, *Idols of Perversity: Fantasies of Feminine Evil in Fin-de-Siècle Culture* (Oxford University Press, 1986).

36
For more on such dance halls, see Hollis Clayson, *Painted Love: Prostitution in French Art of the Impressionist Era* (Yale University Press, 1991). For the specific cabaret depicted in *Tingel-Tangel*, see Prelinger 1996, p. 112, cat. 19.

37

When exhibited in 1897, the print was titled *Hands: Lust for Woman*, which only reinforced its portrayal of male desire; Berman and Van Nimmen 1997, p. 113, cat. 16.

38

Henrik A. Grosch, "Nye arbeider af Edv. Munch: udstillingen hos Blomqvist," *Aftenposten*, Oct. 5, 1895, as quoted in Boe 1971, pp. 216–17.

39

Connelly 1995, pp. 92–93.

40

For more on Toulouse-Lautrec and caricature, see Richard Thomson, "Toulouse-Lautrec and Montmartre: Depicting Decadence in Fin-de-Siècle Paris," in Richard Thomson, Phillip Dennis Cate, and Mary Weaver Chapin, *Toulouse-Lautrec and Montmartre*, exh. cat. (National Gallery of Art, Washington, D.C. / Princeton University Press, 2005), pp. 16–21.

41

On Gauguin's use of yellow paper, see Douglas W. Druick and Peter Kort Zegers, *Van Gogh and Gauguin: The Studio of the South*, exh. cat. (Art Institute of Chicago/ Thames and Hudson, 2002), pp. 275–77; and Heather Leomonedes, "Paul Gauguin's High Yellow Note: The Volpini Suite" (Ph.D. diss., City University of New York, 2006), chap. 3.

42

Charles Dulac, as quoted in Elizabeth Prelinger, "Charles Dulac's *Suite de Paysages*," *Print Quarterly* 12, 1 (1995), p. 47.

43

Woll 2001, pp. 14–15; and Rapetti and Eggum 1991, pp. 244–59. See also Pat Gilmour, "Cher Monsieur Clot ... Auguste Clot and His Role as a Color Lithographer," in *Lasting Impressions: Lithography as Art*, ed. Pat Gilmour (University of Pennsylvania Press, 1988), pp. 154–60.

44

For an example of a black-and-white impression, see Woll 2001, p. 95, cat. 69.

45

Aagot Noss, *Lad og Krone: frå Jente til Brur* (Universitetsforlaget, 1991). My thanks to Kathryn Sullivan for her help in researching this sartorial tradition.

46

For an illustration of the hand-colored version, see Woll 2001, p. 104, where the *Flower of Pain* lily motif further accentuates the man's suffering. These two prints were among the very few transfer lithographs Munch created in the 1890s.

47

Charles Baudelaire, "Her Hair," in *The Flowers of Evil*, ed. Marthiel and Jackson Mathews (New Directions, 1989), p. 32.

48

In 1896, Obstfelder described what he saw as Munch's unique vision: "It has been proven that he sees in wavelengths, he sees the shoreline weave next to the ocean, he sees the branches of the trees in waves. He sees women's hair and women's bodies in waves." Sigbjørn Obstfelder, "Edvard Munch: et forsøg," *Samtiden* 7 (1896), p. 18.

49

For a thorough treatment of *The Mirror*, see Bente Torjusen, "The Mirror," in Eggum 1978, pp. 185–227.

50

Ironically, when he was hospitalized in 1908 for a nervous breakdown, Munch received therapeutic treatment with mild electric currents in an attempt to cure his perceived mental instability. Although the energy at work in these lithographs predates his treatments, immediately after release from the sanatorium in 1909 Munch revealed to his cousin Ludvig Ravensberg that he wanted to return to *The Mirror* and prepare it for wide dissemination, insisting, "I now have to earn money, it is absolutely important for me to earn money." Ludvig Ravensberg diaries, Munch Museum Archives. See also Christoph Asendorf, "Nerves and Electrcity," in *Batteries of Life: On the History of Things and Their Perception in Modernity*, trans. Don Renau (University of California Press, 1993), pp. 153–69.

51

While in Berlin, Munch did print intaglios in the dark brown ink preferred by Otto Felsing and made the rare multicolored intaglios such as *Attraction II* (1895; Museum of Modern Art, New York); for the latter, see Woll 2001, p. 59, cat. 20. For more on Munch's understanding of color theory, see Steinberg 1995.

52

For more on Munch and Mallarmé's relationship, see Jean-Michel Nectoux, *Mallarmé: un clair regard dans les ténèbres; peinture, musique, poésie* (Adam Biro, 1998), pp. 110–18. Another example of his use of colored inks are the bright blue inks used for impressions of *Attraction II*.

53

Schiefler 1907, p. 65.

54

Jonathan Pascoe Pratt and Douglas W. Druick, "Vollard's Print Albums," in *Cézanne to Picasso: Ambroise Vollard, Patron of the Avant-Garde*, ed. Rebecca Rabinow, exh. cat. (Metropolitan Museum of Art /Yale University Press, 2006), pp. 189–91.

55

Erich Büttner, "Der Leibhaftige Munch," in Thiis 1934, p. 92. Munch also made an intaglio print of *The Sick Girl* in 1896 and printed several impressions in color; see Woll 2001, pp. 86–87. For a fascinating period investigation of the merits and pitfalls of color lithography, see André Mellerio, *La lithographie originale en couleurs* (L'estampe et l'affiche, 1898).

56

Edvard Munch to Mrs. Valborg Hammer, undated draft (1896); as quoted in Woll 1996, p. 20.

57

Patricia Berman has noted that her arms are not visible, thus further rendering her "mute and immobilized"; Berman and Van Nimmen 1997, p. 204, cat. 63.

58

The complex printing method for this work is explained in Woll 1991, pp. 184–85; and Prelinger 1996, pp. 189–92, cat. 45.

59

Munch may have been introduced to this process by Paul Herrmann, who used plates with similarly trimmed corners; see Woll 1996, p. 23.

60

Ludwig Ravensberg diaries (note 50).

61

For more on craft revivals, see Berman 1993c.

62

See Greve 1963. For more on Munch and material-based modern art, see Buchhart 2007.

63

Glaser 1917, p. 50.

64

Robin Reisenfeld, "Cultural Identity and Artistic Practice: The Revival of the German Woodcut" (Ph.D. diss., University of Chicago, 1993).

65

For more on the revival of the woodcut in France and Jarry specifically, see Baas and Field (note 27).

66

[Alfred Jarry], "L'ymagier," *L'Ymagier* 1 (1894), pp. 5–7.

67

Max Linde, *Edvard Munch und die Kunst der Zukunft* (Friedrich Gottheiner, 1903), p. 8. Regarding this woodcut and the various papers used to print it, see Akira Kurosaki, "Moonshine: A Study of the Paper used for Edvard Munch's Color Woodcut," *Journal of Kyoto Seika University* 4 (1993), pp. 71–128.

68

Their correspondence is housed in the Munch Museum Archives. For more on this issue, see Rapetti and Eggum 1991, pp. 203–204; Woll 1996, p. 26; and Baas and Field (note 27), p. 144. Although there is no evidence that Munch would have seen it, Gauguin did hold an exhibition in his Paris apartment in Dec. 1894 that included his woodcuts of 1893–94; see Richard Brettell et al., *The Art of Paul Gauguin*, exh. cat. (National Gallery of Art, Washington, D.C. / Art Institute of Chicago, 1988), p. 352.

69

A copy of the catalogue is housed in the Munch Museum Archives; see also Sigurd Schulz, *Willumsens Graphik* (Copenhagen, 1961), cat. 16, p. 23.

70

Berman and Van Nimmen 1997, p. 149, cat. 35. For more on this series, see Eggum 2000, pp. 147–55.

71

Tøjner 2001, p. 132.

72

As quoted in ibid., p. 131.

73

For a fuller treatment of the separate blocks and printings in these two prints, see Prelinger 1996, pp. 170, 176, cats. 39, 41.

74

Curt Glaser, "Edvard Munch als Graphiker," *Kunst und Künstler* 11 (1913), p. 574.

75

For more on the different blocks used in the printing of the various states, see Prelinger 1996, pp. 161–66, cat. 37.

THE METABOLIC MUNCH:
REPRESENTING PERSECUTION AND REGENERATION

The intensely shifting, culturally complex period around the turn of the twentieth century witnessed Munch's commercial and professional rise to fame but also his physical and emotional collapse: after several efforts to cure his alcoholism and increased paranoia, the artist checked himself into a psychiatric clinic for eight months between 1908 and 1909. One might imagine that his work would have become even more tortured as he moved toward this frightening crescendo. But, in fact, Munch remained in control of his public image, his exhibition and marketing strategies, and his artistic production. Indeed, over the course of the previous decade, the artist simultaneously created images of violent self-persecution and buoyant vitality. By no means diametrically opposed, these images of destruction and health register in yet another way the profound ambivalence that, as we have seen, characterizes Munch's life and work. In this chapter, we will examine his diverse pictures from this period—motifs from *The Frieze of Life*, crucifixion scenes, and images of bathers—considering how all of them operated as powerful, inextricably linked forms of self-representation that the artist drew upon as he attempted to metamorphose and transform even as he deteriorated.

The allegorical and collective nature of the artist's aims for *The Frieze of Life*, for which he had frequently used the Åsgårdstrand landscape as a backdrop, are encapsulated in his encyclopedic *Dance of Life* [**170**]. Munch described this painting, which was among the last canvases created for the series, as follows:

I danced with my first love—the painting was based upon these memories. The smiling blonde woman enters—she wants to pick the flower of love—but it escapes her grasp. On the other side of the painting she appears dressed in black mourning clothes, looking at the dancing couple—she is an outcast—just like me. Rejected from the dance. Behind her, the dancing mob moves like a storm in one another's arms.[1]

As with so many of his works, figures and motifs reappear: at left is the innocent woman in a speckled dress, who reaches for the flower of love; at center is the priest or monk who embodies the artist himself, dancing with the femme fatale, whose red dress and hair envelop him; and at right is an older woman in mourning. Although the three women have been identified as both Milly Thaulow and Tulla Larsen—even by the artist himself—they can perhaps best be seen as

archetypes rather than particular individuals. Here, Munch sets his familiar themes of life, love, and death against the whirling crowd who dance ecstatically in a field with the setting summer sun streaking the water behind them.[2] The sun is not red, but rather echoes the pink flower of love and the pastel hues of the sunset. Like *Summer Night's Dream: The Voice* (p. 75, fig. 73), the painting can be associated with Saint Hans's Night, an evening of revelry that marked the summer solstice with a combination of secular and religious celebrations.[3]

Images of people attired in native dress and dancing in the countryside were not uncommon at this time. Anders Zorn's celebrated *Midsummer Dance* [**171**], for example, documents a Swedish midsummer festival, and József Rippl-Rónai's vibrant, pastel-shaded lithograph *The Country Dance* [**172**] depicts dancers in a remote, mountainous region of southern France. Munch's variation on this theme, however, is far more dreamlike and cerebral.[4] In *Dance of Life*, he sought to distill his interrelated motifs of purity, sexuality, and death, bringing the events, landscapes, and loves of his life together in one moment in time. He was also attempting to produce a finale to *The Frieze of Life*, which he was obsessively trying to display in its entirety, finally doing so at the Berlin Secession exhibition of 1902 and again in a Leipzig gallery the following year (see p. 217).[5]

Even as Munch returned to nature, creating images that at once celebrated life's forces and mourned its passing, he also continued his representations of personal and existential torment. Indeed, during this period, he participated in over one hundred exhibitions that capitalized on public perceptions of his insanity and ghoulishness, and also directed his efforts at portraiture and graphic works as he labored to stimulate and control the exploding market for his art. These impulses—physical wellness and mental instability, rural serenity and urban ambition, surging masculinity and sexual ambiguity—coalesced in the complex period between 1897 and 1912. Despite his severe alcoholism and the frightening physical and emotional effects it wrought, only briefly—from 1904 to 1906—did Munch allow dealers to handle the sale of his paintings and prints; otherwise, he conducted a lively and exhaustive correspondence with each and every individual who was interested in buying.

The vast network of dealers, museums, and private collectors with whom he dealt shows a figure very much in charge

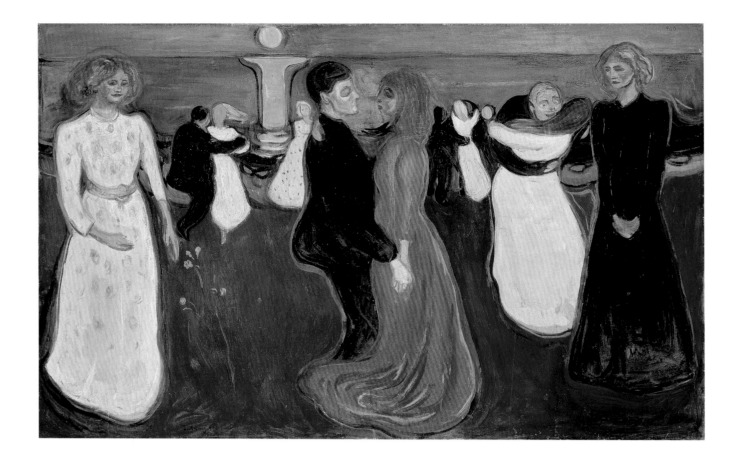

170 **EDVARD MUNCH** *Dance of Life*, 1899/1900. Oil on canvas; 125 × 191 cm (49¹/₄ × 74³/₄ in.). The National Museum of Art, Architecture and Design, Oslo, NG.M.00941. Cat. 73.

171 **ANDERS LEONARD ZORN** *Midsummer Dance*, 1903. Oil on canvas; 117.5 × 90 cm (46¹/₄ × 35 in.). Nationalmuseum, Stockholm.

172 **JÓZSEF RIPPL-RÓNAI** (Hungarian, 1861–1927). *The Country Dance*, 1896. Lithograph printed from six stones in gray, light yellow, dark yellow, green, blue, light orange, pink, and purple ink on ivory Japanese paper; image: 39.6 × 52.9 cm (15⁵/₈ × 20³/₄ in.); sheet: 43.3 × 56.4 cm (17 × 22¹/₄ in.). The Art Institute of Chicago, gift of the Marjorie Blum-Kovler Collection and the Harry and Maribel G. Blum Foundation, 1995.49. Cat. 134.

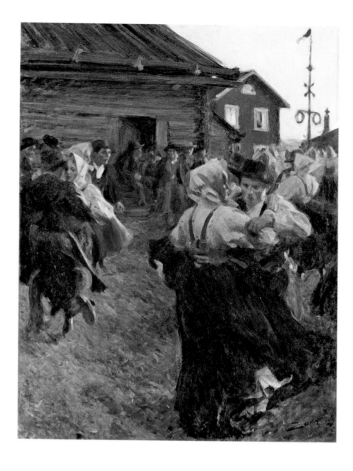

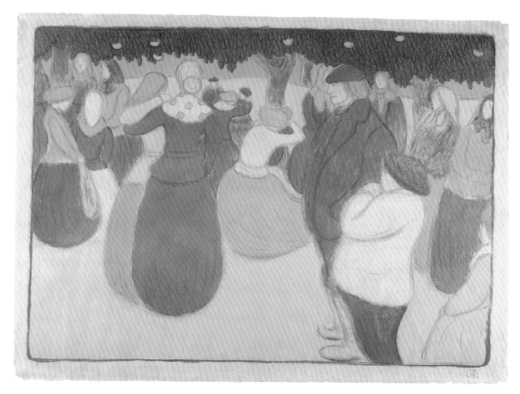

of his place in the contemporary art world and well aware of how to adjust his prices to his own benefit. These two aspects of his personal and professional life—one desperate and erratic, the other self-possessed—are intimately connected to the metamorphic imagery he used in his works. As we will see, the artist, motivated largely by the professional appreciation he continued to actively seek, was attempting to reinforce and expand upon his positive public reception and regenerate his physical body. In assessing Munch's post-1900 work, and particularly the effect of his prolonged hospitalization in 1908 and 1909, many scholars have argued for the existence of two different artists, one "insane" and the other newly "sane." However, both Munch's imagery and his ambitions at this time were far more complex than these binary positions suggest. The sick and the healthy Munch coexisted, as a careful look at his art and his relationship to the market reveal.

I. Life, Death, and Resurrection

Munch made two prints in 1897 that reveal his investment in the possibility of bodily, psychic, and spiritual transformation. Included in his portfolio *The Mirror* (see. p. 136), *Metabolism* and *Funeral March* connect to the narrative framework of *The Frieze of Life*, chronicling the human experience of love and death. When he first exhibited *The Mirror* in 1897, he used these two works to begin it, a telling choice that suggested the importance of death, transmutation, and resurrection in his evolving conception of life and the world.[6] The composition of *Metabolism* [173] is half-death, half-life: at bottom, the decomposing body of a raven-haired woman, buried in the earth, releases spermlike organisms that float up toward the living world. This realm, in turn, is embodied in a pregnant woman who rests against the Tree of Life, placing a hand on her growing belly as she looks out upon a radiant landscape. Between the two figures appears the head of an unborn child, who exists in the liminal space between death and life. Writing of a related series of drawings in 1896, Munch reflected, "Man ... fertilizes the earth while he is consumed and then gives nourishment to new life."[7] Here, he captured this process in a way that is both macabre and hopeful. As Patricia Berman and Shelley Wood Cordulack have argued elsewhere, Munch's metabolic imagery can be clearly tied to scientific and religious discourses of his day that unified nature and spirituality,

physiology and immortality.[8] Like the electrical currents and lines of force in the *Attraction II* (p. 134, fig. 142) and *Madonna* lithographs (p. 127, figs. 128–29), the organisms that emanate from the corpse in *Metabolism* invigorate the world: their energy flows up from the bottom right, creating a frame that extends across the sky and back down through the tree.

Within *The Mirror*, Munch pursued *Metabolism*'s theme of rebirth and transformation in *Funeral March* [174], also titled *Toward the Light*. Here, a corpse in a casket is being raised up by a resurrected mass of bodies. The writhing forms, which include a number of nude women and one clothed man, are separated from the grotesque, disembodied heads in the foreground. Their hollow eyes suggest decomposition, with the exception of the lone female head, which appears to sleep atop the wreckage. The scene as a whole is permeated by lines of force that sweep upward like a geyser of water and smoke. The "march" of the title is not earthly but rather cataclysmic and otherworldly: death combines with life, religion with sexuality, past with future as the corpse raises its head as if to observe what is to come. Munch interpreted a similar image by saying, "Death is the beginning of new life," which indicates that this is an image of resurrection and hope rather than death and destruction.[9] The process he used to create this print—and one he rarely adopted—was zincography, which is similar to lithography but involves a thin zinc plate rather than a cumbersome, expensive stone. While the images they print live on, zinc plates corrode and oxidize easily, lasting for only a short time; this characteristic makes them a potentially symbolic choice for a work such as this, which depicts a spiritual and physical transition from one state to another.

Another work from this moment that takes one subject and transforms it into another is *The Island* [175]. In this ethereal, mysterious painting, the artist represents the small island of Ulvøy near Kristiania, which could be seen from the house where his sister Laura and aunt Karen lived at this time. The island appears as a mound of warm brown paint silhouetted against the setting sun, while bursts of blue and yellow set off the night sky above and send flecks of purple-blue into the water below. At lower left is a strange, tall plant with not one but two human features: its shape suggests a human body, and its "head" is painted with eyes and a

dejected face that looks out sorrowfully toward the island and the sky above it. The brown, boatlike shape below echoes that of the island and is likely meant to depict rocks on the beach, or perhaps a shore with melting snow.[10] Another intensely odd, barely visible element is a head, sketched in blue, that peeks up above the left-hand side of the island; this belongs to the Norwegian dramatist Henrik Ibsen, who Munch frequently depicted and whose portrait he completed the previous year. This painting modernized Max Klinger's print after Böcklin's phenomenally popular *Isle of the Dead* [176], which could be found in many a German home. It also, however, suggests that Munch was exploring a unified vision of nature in which the boundaries between animal and vegetable, figure and landscape had begun to blur.

A few years later, in his drawing *The Empty Cross* [178], Munch placed himself at the center of yet another scene of death and potential rebirth. Again representing himself as a monk—a visual play on his last name—the artist stands amid a world of sin, redemption, and hell, as if facing a choice between an uncertain salvation on one hand and sure damnation on the other. At left, he assembled a number of "sinful" figures from his earlier works, including a prostitute and nude lovers in an embrace. Above him is an empty cross with mourning men and women at its base, and to the right struggle drowning figures seemingly taken from an image of the Last Judgment. A blood red sun hovers over the entire tableau. The monk's tentative expression and stance suggest that he does not know which of these options to choose—just the dilemma that Munch evoked in a diary passage of around 1908 that is connected to this drawing:

The sun shines purple over the world as through sooted Glass—The Cross on the hill in the Background is empty—And weeping Women pray toward the empty Cross—Lovers—The Whore—The Drunkard—and below the Criminal—And to the right—a cliff towards the Sea—People totter down towards the Cliff—And cling to the Edge, Terrified—There is a Monk amidst the Chaos—bewildered. And with a Child's Terrified Eyes—he asks Why? Whereto—It was me now—Love and Vice raved in the Town—The Horror of Death lurked—and the Cross was empty.[11]

Despite his many years of bohemian living, it seems that Munch had not yet abandoned the Christian spiritual landscape of damnation and salvation. The empty cross suggests that while Christianity offered little in the way of a solution, it did provide a language that Munch could use to represent the problems he faced—and to articulate his hope for some sort of redemption.

At the same time Munch created this conflicted sheet, he was working on the powerful canvas *Golgotha* [179], in which a crucified figure is mocked by a jeering crowd. This image, which combines Christian themes with Munch's own anxieties, features the inscription *E. Munch Kornhaug Sanatorium 1900* in bright red-orange at the upper right. Following years of obsessive travel, severe alcohol abuse, and the unrelenting anxiety produced by his relationship with Tulla Larsen (see p. 216), Munch began the process of emotional and physical recovery by checking himself into a series of sanatoria. The sensuous Tulla, who came from a prosperous Norwegian merchant family, desired increased intimacy and eventually marriage; Munch rebuffed her, fearing that complete physical and emotional union would destroy his art. However, Larsen continued to pursue—and even stalk—him, and their relationship ended definitively and dramatically in 1902 when they tussled over a pistol and part of one of Munch's fingers was shot off.[12] The paranoia that developed during and after this tumultuous affair only served to reinforce the artist's feelings of persecution. Munch's prominent inscription on *Golgotha*, which he created just after his first breakup with Larsen, served to self-consciously identify his plight with that of the crucified Christ.

The painting's dramatic subject matter and agitated style of execution combine to create a work of great force. Here, the lone, central figure appears meek and frail in comparison to the surging, frenzied group that gathers to torment him. The fact that Munch departs from traditional representations of the Crucifixion, in which Jesus was executed along with two criminals, reinforces the sense that this parable is about the artist himself. The menacing crowd combines figures from Scripture—for instance, the helmeted soldier on the left and the veiled and weeping Marian figure on the right—with other identifiable figures in Munch's life, including his onetime friend Przybyszewski just below the cross, his teacher Krohg at the far left, and the artist himself, who appears in profile next to Przybyszewski. The fluid, active

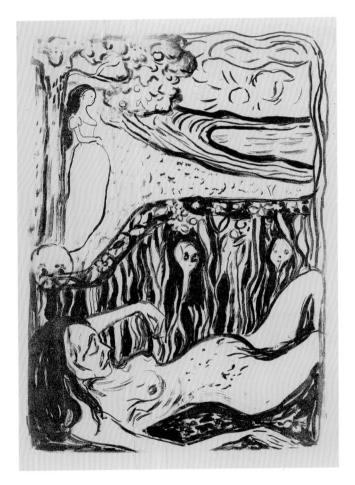

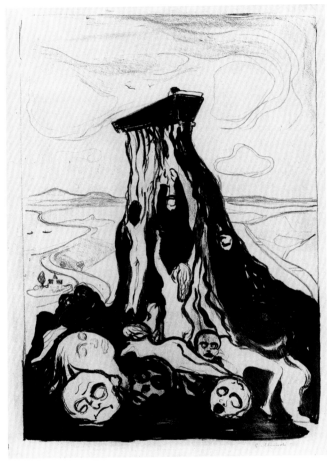

173 **EDVARD MUNCH** *Metabolism*, 1897. Lithograph in back ink on cream wove paper; image: 36 × 24.5 cm (14 1/8 × 9 5/8 in.); sheet: 50.2 × 32.7 cm (19 3/4 × 12 7/8 in.). Munch Museum, Oslo, MMG 227-1. Cat. 62.

174 **EDVARD MUNCH** *Funeral March*, 1897. Zincograph in black ink on grayish ivory China paper; image: 37.5 × 55.6 cm (14 3/4 × 21 7/8 in.); sheet: 59.8 × 42 cm (23 9/16 × 16 9/16 in.). National Gallery of Art, Washington, D.C., gift of The Epstein Family Collection 2006, 2006.51.4. Cat. 61.

175 **EDVARD MUNCH** *The Island*, 1900/01. Oil on canvas; 99 × 108 cm (39 × 42 1/2 in.). Private collection. Cat. 76.

176 **MAX KLINGER (AFTER ARNOLD BÖCKLIN)** *The Isle of the Dead*, 1890. Etching and aquatint in black ink on heavyweight ivory wove paper, laid down on ivory wove plate paper (chine collé); plate: 61.3 × 77.4 cm (24 1/8 × 30 1/2 in.); sheet: 67.6 × 87.4 cm (26 5/8 × 34 3/8 in.). The Art Institute of Chicago, gift of Jack Daulton, 2000.111. Cat. 121.

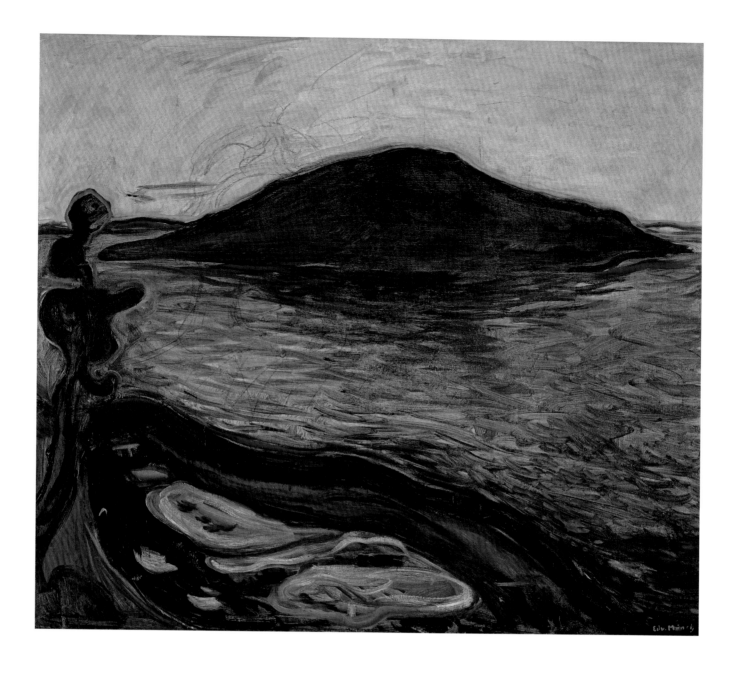

handling creates a feeling of frenzy, with the figures painted in broad, singular strokes and the sky in veils of purple and electric blue.

As he conceived works such as these, there can be no doubt that Munch drew on a number of models. In the 1890s, Belgian, French, and German visual culture was saturated with depictions of Christ's life; some of these were personal in nature, and others were set amid the whirling sociopolitical upheavals of the day, which ranged from debates about church corruption to questions regarding the place of religion in the wake of Darwin's theory of natural selection. As we have seen, Gauguin frequently turned to representations of Christ to symbolize his own experience of suffering, betrayal, and public misunderstanding (see p. 17, fig. 7). Another influence on Munch was James Ensor, whose monumental *Christ's Entry into Brussels in 1889* [177] shows Jesus processing into the city during the revelry of Mardi Gras, his magisterial presence dwarfed by caricatural representations of the military, the clergy, and government officials.[13] Munch's *Golgotha* displays a red, flaglike cloud that moves across the sky like the prominent scarlet banner in *Christ's Entry*. Two years earlier, Ensor completed the smaller painting *Christ Tormented* [180], which is traditional in some ways but utterly fantastic in others, with its grotesque, demonic characters. Here the dying figure of Christ is surrounded by devils and large masked figures who taunt and torture him, rendered in frantically animated brushstrokes and flicks of the palette knife that add to the surreal nature of the scene. Due to the popularity of such images,

Ensor created a series of modestly priced, hand-colored etchings several years later; among these is *Christ Tormented by Demons* [181], another crucifixion scene that features skeletons and devils performing obscene acts. Munch would have been familiar with Ensor's work through pan-European exhibitions and publications.[14]

Ensor's fellow Belgian Henri de Groux was known for similar images. Dedicated to the resurgence of national art, he was involved with several vanguard exhibition societies such as Les Vingt, which promoted Belgium's culture while harshly critiquing its political and religious establishment.[15] The power of his *Christ among His Tormentors* [182] springs not only from its horrific subject matter, but also from its pulsating, proto-Expressionist style. The strong lines of the lithograph and the pastel that cover it accentuate the violent force of the crowd, which includes dogs, Roman soldiers, and a mother holding her baby. This orgiastic behavior contrasts markedly with Jesus's static posture and gentle visage.

Max Klinger's *A Life*, a series that inspired Munch in many ways, was also framed by religious images that emphasize the moral tenor of the contemporary subject matter within. One of these [see 183] depicts an anonymous Christlike figure who is doomed to suffer, as the inscription on the cross—and the title of the work—exhort him to. Although this spectral form dominates the scene, it is Klinger's subject, a fallen woman who has drowned herself, who is the true victim of society's double standard.[16] If Munch was responding to images like Ensor's, de Groux's, and Klinger's, however, he was also transforming them. *Golgotha*, for instance, registers the artist's dramatic sense of paranoia and visualizes his feelings of persecution, but the subject of the Crucifixion also seems to hold out the possibility of hope and metamorphosis. Indeed, his pointed inclusion of the Kornhaug inscription in the apocalyptic sky adds an element of expectation that his time there would be transformative. Like *Metabolism* and *Funeral March*, which consider resurrection and transmutation, *Golgotha* explores death and the possibility of rebirth in yet another way.

II. Munch's Bathers: Masculinity Resurgent

During the mid-1890s, as we have seen, Munch was creating images of the femme fatale, portraying himself as a smoking bohemian, and associating his body with death itself in images

177

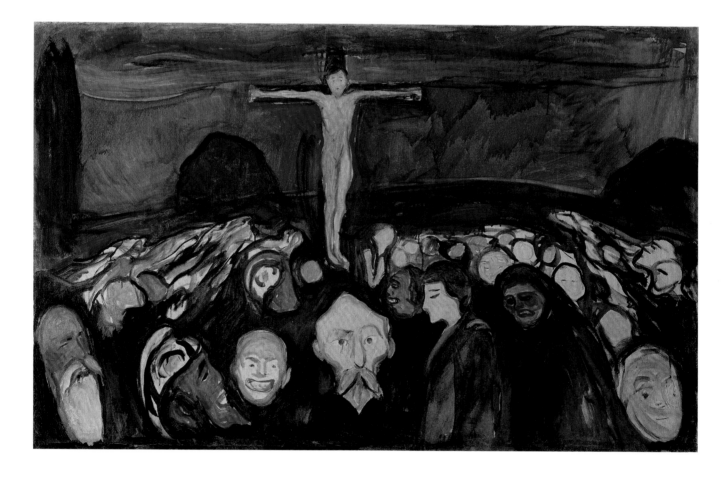

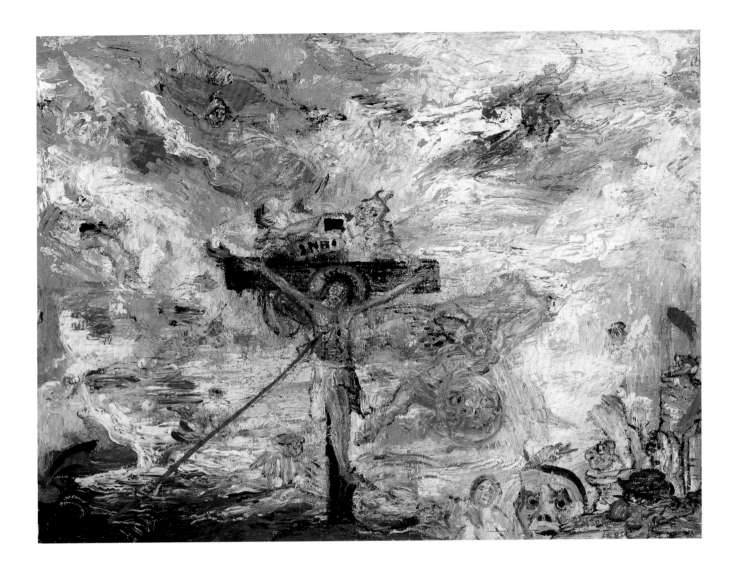

180 **JAMES ENSOR** *Christ Tormented*, 1888. Oil on linen; 55.3 × 70.2 cm (21⁷/₈ × 27⁵/₈ in.). Mildred Lane Kemper Art Museum, Washington University, St. Louis, bequest of Morton J. May, 1968, WU 4391. Cat. 100.

181 **JAMES ENSOR** *Christ Tormented by Demons*, 1895. Etching in black ink with additions in brush and orange-red, blue, yellow, and pink watercolor and pink, orange, and blue crayon on cream wove paper (discolored to tan); plate: 17.9 × 24.3 cm (7 × 9¹/₂ in.); sheet: 35.6 × 47.7 cm (14 × 18³/₄ in.). The Art Institute of Chicago, restricted gift of Dr. Eugene Solow, 1975.499. Cat. 101.

182 **HENRI DE GROUX** (Belgian, 1867–1930). *Christ among His Tormentors*, 1894/98. Pastel over lithograph in black ink with additions in crayon and graphite on cream wove Canson and Montgolfier paper; 59.3 × 81.4 cm (23³/₈ × 32 in.). The Art Institute of Chicago, Mr. and Mrs. Robert Hixon Glore Fund, 1997.414. Cat. 97.

183 **MAX KLINGER** *Suffer!*, plate 14 from the series *A Life*, 1884. Etching, aquatint, and drypoint in black ink on grayish ivory wove paper, laid down on heavyweight cream laid plate paper (chine collé); plate: 36.8 × 26 cm (14¹/₂ × 10¹/₄ in.); primary support: 35.9 × 25 cm (14¹/₈ × 10 in.); secondary support: approx. 78.8 × 57.5 cm (31 × 22⁵/₈ in.). The Art Institute of Chicago, John H. Wrenn Memorial Endowment, 2000.419.14. Cat. 117.

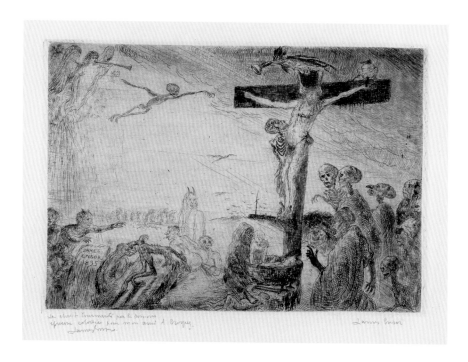

such as *Self-Portrait* (p. 123, fig. 122). In works like these, bodies are seen as weak, feminized, and restrained. Both in self-representations such as *Blossom of Pain* (p. 62, fig. 60) and in those of the dangerous women he depicted in *Madonna* (p. 83, fig. 82) and *The Mermaid* (p. 76, fig. 75), the figures are pinioned, entrapped by turns in the ground, by the bottom of the picture plane, or in the water, limited by their own inability to transform or escape. Even if they are powerful in sexual potency or creative force, they are immobile, cut off at the waist. At the same time, Munch was also producing many images of bathers—males and females, adults and children. Like his images of crucifixion and rebirth, these pictures were often concentrated around the moment when Munch was at his most physically and emotionally unstable, desperate for health yet unable to attain it.

Among his first full-scale explorations of the nude male body outdoors was *Bathing Boys* [185]. Created in 1894—the same moment as the more sensual, disturbing *Ashes* and *Vampire*, which show men being devoured or destroyed by women—*Bathing Boys* appears as a breath of fresh air. Munch places one boy in the position of the viewer, showing him from behind as he interacts with his cohorts, who swim partly

above and partly below the water's surface. Their bodies appear to stretch and change shape under water, revealing both the artist's fascination with the science of vision and his debt to Symbolist imagery, in which questions of the unknown and unknowable became a focus of investigation. In both France and Germany, countless scientific journals and illustrated books were being published to feed the public's insatiable desire to see what had heretofore been invisible. One such publication was the German zoologist Ernst Haeckel's *Art Forms in Nature* (1899–1904), which investigated and celebrated Darwin's theories, and which shows the morphology of creatures such as the frog from tadpole to adulthood [see **184**]. As mentioned in chapter two, Symbolist artists such as Odilon Redon were intent on mining the latest images of underwater, celestial, and microscopic phenomena for their own work, possibly using popular journals like *La Nature* as visual sources.[17]

Earlier, Munch had addressed the question of the seen and the unseen, the real and the surreal in his painting *Vision* [**186**], in which a bohemian artist's head—perhaps his own—floats menacingly on the surface of the water. As Munch described the image, "I lay in the mud among vermin and slime, I longed for the surface. I lifted my head above the water. Then I saw the swan—its shining whiteness."[18] In *Boys Bathing*, however, the figures seem to frolic in the water easily, embodying a childlike purity that presents a radical alternative to *Puberty* (p. 86, fig. 87) of the same year, in which a girl of about the same age is held captive by fear of her own body.

This scene of outdoor fun is also, like *Vision*, slightly disquieting. The boy in the foreground, for instance, does not stand on the wooden platform but in some other space slightly under it. This gives both his body and the entire canvas a sense of instability. The amorphous green and red forms at lower right and left add an element of the unknown: are these animals, plants, or people lurking below the surface? The fact that the front-facing boys are faceless is similarly unsettling. It has been suggested that such visual dislocations relate to contemporary discourse around Darwin's theories and that the boys in water appear to symbolize a regression to an earlier life form.[19] Indeed, evolution was a focus of attention in the 1890s, and an issue that Munch clearly grappled with as he pursued his own interest in metamorphoses both

184 *Hyla. Batrachia. Frogs.*, plate 68 of Ernst Haeckel, *Art Forms in Nature* (Verlag des Bibliographischen Instituts, 1899–1904).

185 **EDVARD MUNCH** *Bathing Boys*, 1894. Oil on canvas; 92 × 150 cm (38 1/3 × 60 1/4 in.). The National Museum of Art, Architecture and Design, Oslo, NG.M.01866. Cat. 21.

186 **EDVARD MUNCH** *Vision*, 1892. Oil on canvas; 72 × 45 cm (28 3/8 × 17 3/4 in.). Munch Museum, Oslo, OKK M114.

187 **EDVARD MUNCH** *Bathing Women*, 1894. Pastel on canvas; 80 × 83 cm (31 1/2 × 32 5/8 in.). Private collection.

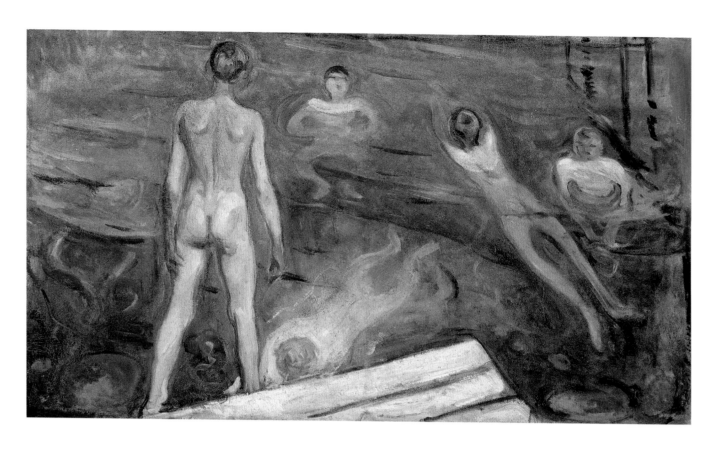

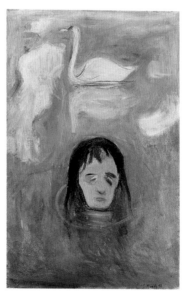

bodily and spiritual. Connected to these investigations were developments in the study of adolescence, as both male and female sexuality became an area of scientific and cultural inquiry.[20] In light of these overlapping discourses, we can understand *Boys Bathing* as exploring liminal states of being, as the swimmers appear to change into tadpoles even as we know they are becoming men.

Munch's luminous pastel *Bathing Women* [187], created the same year, uses the bathing motif to explore the similarities and differences between men and women, adolescents and adults. Here, two grown women stand on a rocky, ill-defined precipice; one either prepares to dive into the water or has just emerged from it, observed by her companion. Below, two youngsters—visual quotations from *Bathing Boys*—wait for her as well. Munch describes the boys as freely enjoying their nudity and mobility in the water, while the earthbound women

are far more tentative. Meanwhile, a top-hatted man at the far upper left takes in their naked forms. Social mores permitted men to bathe nude in their own company but forbade both mixed-sex swimming and any nude bathing by women. Apart from the unobserved voyeur, however, Munch seems to suggest none of the sexual friction that such prohibitions anticipated, and the bodies of the women and the boys are similarly sinuous and feminine.

Munch addressed the theme again in *Boys Bathing* [188], which he executed in a burnished color aquatint. This was a medium that he used—with the sole exception of this print—for images of women, which included *Young Woman on the Beach* (p. 143, fig. 152), *Nude Standing in an Interior, Reclining Nude,* and *On the Waves of Love,* all from 1896.[21] It is unsurprising that the one male-dominated image in this group depicts the androgynous bodies of young male bathers. Like the earlier painting, to which it relates, the aquatint focuses the viewer's attention on two divergent parts of the composition: the aquatic movements of the bathers and the backs of the three boys who observe them. The underwater portions of the swimming boys are printed in green, emphasizing their attenuated forms. Their pale, slight bodies again suggest their youthful immaturity and add a sense of vulnerability to the image. One boy, draped in a dark orange bathing gown, serves to reinforce the nakedness of the others.

In images such as these, Munch was at once responding to and transforming a motif that was common in Norwegian and German art of his day. Hans Heyerdahl and Max Liebermann's large canvases, both entitled *Bathing Boys,* celebrated the popular pastime, focusing on their subjects' connection to the land and sea while also acknowledging their nudity in different ways. Heyerdahl's monumental work [189] represents a group of lads in the vicinity of his summer home, which was located, like Munch's, in Åsgårdstrand. Here, the four figures do not interact, but instead exist in their own separate realms. When read from right to left, the composition suggests the passage of time from a clothed, seated youth to one who stands, dives, and finally swims. The standing boy dominates the canvas; although his sense of modesty is palpable as he covers his genitals and casts his eyes downward, his pose is a direct quotation of Michelangelo's proud *David* (1501–04; Accademia, Florence), which Heyerdahl had seen a few years

188

188 **EDVARD MUNCH**. *Boys Bathing,* 1896. Burnished aquatint in blue-green, yellow-green, dark orange, brown-gray, and brown, inked à la poupée, on buff laid Arches paper; plate: 29.7 × 23.6 cm (11 3/4 × 9 1/4 in.); sheet: 44.8 × 31 cm (17 5/8 × 12 1/4 in.). The Art Institute of Chicago, gift of the Print and Drawing Club, 1947.22. Cat. 47.

189 **HANS HEYERDAHL** *Bathing Boys,* 1887. Oil on canvas; 140 × 132 cm (55 1/8 × 52 in.). Drammens Museum, DFG 136. Cat. 113.

190 **MAX LIEBERMANN** (German, 1847–1935). *Bathing Boys,* 1900. Oil on canvas; 113 × 152 cm (44 1/2 × 59 7/8 in.). Stiftung Stadtmuseum, Berlin, GEM 92/14. Cat. 124.

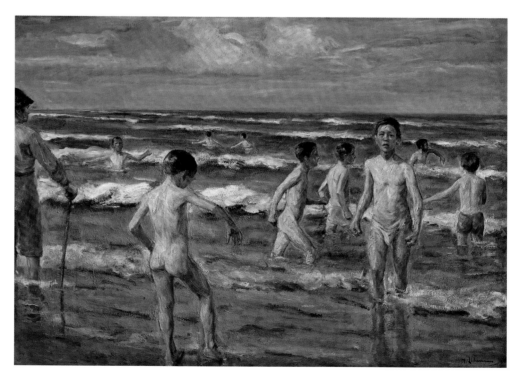

earlier.[22] Liebermann's canvas [190], a similarly celebratory depiction of swimming youths, is set on the beaches of Scheveningen in Holland. In this spacious environment, the artist represents a group of bathing boys and men in various stages of entering and leaving the water.[23] One boy faces the viewer clad in a bathing suit, exemplifying the German obscenity laws that forbade the depiction of full frontal male nudity.[24] The man who watches from the left serves as a reminder of the old age that will come soon enough.

Whereas Heyerdahl's and Liebermann's canvases depict the pleasures of the open air, Munch's are claustrophobic despite their ostensibly outdoor settings, in many ways akin to the repressive, enclosing spaces of his *Vampire* and *Madonna*. In *Bathing Boys* and *Boys Bathing*, Munch presented his subjects' androgynous forms against abstracted landscapes, focusing on the oddities of their bodily transformations in and against water. Despite their apparent differences, the liquid, liminal forms of the prepubescent boys and the pinioned bodies of the sexualized men and women are ideologically similar.[25] All are in a situation, whether psychic or physiological, that is seemingly controlled by forces outside of themselves.

In 1899, at around the moment that Munch first took the cure at Norwegian spas, he created his first images of adult male bathers, works that inaugurated a decade of canvases populated by virile men on the shore, resting or performing vigorous exercise. Such pictures were a direct result of both his current distresses and his strong desire for renewed well-being. The artist's alcoholism and poor health had caused him emotional and physical problems throughout the decade; by this time, they had reached a crisis point. In his frequent correspondence with the collector and scholar Gustav Schiefler, who authored the first catalogue raisonné of his prints, Munch discussed his drinking and its relationship to his work. Writing from his summer home at Åsgårdstrand in 1905, he explained: "For a long while I have been overly nervous—and this winter—as you probably noticed—more than before—there was too much travel and exhibitions [to organize]—and I cannot deny that I became filled with self-persecution mania—I do all I can so that the attacks do not hinder my work—but—at every opportunity—I drink to animate ... then I have a tremendous desire to work, and am full of ideas ... [but] my emotions

oscillate from the highest strength to the deepest depression."[26] He then went on to say that fresh air helped to calm him, but the anxiety returned; "In any case," he remarked, "I will now very methodically try to find the help of a doctor to cure me."[25]

The same summer, he wrote again about his continued desire to find relief from his anxieties and alcoholism: "I once went to a cure house and the same destruction of spirit repeated itself.... When I live quietly here [in Åsgårdstrand] and bathe regularly, I am okay."[27] By this point, however, he had been seeking the therapeutic effects of outdoor bathing and spa visits on and off for more than five years. Munch's stays had ranged from weeks to months and, despite their duration, as he himself revealed, he inevitably returned to his life of excessive drinking, relentless traveling, and increased paranoia. This extended "nerve crisis," as he called it, precipitated both images of persecution but also intermittent representations of the healthy, muscled male body. These robust figures reflected the influence of the contemporary movement known as *Freikörperkultur*, which celebrated the physical and spiritual renewal possible in nudism, bathing, and soaking up the sun. Although its political background ranged from the avant-garde to the virulently anti-urban and tacitly anti-Semitic, there was a growing sense that this return to nature and physical health would have a regenerative effect on the human spirit. The contemporary nudist movement in Germany precipitated many such celebratory images such as Hugo Höppener's famous *Hymn to Light*, which depicted a virile nude male reaching toward the sun.[28]

Bathing was promoted as a way to stay physically fit, and as a potential cure for weak lungs and poor nerves, from which Munch perennially suffered. Prior to the 1890s, spas were considered mere leisure spots, but their medicinal focus strengthened beginning in the last decade of the century, with the advent of private sanatoria focused on alcoholism, neurasthenia, and tuberculosis.[29] Two of Munch's woodcuts from 1899 exemplify current attitudes toward the positive effect of outdoor exercise on the male body. *Boys Bathing* [191], for instance, depicts a muscular man standing on the shore of a lake or pond, observing boys swimming. The artist used his jigsaw method to separate the realm of the strong, determined man, printed in yellow over blue, from the blue-green, watery realm of the boys. The figure on the shore seems to look out-

191 **EDVARD MUNCH** *Boys Bathing*, 1899. Woodcut printed from two blocks (one sawn into two sections) in blue, green, and light orange ink on cream card; image: 38 × 44.8 cm (15 × 17 5/8 in.); sheet: 46.5 × 60.1 cm (18 1/4 × 23 5/8 in.). The Art Institute of Chicago, Clarence Buckingham Collection, 1963.296. Cat. 69.

192 **EDVARD MUNCH** *Man Bathing*, 1899. Woodcut printed from two blocks in blue, green, and orange ink on grayish ivory card; image: 44.4 × 44.4 cm (17 1/2 × 17 1/2 in.); sheet: 48.7 × 66.2 cm (19 1/8 × 26 1/8 in.). The Art Institute of Chicago, Clarence Buckingham Collection, 1963.295. Cat. 70.

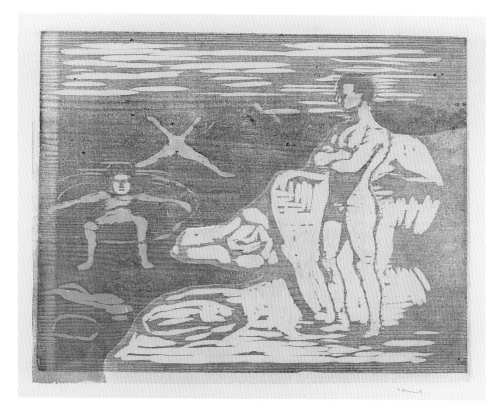

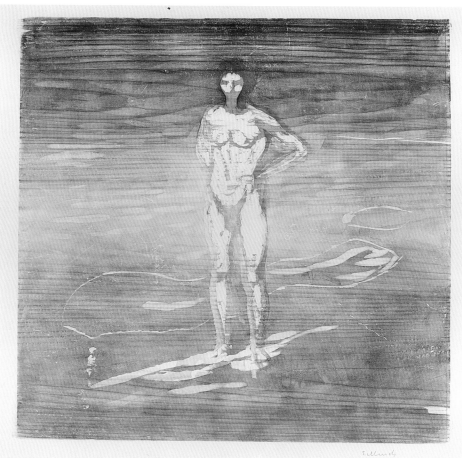

ward, as if contemplating a view suffused by the sun's golden rays. Similarly, the figure in *Man Bathing* [192] is chromatically connected to the water that surrounds him. Here, the grain of the woodblock acts as a compositional element, doubling as water. The inking is subtle and layered: Munch used one block for the background and another for the figure, which he printed in an earthy orange on top of ethereal shades of blue, green, and purple. The man stands fully nude, arms on his hips, exuding an air of relaxation and strength. Unlike the androgynous boys, who seem to shift shape underwater, these virile men exude power and stability.

The increased popularity of images such as these—and of the new bathing culture itself—was part and parcel of contemporary debates surrounding gender roles. These were attracting significant attention in Germany and Norway, where Munch spent most of his time between 1899 and 1908. Fanning the flames were publications such as Otto Weininger's strident, pseudoscientific *Sex and Character* (1903), which outlined stark intellectual, physical, and social differences between men and women. Weininger's deeply misogynist and anti-Semitic tone remained influential to the burgeoning literature on race and gender in fin-de-siècle Germany and Austria. This manifesto, as Weininger stated in his introduction, referred to the contrast between man as moral and strong and woman as evil and passive. This dichotomy was then extended to race: Jews were equated with femininity and Aryans with masculinity. Weininger's text was extreme to be sure, but its vast popularity suggests that it gave voice to many readers' anxieties.[30] As nervousness increased about modern women who worked, rode bicycles, smoked cigarettes, and openly pursued men and other women sexually, fears arose not only about women's emancipation but also about a perceived crisis of masculinity.[31]

Two caricatures that appeared in the German popular satirical journals *Jugend* and *Simplicissimus* around 1900 show how some of these fears about gender manifested themselves, albeit humorously.[32] One, entitled *The Third Sex* [193], depicts a group of modern women seated around a table. The conversation flows as follows: "What are you currently writing, Miss Lilienstiel?"—"A novel"—"What is it called?"—"*Messalina*"—"Historical then?"—"No, hysterical."[33] Three of the women represented are excessively masculine, with unattractive, mannish

193 OTOLIA KRASZEWSKA (Polish, 1859–1938). *The Third Sex.* Published in *Jugend* 31 (1900), p. 525. Ryerson Library, Art Institute of Chicago.

194 FERDINAND VON REZNICEK (Austrian, 1868–1909). *The Backfisch.* Published in *Simplicissimus* 4 (1899/1900), p. 36.

195 EDVARD MUNCH *Bathing Young Men*, 1904. Oil on canvas; 194 × 290 cm (76 3/8 × 114 1/8 in.). Munch Museum, Oslo, MMM 901. Cat. 83.

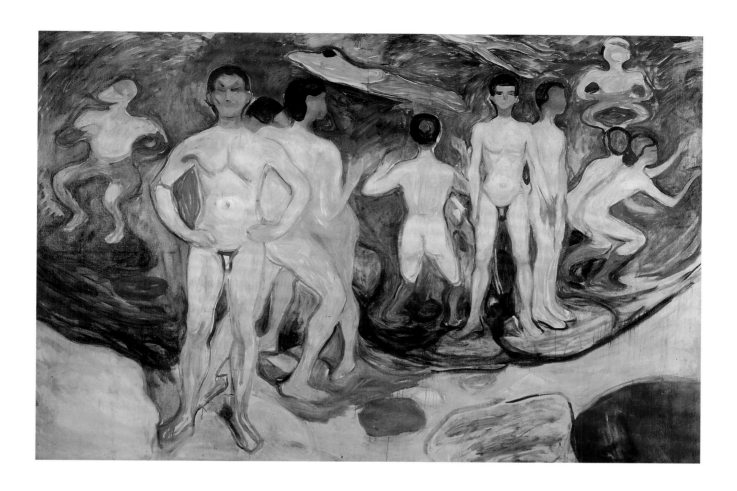

faces and thin, desexualized bodies. A fourth woman, overtly sensual and voluptuous, sits smoking a cigarette, which was then perceived as an act of defiance and immorality; a fifth looks on with a blank stare. The term *third sex*, which originated in contemporary scientific parlance, was used to denote women whose appearance was explicitly masculine, including lesbians, feminists, and creative women whose hysterical thoughts and independent careers lured them away from hearth and home. Another related image [194] voices concerns about male effeminacy, foretelling the disastrous effects on society if these erosions of traditional gender roles continued unchecked. In this caricature by Ferdinand von Reznicek, we see an effeminate, presumably intellectual man smoking a cigarette. He stares rather disinterestedly at an attractive young woman who appears to swoon over his genius.

It is in light of these broad cultural worries about sexuality and masculinity that we must consider both Munch's experience and his art. From his alcoholism to his chronic lung condition, from his aversion to marriage to his fear of being physically and emotionally enveloped by women, he had been cast—and had cast himself—as vulnerable. Paintings such as *Vampire* (p. 82, fig. 81) and *Ashes* (p. 100, fig. 100) depict women as destructive victors and men as weak vic-

tims. Although the bathing boy pictures do not display this dynamic, they clearly invest their subjects with childlike vulnerability rather than manly authority. For the artist, to embrace the idea of *Freikörperkultur*, of natural and physical strength, was to embrace the potential that he might be able to regain his masculine power, that he might move away from victimization and toward restoration.

His monumental painting *Bathing Young Men* [195], the largest he had undertaken thus far, argues for his ambition on this front.[34] Here, the eight nude men and boys who stand in the foreground serve as an encyclopedia of movement, swimming, standing, walking, stooping, and diving. These Muybridge-like transformations are perhaps not coincidental, since it was at this moment that Munch took up photography seriously, even using his own nude body as a subject.[35] In the canvas, the figures' awkward, static postures seem contrived, posed but nonetheless powerful. They are differentiated by their activity, not by physiognomy, and all but three of their faces go undescribed.[36] The semicircular shape of the rocky shore serves to give the composition a staged appearance, as if the subjects are performing for an audience. The flattened, curvilinear space and bodily distortions, when combined with the open brushwork and dripping veils of matte paint, create the almost otherworldly impression that time has stood still.

The stilted poses of these men are belied, however, by the great energy that Munch evidently put into his own outdoor activities. His friend Christian Gierloff, possibly one of the bathers depicted here, reminisced about their bathing excursions during the summer of 1904 in Åsgårdstrand, where Munch created this canvas: "The sun baked us all day and we let it do so. Munch worked a little on a painting of bathers, but for most of the day, we lay, overcome by the sun, in the sand by the water's edge, between large boulders, and we let our bodies drink in all of the sun they could. No one asked for a bathing suit; the only thing that lay between us was July's warm breezes ... toward the evening the spell [broke] ... we awakened from our summer day's torpor."[37] Gierloff described a sense of camaraderie between Munch and his friends, who gathered to celebrate the beauty of the outdoors and the rejuvenating activity of bathing in the sun. Like Paul Cézanne's arcadian image *The Bathers* [197]—and perhaps

196

196 EDVARD MUNCH. *Portrait of the Linde Sons*, 1903. Oil on canvas; 144 × 179 cm (56 1/2 × 70 1/2 in.). Museum Behnhaus, Lübeck.

197 PAUL CÉZANNE (French, 1839–1906). *The Bathers*, 1896/98. Lithograph printed from seven stones in black, blue, pale gray, green, yellow, beige, orange, and pink ink on ivory laid paper; image: 42.2 × 52.8 cm (16 5/8 × 20 3/4 in.); sheet: 46.4 × 56.9 cm (18 1/4 × 22 3/8 in.). The Art Institute of Chicago, William McCallin McKee Memorial Fund, 1932.1297. Cat. 95.

198 PAUL CÉZANNE. *Bather, Seen from the Back*, 1879/82. Oil on canvas; 31.7 × 21.6 cm (12 1/2 × 8 1/2 in.). The Art Institute of Chicago, Brooks McCormick Estate, 2007.289. Cat. 94.

199 EDVARD MUNCH *Bathing Boys*, 1904/05. Oil on canvas; 57.4 × 68.5 cm (22 5/8 × 27 in.). Private collection. Cat. 84.

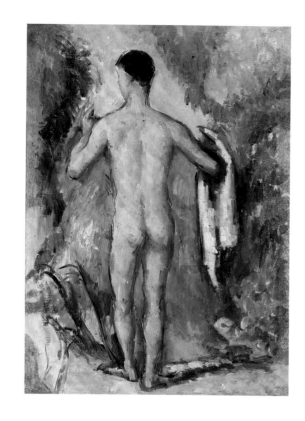

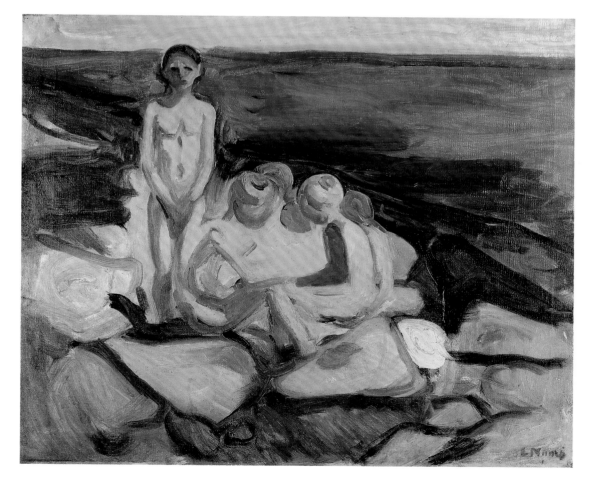

Bather, Seen from the Back [198], which may have been cut from a larger composition—*Bathing Young Men* depicts a safe, idyllic space of homosocial physical activity.[38]

Around the same time Munch created *Bathing Young Men*, he made the smaller panel picture *Bathing Boys* [199], formerly known as *The Lonely One*. One of three variations on a theme that he had taken up ten years earlier, this is by far the most naturalistic in color and emotive in feel. In this investigation of boyhood, four lads huddle together in a group amid the rocks of what is likely the Åsgårdstrand shore. To the side stands a shy boy who shields himself protectively as he stares out at the viewer. While his friends' bodies are one with the land, his stretches upward toward the sea and sky, perhaps reflecting a new awareness of his sexuality and the world outside of boyhood thoughts. Here, Munch's eye for his figures' tentative gestures is strikingly different than the stylized boldness of *Bathing Young Men*. Indeed, the artist had just completed a commissioned painting of his patron Max Linde's four young sons [196], and his work had brought him into increased contact with children, whose psychology he investigated frequently in the following years. In fact, Munch had become very sought after as a portraitist of both adults and children, and in 1904 the Berlin dealer Paul Cassirer mounted an exhibition of these works.

Directly connected to Munch's deteriorating physical and mental health and his desire for regeneration were his ambitions in the marketplace and on the exhibition circuit. Between 1900 and 1908 he traveled incessantly—one could even say obsessively—organizing over fifty-five solo and group exhibitions of his work throughout Europe, and carrying on voluminous correspondence to encourage and secure additional displays and seek increased income. As interest in his work reached its peak, the artist began to negotiate with two dealers— Bruno Cassirer in Berlin for his graphic works and Commeter in Hamburg for his paintings—to handle his sales in Germany, where the majority of his market was concentrated. His patron Linde had suggested that these arrangements would be best for Munch, relieving him of financial concerns and perhaps freeing up more of his time to work. Many drafts of the 1904 contracts with Cassirer were drawn up, with advice and corrections from Linde, Schiefler, and others, showing the trepidation with which Munch relinquished control over

his sales, and his friends' concern that he not be taken advantage of.[39] After three years, Munch began the difficult process of extricating himself from the contract when it expired in 1907; the following year, he wrote with relief to the publisher Reinhold Piper, "I am free of Bruno Cassirer."[40]

Amid this time of emotional and professional upheaval, Munch did, as he expressed to Schiefler, experience moments of quiet in his longtime sanctuary at Åsgårdstrand. It was likely in this setting that he represented himself in the large-scale woodcut *Self-Portrait in Moonlight* [200], a reconsideration of his earlier *Moonlight* (1893; National Museum of Art, Architecture, and Design, Oslo). In this image, the artist placed himself in front of a similar window and wood-slatted house, where he is surrounded by his signature halo-shadow. Unlike the slightly unnerving female subject in his printed version of the painting, *Moonlight I* (p. 145, fig. 155), Munch appears well-dressed, confident, upright, and imposing. The artist printed this work himself, selectively and imperfectly inking his body in stark black while allowing the rest of the sheet to shimmer with the blue color of evening. Perhaps another attempt to replace a dangerous woman with a healthy man, this image projects a strong sense of self-assuredness and virility that was markedly different from Munch's public image and his current mental and physical state. The landscape of Åsgårdstrand itself also became a focus of Munch's more positive artistic vision. In *Trees and Garden Wall in Åsgårdstrand* (p. 72, fig. 70), the artist returned yet again to the setting of his earlier, mysterious *Starry Night* (p. 71, fig. 68), approaching the motif in a markedly different way. Instead of depicting a scene of anticipation and foreboding from above, he offered a daytime view that shows the wall and large linden trees of the Kiøsterud property straight on. With its curving pink pathway, this brightly colored, almost Fauvist image invites us to take a stroll, to view the landscape as an old friend.

Munch's emotional stability dramatically fluctuated between 1907 and 1909, as it had for many years, and he again sought relief in spas and nature retreats such as Warnemünde, a summer resort village on the Baltic coast [see 201 and p. 218]. It was here, in his German Åsgårdstrand, that the artist created the enormous *Manhood, Bathing Men* [202], which later became the central panel of a triptych that featured smaller rectangular

200 EDVARD MUNCH *Self-Portrait in Moonlight*, 1904/06. Woodcut printed from one block in blue and black ink on cream wove paper; image: 75.4 × 42.3 cm (29 5/8 × 16 5/8 in.); sheet: 80 × 57.1 cm (31 1/2 × 22 1/2 in.). The Art Institute of Chicago, Clarence Buckingham Collection, 1963.290. Cat. 85.

201 Munch pauses while painting *Manhood, Bathing Men* (fig. 202) on the beach at Warnemünde, 1907. Munch Museum, Oslo.

202 EDVARD MUNCH *Manhood, Bathing Men*, 1907–08. Oil on canvas; 206 × 227 cm (81 1/8 × 29 3/8 in.). Ateneum Art Museum, Helsinki.

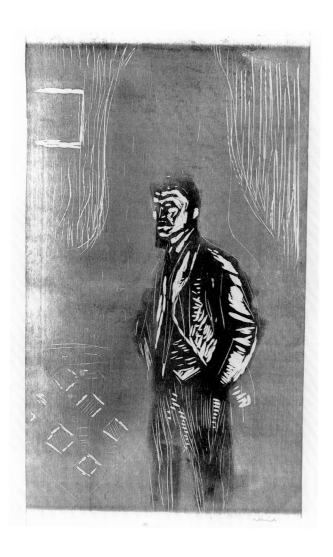

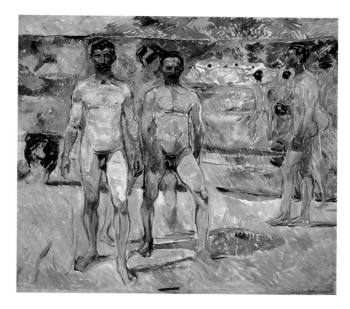

panels of bathing boys and an older man. While vaguely depicting frolicking swimmers in the background, Munch focused instead on the two men who stride defiantly toward the viewer and on another who moves in from the right; their tanned faces and arms suggest the outdoor activities that have shaped their strongly muscled bodies. Munch divided the landscape into distinct, horizontal bands, positioning the men as vertical contrasts and activating the water and sky with criss-crossing strokes. As letters from Schiefler reveal, the unvarnished nudity in this canvas and *Bathing Young Men* led the Salon Clematis, a Hamburg art gallery, to refuse to exhibit the latter work for fear of police recrimination; instead, the painting remained unviewed in the dealer's basement.[41]

Munch returned to Warnemünde in the summer of 1908, but this time his stay and the months that followed were far less auspicious and healthful. By September, he was drinking morning and night, and the resulting dementia, hallucinations, and paralysis finally drove him to Dr. Daniel Jacobson's well-known clinic in Copenhagen. The artist later wrote of this decisive and self-destructive period:

I can remember the days before I was admitted to the clinic in Copenhagen, the way I senselessly poured wine and cognac down my throat and smoked the strongest cigars. . . . I remember one particular moment . . . just before the poison reached a critical point in my brain—a cell whose destruction could bring about my death. And I remember being aware of this, and wanting to hinder it from happening. A couple of days later I was struck down by an attack which brought me close to death.[42]

Munch's health returned over the following eight months, once he stopped drinking and received the rest and medical attention he needed. While at the clinic, Jacobson encouraged him to continue his creative efforts, and he even made a powerful, full-length portrait of the renowned psychiatrist.[43] However, this quietude and return to health did not expunge from his work the tortured self-representations of the previous decade. Here, he created a powerful series of transfer lithographs chronicling the tale of Alpha and his love Omega, or, as he earlier referred to them, "the first human beings."[44] True to form, the destructive Omega begins sexual adventures with many of the animals in paradise; Alpha kills his wife for her indiscretion; and her grotesque, half-animal, half-human progeny murder him. In *Alpha's Despair* [203], a direct quotation from *The Scream*, the man cries out in desperation and anger.[45] As this portfolio suggests, in a very public sense, Munch's "emotional breakdown" only served to intensify his mythic reputation for self-destruction and fuel the ever-increasing market for his work. It remains unclear, however, what exactly brought on Munch's collapse—whether it was the end of a long descent into madness or primarily a physiological consequence of his alcoholism. However, he responded to his situation like the good businessman he was, orchestrating many exhibitions while staying in the clinic under Jacobson's care, remaining productive and savvy at exactly the moment when we might expect him to have

203

203 EDVARD MUNCH *Alpha's Despair*, from *Alpha and Omega*, 1908/09. Transfer lithograph with crayon in black ink on heavyweight buff wove paper; image: 41.9 × 34 cm (16 1/2 × 13 3/8 in.); sheet: 65.1 × 48.1 cm (25 5/8 × 18 15/16 in.). The Art Institute of Chicago, Clarence Buckingham Collection, 1963.354.

unraveled. Ironically, the same year he was admitted, the artist received the coveted Royal Order of Saint Olav, which was awarded by the king of Norway. This honor served to legitimate his artistic practice, underscoring his phoenixlike recovery from his own physical and emotional conflagration.

IV. Epilogue

Until the publication of revisionist histories of Munch's later work over the past two decades, the standard narrative held that there was an angst-ridden, "before" Munch who experienced a nervous breakdown and recuperated at Jacobson's clinic, and an "after" Munch, who sobered up and retreated to an isolated existence in the country, producing serene landscapes and pouring his energies into monumental projects to celebrate the Norwegian nation.[46] As we have seen repeatedly, these mythic constructions are often overly simplified, and fail to capture the complexity of reality. After leaving Jacobson's care, Munch did indeed slow his frenetic travel schedule, curtail his excessive alcohol consumption, dedicate increased energy to nationally oriented projects, and take up residence at a series of bucolic estates on the outskirts of Kristiania. But this did not mean that his works were devoid of the grim themes or nervous, expressive energy that had become his hallmarks. The "post-breakdown" Munch was equally complex, and by no means isolated from society or unaware of continental trends such as Fauvism and Expressionism. His imagery did shift toward the increased production of landscapes, but disturbing canvases such as *The Murderer* [204] suggest a continued fascination with the psychology of violence and irrationality. As well, the artist came to focus more intently on themes of workers and labor, pursuing a more self-conscious engagement with social issues. While he took up these new themes, however, the earlier ones were still very much a part of his artistic and emotional repertoire, and Munch revisited images such as *Jealousy*, *Vampire*, and *Starry Night*, placing them in new settings, adopting a freer, more abstracted painting style and a brighter range of hues. Now that he had gained critical acclaim, it seems that Munch was interested in positioning himself differently, but with the same zeal we have come to expect.

Among the projects that occupied Munch most intently during the years immediately after 1909 was the competition to decorate the University of Kristiania's Aula, or festival hall, with monumental canvases. Following a lengthy, heated debate in the popular press, Munch won the competition, creating three large-scale and eight smaller canvases replete with allegories of fertility, motherhood, and Norwegian history and folklore.[47] The focal point of the murals—and indeed of the hall itself—was *Sun* [205]. In this powerful work, radiating beams explode over the water and rocky landscape, sparkling in bright blues, greens, reds, and yellows that reach to the outer edges of the canvas and, one senses, the world. As we have seen, Munch represented the transformative effects of hydrotherapy in his bather pictures, and that transcendental approach extends to this electrifying image. In the medical and scientific discourse of the day, heliotherapy was considered an effective treatment, particularly for the degenerative symptoms of mental illness, neurasthenia, and tuberculosis. Hand in hand was the lifestyle reform movement known as Vitalism, in which figures ranging from the scientist Ernst Haeckel to the philosopher Friedrich Nietzsche promoted the Dionysian, curative, and near-religious properties of the sun as a vital link in the evolutionary chain of social and corporeal health.[48]

At the same moment he was creating his Aula paintings and gaining increased acceptance at home, Munch continued to receive accolades and honors in Germany. The pinnacle of this reception was the 1912 Sonderbund exhibition in Cologne. Both the organizers of the display and the critics who responded to it effectively positioned Munch as the spiritual and aesthetic founder of German Expressionism. Presented alongside Cézanne, Gauguin, and Van Gogh as one of the most powerful non-German influences on contemporary art, Munch was transformed from a dangerous, mentally ill influence on German culture into a celebrated art-world star. The exhibition's curator, Richard Reiche, wrote to Munch inviting him to participate, explaining that his overarching aim was to show a developmental history of Expressionism and its triumph over Impressionism.[49] Separated entirely from those of his Norwegian contemporaries, Munch's works were placed deliberately amid the Expressionists', as if to emphasize the power of his example. The images that the artist suggested for inclusion were themselves revealing, as he carefully excluded works of existential angst and personal anguish such as *The Scream*

204 EDVARD MUNCH *The Murderer*, 1910. Oil on canvas; 94.5 × 154 cm (37 1/4 × 60 5/8 in.). Munch Museum, Oslo.

205 EDVARD MUNCH. *Sun,* 1912. Oil on canvas; 123 × 176.5 cm (48 3/8 × 69 1/2 in.). Munch Museum, Oslo, MMM 822. Cat. 86.

or *Death in the Sickroom* (p. 105, fig. 104). Those had become staples of his painted repertoire—signature, iconic works that were included in nearly all of his major shows since 1893. But it was not the tormented, anxious self that Munch primarily chose to portray in the Sonderbund. Instead, his intention was to transform himself into the respected, moderate father figure of contemporary German art by displaying bathers, landscapes, portraits, and pictures of workers that connected him to Expressionism both visually and textually.

Chromatic vibrancy, near abstract mark making, and flat surface pattern were hallmarks of Fauvist and Expressionist style. Munch no doubt chose to display certain works at this venue precisely because they made him seem relevant to his European contemporaries. Ferdinand Schmidt, a critic writing for the art journal *Zeitschrift für bildende Kunst*, reversed two decades of harsh criticism, arguing, "While not all the works are perfect, the good ones already appear classic to us, and it is difficult to understand why people only a few years ago laughed at it."[50]

There is no question that Munch influenced the German Expressionists. In frequent letters to Munch, Karl Schmidt-Rottluff, one of the founders of Die Brücke, beseeched him to send examples of his woodcuts or paintings to the group's annual exhibitions.[51] Erich Heckel's *Two Seated Women* [206] displays a debt to Munch in both its subject matter—a celebration of nudity in nature—and in its raw, jagged cutting and inking of the block.[52] And yet it can be argued that inspiration flowed in the other direction as well. For example, Munch's powerful color woodcut *Sunbathing I* [207] exemplifies a chromatic and stylistic shift that seems to have been inspired by Heckel's work. Here, the gouges are more angular, agitated, and multidirectional, and the hues more vibrant and rich than his more subdued *Man Bathing* of 1899 (p. 173, fig. 192). The rather masculine woman bather rests on the shore, taking in the rays of the sun.

As we have seen, the consistent ambivalence in Munch's art surrounding health and illness, masculinity and femininity, and moral regeneration and decay were particularly visible in the turbulent period just before and after the turn of the twentieth century. What these works show us, in fact, is that there exists no "healthy" or "unhealthy" Munch. Indeed, there never did: from the beginning, these two extremes inhabited the same mind and body, and the artist performed them in a very public way through his art and exhibition strategies. By presenting himself simultaneously as a sensual man who dances with his lover; a persecuted, Christlike figure hanging on the cross; a sinuous bather; and finally a screaming Alpha forsaken by his Omega, Munch literally and symbolically transformed himself into a motif that registered the intense, shifting nature of his own experience.

Edvard Munch constructed his identity and his art in ways that were both careful and confounding. His work and his persona play with and ultimately collapse the binaries of desire and disgust, native and foreign, sacred and profane. This is one reason that, for many decades, it has been easier to see the artist as the caricature he has become: a human version of the tormented figure in *The Scream*, perpetually in the midst of an emotional and existential crisis. But what gets lost in that presentation, and what I have tried to reintroduce here, is the ambivalence and complexity of his life and work, and of the larger culture that produced and surrounded him. This complexity was not only a part of the artist's psyche; he externalized it in his images, exhibitions, and self-representations both written and visual. It was perceived by the contemporary critics who reacted to him, and in turn influenced the way he saw himself. Together, they collaborated in creating the mythic figure that Munch "became" early on in his career, the one we have come to know. To recover yet other Munchs—the attentive nephew, the ambitious and savvy marketer, the technically adventurous printmaker, the lover of sun and sea—is to reveal the artist and his work as more slippery, more engaging, and, in the end, more richly challenging.

206 ERICH HECKEL (German, 1883–1970). *Two Seated Women*, 1912. Woodcut in black ink over monotype in green-blue, yellow, and pink opaque watercolor on heavyweight mottled gray wove paper; image: 29.5 × 29.4 cm (11 5/8 × 11 5/8 in.); sheet: 39 × 43.4 cm (15 3/8 × 17 1/8 in.). The Art Institute of Chicago, anonymous gift, 1948.41. Cat. 112.

207 EDVARD MUNCH *Sunbathing I*, 1915. Woodcut printed from two blocks in pink, orange, red, yellow, yellow-green, blue, green, and brown ink on heavyweight cream wove paper; image: 35.1 × 57.4 cm (13 7/8 × 22 5/8 in.); sheet: 55.2 × 73.1 cm (21 3/4 × 28 3/4 in.). The Art Institute of Chicago, Clarence Buckingham Collection, 1963.309. Cat. 87.

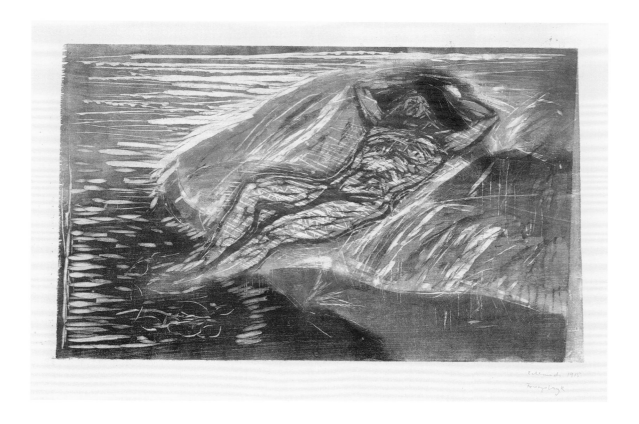

NOTES

The sections in this chapter on bathers and in the epilogue regarding *Sun* are indebted to the scholarship of Patricia Berman, whose articles—particularly Berman 1993a and Berman 2006b—served to inspire the methodologies herein. I am grateful not only for the information she so generously shared but also for her thoughtful critique of this entire manuscript. Thanks also to Jenny Anger, who offered many valuable comments on this chapter.

1

As quoted in Tøjner 2001, p. 196.

2

Iris Muller-Wëstermann, "*The Dance of Life,*" in Eggum 2000, p. 78. The artist had already combined these motifs in *Woman* (1894; Rasmus Meyer Collection, Bergen).

3

Berman 1986, p. 192.

4

For more on the Zorn painting, see Rosemary Hoffman, "*Midsummer Dance,*" in Varnedoe 1982b, p. 234, cat. 94.

5

For instance, Munch wrote incessant letters to the British composer Frederick Delius asking about exhibition possibilities in France and England; see Smith 1983, pp. 71–89.

6

Torjusen 1978, pp. 188–90.

7

As quoted in ibid., p. 215. For images of this related series of drawings, illustrations for Baudelaire's *Flowers of Evil,* see Rapetti and Eggum 1991, p. 327. In his painting *Metabolism* (1898/99; Munch Museum), Munch also visualized the connections between love, death, and metamorphosis with the related motif of Adam and Eve at the Tree of Knowledge. The original painted-wood frames of the *Madonna* and *Metabolism* paintings, like those in the printed versions, echo the events unfolding inside.

8

See Berman 2006a and Cordulack 2002, pp. 94–100.

9

As quoted in Tøjner 2001, p. 104; for more on this motif, see Eggum 1978; Høifødt 2006; and Schiefler 1907, p. 84. This print relates to Munch's later, greatly expanded *Human Mountain* project; see the Munch Museum's extensive historical and conservation documentation on the painting and its related sketches at www.munch.museum.no/content.aspx?id=85.ct.

10

The latter reading was proposed by Jens Thiis, who once owned the painting; see Thiis 1933, p. 276. Curt Glaser also suggested that this white matter was melting snow; see Glaser 1917, p. 38.

11

As quoted in Berman 2006a, pp. 35–36. See also Bruteig 2005, pp. 30–35; and Høifødt 1988, pp. 54–55, in which the passage is dated and connected to this specific drawing.

12

For more on Munch and Larsen's relationship, see Heller 1984, pp. 166–73; and Berman and Van Nimmen 1997, pp. 164–66.

13

For more on this monumental painting, see Patricia G. Berman, *James Ensor: 'Christ's Entry into Brussels in 1889,'* Getty Museum Studies on Art (Getty Publications, 2002). It is unknown whether Munch could have seen Ensor's *Christ's Entry* by this time, but he may have been familiar with the etching made after it.

14

For more on Ensor and Munch, see Eggum 1980. On Darwin's impact on the visual arts, see Linda Nochlin and Martha Lucy, eds., *The Darwin Effect: Evolution and Nineteenth-Century Visual Culture, Nineteenth-Century Art Worldwide* 2, 2 (Spring 2003), www.19thc-artworldwide.org/spring_03/index.shtml.

15

Rapetti and Eggum 1991. Regarding the sociopolitical relevance of crowd imagery at this moment in European art, see Nancy Davenport, "*Christ aux Outrages* by Henri De Groux: Fin-de-Siècle Religion, Art Criticism, and the Sociology of the Crowd," *Religion and the Arts* 7, 3 (2003), pp. 275–98.

16

Another potential German model for Munch's representations of martyrdom was the Munich artist and Darwinophile Gabriel Max, whose *Christian Martyr on the Cross (Saint Julia)* (1865; State Hermitage Museum, St. Petersburg) was illustrated in Richard Muther, *Geschichte der Malerei im XIX. Jahrhundert* (1893), vol. 1, p. 431.

17

See Douglas W. Druick et al., *Odilon Redon: Prince of Dreams, 1840–1916,* exh. cat. (Art Institute of Chicago/Harry N. Abrams), pp. 146–49.

18

As quoted in Heller 1984, p. 92. For more on *Vision,* see Heller 1973b.

19

Robert Rosenblum, *Modern Painting and the Northern Romantic Tradition: Friedrich to Rothko* (Harper and Row, 1975), p. 114.

20

For more on these issues as they relate to Munch, see David Ehrenpreis, "The Figure of the Backfisch: Representing Puberty in Wilhelmine Germany," *Zeitschrift für Kunstgeschichte* 67 (2004), pp. 479–508.

21

For illustrations of these prints, see Woll 2001, pp. 76–82, cats. 47–48, 50.

22

Einar Wexelsen, "Hans Heyerdahl: Fra München og Paris til somre i Åsgård-strand," in *Hans Heyerdahl (1857–1913): Fra Paris til Åsgårdstrand,* exh. cat. (Haugar Vestfold Kunstmuseum, 2001), pp. 69–70.

23

For more on Liebermann's bathing pictures, see David Katz, "Max Liebermann: Living History, and the Cultivation of the Modern Elite" (Ph.D. diss, University of Minnesota, 1997), chap. 8. On the subject of male bathers in Germany at this time, see Barbara C. Buenger, "Beckmann's Beginnings: 'Junge Männer am Meer,'" *Pantheon* 41 (1983), pp. 134–44.

24

For more on these obscenity laws, known as the *lex Heinze,* see Benjamin Carter Hett, "'The Captain of Köpenick' and the Transformation of German Criminal Justice," *Central European History* 36, 1 (2003), pp. 8–11.

25

For more on German gender anxiety at this time, see Jenny Anger, *Paul Klee and the Decorative in Modern Art* (Cambridge University Press, 2004); and John C. Fout, "Sexual Politics in Wilhelmine Germany: The Male Gender Crisis, Moral Purity, and Homophobia," *Journal of the History of Sexuality* 2, 3 (1992), pp. 388–421.

26

Munch and Schiefler 1987, pp. 118–19. Regarding contemporary views on the curative effects of sea air and bathing, see E. Kruse, *Ueber Seeluft- und Seebadeküren bei Nerven-Krankheiten,* 8th ed. (D. Soltau, 1893). Theories about medicinal cures for alcoholism appeared in popular journals at this time as well; see Klaus Hanssen, "Alkoholisme: (En medicinsk samfundsbetragtning)," *Samtiden* 7 (1896), pp. 1–9.

27

Munch and Schiefler 1987, p. 121.

28

For more on the many drawings, paintings, and prints produced of this image by Hugo Höppener, see Kai Bucholz et al., *Die Lebensreform: Entwürfe zur Neugestaltung von Leben und Kunst um 1900,* exh. cat. (Häusser/Institut Mathildenhöhe, 2001), vol. 2, p. 575; and Jill Lloyd, *German Expressionism: Primitivism and Modernity* (Yale University Press, 1991), pp. 108–09. On issues of homosociality and male bathing, see Whitney Davis, "Erotic Revision in Thomas Eakins's Narratives of Male Nudity," *Art History* 17, 3 (1994), pp. 301–41.

29

Karl E. Wood, "Spa Culture and the Social History of Medicine in Germany" (Ph.D. diss., University of Illinois at Chicago, 2004), pp. 178–83.

30
Izenberg 2000, p. 11. For more on
Weininger, see Sander Gilman, *Smart
Jews: The Construction of the Image
of Jewish Superior Intelligence* (University
of Nebraska Press, 1996), pp. 123–27;
and idem, *The Jew's Body* (Routledge,
1991), pp. 133–38.

31
Izenberg 2000, pp. 1–19.

32
For more on the political bent of these
journals, especially *Kunst für Alle*, see
Lewis 2003. On women's emancipation
in Germany, see Ute Frevert, *Women in
German History: From Bourgeois Emanci-
pation to Sexual Liberation* (Berg, 1988).

33
As translated by Shulamith Behr in idem,
"Veiling Venus: Gender and Painterly
Abstraction in Early German Modern-
ism," in *Manifestations of Venus: Art and
Sexuality*, eds. Caroline Arscott and
Katie Scott (Manchester University Press,
2000), p. 130. For more on the term
third sex, see Brigitte Burns, "Das dritte
Geschlecht von Ernst Wolzogen,"
in Rudolf Herz and Brigitte Burns,
*Hof-Atelier Elvira, 1887– 1928: Ästheten,
Emanzen, Aristokraten* (München
Stadtmuseum, 1985), pp. 171–90.

34
Eggum, Woll, and Lande 1998, p. 65.

35
See Davis (note 28); and Eggum 1989.

36
My thanks to Petra Pettersen for her sug-
gestions when we viewed this work.

37
As quoted in Berman 2008a, p. 69. Arne
Eggum has suggested that *Bathing Men*
may have been created as an unfulfilled
commission for the Duke of Weimar;
see Eggum 1999, p. 39.

38
For more on these issues as they relate
to Cézanne, see Tamar Garb, "Cézanne's
Late Bathers: Modernism and Sexual
Difference," in idem, *Bodies of Modernity:
Figure and Flesh in Fin de Siècle France*
(Thames and Hudson, 1998), pp.
197–218.

39
Letters between Munch, Schiefler, and
Linde attest to the proposed changes in
the contract before it was signed; see
Munch and Schiefler 1987, pp. 73–96,
passim. Schiefler's suggested changes
are listed in Appendix I, pp. 485–88.

40
Edvard Munch to Reinhold Piper, Mar. 23,
1908; as quoted in Woll 2001, p. 18.

41
Munch and Schiefler 1987, pp. 260–61.

42
As quoted in Tøjner 2001, p. 69.

43
For one such portrait, see Prelinger 2001,
p. 31.

44
As quoted in Woll 2001, p. 18.

45
For images of the entire series, see ibid.,
pp. 248–55, cats. 336–57.

46
Some of these revisionist approaches
include Berman 1989; Woll 1993;
Yarborough 1995; and Prelinger 2001.

47
For images of all the murals, see
McShine 2006, pp. 174–75.

48
For more on these literary and scientific
discourses, see Berman 2006b.

49
The correspondence between Reiche and
Munch is reproduced in Thomas Kellein,
ed., *Edvard Munch: 1912 in Deutschland*,
exh. cat. (Kunsthalle Bielefeld, 2002),
pp. 41–48.

50
Ferdinand Schmidt, "Die Internationale
Ausstellung des Sonderbundes in Köln,
1912," *Zeitschrift für bildende Kunst* 23
(1912), p. 234.

51
Several letters from Schmidt-Rottluff on
behalf of Die Brücke request Munch's
participation in the exhibitions; see let-
ters of Oct. 27, 1906; June 6, 1908; June
18, 1908; and one undated. Munch
Museum Archives.

52
For more on the Expressionists and
Munch, see Eggum 1982, pp. 15–20.

ANNA ANCHER
Danish, 1859–1935

A Funeral, 1891
P. 105, FIG. 105

INDIVIDUAL WORKS: TRACING INFLUENCE FROM ANCHER TO ZORN

Britany Salsbury and Jay A. Clarke

For much of the nineteenth and early twentieth century, the Skagen region of Denmark served as a popular refuge for Scandinavian artists such as Johan Christian Dahl and Christian Krohg, who were interested in painting the dramatic local landscape and stark rural settings. The painter Anna Ancher was among the few natives of the remote coastal area to pursue a successful artistic career, and the affection she had for the harsh northern region came to define much of her work.[1] Paintings such as *A Funeral*, with its solemn depiction of a villager's final rites, demonstrate the artist's subdued approach. Dressed in black, a crowd gathers to commemorate the death of Stine Bollerhus, a woman who had served as a model for several of Ancher's other paintings. Despite the deeply emotional subject, the group appears to approach the experience with a candor that mirrors the artist's tone, indicating their familiarity with the ever-present possibility of death.

Ancher did not venture from Skagen until she was thirty, traveling to Paris to study with the well-respected painter Pierre Puvis de Chavannes, who had a private atelier where many female Norwegian artists chose to train. Unlike many other areas of Europe, in Scandinavia, art was an accepted—even encouraged—career path for women in the late nineteenth century, and those who had the financial means could attend private academies and travel abroad.[2] Ancher created *A Funeral* shortly after returning from Paris, and the painting's local subject matter and dramatic light and color—particularly the saturated blue-black tones of the villagers' clothing—demonstrate her effort to synthesize a Nordic heritage with her French training. In 1891, the painting was exhibited at Copenhagen's Charlottenborg Palace, where Munch could have encountered it.

1
Hanne Westergaard, "*A Funeral*," in Hayward Gallery 1986, p. 64, cat. 1.

2
For more on artistic training and opportunities for Scandinavian women during this period, see Behrndt 2002.

HARRIET BACKER
Norwegian, 1845–1932

By Lamplight, 1890
P. 39, FIG. 35

ALBERT BESNARD
French, 1849–1934

Love, c. 1886
P. 55, FIG. 56

Harriet Backer, one of several female painters to gain critical recognition in Norway during the 1880s, was praised for her atmospheric blue interiors. After spending the first two decades of her life studying a variety of subjects, including foreign languages and writing, Backer traveled abroad to Germany and Italy with her sister, Agathe Backer Grøndahl (see p. 213), an accomplished pianist, until 1874. At that time, she decided to focus on painting and went to Munich to train under the landscape artist Hans Gude. She left Germany in 1878 to study at the esteemed Académie Bonnat in Paris (see p. 214), where she soon became one of Léon Bonnat's most prized pupils.[1]

In Paris, Backer fell under the influence of plein-air painting. Upon viewing Claude Monet's exhibition at Galerie Durand-Ruel in March 1883, she wrote enthusiastically to her friend, painter Eilif Peterssen (see p. 204), "After seeing Monet, there didn't seem to be … color in any [other] paintings."[2] She soon began to create interiors characterized by energetic brushstrokes and expressive color. One such work, *By Lamplight*, depicts a solitary young woman reading in a darkened room; the work's deep, vivid blue palette is penetrated only by the reddish tones of the lamp's illumination. At the time, such scenes were popular subjects for female artists due to the association of private space with femininity.[3]

Munch would have seen *By Lamplight* in Kristiania's 1890 Autumn Exhibition or through his association with the artist. Even in Munch's time, critics noted the similarity between Backer's painting and his own *Night in St. Cloud* (p. 38, fig. 34). In his review of the latter work, for example, Andreas Aubert asserted, "After Harriet Backer's sensitive interior … this is the picture which gains most by electric light."[4]

Exhibiting within both academic and vanguard circles, Albert Besnard became commercially successful by creating both sentimentalized portraits of women and socially critical works on paper.[1] *Woman*, his first major print series, unites these two aspects of his work. In its twelve images, a young woman falls in love, bears a child, and is financially ruined following her husband's death. Desperate to support her family, she resorts to prostitution, the humiliation of which leads to her suicide.[2] *Love*, the second image, depicts the woman and her paramour in a pasionate embrace before an open window, her long gown marking a dramatic diagonal across the picture plane; only the man's broad arms are visible as he envelops her. The intense crosshatching and boldly etched lines create vivid contrasts, contributing to the tense energy of the scene.

Although Besnard's *Woman* has been widely interpreted as a sympathetic commentary on the unjust tribulations of women, it was likely created for the delectation of a male audience, who would have found its images titillating. Additionally, the artist's equation of sexual awakening with moral decline—although on the surface portrayed with compassion—suggests the very opposite. In his preface to an 1898 catalogue that featured the series, Besnard characterized the prints as "a few impressions of humanity," but his further description of his subject's fate betrays a decidedly judgmental approach.[3] Due to the artist's strong reputation, Munch likely knew the series, and he could have seen *Love* in Durand-Ruel's 1892 *Exposition des peintres-graveurs* exhibition. The lovers' entwined embrace may have influenced the iconography of *Kiss by the Window* (p. 54, fig. 54) and *The Kiss* (p. 103, fig. 103).

1
Challons-Lipton 2001, pp. 91–92.

2
As quoted in Lange 2002b, p. 121.

3
For more on the interior genre and femininity, see Griselda Pollock, "Modernity and the Spaces of Femininity," in idem, *Vision and Difference: Feminism, Femininity, and the Histories of Art* (Routledge, 2003), pp. 70–127.

4
Marit Lange, "*By Lamplight*," in Hayward Gallery 1986, p. 67, cat. 2.

1
For examples of these paintings, see Royal Academy of Arts, *Post-Impressionism: Cross-Currents in European Painting* (Royal Academy of Arts/Weidenfeld and Nicholson, 1979), pp. 44–46.

2
Because Besnard did not number the prints in *Woman*, it is difficult to know whether this sequence is intended. Loys Delteil considered *Love* to be the second plate in the series; see idem, *Le peintre-graveur illustré (XIXe et XXe Siècles)*, vol. 30, *Albert Besnard* (Da Capo Press, 1969), n.pag., cat. 48.

3
As quoted in ibid.

ARNOLD BÖCKLIN
Swiss-German, 1827–1901

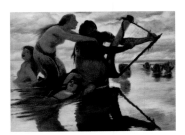

In the Sea, 1883
P. 77, FIG. 76

GUSTAVE CAILLEBOTTE
French, 1848–1894

Paris Street, Rainy Day, sketch, 1877
P. 43, FIG. 41

Trained in Düsseldorf, Arnold Böcklin broke from the traditions of both French and German academic painting to create a distinct and innovative style all his own. His use of intense, vivid color and revival of mythic iconography established him as the preeminent artist in German-speaking Europe during the later decades of the nineteenth century.

Böcklin disliked art that alluded to specific myths or literary texts, instead favoring deliberately vague content that evoked and modernized classical lore. He encouraged this tension between the known and the unknown, objectivity and subjectivity, stating, "It is right that everyone who looks at a picture must consider what that picture says to him. It isn't necessary that it be the same as what the painter had in mind."[1]

In the 1880s, Böcklin transitioned from works like *Villa by the Sea* (p. 69, fig. 66), which fused his traditional training with innovative themes, to the radical, playful, and even grotesque approach to imagery that came to define his career. *In the Sea*, for example, shows a gathering of four singing naiads, two tritons, and a harp-playing centaur that may be a self-portrait. The painting's tangible sense of merriment inspired the artist to refer to it as *Café-Concert in the Sea*.[2] Böcklin spent much of his professional life in Rome, and the influence of Italian Renaissance technique is evident in the way he layered colors and transparent glazes to represent the sea and its mythic creatures.

The inventive nature of works such as *In the Sea* appealed to young northern European artists like Munch, who struggled against the official academic style during the last decades of the nineteenth century. Munch likely viewed the painting at the gallery of the Berlin art dealer Fritz Gurlitt. Such pictures would have inspired Munch to undertake his own revival of ancient iconography and mythology.

Around 1850, the city of Paris began a program of urban renewal that transformed its maze of medieval streets into a landscape of wide, bustling promenades.[1] Gustave Caillebotte's monumental painting *Paris Street, Rainy Day* (1877; Art Institute of Chicago) depicts both the homogenous, modern neighborhoods that resulted and the middle-class public who populated them. This sketch, the last completed for the work, represents an intersection that was familiar to the Impressionists, as it was located near Édouard Manet's studio and Caillebotte's family home.[2] Here, two pedestrians stroll toward the viewer, arm in arm but seemingly unaffected by each other's presence. In the background, similarly fashionable figures pass through the streets alone. The setting's anonymity is emphasized by the dark, monochromatic tones in which each pedestrian is clad. The umbrellas are also rendered in the same silvery gray hue, evoking the rainy atmosphere and punctuating the composition with repetitive shapes.

This sense of isolation and ennui is likely related to contemporary discourse surrounding metropolitan culture. The poet Charles Baudelaire, whose work influenced Caillebotte and others in the Impressionist circle, wrote extensively of the flaneur, a shadowy, anonymous voyeur who traverses the modern city, observing yet never observed. The subjects of *Paris Street, Rainy Day* seem to occupy just such a role. Munch likely knew Caillebotte's highly respected composition through his mentor, Christian Krohg, who enthusiastically viewed the original painting at the Seventh Impressionist Exhibition in Paris (1882). Munch could also have seen this sketch in the museumlike home of Monet, who kept the work in his bedroom.

1
As quoted in Elizabeth Barnes Putz, "Classical Antiquity in the Painting of Arnold Böcklin" (Ph.D. diss., University of California–Berkeley, 1979), p. 271.

2
Jay A. Clarke, "*In the Sea*," Art Institute of Chicago Museum Studies 28, 1 (2002), p. 86.

1
Kirk Varnedoe, "*Rue de Paris: Temps de pluie*," in idem, *Gustave Caillebotte* (Yale University Press, 1987), p. 88, cat. 18.

2
Julia Sagraves, "The Street," in Anne Distel et al., *Gustave Caillebotte: Urban Impressionist*, exh. cat. (Réunion des Musées Nationaux, 1995), p. 95.

JEAN CHARLES CAZIN
French, 1841 – 1901

Ulysses after the Shipwreck, 1880/84
P. 17, FIG. 10

PAUL CÉZANNE
French, 1839 – 1906

Bather, Seen from the Back, 1879/82
P. 177, FIG. 198

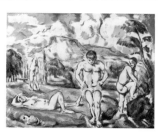

The Bathers, 1896/98
P. 177, FIG. 197

Although Jean Charles Cazin received critical attention primarily for his heroic representations of rural laborers, he also painted numerous canvases that modernized mythic subjects. *Ulysses after the Shipwreck*, for instance, depicts the Greek hero of Homer's epic poem *The Odyssey*, who looks out to sea after losing his entire crew to the wrath of Zeus. Marooned on the fabled island of Ogygia, Ulysses leans against the rocks of the coast, dejected and deep in thought as he yearns for his home, Ithaca.[1] The hero wears a long black robe tied with a red rope, a studio costume that appears in several of the mythological works that Cazin painted around this time. The artist's thin, loose application of paint suggests a brushy execution that belies his rigorous process, which involved repeatedly reworking images until they met his satisfaction.[2] Cazin set *Ulysses after the Shipwreck* on the coast of Equihen, his childhood home, to which he returned in about 1880. Scholars have suggested that the model was his son,

Michel, who would have been around twenty when the work was created and had begun to pursue an artistic career of his own.[3]

Cazin's correspondence with the dealer Charles Hamman, an associate of Georges Petit, suggests that *Ulysses after the Shipwreck* was exhibited in the early 1890s at the Cercle des Mirlitons, one of Paris's many small salons.[4] Munch, who could have seen the painting there, would have known of Cazin's work from its frequent inclusion in the Salon and international exhibitions.

Throughout his career, Paul Cézanne created approximately three hundred works that revised the iconography of bathing. Many of these depict groups of unidealized, androgynous young men, modernizing a classical motif that had traditionally taken eroticized young nude figures as subjects. Cézanne's figures lack the signifiers of virility that characterized depictions of the subject by both his predecessors and contemporaries. Indeed, they often turn away from the viewer, relating to one another within a decidedly masculine pictorial space.

It has been argued that works such as *Bather, Seen from the Back* relate to the artist's nostalgia for his childhood, which was spent largely with male friends in the countryside of Aix-en-Provence.[1] The subject also resonates with his lifelong interest in Greco-Roman mythology and Hellenistic art.[2] *Bather* may be seen as Cézanne's attempt to revisit and update this primeval masculinity—in both a biographical and art-historical

sense—through a modern style and technique.

Commissioned by Ambroise Vollard for his 1898 portfolio, *The Bathers* was created to promote color lithography. The work depicts a group of youths relaxing in a bucolic coastal landscape. Like his other bather images, it also suggests Cézanne's anxieties regarding women. As Vollard once stated of the artist, "Women, even when they were clothed, intimidated him."[3] The space created by this grouping could, therefore, be seen as utopian, free from the anxiety produced by female eroticism.

Munch frequently treated this subject in works such as *Bathing Young Men* (p. 175, fig. 195), which also updates the traditional bathing motif and builds upon Cézanne's exploration of the relationship between masculinity and nature. Munch could have viewed a related work, *Bathers Resting III*, at Vollard's gallery in late 1885, and encountered *The Bathers* in his 1898 portfolio.[4]

1
Ronald Alley, "*Ulysses after the Shipwreck*," in idem, *Catalogue of the Tate Gallery's Collection of Modern Art: Other than Works by British Artists* (Tate Gallery, 1981), p. 98, cat. 4365.

2
Gabriel P. Weisberg, "Jean-Charles Cazin: Memory Painting and Observation in *The Boatyard*," *Cleveland Museum of Art Bulletin* 68, 1 (Jan. 1981), p. 9.

3
Alley (note 1), p. 98.

4
This correspondence is housed in the Research Library, Getty Research Institute, Los Angeles.

1
Tamar Garb, "Cézanne's Late Bathers: Modernism and Sexual Difference," in idem, *Bodies of Modernity: Figure and Flesh in Fin-de-Siècle France* (Thames and Hudson, 1998), p. 210.

2
Mary Louise Krumrine, "Cézanne's Bathers: Form and Content," *Arts Magazine* 54, 9 (May 1980), p. 116.

3
As quoted in Terence Maloon, "Bathers and Nudes," in idem, *Classic Cézanne*, exh. cat. (Art Gallery of New South Wales, 1998), p. 128.

4
Bather may relate to Cézanne's painting *Bathers Resting III* (1875–76; Barnes Collection, Marion, Penn.); see John Rewald, "*Baigneurs au Repos III*," in idem, *The Paintings of Paul Cezanne: A Catalogue Raisonné*, vol. 1 (Harry N. Abrams, 1996), pp. 179–80, cat. 261.

GEORGE CLAUSEN
English, 1852–1944

Schoolgirls, Haverstock Hill, 1880
P. 43, FIG. 42

HENRI DE GROUX
Belgian, 1867–1930

Christ among His Tormentors, 1894/98
P. 167, FIG. 182

In 1880, George Clausen began to adopt gritty, urban subject matter, abandoning his previous idyllic images of working peasants. *Schoolgirls, Haverstock Hill*, which depicts a group of prosperous young woman strolling down a sidewalk toward the viewer, employs the metropolitan environment to address issues of both class and gender. Most likely students at a nearby ladies' academy, the subjects walk through Haverstock Hill, an affluent suburban area of London. Their youth, wealth, and attractiveness are emphasized by the presence of an elderly milk seller, a reminder of beauty's transience.[1] Barely visible at lower right and ignored by the crowd, an impoverished flower girl emblematizes the importance of inner beauty, as one of the schoolgirls extends her arm to give a donation.[2]

In an 1888 article for the *Scottish Art Review*, Clausen admired how the subjects of French painter Jules Bastien-Lepage, who inspired much of his early work,

demonstrated an awareness of the viewer: "He paints a man [who] stands before you and you ask yourself, 'What is he going to say?'"[3] Similarly, Clausen's schoolgirls look back at the artist and, implicitly, the viewer, who is thus positioned as a voyeur. This is particularly the case with the young woman at center, who gazes at the presumably male viewer in a potentially flirtatious manner. Clausen's composition bears strong visual ties to Munch's later paintings *Evening on Karl Johan* (p. 57, fig. 58) and *Anxiety* (p. 90, fig. 90), which feature subjects who address the viewer in an anxious, direct manner. Although *Schoolgirls* was not exhibited widely in Munch's lifetime, it is possible that the Norwegian artist could have encountered it through his association with artists such as Eilif Peterssen (see p. 204), Frits Thaulow (see p. 208), and Erik Werenskiold (see p. 210), who, like Clausen, were members of the Munich Secession exhibition society in the late 1880s and early 1890s.

The son of an eminent religious painter, Henri de Groux created numerous works inspired by and critical of Catholic dogma. Gravitating toward disturbing subject matter and working in an open, expressive style, he questioned the role of the church in fin-de-siècle Europe. *Christ among His Tormentors*, a depiction of Jesus publicly jeered and cowering next to Pontius Pilate, was seen as especially visionary during the artist's lifetime. The surging crowd that surrounds the subject evokes a chaotic sense of unease, and had become a popular motif for artists such as James Ensor (see p. 194) in late-nineteenth-century Belgium. De Groux's claustrophobic composition self-consciously incorporates quasi-nationalistic visual quotations, including the exaggerated movements of Peter Paul Rubens's canvases and Pieter Bruegel's crowded, anticlerical imagery.

After his initial, painted version of 1888–89, the artist printed several lithographic impressions of the *Christ* picture, a number

of which served as compositional bases for unique, hand-colored pastels such as this. Although the painting was rejected by the conservative French Salon, it was accepted for display at the nearby Union libérale des artistes français, where the critic Léon Bloy described it in 1892 as "the most formidable endeavor of Christian spiritualism ... accomplished in painting ... since the Renaissance."[1] Many commentators were so shocked by de Groux's exclusion from the Salon that the artist himself became a martyr of sorts, with the forward-looking critic Camille Mauclair asserting that he was "shamefully banished from this temple."[2]

The chaotic, surging crowd of Munch's *Golgotha* (p. 165, fig. 179) recalls de Groux's image, suggesting that he saw the painted version of the work during its 1892 Parisian exhibition, or perhaps encountered an illustration of the lithograph in a special 1899 issue of the journal *La Plume* devoted to the artist.[3]

1
Malcolm Warner, "*Schoolgirls,*" in Yale Center for British Art, *This Other Eden: Paintings from the Yale Center for British Art*, exh. cat. (Yale University Press, 1998), p. 168, cat. 69.

2
Kristina Huneault, "Flower-Girls and Fictions: Selling on the Streets," *RACAR: Revue d'art canadienne* 23, 1–2 (1996), pp. 52–70.

3
As quoted in Kenneth McConkey, *Sir George Clausen, R.A., 1852–1944*, exh. cat. (Bradford Art Galleries and Museums/ Tyne and Wear County Council Museums, 1980), p. 31.

1
As quoted in Nancy Davenport, "*Christ aux Outrages* by Henry de Groux: *Fin-de-Siècle* Religion, Art Criticism, and the Sociology of the Crowd," *Religion and the Arts* 7, 3 (2003), p. 281.

2
Ibid.

3
See *La Plume* (Apr. 15, 1899), p. 223.

CHARLES MARIE DULAC
French, 1865–1898

The Fish, 1893
P. 131, FIG. 137

MAGNUS ENCKELL
Finnish, 1870–1925

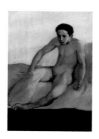

The Awakening, 1894
P. 87, FIG. 89

The first of two major print projects completed by Charles Marie Dulac, *Portfolio of Landscapes* illuminates his technical experimentation with lithography as well as his interest in religious imagery.[1] Trained as a decorative artist, Dulac worked as a commercial painter and wallpaper designer until 1890, when he fell ill, poisoned by the lead found in white pigment. As his health deteriorated, he became increasingly spiritual, aiming to create works that illuminated the relationship between humanity, nature, and God.[2] In order to convey accurately the magnificence of the natural world, he experimented with lithography, pushing the expressive boundaries of the process through the creation of ethereal effects and unusual colors of ink and paper.[3]

The Fish, the first print in the series, depicts two lone figures walking on the shore of an expansive, stylized stream or river. The jarring perspective, particularly its implacably distant vantage point, creates a sense of perpetuity that demonstrates both Dulac's technical skill and his belief in the infinite, omnipotent power of the divine. This interpretation is supported by the work's title, as the fish is a traditional symbol for Christ. Additionally, the transcendental landscape envelops the two subjects and, combined with the tranquil beauty of the scene, alludes to humankind's insignificance in the face of nature. Dulac's series was exhibited repeatedly in Paris during the 1890s, and Munch would certainly have seen *The Fish*, possibly relying upon it as a source for his own lithograph of *The Scream* (p. 131, fig. 138).

Largely credited with bringing Symbolist iconography from France to Finland in the 1890s, painter Magnus Enckell moved to Paris at age twenty-one to enroll in the well-known Académie Julian. While there, he became fascinated with the writings of Joséphin Péladan, who espoused allegorical, religiously inspired art and founded the mystical movement Rosicrucianism.[1] The artist also cited the sensually muscled figure drawings of Michelangelo, which he viewed during a visit to Italy in the early 1890s, as a major inspiration for works such as *The Awakening*.

Created at the height of Enckell's Symbolist period, the image was intended to represent the transformation from boyhood to adult consciousness. The nude young man, who pulls back blankets to emerge from a bed, is poised to step forward but conveys a sense of hesitation. The ambiguous eroticism of *The Awakening* is perhaps related to Enckell's own homosexual impulses, which he explored in the 1890s and—as he confessed on his deathbed to his son—struggled with for much of his life.[2] In contrast to the heavily allegorical tone of most sexually suggestive Symbolist iconography, *The Awakening* was intended to serve as a positive commentary on the process of maturation and development. Although the painting did not gain popularity with the public, it earned Enckell's reputation as an especially progressive artist and linked him more directly with the Rosicrucians, who emphasized similar themes. *The Awakening* is often compared to Munch's painting *Puberty* (p. 86, fig. 87), in which an anxious-looking young woman sits unclothed on the edge of a bed.

1
For more on *Portfolio of Landscapes*, see Elizabeth Prelinger, "Charles Dulac's *Suite de Paysages*," *Print Quarterly* 12, 1 (1995), pp. 41–52.

2
Taube Greenspan, "The Sacred Landscape of Symbolism: Charles Dulac's *La Terre* and the *Cantique des Créatures*," *Register of the Spencer Museum of Art* 5, 10 (1982), p. 68. See also idem, "'Les Nostalgiques' Re-examined: The Idyllic Landscape in France, 1890–1905" (Ph.D. diss., City University of New York, 1981).

3
For more on Dulac's creative process, see Jumeau-Lafond 2006, pp. 109–55.

1
Salme Sarajas-Korte, "Magnus Enckell and *Prometheus Bound*," *Art Museum of the Ateneum Bulletin* 21 (1977/78), p. 40.

2
Salme Sarajas-Korte, "Magnus Enckell's *Swan Fantasy*," *Art Museum of the Ateneum Bulletin* 27 (1985), p. 27.

JAMES ENSOR
Belgian, 1860–1949

AKSELI GALLEN-KALLELA
Finnish, 1865–1931

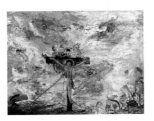

Christ Tormented, 1888
P. 166, FIG. 180

The Intrigue, 1911
P. 57, FIG. 59

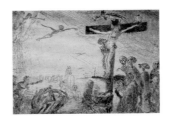

Christ Tormented by Demons, 1895
P. 167, FIG. 181

Väinämöinen and Aino, 1890
P. 77, FIG. 78

Although trained in a traditional manner, James Ensor is known primarily for his enigmatic subjects and highly individualized aesthetic. The son of an alcoholic, unemployed father whom he idolized, the artist had a childhood plagued by anxieties that later manifested themselves in the content of his work. His paintings also often functioned as an expression of his affinity for anarchism and atheism, ideologies perceived as radical and eccentric to his contemporaries. Responding to critical ridicule, in 1881 Ensor joined Les Vingt, a collective that aimed to encourage and exhibit experimental European art.

The personal and professional rejection that Ensor repeatedly faced throughout his life led him to view himself as both martyred and heroic, and he produced numerous images that self-consciously explore the iconography of crucifixion. Among the most overt is *Christ Tormented*, a depiction of a crucified figure in the midst of a fiery sky populated by demons and hollow masks.[1] The grotesque

faces that surround the cross were trademarks of the artist's work, adding autobiographical significance and, perhaps, implying identification with his subject.[2]

The late 1880s and early 1890s are widely considered the apex of Ensor's career, and are marked by his exploration of mask imagery, which he described as a means of personal escape.[3] In 1890, he first painted *The Intrigue*, which depicts a teeming crowd of bizarrely masked figures who ridicule a garishly made-up woman and her dandified companion. In addition to addressing the artist's social anxieties, the image may have been intended to critique the vanity of contemporary society.[4] This second version of *The Intrigue* exemplifies Ensor's tendency to create multiple copies of the same image, a practice echoed by Munch.[5]

Throughout the 1890s, Ensor began to experiment with printmaking as he attempted to further explore key themes. His etching *Christ Tormented by Demons*, for instance, demonstrates the

continued relevance of religion to his work.[6] For this apocalyptic scene, he etched intricate lines into the plate that he then enhanced with watercolor in order to manipulate the image and, ultimately, produce a unique work of art that was as much a painting as an etching.

Ensor's work had a clear and lasting impact on Munch's images of anxiety and torment. Munch could have viewed both *Christ Tormented* and the first version of *The Intrigue* at the 1892 Les Vingt exhibition in Brussels. *Christ Tormented by Demons* was reprinted in a special Ensor-themed issue of *La Plume*, and the wide distribution of the artist's prints would have afforded Munch ample opportunity to see the image in person as well.[7] Ensor's hand coloring may also have inspired Munch, who used it frequently both as a means of experimentation and as a way to add value to his work.

Supported by a government grant, in 1884 Finnish artist Akseli Gallen-Kallela traveled from his rural home to study at the Académie Julian in Paris. Although the young painter initially thrived in the cosmopolitan environment, he soon became profoundly homesick. Upon hearing of a competition sponsored by Helsinki University to create fresco designs for the *Kalevala*, a Finnish epic following the travels and trials of the hero Väinämöinen, the artist left Paris and returned home, determined to win.[1] It was during this period that he created this center panel of the *Aino Triptych*, depicting an important scene in which the elderly Väinämöinen proposes marriage to the young maiden Aino, who drowns herself rather than accept. In doing so, she is transformed into a water nymph. When Aino is caught by Väinämöinen, he believes her to be an unusual fish and unknowingly returns her to the water.[2]

By representing such folklore, Gallen-Kallela engaged in the current trend toward the revival

1
For further information on Ensor's adaptation of masks and its relationship to contemporary culture, see Patricia G. Berman, "The City, the Street, and the Urban Spectacle," in idem, *James Ensor: Christ's Entry into Brussels in 1889*, Getty Museum Studies on Art (Getty Publications, 2002), pp. 20–34.

2
Dennis Adrian, "*Christ in Torment*," in Jane E. Neidhardt, ed., *A Gallery of Modern Art at Washington University in Saint Louis* (Washington University Gallery, 1994), p. 94, cat. 39.

3
Roger Van Gindertael, *Ensor*, trans. Vivienne Menkes (New York Graphic Society, 1975), p. 111.

4
Diane Lesko, *James Ensor: The Creative Years* (Princeton University Press, 1985), pp. 151–52.

5
Sandra LaWall Lipshultz, "*The Intrigue*," in *Selected Works: The Minneapolis Institute of Arts* (Minneapolis Institute of Arts, 1988), p. 174.

6
For Ensor's disillusionment with the Catholic Church in Belgium, see Susan M. Canning, "The Devil's Mirror: Private Fantasy and Public Vision," in *Between Street and Mirror: The Drawings of James Ensor*, ed. Catherine de Zegher, exh. cat. (The Drawing Center, 2001), pp. 67–68.

7
See *La Plume* 232 (Dec. 15, 1898), p. 713.

1
For further information on the numerous *Kalevala* competitions during the late nineteenth century, see Janne Gallen-Kallela-Sirén, "Aksel Gallén and the Constructed Nation: Art and Nationalism in Young Finland, 1880–1900." (Ph.D. diss., New York University, 2001).

2
David Jackson and Patty Wageman, eds., *Akseli Gallen-Kallela: The Spirit of Finland*, exh. cat. (Nai Publishers, 2006), pp. 42–43.

PAUL GAUGUIN
French, 1848–1903

The Arlésiennes (Mistral), 1888
P. 91, FIG. 92

Human Sorrow, 1889
P. 131, FIG. 136

Auti te pape
(Woman at the River), 1893/94
P. 145, FIG. 156

of Finnish national traditions. For many artists, the political turmoil of Finland's conquest by Russia in 1809 fostered a desire to return to the country's defining history and culture during the ensuing decades. The monumental, ornate frame surrounding this painting, for example, evokes the richly decorated interiors of Scandinavian churches during the Middle Ages, a time before Finland became subject to outside influence.[3] Gallen-Kallela's project of national revival echoed those of Munch and other contemporary Norwegians, whose own nationalist ambitions prompted them to revive ancient folktales such as those published by Peter Christen Asbjørnsen and Jørgen Moe (see p. 98, fig. 99). Munch and Gallen-Kallela held a joint exhibition in 1895 at the Ugo Barroccio Gallery in Berlin (see p. 215), but Munch could have encountered this painting three years earlier in Paris.

In the late 1880s, Paul Gauguin shifted his subject matter from landscapes and still lifes, and began to investigate the mystical and spiritual aspects of everyday life. From this point on, he focused on images of women as a way to explore—and, often, eroticize—cultures that were considered exotic and primitive.

In The Arlésiennes (Mistral), a self-consciously enigmatic image, two cloaked women stroll through a public garden in Arles, enveloped in dark shawls that suggest a state of mourning. In the distance, two other strollers wear their shawls in a more traditional fashion. Scholars have suggested that the large bush in the foreground represents a modified self-portrait, contributing to the supernatural quality evoked by the work's stylized, geometric forms.[1] The plant partially obscures the women as they lean into the cold, dry mistral wind.

A year later, the artist began to experiment with printmaking while living in Paris. In Human Sorrow, he again adapted a female subject to explore everyday themes. The work depicts a pensive young woman holding her head in her hands while a man hovers nearby, gazing furtively. In the distance, an elderly woman, who appears to be wearing traditional Breton head covering, appears shocked by the couple.[2] The young woman's lack of head covering would have carried a sexual connotation, as such attire was explicitly required until a woman's wedding night. The man may be a lover, and the title of the work suggests the disgrace and sorrow of a failed sexual relationship.[3] Part of The Volpini Suite, which was printed on distinctive canary yellow paper, Human Sorrow was the only image to have been rendered in reddish brown ink.

The works Gauguin created in Tahiti, which he first visited in 1891, adapt women as signifiers of sexual availability and emblems of exoticism.[4] The artist's travel memoir, entitled Noa Noa, included ten woodcuts including Auti te pape (Woman at the River), which shows one young woman

sitting on an abstracted shore as another dives into the waves. The image likely depicts Gauguin's thirteen-year-old "wife," Tehamana, who functioned both as an artistic muse and a symbol of sexual freedom.[5] Slow sales of Noa Noa were doubtless due to this provocative content, combined with Gauguin's unorthodox use of the woodcut medium.[6] Here, the artist had experimented with the cutting, inking, and printing processes to create rough yet rich layers and textures.

Munch may have seen The Arlésiennes (Mistral) in the gallery of Theo van Gogh in 1889, the same year that he could have viewed Human Sorrow at the Group Exposition of Impressionists and Synthetists in Paris. The woodcuts of Noa Noa have been frequently cited as an inspiration for Munch's own experiments with the technique, and the Norwegian artist could have seen them through the collector William Molard, whom he knew in Paris.

3
John Boulton Smith, "Art Nouveau and National Romanticism in Finland," Apollo 115, 243 (May 1982), p. 380.

1
Debora Silverman, Van Gogh and Gauguin: The Search for Sacred Art (Farrar, Straus and Giroux, 2000), p. 250.

2
Caroline Boyle-Turner, "Les Misères Humaines," in idem, The Prints of the Pont-Aven School: Gauguin and his Circle in Brittany, exh. cat. (Smithsonian Institution Traveling Exhibition Service, 1986), p. 44, cat. G2.

3
Silverman (note 1), p. 275.

4
For more on Tahiti and sexuality in Gauguin's work, see Peter Brooks, "Gauguin's Tahitian Body," in The Expanding Discourse: Feminism and Art History, eds. Norma Broude and Mary D. Garrard (Icon Editions, 1992), pp. 331–45.

5
Nancy Mowll Mathews, Paul Gauguin: An Erotic Life (Yale University Press, 2001), p. 179.

6
Richard S. Field, "Gauguin's Noa Noa Suite," Burlington Magazine 110, 786 (Sept. 1986), p. 510.

VINCENT VAN GOGH
Dutch, 1853–1890

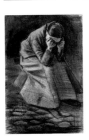

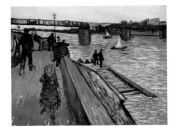

Weeping Woman, 1883
P. 17, FIG. 8

The Bridge at Trinquetaille, 1888
P. 91, FIG. 91

During his brief but prolific career, Vincent van Gogh created numerous works exploring the theme of isolation. Although often tied to the artist's volatile mental health, this melancholy iconography also stemmed from his insatiable desire to depict the whole of human experience. As he wrote to his brother Theo in 1882, "I want to go through the joys and sorrows of domestic life in order to paint it from my own experience."[1]

Weeping Woman depicts isolation in the form of a seated female figure who leans forward, burying her head in her work-roughened hands. Vigorously executed in black and white chalks, the darkly monochromatic drawing emphasizes the textured topography of the paper itself, enhancing the subject's coarseness. Around the time he created this sheet, Van Gogh began to depict sociopolitical, moralistic themes that were well suited for reproduction in journals.[2] These images would have provided supplemental income for the perennially destitute artist.

Weeping Woman represents the artist's frequent model and lover Sien Hoornik as one particular victim of moral hypocrisy: the shunned, isolated figure of the fallen woman.[3] The traumatic events of Hoornik's life—which included losing two children in childbirth and turning to prostitution due to extreme poverty—clearly echoed the theme of the drawing.

The Bridge at Trinquetaille explores the theme of isolation more subtly. In a further effort to paint from experience, the artist traveled to the southern French city of Arles in 1888. In *The Bridge at Trinquetaille*, which depicts a structure spanning the Rhône River, a girl walks alone toward the viewer, holding a hat in front of her face. Although several men congregate along the shore, sailboats populate the river, and crowds cross the distant bridge, she remains aloof and introspective. The heavy, intentional brushstrokes and vivid pink and yellow hues evoke an emotional response, heightening our sense of the

figure's solitude as she literally fades into her surroundings.

Munch may have seen the latter work when it was exhibited in 1891 at the Salon des Indépendants, and it may well have influenced the isolated subjects and vanishing perspective of *Anxiety* (p. 90, fig. 90) and *The Scream* (p. 92, fig. 93), which he created shortly thereafter. Munch could have viewed works similar to *Weeping Woman* in the collection of Theo van Gogh before 1891.[4]

1
As quoted in Carol Zemel, "Sorrowing Women, Rescuing Men: Van Gogh's Images of Women and Family," *Art History* 10, 3 (1987), p. 351.

2
Belinda Thomson, *Van Gogh* (Art Institute of Chicago, 2001), p. 19.

3
For a detailed exploration of this theme in Van Gogh's oeuvre, see Zemel (note 1), pp. 351–68.

4
Theo van Gogh owned a copy of his brother's *Sorrow*, a lithograph based on a drawing (1882, Wallsall Museum and Art Gallery) of the same year. See Sijraar van Heugten and Fieke Pabst, *The Graphic Work of Vincent van Gogh* (Waanders, 1995), pp. 39–43, cat. 2.

EUGÈNE GRASSET
French, 1841–1917

The Acid Thrower, 1894
P. 127, FIG. 131

HENRI CHARLES GUÉRARD
French, 1846–1897

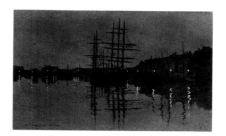

The Basin at Dieppe, 1883 / 89
P. 41, FIG. 38

Eugène Grasset, who was noted for his role in the burgeoning Art Nouveau movement, created numerous posters for Montmartre cabarets, many of which featured idealized female subjects in a style evocative of stained glass. During the 1890s, however, the artist began to create and exhibit far more sinister prints of women drawn from contemporary Parisian life. Whereas his earlier subjects were often clad in medieval-inspired costumes, works such as *The Acid Thrower* represented decidedly modern femmes fatales. In this image, a young woman with long, flowing red hair gazes menacingly at the viewer while holding a small bowl of acid.

Beginning in the 1880s, throwing acid to burn and disfigure victims had become a sensationally popular crime of passion that French newspapers had begun to report with increased frequency.[1] *The Acid Thrower* demonstrates a fascination with the city's seedy underworld, an interest that continued with his later, celebrated lithograph *The Morphine Addict* (1897). This imagery drew upon both news reports and the prevailing fashion of representing women as inherently sinister. With their heavy outlines and flat panels of color, Grasset's images were inspired both by decorative art and Japanese woodblock prints; here, the latter influence is particularly evident in the jagged, stylized clouds surrounding the woman's head and the seemingly frozen waves of acid in her bowl.[2] *The Acid Thrower* was created photographically after a drawing, using the newly invented gillotage process, and then colored with stencils for its 1894 publication in *L'Estampe originale.*[3] The work was also exhibited in 1895 at the Galerie Laffitte in Paris, where Munch could have viewed it, adopting Grasset's dark outlines and caricatural style.

After the unexpected death of his wife, the accomplished painter Eva Gonzales, Henri Guérard began to travel widely, using the locales he visited—French vacation destinations such as Dieppe, Le Havre, and Honfleur—as subjects for his work. Skillfully etched landscapes like *The Basin at Dieppe* won him favor in vanguard circles, and one of the founding fathers of Impressionism, Édouard Manet, became his mentor. Manet later described Guérard as "our only etcher of etchings," praising his superiority to other contemporary practitioners.[1]

Guérard, who created almost five hundred prints in various styles and techniques, began his most prolific period in 1883, the year *The Basin at Dieppe* was originally conceived. A night view, this particular print depicts a number of ships that are harbored on the coast of northern France, emphasizing the jagged reflections created by water and light. As with Guérard's other works of this time, the piece is almost monochromatic, with blue-gray hues dominating the palette. These tones evoke a melancholy mood that is perhaps tied to the experience of an unfamiliar place. This color scheme, combined with the nighttime imagery, attests to Guérard's admiration for the American expatriate James McNeill Whistler (see p. 210), who was noted for his nocturnal seascapes.[2] The French artist, in fact, created etched reproductions of numerous works by Whistler during the course of his career. These reproductions, as well as prints based on his travels, had an important role in the revival of etching in late-nineteenth-century France. In conjunction with artists such as Manet, Guérard worked to promote the idea that original prints such as *Basin at Dieppe* held value as independent means of artistic expression. His travel images were exhibited widely, and Munch may have viewed several of Guérard's nocturnal seascape etchings at the 1889 *Exposition des peintres-graveurs* in Paris.

1
For more on this crime, see Ann-Louise Shapiro, *Breaking the Codes: Female Criminality in Fin-de-Siècle Paris* (Stanford University Press, 1996), pp. 78–80.

2
Victor Arwas, *Berthon and Grasset* (Rizzoli, 1978), p. 64.

3
Phillip Dennis Cate, *Prints Abound: Paris in the 1890s: From the Collections of Virginia and Ira Jackson and the National Gallery of Art,* exh. cat. (National Gallery of Art, Washington, D.C., 2000), p. 24.

1
Jean Adhémar and Jacques Lethève, *Inventaire du Fonds Français après 1800,* vol. 9 (Bibliothèque Nationale, 1955), p. 450.

2
Gabriel P. Weisberg, "Henri Guérard and the Liberation of Nineteenth-Century Printmaking," in Ivo Kirschen, ed., *Henri Charles Guérard, 1846–1897: 108 Original Prints,* exh. cat. (Merrill Chase Galleries, 1981), p. v.

VILHELM HAMMERSHØI
Danish, 1864–1916

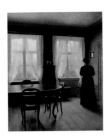

Interior, Frederiksberg Allé, 1900
P. 53, FIG. 52

ERICH HECKEL
German, 1883–1970

Two Seated Women, 1912
P. 185, FIG. 206

Interior, Frederiksberg Alée epitomizes Vilhelm Hammershøi's signature depictions of lone female subjects in hazy interior settings, works that are noted for their melancholic sense of intimacy. The foggy, neutral tones of such images are likely rooted in the monochromatic palette of contemporary black-and-white and tinted photographs, which includes muted grays, pinks, and yellows resembling those in this canvas. This relationship was so clear to viewers at the time that in 1907, *The Amateur Photographer* implored its readers to visit a London exhibition of Hammershøi's paintings, asserting that doing so would "send one away with a keen desire to improve one's work."[1] Indeed, in creating *Interior, Frederiksberg Allé*, the artist took inspiration from an 1890 photograph that showed the dining room in the Copenhagen apartment he shared with his parents.[2] In that image, Hammershøi's fiancée stands before a bright window, clad entirely in sharply contrasting black.[3]

With its hazy, soft focus, *Interior, Frederiksberg Allé* differed considerably from the sharp contours of conventional Danish painting. Although Hammershøi did not explicitly mention the work of Caspar David Friedrich as a source, his canvas recalls and updates the German Romantic painter's frequently adapted motif of a brooding figure looking out a window, viewed from behind.[4] Hammershøi's distinctive style led to his academic dismissal, but it brought recognition from younger contemporaries, who saw his work as daring and new. In autumn 1891, Munch could have seen a similar interior, *Bedroom* (1890, private collection), which was included in Copenhagen's first annual Free Exhibition, a display of progressive art organized by young Danish practitioners.[5]

The German Expressionist Erich Heckel was best known for his central role as a founder of Die Brücke, a group that eschewed academic art in favor of a spiritual, emotive style and synthesized stylistic elements of African sculpture with Renaissance printmaking techniques. Brücke artists depicted both the bustling crowds of urban, industrialized Germany and, conversely, the utopian relationship between man and nature that they believed could be found in the remote countryside. Educated at Dresden's Technical High School and influenced by the woodcuts of Paul Gauguin (see p. 195), Félix Vallotton (see p. 209), and Munch, Heckel formed Die Brücke in 1905 with fellow students Fritz Bleyl, Ernst Ludwig Kirchner, and Karl Schmidt-Rottluff. The group moved to Berlin in 1911, dividing their time between the city's bohemian scene and the rural lakes and beaches surrounding the metropolis.[1]

Two Seated Women depicts a pair of nude female figures reclining on an expansive, rocky beach.

In the summer of 1912, the year this print was created, Heckel traveled with Kirchner to Fehmarn, an island off the northern coast of Germany; there, he experienced the sort of return to nature that this woodcut both depicts and encourages. Heckel cut the figures from the block in an angular style that recalls the Palauan carved beams that Brücke members encountered in Dresden's Ethnological Museum around 1910.[2] In their very imperfection, the vivid pink, teal, and yellow inks—as well as the rough carving and uneven application of monotype ink—capture the freedom of early Expressionist style.[3] Munch was well acquainted with Die Brücke's theories and production both through its members' exhibitions in Berlin and Dresden and their frequent letters asking him to join their ranks.

1
As quoted in Sato, Fonsmark, and Krämer 2008, p. 21.

2
Ibid., p. 148, cat. 26.

3
This photograph is reproduced in Poul Vad, *Vilhelm Hammershøi and Danish Art at the Turn of the Century* (Yale University Press, 1992), p. 370.

4
See Lorenz Eitner, "The Open Window and the Storm-Tossed Boat: An Essay in the Iconography of Romanticism," *Art Bulletin* 37, 4 (Dec. 1955), pp. 281–90.

5
For an image of *Bedroom*, see Sato, Fonsmark, and Krämer 2008, p. 144, cat. 10.

1
For a detailed study of Die Brücke's excursions and the works they inspired, see Jutta Hülsewig-Johnen and Thomas Kellein, eds., *Die Badenden: Mensch und Natur im deutschen Expressionismus*, exh. cat. (Kunsthalle Bielefeld, 2000).

2
Jill Lloyd, *German Expressionism: Primitivism and Modernity* (Yale University Press, 1991), pp. 26–27.

3
Clarke 2002, p. 32.

HANS HEYERDAHL
Norwegian, 1857–1913

ERNST JOSEPHSON
Swedish, 1851–1906

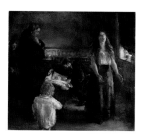

The Dying Child, 1889
P. 31, FIG. 29

Bathing Boys, 1887
P. 171, FIG. 89

The Water Spirit, 1884
P. 77, FIG. 77

Hans Heyerdahl, who trained in Kristiania, Munich, Paris, and Italy, experimented with a wide variety of styles and subjects throughout his career. At the Munich Academy, he turned from an early interest in landscape to history painting and portraiture. Exposed to Naturalist and Impressionist currents in Paris, Heyerdahl came to combine the heightened emotion of religious painting with the intimate nature of portraiture in works such as *The Dying Child* (1881; Musée Francisque Mandet, Riom). In this later version, a sickly baby is surrounded by a distraught father kneeling at its cradle; a somber doctor whose resignation signals hopelessness; a mother who prays to God with upturned eyes; and two servants or grandparents in the background. A highly personal work, the painting chronicles the death of Heyerdahl's own sibling: the crying boy seen from behind in the foreground is the artist himself, placed in the viewer's position so that we mourn with him. The painting

was awarded the coveted Grand Prix de Florence, which carried with it a two-year grant to study in Florence.[1]

Heyerdahl's time in Italy profoundly affected his motifs and painting style. While there, he became acquainted with the Swiss-German artist Arnold Böcklin (p. 190), whose mythic, immensely popular sea creatures perhaps inspired Heyerdahl's renewed interest in seaside imagery following his return to Norway. *Bathing Boys*, for instance, represents a group of four youths in various states of movement and undress. By the late 1880s, Åsgårdstrand, where both Heyerdahl and Munch spent their summers, had become a center for bathing culture in Norway— not just a rural retreat, but a full-fledged tourist destination.[2] While the figures in *Bathing Boys* do not partake in the social or medicinal aspects of this newly revered sport, they may very well be connected to a burgeoning interest in the curative effects of the sun and sea.

Ernst Josephson began his career with traditional training at Stockholm's Royal Academy of Art, enhancing his studies with trips to Paris and Rome in 1875 and 1878, respectively. During the 1870s, the artist first began to explore the theme of the water spirits Näcken and Strömkarlen, popular characters of Norwegian folklore that migrated into Sweden.[1] These creatures, like their feminine counterpart the mermaid, lured listeners to the water's edge with harp music only to disappear, causing the entranced humans to drown. In 1872, before leaving Sweden, Josephson had traveled to the remote Norwegian village of Eggedal where he encountered a waterfall evocative of the folktale.[2] He soon created *The Water Spirit*, which depicts a muscular young man passionately playing a fiddle amidst a waterfall. The painting's somber tones are punctuated only by the light falling on the sprite's body and by the surging water that surrounds him.

The artist completed three versions of *The Water Spirit* between

1882 and 1884, but the image was met with derision by his Scandinavian peers, who favored a precise, Naturalist style and considered Josephson's Romantic adaptation of myth antiquated and his brushwork too free and expressive.[3] Faced with this rejection and suffering from declining mental health, he retreated to a remote cottage in Brittany. *The Water Spirit* only received critical acclaim a decade later due to its indigenous Scandinavian subject matter, which was increasingly promoted at this time by the National Romanticism movement. Munch could have seen the initial version of the painting in Paris through its first owner, Theo van Gogh; he may also have had access to the final version, which was in the collection of his contemporary, the artist Prince Eugen of Sweden, who acquired it in 1893.

1
Trond E. Aslaksby, "Hans Heyerdahl i Paris," in Svein Olav Hoff, ed., *Kunst og Kommentar* (Tell, 1992), p. 55. Capitalizing on the success of the 1881 work, Heyerdahl made several smaller versions of the composition for sale in Norway. The one illustrated here repeats but reverses the larger work, exaggerating the mother's beseeching gesture.

2
For more on the history of Åsgårdstrand, see Arne Eide, *Åsgårdstrand: om hvite hus og løvkroner spredt historikk* (J. W. Eides, 1946).

1
For further information on these myths, see John Lindow, *Swedish Legends and Folktales* (University of California Press, 1978), pp. 121–24.

2
Michelle Facos, "A Controversy in Late Nineteenth Century Painting: Ernst Josephson's *The Water Sprite*," *Zeitschrift für Kunstgeschichte* 56, 1 (1993), p. 62.

3
Ibid., p. 70.

MAX KLINGER
German, 1857–1920

Abandoned, 1884
P. 143, FIG. 153

Suffer!, 1884
P. 167, FIG. 183

In the Park, 1887
P. 55, FIG. 55

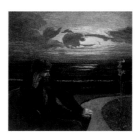

Night, 1889
P. 17, FIG. 11

Dead Mother, 1889
P. 107, FIG. 107

Max Klinger was among Germany's most revered printmakers in the 1880s and 1890s. Working primarily as a graphic artist but also as a sculptor and painter, he completed fourteen print cycles dealing with themes of love, death, and historical myth. Klinger was also commissioned to create reproductive etchings after four works by Arnold Böcklin (see p. 190), including the immensely popular image *The Isle of the Dead*. In this painting, which Böcklin created to induce dreams, a veiled widow accompanies the coffin of her husband to a remote island that will serve as his final resting place.

Klinger's moralizing series *A Life* (1884) details the traumatic experiences of a young woman who is abandoned by her lover, ostracized by society, and forced into prostitution.[1] Beginning with an image of Eve, the portfolio attempts to critique traditional Christian beliefs in woman as the cause of original sin. *Abandoned*, the fifth print, depicts the subject walking along the shore, holding her face in anguish. A cloud above her head—shaped like a clenched hand, perhaps an allusion to God—and the vivid brown-red ink echo her emotional state. The later print *Suffer!* depicts the woman sobbing to a companion in front of a shadowy reflection of a crucifix. Unlike traditional representations, this crucifix reads "Suffer!" Through questioning the possibility of redemption in the Christian sense, *A Life* criticizes moral hypocrisy, bringing biblical lessons to bear on contemporary society. Klinger's later series *A Love* depicts a similar narrative of seduction, abandonment, and death. *In the Park*, the fourth print, reveals a clandestine meeting between the two lovers, who passionately embrace. The visual contrast between the man and the woman alludes to the catastrophic events that are to unfold. It is highly probable that Munch knew this work, perhaps using it as the basis for his own painted series, *A Love*.

In the haunting portfolio *On Death, Part I*, Klinger reflected upon the indiscriminate nature of death, including depictions of a drowning at sea, a farming accident, and an electrocution by lightning. The frequent presence of the robed, ominous figure of Death recalls German Renaissance prints that show the skeletal figure dancing with young lovers or beautiful women as a reminder of their imminent demise. The first print, *Night*, is a self-portrait that represents a lone figure seated beside the open sea, contemplating a single lily. Klinger's combination of religious, Northern Renaissance, and contemporary imagery in this series exemplifies his frequent use of timeless motifs to comment on modern society, a practice Munch later adopted. The influence that *Night* had on the young Norwegian artist's *Melancholy* (see p. 17, fig. 6) is evident, as the latter work focuses on a similar, lonely figure by the seashore.

Klinger revisited the theme of death in the series *On Death, Part II*, which contains more symbolic images of mortality. *Dead Mother*, the tenth plate, depicts a young woman with flowing hair lying in an open casket. On her chest sits a small infant who gazes directly at the viewer. The artist intended this work to express the ability of life to continue even in the face of death itself. In 1893, Munch created the painting *Death and Spring* (p. 106, fig. 106), which directly quoted from Klinger's print.

Munch was introduced to Klinger's art by his mentor Christian Krohg and would have encountered his prints in Paris after 1889 and in Berlin after 1892 in both exhibitions and dealers' shops. Indeed, Klinger's wide popularity makes it highly probable that Munch knew his work well, incorporating its motifs and techniques into his own practice.

1
Kirk Varnedoe and Elizabeth P. Streicher, "A Life," in idem, *The Graphic Works of Max Klinger* (Dover, 1977), p. 81.

NOT PICTURED
The Isle of the Dead, 1890
P. 163, FIG. 176

CHRISTIAN KROHG
Norwegian, 1852–1925

Village Street in Grez, 1882
P. 42, FIG. 39

WALTER LEISTIKOW
German, 1865–1908

Evening Mood at Schlachtensee, c. 1895
P. 67, FIG. 64

Christian Krohg's *Village Street in Grez* demonstrates the painter's emphatic beliefs regarding aesthetics, politics, and their role in artistic production. In the image, pedestrians walk down a narrow village street on a rainy day, huddling under large, dark umbrellas. Rendered predominantly in blue-gray hues, the work reflects the characteristic palette of the Scandinavians working in the artist colony of Grez-sur-Loing during the 1880s. It also captures the environment in which it was created: the village, located south of Paris, was noted for the gray rock used to construct its homes and streets, which are mirrored in the cloudy Loing River.[1]

Here, the melancholy, rainy atmosphere is echoed by the attire of the main figure who, wearing a worker's smock, walks immediately in front of the viewer. Krohg's decision to include this man reflects his preference for realistic, proletarian content, a politically motivated practice that was seen as radical at a time when idealization was the norm. That the

worker's point of view coincides with the viewer's can be seen as an egalitarian gesture, suggesting the viewer and subject as equal to the artist himself. Krohg's canvas bears overt ties to Caillebotte's iconic composition *Paris Street, Rainy Day* (see p. 43, fig. 41), in which figures are likewise represented from the viewer's vantage point while they stroll down a rainy street. Krohg's smocked workers may relate to those in another Caillebotte canvas, *House Painters* (1877; private collection); the artist would have been familiar with Caillebotte's work from the time he spent in Paris.[2]

Dismissed from the Berlin Academy at age eighteen for lack of talent, Walter Leistikow spent much of his career developing a signature style that diverged from the staid formality of academically sanctioned work. This style found expression in evocative landscapes such as *Evening Mood at Schlachtensee*, which the artist executed in the woodlands surrounding Berlin, where he had taken up residence in the summer of 1895.[1] In this mysterious scene, a sun sets over the placid, expansive Schlachtensee, creating vivid ripples across the water's reflective surface. A small glen of trees punctuates the composition, suggesting that the viewer looks out from within its sparse embrace. In paintings like this one, Leistikow productively transformed the French Impressionist idiom into a symbolic, indigenous style all his own, conceiving landscape as a subjective experience that the artist and viewer could share.

During the 1890s, Leistikow worked exclusively on landscapes, which were met with both scorn

and praise; conservative critics berated his paintings as unrecognizable, yet dealers purchased them until, as the artist told the painter Lovis Corinth, he "waded in money."[2] The commercial and critical success of his vanguard style caused Leistikow to further disdain the academy, and in 1898, with artists such as Max Liebermann (see p. 202), he formed the Berlin Secession, an exhibition society that formally withdrew from the city's traditional artistic milieu. As the progressive critic Julius Elias remarked following the artist's suicide: "Leistikow did not forego the temptation to see German landscape with French eyes."[3]

Munch would have been familiar with *Evening Mood at Schlachtensee* due to his friendship with Leistikow and his affiliation with the Berlin Secession. The correspondence between the two artists, and Munch's time in Berlin during the early 1890s, would have afforded them ample opportunity to share their approaches to landscape imagery.

1
Michael Jacobs, "The Bethlehem of Modern Painting: Barbizon and Grez-sur-Loing (France)," in idem, *The Good and Simple Life: Artist Colonies in Europe and America* (Phaidon, 1985), p. 30.

2
Varnedoe 1979, p. 88.

1
William Vaughan, "*Evening Mood at Schlachtensee*," in Ingrid Ehrhardt and Simon Reynolds, eds., *Kingdom of the Soul: Symbolist Art in Germany, 1870–1920*, ed. exh. cat. (Prestel, 2000), p. 97, cat. 42.

2
Walter Leistikow, quoted in Peter Paret, *The Berlin Secession: Modernism and its Enemies in Imperial Germany* (Harvard University Press, 1980), p. 40.

3
Julius Elias, "Walter Leistikow," in *Walter Leistikow: Katalog der Ausstellung des Nachlasses Walter Leistkows* (Berlin, 1908), p. 19.

MAX LIEBERMANN
German, 1847–1935

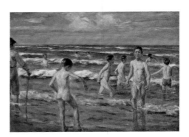

Bathing Boys, 1900
P. 171, FIG. 190

HENRI JEAN GUILLAUME MARTIN
French, 1860–1943

Silence, 1894 / 97
P. 85, FIG. 85

An early advocate of Impressionism in Germany, the painter and printmaker Max Liebermann was the founder of the vanguard Berlin Secession, the president of the Berlin Academy of Art, and arguably the most influential artist of his generation. In the 1880s, he was dubbed "the apostle of ugliness" by conservative critics due to his heavy, paint-laden brushstrokes and common subject matter, although anti-Semitism was an abhorrent undertone in some of these remarks. Around 1900, however, Liebermann began to lighten his palette and create pictures that captured the daily life of the upper class, to which he belonged.[1]

One such work is *Bathing Boys*, which depicts a group of lively young swimmers on a summer day. Liebermann and his family had begun to vacation in the Dutch coastal areas of Scheveningen and Nordwijk in the 1870s, and the beach represented is likely in one of those regions. *Bathing Boys* exemplifies the period's increased interest in sport and exercise, as physical fitness and outdoor activity—as opposed to manual labor—came to be seen as integral to a healthy bourgeois lifestyle. In his 1912 study of the artist, critic Karl Scheffler praised the painting, remarking that it "gives the mood of the sea and the naked body under the forces of light, wind, reflex, and space with a surprising accuracy."[2] Liebermann revisited this theme—which would continue to grow in popularity throughout the early twentieth century—in a number of paintings and prints between 1896 and 1909. Munch could have seen *Bathing Boys*, which was exhibited widely, at the second exhibition of the Berlin Secession in 1900, or through Liebermann's (and later Munch's) dealer, Paul Cassirer, who first owned it.

Trained as an academic painter, Henri Martin became interested in Symbolist iconography for a brief period during the early 1890s. Early in the previous decade, he was awarded a grant to travel throughout Italy with his colleague, the artist Edmond Aman-Jean. Inspired by the natural beauty he witnessed there, Martin produced work that became increasingly experimental and visually diffuse. In 1892, both he and Aman-Jean included work in the first annual Rosicrucian Salon, a collaborative exhibition that promoted the mystical and religious in Symbolist art. *Silence* suggests the thematic importance of quietude and mystery and the related prevalence of the femme fatale at this moment in French art. A lone woman stands in the midst of a hazy, enveloping landscape, covering her face with her long hair in a gesture of isolated enclosure.

Martin was one of a number of Symbolist artists to represent women as physical manifestations of silence, believing that abstinence from speech resulted in a deeper sense of spirituality.[1] Despite his figure's religious undertones, her direct, suggestive gaze also argues for a sexual reading of the image. The thistle plant next to her, for example, traditionally symbolizes both sin and martyrdom, and, when taken together with the Christlike crown of thorns in her hair, may allude to original sin. At this time, visual culture was full of such femmes fatales, women believed to possess a power to titillate, disgust, and harm—hence the desire to represent them as silent. The catalogue of the 1898 Rosicrucian Salon alludes to the importance of such symbolic images, explicitly advising artists that "preferred subjects" included "allegory, expressed as 'modesty and truth.'"[2] *Silence* was included in Ambroise Vollard's 1897 *Album des peintres graveurs*, a deluxe print portfolio to which Munch had contributed the previous year.

1
Maria Makela, *The Munich Secession: Art and Artists in Turn-of-the-Century Munich* (Princeton University Press, 1990), p. 84.

2
Karl Scheffler, *Max Liebermann* (R. Piper, 1912), p. 161.

1
Jean-David Jumeau-Lafond, "*The Silence*," in Jumeau-Lafond 2006, p. 250.

2
Ordre de la Rose + Croix du Temple et du Graal, sixième salon catalogue, exh. cat. (Paris, 1897), p. 32.

CLAUDE MONET
French, 1840–1926

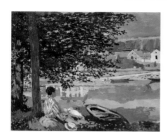

On the Bank of the Seine,
Bennecourt, 1868
P. 15, FIG. 4

The Red Kerchief, Portrait
of Madame Monet, 1873
P. 53, FIG. 53

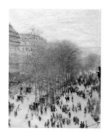

The Boulevard des Capucines,
1873
P. 46, FIG. 46

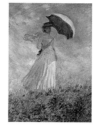

Study of a Figure Outdoors
(Facing Right), 1886
P. 48, FIG. 48

Claude Monet is popularly known for his role in developing and popularizing Impressionism's paint-laden brushstrokes, light palette, and leisurely images; he also, however, engaged in rigorous technical experimentation, often implementing unorthodox viewpoints and framing techniques. This practice, grounded in a desire to approximate visual experience, contributed to a distinct aesthetic that was more radical and complex than is typically assumed.

An early instance of Monet's bold compositional framing can be seen in *On the Bank of the Seine, Bennecourt*, which depicts his mistress (and later, first wife) Camille Doncieux relaxing on a pleasant spring day. Visible across the water is the rural village of Bennecourt, from which the couple had rowed using the boat in the foreground.[1] Doncieux is seen from an elevated position, as if being watched from a distance. The expansive landscape scene effectively combines her vantage point with that of the viewer, assigning her a role that is at once active and passive, observing and observed.

In a later painting, *The Red Kerchief, Portrait of Madame Monet*, the artist constructs his view more definitively and intimately, framing Doncieux within a large set of French doors. Here, she wraps a red scarf tightly around her head as she hurries through a snowy landscape. The bright hue of the kerchief echoes the vivid winter light and strikingly contrasts with the heavy, gray brushstrokes of the interior. At around this time, Monet painted numerous window scenes that he referred to as "my views."[2]

In *The Boulevard des Capucines*, the artist again used dramatic framing techniques to manipulate and construct the viewer's experience of time and space. The painting depicts a swarming Parisian street as if seen through a high window. This bird's-eye view is enhanced by the inclusion of two blurry, top-hatted men who lean in on the far right, as if on a nearby balcony. The figures below are constructed from single black strokes so that they appear obscured, as if viewed from a distance.[3] The fact that Monet may have completed this work in the studio of the famed photographer Nadar alludes to the relationship between its radical perspective and this developing medium.[4]

In *Study of a Figure Outdoors (Facing Right)*, a work of over a decade later, Monet used viewpoint to simulate visual experience. Here, a young woman stands at the top of a grassy hill, holding a parasol to deflect the sun's rays. She is seen from an extremely low viewpoint, implying, perhaps, that the viewer is a voyeur who watches her from further down the slope. This angle may also reflect Monet's growing interest in Japanese woodblock prints, which often utilize such jarring perspective.

Munch was undeniably influenced by Monet's implementation of unorthodox framing devices and constructed viewpoints. The young Norwegian artist likely viewed both *On the Bank of the Seine, Bennecourt* and *The Boulevard des Capucines* at Galerie Georges Petit in Paris, where they were shown in 1889. He could have encountered *Study of a Figure Outdoors (Facing Right)* at an 1891 exhibition at Galerie Durand-Ruel, and may have seen *The Red Kerchief, Portrait of Madame Monet* at the artist's home, where it remained until his death.

1
Gloria Groom, *"On the Bank of the Seine, Bennecourt,"* in Douglas W. Druick and Gloria Groom, *The Age of Impressionism at the Art Institute of Chicago* (Yale University Press, 2008), p. 49, cat. 13.

2
Steven Z. Levine, "The Window Metaphor and Monet's Windows," *Arts Magazine* 54, 3 (Nov. 1979), p. 102.

3
Joel Isaacson, *"The Boulevard des Capucines,"* in idem, *Claude Monet: Observation and Reflection* (Phaidon, 1978), p. 205, cat. 41.

4
Paul Hayes Tucker, *Claude Monet: Life and Art* (Yale University Press, 1995), p. 78.

EILIF PETERSSEN
Norwegian, 1852 – 1928

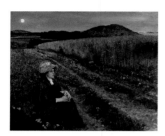

Summer Evening at Sandø, 1884/94
P. 15, FIG. 5

Afternoon at Dælivannet, 1886
P. 33, FIG. 31

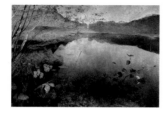

Nocturne, 1887
P. 19, FIG. 13

Trained primarily in Munich, Eilif Peterssen gained popularity for his staid historical paintings depicting monumental episodes from Norway's past. In the early 1880s, he came to reject this style, foregoing its dark, formulaic tones in favor of the loose brushstrokes and indigenous subject matter of the National Romantic movement. He also spent several years in Italy, where he was exposed to the trend toward plein-air and rural genre scenes.[1] Inspired by this innovative approach, in 1883 the artist returned to Kristiania and began *Summer Evening at Sandø*, a work that synthesizes distinctly Norwegian imagery, rural content, and open brushwork. Here, a young woman sits lost in thought, alone in an expansively rolling field on the remote island of Sandø.

In the summer of 1886, Peterssen traveled to Fleskum, a farm and artist colony just west of Kristiania (see p. 213). Although the stay was intended primarily to foster a sense of support and community between the artists, who included Harriet Backer

(see p. 189) and Erik Werenskiold (see p. 210), a particular chromatic emphasis emerged in the works created there, as the group adopted an expressive, emotive blue tonality in their rural scenes.[2] Peterssen's *Afternoon at Dælivannet* depicts a moody landscape of blue, green, and purple—with a trace of a crescent moon—reflected in the tranquil surface of Lake Dælivannet. Praising the artist's new landscapes, critic Andreas Aubert asserted that they made the viewer want to "go in and rest his arm on the tree-trunk, lean his head against his hand and stare down into the [water's] depths, lost in the waking dream of the night."[3]

Possibly responding to this assessment, the following summer Peterssen created *Nocturne*, in which he modified the landscape of *Afternoon at Dælivannet* to incorporate a lone female subject. Here, a young woman—perhaps a water sprite or forest nymph—leans on a battered tree trunk, looking into the glistening lake. Her mysterious presence alludes to Peterssen's

developing interest in Symbolist content and was likely inspired by the work of Pierre Puvis de Chavannes, which played a decisive role in his embrace of a lightened palette, elegiac mood, and nymphlike subjects.[4] However, this juxtaposition of a young woman and a decaying tree is also a traditional Scandinavian motif contrasting life and death, which suggests that Peterssen's goal was to combine French and native influences to create a decidedly modern Norwegian art.[5] Munch would have been familiar with all three of these works due to his friendship with the artist.

1
Knut Berg, "Eilif Peterssen," in Hayward Gallery 1986, p. 210.

2
Torsten Gunnarsson, *Nordic Landscape Painting in the Nineteenth Century*, Nancy Adler, trans. (Yale University Press, 1998), p. 208.

3
Ibid., pp. 211–22.

4
Lange 2002a, p. 271.

5
Rosemary Hoffmann and Oscar Thue, "*Summer Night*," in Varnedoe 1988, p. 207, cat. 86.

ODILON REDON
French, 1840–1916

Death: "My Irony Surpasses All Others," 1888
P. 85, FIG. 86

JÓZSEF RIPPL-RÓNAI
Hungarian, 1861–1927

The Country Dance, 1896
P. 159, FIG. 172

Deeply interested in the literature of his time, Odilon Redon created a large body of lithographs based loosely on contemporary written sources. Redon's darkly imaginative images for Gustave Flaubert's *Temptation of Saint Anthony* (1874) established his reputation as a inventor of dreamlike creatures inhabiting mysterious landscapes.[1] Flaubert's novel details the temptations experienced during one day in the life of the fourth-century saint, and was intended to serve as a loosely autobiographical metaphor for the decadence of nineteenth-century Paris.[2]

To Gustave Flaubert, Redon's second series of works illustrating the novel, consists of six images accompanied by passages from the text. The third print, *Death: "My Irony Surpasses All Others,"* depicts personifications of Lust (the curvaceous body of a young woman) and Death (the gaunt face of an old woman), who combine forces in order to seduce Saint Anthony and convince him to commit suicide. Redon's grainy use of lithographic crayon creates a dramatic effect that contrasts dark and light, enhancing the print's portrayal of good and evil and evoking the otherworldliness of the subject. *Death* received particular praise from the Symbolist poet Stéphane Mallarmé, who asserted that he "[did] not think any artist [besides Redon] would have made, or poet would have dreamt, so absolute an image."[3] *To Gustave Flaubert* was exhibited and circulated widely in Paris, so Munch could have known it from a variety of venues or, perhaps, through Mallarmé. The pose of the figure in *Madonna* (p. 83, fig. 82) echoes that of the woman in *Death*.

József Rippl-Rónai's *Country Dance* demonstrates both the artist's signature style and his role in expanding and exploring color lithography in 1890s France. Breaking away from Budapest's traditionalist Nagybánya School, he left in 1884 to study at the Munich Art Academy and moved to Paris three years later on a grant awarded by the Hungarian government. While there, he viewed the 1889 exhibition of drawings, lithographs, and paintings at the Café Volpini, including seventeen works by Paul Gauguin (see p. 195), whose work inspired him to travel to the rural artists' colony at Pont-Aven, Brittany, later that year.[1] The town was home to a loosely formed school associated with Gauguin, a popular destination for young artists hoping to study his experimental use of color and bold adaptation of peasant imagery.

The Country Dance depicts a group of friends and neighbors gathering to socialize and celebrate. Their particular style of clothing suggests that the scene takes place in the Pyrenees, an area of France that the artist had visited during his travels.[2] Executed in bold, flat patches of color, the work corresponds with the *cloisonnisme* movement promoted by Gauguin.[3] This style drew influence from medieval stained glass windows and Japanese prints, and was distinguished by simplified, planar forms that were distinctively outlined and filled in with vivid color.[4] The Pyrenees region was, in fact, noted for its picturesque medieval churches, including the Sanctuary of Our Lady of Lourdes, making it an appropriate subject for Rippl-Rónai's experiments with this particular style. *The Country Dance* was included in dealer Ambroise Vollard's 1898 *Album des peintres-graveurs*, which promoted the developing medium of color lithography. Munch could have encountered it there, as he also contributed a lithograph to the portfolio.

1
For more on Redon's literary illustrations, see Fred Leeman, "Odilon Redon: The Image and the Text," in Douglas W. Druick et al., *Odilon Redon: Prince of Dreams, 1840–1916*, exh. cat. (Art Institute of Chicago/Harry N. Abrams, 1994), pp. 175–94.

2
See Stephen F. Eisenman, *The Temptation of Saint Redon: Biography, Ideology, and Style in the Noirs of Odilon Redon* (University of Chicago Press, 1992), chap. 3, pp. 177–228.

3
As quoted in Leeman (note 1), p. 193.

1
Mária Bernáth, "Ein mitteleuropäisches Modell: Einflüsse und Assimilationen im malerischen Werk József Rippl-Rónais," in Schirn Kunsthalle Frankfurt, *József Rippl-Rónai, 1861 bis 1927: Ein Ungar in Paris*, exh. cat. (Umschau/Braus, 1999), p. 25.

2
Éva Bajkay and Katalin Szabó, "Dorffest (La fête au village)," in ibid., p. 195, cat. 84.

3
Phillip Dennis Cate, "Prints Abound: Paris in the 1890s," in Phillip Dennis Cate, Gale Barbara Murray, and Richard Thomson, *Prints Abound: Paris in the 1890s; from the Collections of Virginia and Ira Jackson and the National Gallery of Art*, exh. cat. (National Gallery of Art, Washington, D.C., 2000), p. 22.

4
Robert Goldwater, *Symbolism* (Harper and Row, 1979), p. 95.

AUGUSTE RODIN
French, 1840–1917

The Kiss, 1886
P. 55, FIG. 57

FÉLICIEN ROPS
Belgian, 1833–1898

The Greatest Love of Don Juan, 1882 / 83
P. 87, FIG. 88

In 1887, Auguste Rodin's *The Kiss*, composed of a sinewy man wrapped around a curvaceous woman, created an uproar when it was exhibited in Paris and Brussels. Inspired by Dante Alighieri's epic poem *The Divine Comedy* (1321), the sculpture depicts the adulterous Francesca da Polenta, who married the nobleman Gianciotto Malatesta da Rimini but later fell in love with his brother Paolo.[1] Upon discovering their betrayal, her husband murdered the lovers, condemning them to the second circle of hell.[2] The couple in Rodin's sculpture lacked historical costume and appeared in an outdoor setting, resting upon a rock rather than a piece of fourteenth-century furniture. This purposeful elision of the historical and erotic led many viewers to interpret the work as an obscene representation of a contemporary couple.[3] In part due to this sensational reception, viewers traveled in droves to view *The Kiss* at venues that included the 1893 World's Columbian Exposition in Chicago and the 1898 Paris Salon.

Munch could have encountered the piece at its 1888 Copenhagen exhibition, in which his work also appeared, or when it was reproduced in a special, Rodin-themed issue of the Parisian journal *Revue illustrée* the following year.[4] *The Kiss* undoubtedly informed Munch's own prints and paintings of couples locked in an amorous embrace. This influence was, in fact, noted by his patron Max Linde—himself a Rodin collector—who cited *The Kiss* as the inspiration for Munch's later etching and woodcut of the same title.[5]

Originally from a small rural town, Félicien Rops left home in 1853 to study printmaking in Brussels, the epicenter of Belgium's artistic community. He traveled to Paris for the first time nine years later, and spent his long stay developing a natural aptitude for etching. Fascinated by the activities of the city's population, Rops began to represent female subjects, from common streetwalkers to the fashion-obsessed bourgeois, as metaphors for modern life and the repressive nature of its moral codes.[1]

One of a series of illustrations for a collection of short stories by Jules Barbey d'Aurevilly entitled *Les Diaboliques*, *The Greatest Love of Don Juan* demonstrates the artist's interest in depicting sexual mores. The tale's narrator is the Comte de Ravila de Ravilès, a Don Juan character who tells of his greatest conquest, which is psychological rather than passionately physical: the unattractive, devout daughter of one of his paramours believes she has become impregnated after sitting on his recently vacated chair.[2] Rops's drawing embodies the story's subtle irony. The simple composition of the image, as well as the awkward adolescent's stiff posture and nudity—except for religious medals worn around her neck—capture the terror she is experiencing. Behind her looms the shadow of the count himself.[3]

The Greatest Love of Don Juan was included in the 1889 Les Vingt exhibition in Brussels. Munch could have encountered the image in an 1883 print portfolio of the illustrations for *The Diaboliques* or in a later illustrated book of etchings and heliogravures that was published in numerous editions between 1886 and 1889.[4] Although the image bears irrefutable similarities to Munch's *Puberty* (p. 86, fig. 87), the artist was evasive about its influence, admitting that he may have seen the print before he painted the 1894 version of the work, but insisting, "When I painted [the 1886 version], Félicien Rops was completely unknown to me."[5]

1
For more on this work, see Antoinette Le Normand-Romain, *The Kiss by Rodin*, trans. Davidson and Michael Gibson (Réunion des Musées Nationaux, 1996), p. 9.

2
Ibid., p. 10.

3
Jeanne L. Wasserman, "The Kiss," in idem, *Metmorphoses in Nineteenth-Century Sculpture*, exh. cat. (Fogg Art Museum, 1975), p. 169.

4
Octave Mirbeau,"Auguste Rodin," *Revue illustrée* (July 15, 1889), p. 77.

5
Max Linde, *Edvard Munch und die Kunst der Zukunft* (Gottheiner, 1902); text repr. in *Edvard Munch und Lübeck*, exh. cat. (Museum für Kunst und Kulturgeschichte der Hansestadt Lübeck, 2003), pp. 153–54.

1
Edith Hoffmann, "Rops: peintre de la femme moderne," *Burlington Magazine* 126, 974 (May 1984), p. 260.

2
See Jules Barbey d'Aurevilly, *The Diaboliques*, trans. Ernest Boyd (Knopf, 1933), pp. 51–74.

3
Brooklyn Museum, *Belgian Art, 1880–1914*, exh. cat. (Brooklyn Museum, 1980), p. 143.

4
For more on Munch and Rops, see Bjerke 2006a.

5
As quoted in Rapetti and Eggum 1991, p. 156. See also Sherman 1976.

DANTE GABRIEL ROSSETTI
English, 1828–1882

Beata Beatrix, 1872
P. 84, FIG. 83

The painter Dante Gabriel Rossetti founded the Pre-Raphaelite brotherhood, an artistic collaborative united by its members' mutual desire to emulate and revive the style and subject matter of Italian Renaissance art. Rossetti began his training at London's Royal Academy, but soon withdrew due to his disinterest in traditional studies. He continued to paint independently while simultaneously translating the works of early Italian poets, including Dante Alighieri's *La Vita Nuova* (1295). This autobiographical text, which described the poet's fruitless desire for a woman named Beatrice, affected Rossetti deeply and inspired a number of his paintings.

Rossetti's best-known work, *Beata Beatrix* depicts the elusive figure with her head lifted upward in what the artist described as "a trance or sudden spiritual transfiguration."[1] He often compared his wife, the painter Elizabeth Siddal, to the character of Beatrice in her role as muse, and he created the first version of this work

(1864/70; Tate, London) to commemorate her suicide in 1864. The original canvas was well received, and Rossetti began work on this second, commissioned version—which he admittedly created primarily for profit—the following year.[2] Both the subject's transfixed, upward facing pose and the representation of a subject tied to unrequited love seem to have influenced Munch, whose 1895 *Madonna* (p. 83, fig. 82) contains direct stylistic and contextual references to Rossetti's image. *Beata Beatrix* was reprinted in Richard Muther's seminal book *Modern Art* (1893–94), which Munch could have seen in Berlin.[3]

AUGUST STRINDBERG
Swedish, 1849–1912

The Vita Märrn Seamark II, 1892
P. 73, FIG. 71

Best known as a playwright, August Strindberg began his artistic practice in 1869 after an influential summer spent in Stockholm with a group of young Swedish painters including Per Ekström. A self-taught artist, Strindberg admired Ekström's bold, plein-air approach to landscape and ultimately adopted the open brushwork of French Impressionism, developing a stormy, vibrant palette and gestural immediacy all his own. He pursued the study of a number of subjects during his lifetime, ranging from aesthetics and photography to chemistry and cosmology, and these informed his approach to the visual and literary arts.

In 1892, Strindberg moved to Dalarö, an island near Stockholm, and began work on an expressive series of seascapes. One of these, *The Vita Märrn Seamark II*, is among the starkest of what the artist termed his "symbolic landscapes." Emblematic of the relationship between humanity and nature, the painting relates to Strindberg's vaguely autobio-

graphic novel *By the Open Sea* (1889), in which the main character becomes increasingly isolated and mentally unstable after relocating to a remote archipelago.[1] Strindberg himself was highly neurotic and emotionally unbalanced. It is possible that the isolated white seamark, or navigational reference point atop the rocky cliff in *The Vita Märrn Seamark II* acts as a self-portrait: like the artist, it is faced with the challenge of remaining stable amid violent storms. The title itself reflects Strindberg's fascination with cosmology, since *mare* (or *märnn*) is a term that describes the dark areas on the moon and Mars.

The year he painted this work, Strindberg traveled to Berlin, where he began to associate with a group of artists and writers that included Munch. Influenced by Strindberg's use of celestial photography (see p. 73, fig. 72), Munch adopted these theories in his painting *Starry Night* (p. 71, fig. 68), the first version of which was executed soon after his time with Strindberg in Berlin.[2]

1
Dante Gabriel Rossetti, quoted in Patricia McDonnell and Timothy R. Rogers, "Beata Beatrix," in Brown University Department of Art, *Ladies of Shalott: A Victorian Masterpiece and Its Contents*, exh. cat. (Bell Gallery, 1985), p. 140, cat. 39.

2
Virginia Surtees, *The Paintings and Drawings of Dante Gabriel Rossetti (1828–1882): A Catalogue Raisonné* (Clarendon Press, 1971), p. 95, cat. R3.

3
Thanks to Frank Høifødt for bringing the Muther illustration to our attention.

1
Per Hedström, "Strindberg as a Pictorial Artist: A Survey," in idem, *Strindberg: Painter and Photographer* (Yale University Press, 2001), pp. 9–102.

2
Lippincott 1988, pp. 42–45.

FRANZ VON STUCK
German, 1863–1928

Sin, c. 1893
P. 84, FIG. 84

FRITS THAULOW
Norwegian, 1847–1906

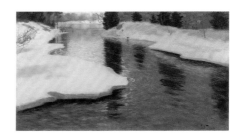

Melting Snow, 1887
P. 19, FIG. 14

Sin, first painted in 1893, earned Franz von Stuck celebrity status in fin-de-siècle Germany due to its titillating combination of religion and sexuality. The image, which the artist revisited in at least eleven paintings and numerous prints, depicts a darkly seductive Eve figure who is nude except for her long, enveloping hair and a gigantic, phallic snake that wraps around her and ultimately meets the viewer with a menacing gaze. A formative figure in the vanguard Munich Secession, Stuck spent much of his career exploring themes related to eroticism, morality, and women. While connected to the femme fatale iconography of contemporary artists such as Max Klinger (see p. 200) and Félicien Rops (see p. 206), these interests also constituted a reaction against the increasing censure, conservatism, and power of the Catholic Church in Munich.[1]

Sin was initially exhibited at the first annual Munich Secession in 1893 and gained immediate notoriety. Huge crowds assembled to view the painting during its initial exhibition, and later in Munich's Neue Pinakothek, for which it was immediately purchased. Thomas Mann registered the work's popularity in his novel *Gladius Dei* (1902), describing an image that stood in a shop window, "framed with exquisite taste in a gold frame.... A Madonna, completely modern and free of any conventions ... bared and beautiful ... [She was] a woman to drive you insane."[2] The large, gilt pillars of the frame containing the 1893 and 1895 versions reveal both Stuck's skilled craftsmanship and his keen interest in Greco-Roman art.

Sin was reproduced widely in contemporary periodicals and, in the early twentieth century, the subject's coyly smiling face was even included in an advertisement for mouthwash.[3] Its ubiquitous presence—as well as Stuck's immense fame—would have made *Sin* readily familiar to Munch, allowing its dark sensuousness to influence his own images of women.

Trained as both a landscape and marine painter, Frits Thaulow created an innovative, signature fusion of these two genres, which led him to be christened the "painter of the stream, the snow, and the night."[1] Because Norway had no formal school for advanced artistic training, in 1870 Thaulow traveled to Copenhagen to study at the Art Academy. During the early 1880s, he lived and worked in Paris with fellow Norwegians Christian Krohg (see p. 201) and Erik Werenskiold (see p. 210). Upon their return, the trio began to define and then promote a native school of painting combining French stylistic elements with identifiably Nordic imagery.

It was during his time in Paris that Thaulow encountered Impressionism, a style he came to enthusiastically advocate. Back in Norway, he founded a school of open-air painting in the small village of Modum, where Munch became his pupil. Thaulow's work was well received both at home and abroad, and was particularly sought-after in America.

Melting Snow, the most famous of his pictures, depicts the Lysaker River in the spring of 1887, as it gently flows through snow-covered banks toward the viewer. The bright blue and green hues epitomize the look of contemporary Norwegian blue mood painting. Thaulow created four renditions of the pastel, which were exhibited widely at venues including the 1887 Autumn Exhibition in Oslo, the prestigious Exposition Universelle held in Paris two years later, and the 1893 World's Columbian Exposition in Chicago, where the Art Institute's version was greatly admired.

1
Maria Makela, *The Munich Secession: Art and Artists in Turn-of-the-Century Munich* (Princeton University Press, 1990), p. 109.

2
As quoted in Edwin Becker, *Franz von Stuck, 1863–1928: Eros and Pathos*, exh. cat. (Van Gogh Museum, 1995), p. 19.

3
Gudrun Körner, "Sin and Innocence: Images of Women in the works of Franz von Stuck," in Ingrid Ehrhardt and Simon Reynolds, eds., *Kingdom of the Soul: Symbolist Art in Germany, 1870–1920*, exh. cat. (Prestel, 2000), p. 157.

1
Gabriel Mourey, "Fritz Thaulow: The Man and the Artist," *Studio* 11, 51 (1897), p. 7.

HENRI DE TOULOUSE-LAUTREC
French, 1864–1901

Jane Avril, 1893
P. 129, FIG. 134

FÉLIX VALLOTTON
Swiss, 1865–1925

The Funeral, 1891
P. 132, FIG. 139

Henri de Toulouse-Lautrec earned his reputation primarily through his many lithographic posters of Parisian cabarets and celebrities, images that functioned as both independent works of art and commercial advertisements. *Jane Avril* demonstrates this duality, as it was created to promote the performance of the artist's friend at one of the city's oldest dance halls, the Jardin de Paris. Commissioned by Avril herself, the work depicts the dancer kicking forward a leg that is suggestively clad in a black stocking. The uniformly beige stage serves as a contrast to the subject's vivid orange dress, yellow petticoats, and bright blonde hair. The frame, which emerges from the neck of the musician's contrabass, suggests both the entertaining atmosphere of the club and Avril's status as an object of public delectation, as the musician—along with the viewer—gazes up at her open skirts.[1]

Jane Avril is among the earliest images Toulouse-Lautrec created of the popular performer, whom he first met around 1893. Avril had a deep respect for the artist's work and requested that he create her publicity images whenever possible. In her memoirs, she credited this poster with launching her lengthy cabaret career.[2] Its titillating image, permissible only after moral standards for publicly displayed posters were relaxed in 1881, would have indeed drawn great attention to her sexual allure.[3] Such images, widely seen as crass in both subject matter and appearance, used the bold possibilities of color lithography to their advantage, attracting a wide and varied audience to the cabarets.[4] Munch would have likely known this print and others by Toulouse-Lautrec through their wide circulation and presence in dealer's shops, and through his friend and mentor Julius Meier-Graefe, who championed Toulouse-Lautrec's work as well as Munch's.

Although he is credited with renewing and inspiring widespread interest in the woodcut, Félix Vallotton was originally trained as a painter at the Académie Julian in Paris. He began to experiment with printmaking around 1888, hoping to alleviate his financial difficulties by creating etched copies after the Old Masters and popular Salon artists for use in illustrated journals.[1] He first turned to the woodcut around 1891, perhaps inspired by his friend, the Symbolist printmaker Charles Maurin, who had likewise shown interest in reviving, experimenting with, and ultimately expanding the medium's visual and technical vocabulary.[2] Additionally, the explosive popularity of Japanese woodblock prints had profound influence on artists in 1880s and 1890s Paris, inspiring the bold lines and vivid contrasts Vallotton favored.[3]

The Funeral exemplifies the way in which these technical influences combined with the artist's interest in representing modern urban life. The first of several such scenes, the print depicts a gravedigger laboriously lowering a coffin while a group of mourners look on. The agility of the work's icily clean and precise lines inspired critic and literary figure Octave Uzanne to use it as an illustration for an 1892 article in *L'Art et l'idée*, in which he praised Vallotton as the leader of the contemporary woodcut revival.[4] The artist's technical virtuosity was also singled out by the eminent German art historian and critic Julius Meier-Graefe, who published the first illustrated biography of Vallotton in 1898. Munch likely knew of both publications and, given his close friendship with Meier-Graefe, was undoubtedly influenced by Vallotton's stark graphic vocabulary and approach to morbid themes.

1
Mary Weaver Chapin, "Stars of the Café-Concert," in Richard Thomson, *Toulouse-Lautrec and Montmartre*, exh. cat. (National Gallery of Art, Washington, D.C., 2005), p. 139.

2
Claire Frèches-Thory, "*Jane Avril au Jardin de Paris*," in Hayward Gallery, *Toulouse-Lautrec*, exh. cat. (South Bank Centre/Réunion des Musées Nationaux, 1991), p. 298, cat. 83.

3
Douglas Druick and Peter Zegers, *La Pierre Parle: Lithography in France, 1848–1900*, exh. cat. (National Gallery of Canada, 1981), p. 78.

4
Jack Spector, "Between Nature and Symbol: French Prints and Illustrations at the Turn of the Century," in Philip Dennis Cate, *The Graphic Arts and French Society, 1871–1914* (Rutgers University Press, 1988), pp. 85–86.

1
Mary Anne Stevens, *The Graphic Work of Félix Vallotton, 1865–1925*, exh. cat. (Arts Council of Great Britain, 1976), p. 8.

2
Jacquelynn Baas, "Charles Maurin," in Jacquelynn Baas and Richard S. Field, *The Artistic Revival of the Woodcut in France, 1850–1900*, exh. cat. (University of Michigan Museum of Art, 1984), p. 84.

3
Regarding the influence of Japanese prints on Vallotton, see Siegfried Wichmann, "Vallotton's Woodcuts and the Orient," in idem, *Japonisme: The Japanese Influence on Western Art in the 19th and 20th Centuries*, trans. Mary Whittall et al. (Harmony, 1981), pp. 70–73.

4
Octave Uzanne, "La Renaissance de la gravure sur bois—un néo-xylographe: M. Félix Vallotton," *L'Art et l'idée* 1, 2 (Feb. 1892), pp. 112–19.

ERIK WERENSKIOLD
Norwegian, 1855–1938

In Familiar Surroundings, 1882
P. 25, FIG. 22

JAMES MCNEILL WHISTLER
American, 1834–1903

Valparaiso Harbor, 1866
P. 40, FIG. 36

Created after the artist's enthusiastic viewing of the Second Impressionist Exhibition in Paris, *In Familiar Surroundings* demonstrates Erik Werenskiold's interest in plein-air practice and indigenous settings. Here, his fashionably dressed fiancée, Sophie Thomesen, stands in the midst of an untamed landscape, where plants intertwine with the rocky, distinctively Norwegian terrain. The palette is dominated by the color green, which the artist favored during the 1880s. Two worn white chairs distinguish the setting as a garden—specifically one at the Thomesen family home in southern Norway—and suggest, as the title states, that this place is comfortable and familiar.[1]

Werenskiold was first exposed to French art upon moving to Paris in 1881, after studying at the Munich Art Academy. A year later, he wrote of his enthusiasm for practitioners such as Gustave Caillebotte (see p. 190) and Claude Monet (see p. 203) in his essay "The Impressionists," published in the Norwegian journal *Nyt Tidsskrift* (see p. 24). In this text, he attempted to promote the style in Scandinavia, describing Impressionism's immediacy as "only proper; since painting should make its impact by illusion … [and] make an impression corresponding as closely as possible to that of Nature herself."[2] In 1883, he returned to Norway and began—through both his writings and works such as this—to encourage the development of a national art that synthesized French style with distinctively Nordic content. The motif of a single female figure in landscape was later adapted by Munch, who knew Werenskiold well.

Valparaiso Harbor is one of a group of three works that James McNeill Whistler may have created as a result of his time in Chile. The artist traveled widely throughout his life, and, as a result, his paintings often combined elements of the various cultures he experienced. Born in the United States, he spent much of his education and career in Europe and regretted that he had not volunteered to fight in the Civil War.[1] In 1866, when Whistler heard about the Chileans' struggle to maintain independence from Spain, he traveled to assist them. The natural landscape he encountered inspired him and became the subject of *Valparaiso Harbor*.

Upon arriving in Valparaiso, located on the southernmost tip of Chile, Whistler began to create seascapes that captured the foggy effects produced by the convergence of cold and warm air—and amplified by the smoke left after Spain's bombardment of the coast.[2] In *Valparaiso Harbor*, he depicted several ships near one of the city's piers, using a singular viewpoint that evokes Japanese woodblock prints. The artist had first become acquainted with their flattened perspective technique at the 1862 International Exhibition in London, gradually incorporating it into his paintings. The dramatic composition of *Valparaiso Harbor*, as well as its blue tones, contrasting yellow-browns, and hazy atmosphere, clearly influenced Munch's *Seine at St. Cloud* (p. 41, fig. 37). In fact, *Nocturne in Blue and Gold: Valparaiso Bay* (1866; Freer Gallery of Art, Washington, D.C.), to which this work is related, was exhibited at the 1890 Salon, where Munch could have seen it.

1
Mareike Henning, "*In Familiar Surroundings*," in Sabine Schulze, ed., *The Painter's Garden: Design, Inspiration, Delight*, exh. cat. (Städel Museum/Hatje Cantz, 2006), p. 176, cat. 64.

2
As quoted in Messel 2002, p. 212.

1
Richard Dorment, "Valparaiso," in Richard Dorment and Margaret F. MacDonald, *James McNeill Whistler*, exh. cat. (Tate Gallery Publications, 1994), p. 115.

2
Katherine Emma Manthorne, *Tropical Renaissance: North American Artists Exploring Latin America, 1839–1879* (Smithsonian Institution Press, 1989), p. 165.

ANDERS LEONARD ZORN
Swedish, 1860–1920

Fisherman at St. Ives, 1891
P. 149, FIG. 161

While an accomplished painter, Anders Zorn was also highly regarded as a printmaker. The intense, activated lines he created with his etcher's needle were praised for their primitive appearance, reflecting the common perception that Scandinavian artists drew from a deep well of indigenous, raw energy.[1] *Fisherman at St. Ives* demonstrates Zorn's free, impulsive style in its quick yet skillful rendering. In the image, a couple stands on the edge of a bridge, facing the open sea while the sun sets in the distance. The female subject's presence is overlooked in the title, perhaps suggesting the relative insignificance of women to what was then considered a solely male profession.

Zorn constructed *Fisherman at St. Ives* entirely of conspicuous individual strokes that he varied in direction, intensity, and length to create dramatic contrasts. He had developed this technique in the 1880s, while studying in London. He started his training at Stockholm's Royal Academy of Arts but became frustrated with the emphasis placed on the Old Masters and left for England, which was a center for the contemporary etching revival fueled by the work of artists such as Francis Seymour Haden and James McNeill Whistler. After moving to Paris in 1887, Zorn was inspired by the work of the late Édouard Manet, emulating his practice of creating form through the use of dynamic lines rather than crosshatching.[2] Employing this technique, the artist executed numerous etched reproductions of his own canvases. *Fisherman at St. Ives*, for instance, records an oil painting of the same title, which had received an honorable mention at the 1888 Salon. Zorn's prints were widely circulated, and Munch would have undoubtedly encountered them, inspiring him to describe his admiration for "the force which spills from his work and . . . the great genius spread generously through his art."[3]

1
Elizabeth Broun, *The Prints of Anders Zorn*, exh. cat., (Spencer Museum of Art, University of Kansas, 1979), p. 18.

2
Ibid., p. 16.

3
As quoted in ibid., p. 20.

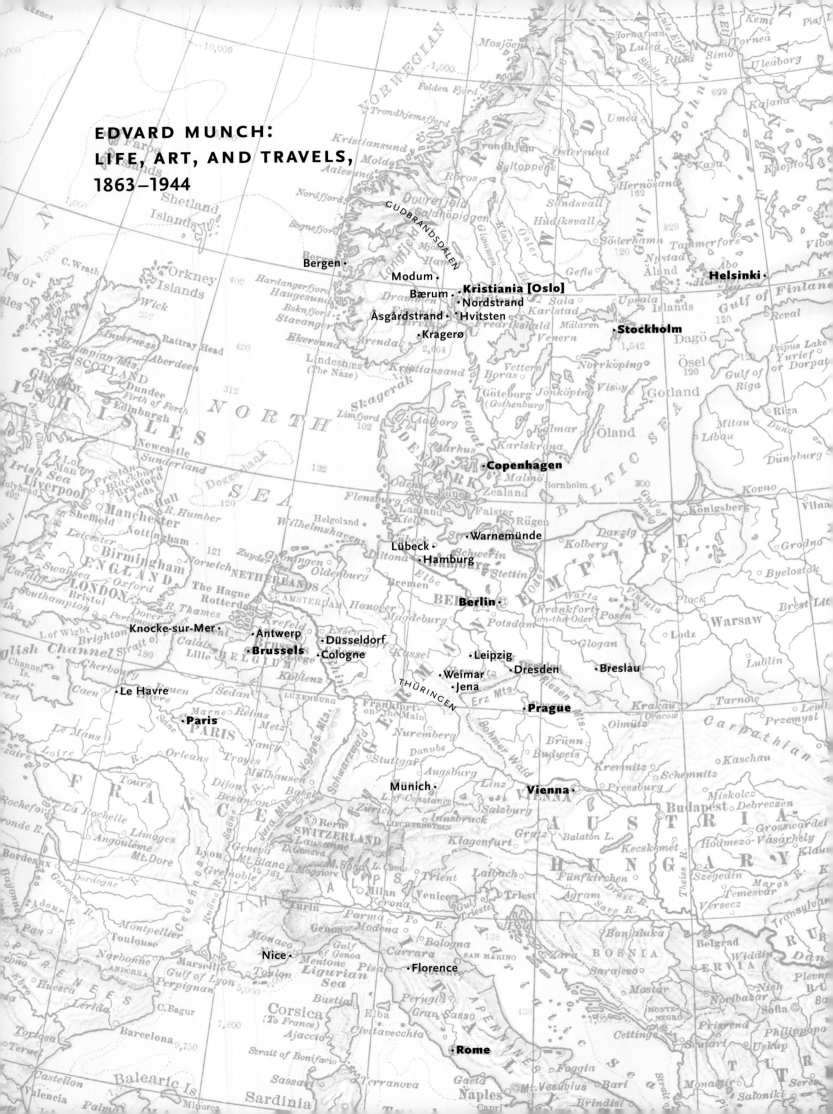

EDVARD MUNCH:
LIFE, ART, AND TRAVELS,
1863–1944

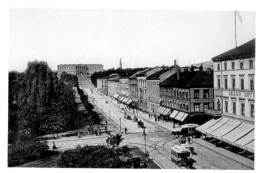

Postcard of Karl Johan Street, Kristiania, showing the Royal Palace in the distance, c. 1890. Bymuseum, Oslo.

Pultosten Building on Stortingsplass, Kristiania, where Munch rented studio space in fall 1882. Munch Museum, Oslo.

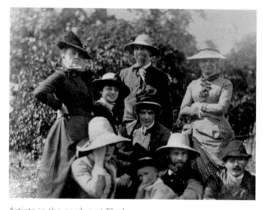

Artists in the garden at Fleskum, 1886. Front, from left: Sophie Werenskiold, Sigrun Munthe, Erik Werenskiold and son Werner, Eilif Peterssen. Back, from left: Kitty Kielland, Maggie Skredsvig, Christian Skredsvig, Agathe Backer Grøndahl. The National Museum of Art, Architecture and Design, Oslo.

Born on December 12 near Løten, Hedmark County, Norway	**1863**
Family moves to Kristiania (renamed Oslo in 1924), where his father, Christian, continues to work as an army doctor	**1864**
Mother, Laura Cathrine, dies of tuberculosis; her sister, Karen Bjølstad, assumes management of the household	**1868**
Leaves the Cathedral School due to illness and starts home schooling; also begins to visit the Kristiania Art Association and its exhibitions	**1875**
Older sister Sophie dies of tuberculosis at age 15	**1877**
Trains as an architect at the Royal Technical College before he decides to become a painter and enrolls in the Royal School of Design	**1879–81**
Rents space in the Pultosten building, which also housed the studios of progressive artists Christian Krohg, Frits Thaulow, and Erik Werenskiold. His work is supervised and corrected by Krohg	**1882**
First Autumn Exhibition organized in opposition to the conservatism of the Kristiania Art Association	
Attends painter Frits Thaulow's Open-Air Academy in Modum	**1883**
Shows his first painting at the Autumn Exhibition, Kristiania	
Begins to associate with Kristiania's bohemian community, which includes the avant-garde of Norway's naturalistic artists and writers	**1884**
Spends the month of September at Modum	
Awarded the Schäffer Bequest Fund but is too ill to travel to Paris	
In May, travels to Paris via Antwerp, where he shows in the Norwegian section of the World's Fair	**1885**
Stays in Paris for three weeks, studying at the Musée du Louvre and visiting exhibitions	
Meets the married Milly Thaulow, with whom he begins an affair	
Hans Jaeger publishes the scandalous *From the Kristiania Bohemians*	
Moves closer to the Kristiania bohemians and their leader, Jaeger	**1886**
Exhibits four paintings in the Autumn Exhibition, including *The Sick Child*, which rouses a storm of controversy	
The Fleskum Summer: Norwegian artists, including Eilif Peterssen and Erik Werenskiold, gather at a farm in Bærum, exploring the potential of blue mood painting	

1888	Shows three works at the *Nordic Exhibition of Industry, Agriculture, and Art* in Copenhagen and visits its large-scale display of modern French art

1889 Holds first solo exhibition in Kristiania, for which he charges an entrance fee

Spends the summer in a rented cottage in Åsgårdstrand

Receives state scholarship and travels to Paris in October; studies at the atelier of Léon Bonnat and meets the circle of avant-garde painters around Theo van Gogh

Returns to Norway in November, following the death of his father

Moves back to Paris in early December; soon relocates to suburban St. Cloud

Forms an intense friendship with the Danish poet Emanuel Goldstein

The Munch family at their rented cottage in Åsgårdstrand, 1889. Edvard paints at his easel while his sisters Inger and Laura stand at the gate and the door, respectively. Munch Museum, Oslo.

1890 Writes the "St. Cloud Manifesto"

Summers in Åsgårdstrand and Kristiania

Exhibits three paintings in the Autumn Exhibition, Kristiania

Receives a second state scholarship and returns to France in November, staying at Le Havre due to illness

1891 Leaves Le Havre early in the year for Nice, traveling to Paris at the end of April

Returns to Norway via Antwerp at the end of May, spending the summer in Åsgårdstrand

Exhibits three paintings in the Autumn Exhibition, Kristiania

Receives third state scholarship

In autumn, returns via Copenhagen to Paris

Travels to Nice in December

Studio of Léon Bonnat, Paris, March 1890. Munch began his studies with Bonnat the previous autumn. Munch Museum, Oslo.

1892 Leaves Nice at the beginning of April, traveling to Norway with a short stop in Paris

Summers in Åsgårdstrand and Kristiania

Second solo exhibition at the Tostrup Building, Kristiania, prompts an invitation to show in Berlin

In November, solo exhibition opens at the Verein Berliner Künstler; closed a week later following a debate and vote by members of the Artists' Association. Exhibits his own version of the Verein show over the course of a year in Düsseldorf, Cologne, again in Berlin, Breslau, Dresden, and Munich

Postcard of the Hôtel-Restaurant du Belvédère, St. Cloud. Munch and his friend Emanuel Goldstein lodged on the second floor in early 1890. Munch Museum, Oslo.

Munch's postcard of Unter der Linden, Berlin, sent to his aunt Karen Bjølstad c. 1904. Munch Museum, Oslo.

Poster from Munch's exhibition at Ugo Barroccio's gallery at Under den Linden 16, Berlin, 1895. Munch Museum, Oslo.

In Berlin, frequents the bohemian Black Piglet Café with friends Dagny Juel, Stanislaw Przybyszewski, and August Strindberg

Based in Berlin · 1893

Exhibits in Copenhagen in February and March; while there, he may have seen the Free Exhibition, which showed major works by Gauguin and Van Gogh

Spends September and October in Norway

The Frieze of Life begins to take shape

Based in Kristiania · 1894

The Work of Edvard Munch: Four Contributions, edited by Stanislaw Przybyszewski, is published in Berlin

Spends September in Stockholm for his first Swedish exhibition, which later travels to Berlin

Produces his first intaglio prints

Exhibits with the Finnish artist Akseli Gallen-Kallela at the Ugo Barroccio Gallery, Berlin · 1895

Julius Meier-Graefe publishes a portfolio of eight intaglio prints by Munch

Summers in Nordstrand and Åsgårdstrand

Large exhibition at the Blomqvist Gallery, Kristiania, culminates in a public debate on Munch's sanity

Brother Andreas dies

Exhibits at the Salon des Indépendants · 1896

Stages a solo exhibit at Siegfried Bing's Salon de l'Art Nouveau, Paris

Spends August at the Belgian resort of Knocke-sur-mer

Back in Paris, where he creates decorations for Ibsen's *Peer Gynt* and illustrations for Baudelaire's *Flowers of Evil*, and creates his first color lithographs and woodcuts

In July, paints the decorative panel *Mermaid* (p. 76, fig. 75) for Axel Heiberg's home in Lysaker, near Kristiania

In March, travels to Brussels, where he participates in an exhibition at the artistic society La Libre Esthétique · 1897

Travels back to Paris in April, where he shows work in the Salon des Indépendants

Returns to Norway in June, and in July buys his own house in Åsgårdstrand

In September, opens a major retrospective exhibition at Dioramalokalet, Kristiania

1898 Spends March and April in Berlin; in May, returns to Paris, where he participates at the Salon des Indépendants

Summers in Åsgårdstrand

Meets Tulla Larsen, with whom he begins a tumultuous relationship

Travels extensively throughout Europe, pursued by Larsen

1899 In January, illustrates a special issue of the journal *Quickborn* containing text by Strindberg

In April, journeys to Florence via Berlin, Paris, and Nice, spending May in Rome

Summers in Nordstrand and Åsgårdstrand

During the fall and winter, retreats to the sanatorium at Kornhaug, in the Gudbrandsdalen region of Norway

1900 In March, travels back to Berlin, then to Paris, Dresden, Italy, and Switzerland, continuing and finally seeking to end his entanglement with Larsen

Returns to Norway alone in November, settling in Nordstrand

1901 Summers in Åsgårdstrand

In October, exhibits 106 works at the Hollaendergården in Kristiania, returning to Berlin in November

1902 Spends the winter and spring in Berlin, where he shows the complete *Frieze of Life* at the Berlin Secession; the exhibition is expanded to include prints and travels to Leipzig the following year

Introduced to the Lübeck physician Max Linde, who writes a book on his art and commissions him to produce the print portfolio *From Max Linde's House*

Summers in Åsgårdstrand

Is shot in the left hand as he attempts to terminate his liaison with Tulla Larsen

Introduced to the Hamburg collector and lawyer Gustav Schiefler, who starts working on a catalogue of all his prints

1903 Winters in Berlin and returns to Paris in March; there, he joins the Société des Artistes Indépendants

Munch's panel *Mermaid* (p. 76, fig. 75) installed in collector Axel Heiberg's home in Lysaker, near Kristiania. Munch Museum, Oslo.

Munch and Tulla Larsen, 1899. Munch Museum, Oslo.

Munch's studio at Lützowstrasse
82, Berlin, 1902. Visible to the
left of the door is *Girls on the Pier*.
Munch Museum, Oslo.

The Frieze of Life installed at P. H.
Beyer and Son, Leipzig, 1903.
Visible from left to right are *Red
Virginia Creeper*, *The Scream*,
Anxiety, *Evening on Karl Johan*,
Death in the Sickroom, *At the
Deathbed*, and *The Dead Mother
and Her Child*. Munch Museum,
Oslo.

Meets the English violinist Eva Mudocci, who becomes
a close friend and muse

Summers in Åsgårdstrand

Spends April and September in Lübeck, painting portraits
of Linde and his four sons

Winters in Berlin; exhibits twenty paintings at the Vienna
Secession

Travels to Paris in February for the Salon des Indépendents

Signs exclusive contracts with the Hamburg dealer
Commeter for the sale of his paintings, and with the
publisher Bruno Cassirer for the German sale of his
graphic work

Stays in Weimar from the beginning of March into April,
painting a portrait of his friend and patron Harry Kessler
and a posthumous portrait of the philosopher
Friedrich Nietzsche

Summers in Åsgårdstrand

Commissioned to paint a frieze (ultimately rejected) for the
nursery in Linde's house

During February and March, stages successful exhibition in
Prague at the invitation of the Secessionist Mánes group

Returns to Åsgårdstrand in June but departs in July, spending
the fall in Denmark and Germany

In November, takes the cure at spas in the Thüringen area
of Germany, trying to overcome his anxiety and alcoholism

Stays in Thüringen until summer, when he travels to Berlin,
Weimar, and Jena, executing portrait commissions and
creating design sketches for theater impresario Max Reinhardt's
production of Ibsen's *Ghosts*

Retreats to Thüringen in November

Winters in Berlin, where he works on new decorations for
Max Reinhardt's theater

In April, travels to Stockholm, where the Swedish collector
Ernst Thiel buys many paintings

Terminates contracts with Commeter and Cassirer

Stays for the summer and fall in Warnemünde, a German
resort on the Baltic Sea

Winters in Berlin; returns to Warnemünde in March,
remaining through the summer

1904

1905

1906

1907

1908

Longtime supporter Jens Thiis, now director of Norway's National Gallery, purchases Munch's work for the museum, as does Rasmus Meyer, an important collector from Bergen

Travels to Copenhagen in the autumn; there, admits himself to Dr. Daniel Jacobson's clinic, where he remains for eight months, all the while orchestrating exhibitions in Denmark, Germany, Norway, and Sweden

Receives Norway's Royal Order of Saint Olav

1909 Resides at Jacobson's clinic during the winter and spring

Returns to Norway in May, settling in Kragerø

Begins design work on decorations for the University of Kristiania Festival Hall, known as the Aula

1910 Seeking more room to work and store his paintings, buys the Nedre Ramme estate at Hvitsten, where he continues to work on the Aula decorations

1911 Resides at Hvitsten for most of the year, spending the fall and winter in Kragerø

Wins the Aula competition

1912 Accorded a place of honor at the seminal Sonderbund exhibition in Cologne, which focused on the work of Expressionists and their predecessors

1913 Spends fall in his homes at Kragerø, Hvitsten, and the newly rented Grimsröd Manor in Jeløya

1914 In winter, journeys to Paris and Berlin

In May, the University of Kristiania accepts the Aula decorations after years of discussions and conflicts

Summers in Kragerø and Hvitsten

1915 Begins to curtail his travel due to the events of World War I but gives financial aid to German artists

1916 Buys a small estate at Ekely, near Kristiania, where he spends most of his time up to his death

The Aula decorations are unveiled

1918 Stages an exhibition at Blomqvist in Kristiania, where he revisits *The Frieze of Life* and publishes a pamphlet defending his work and taking Norwegian critics to task for their early neglect

1922 Paints murals for the workers' dining room at the Freia Chocolate Factory, Kristiania

Travels to Germany and Switzerland

Munch's postcard from Warnemünde, sent to his aunt Karen Bjølstad, 1907. Munch Museum, Oslo.

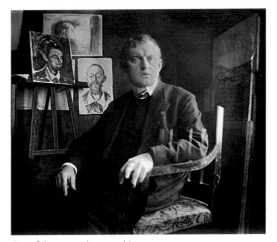

One of the many photographic self-portraits Munch took in Dr. Daniel Jacobson's clinic, Copenhagen, 1908. The artist displays his damaged left hand prominently. Munch Museum, Oslo.

57
The Sick Child I, 1896
Transfer lithograph printed from four
stones in black, dark gray, red, and
light yellow ink on ivory China paper
Image: 41 × 57 cm (16 9/16 × 22 7/16 in.)
Sheet: 44.5 × 58.4 cm (17 1/2 × 23 in.)
Collection of Catherine Woodard
and Nelson Blitz, Jr.
Woll 72
P. 139, FIG. 149

58
Vampire II, 1896
Lithograph printed from two stones
in black and red-brown ink with
woodcut printed from one block
(sawn into four sections) in tan,
blue, and blue-black ink on cream
Japanese paper
Image: 38.3 × 55 cm (15 1/8 × 21 11/16 in.)
Sheet: 40.6 × 57.2 cm (16 × 22 1/2 in.)
Collection of Catherine Woodard
and Nelson Blitz, Jr.
Woll 41
P. 125, FIG. 126

59
Young Woman on the Beach, 1896
Burnished aquatint and drypoint
in purple, blue, gray, and yellow,
inked à la poupée, on cream laid
Arches paper
Plate: 28.7 × 21.8 cm (11 1/4 × 8 1/2 in.)
Sheet: 44.5 × 31 cm (17 1/2 × 12 1/4 in.)
The Art Institute of Chicago, Clarence
Buckingham Collection, 1969.252
Woll 49 i/vii
P. 143, FIG. 152

60
The Kiss, 1896/97
Oil on panel
38.5 × 31 cm (15 1/8 × 12 3/16 in.)
Private collection, courtesy Galleri
Kaare Berntsen, Oslo
EM 397
P. 103, FIG. 103

61
Funeral March, 1897
Zincograph in black ink on grayish
ivory China paper
Image: 37.5 × 55.6 cm (14 3/4 × 21 7/8 in.)
Sheet: 59.8 × 42 cm (23 9/16 × 16 9/16 in.)
National Gallery of Art, Washington,
D.C., gift of The Epstein Family
Collection 2006, 2006.51.4
Woll 103 only state
P. 162, FIG. 174

62
Metabolism, 1897
Lithograph in black ink on cream
wove paper
Image: 36 × 24.5 cm (14 1/8 × 9 5/8 in.)
Sheet 50.2 × 32.7 cm (19 3/4 × 12 7/8 in.)
Munch Museum, Oslo, MMG 227-1
Woll 104 only state
P. 162, FIG. 173

63
Mystical Shore, 1897
Woodcut printed from two blocks
in dark blue, light blue, orange, and
green ink on cream wove paper
Image: 37.2 × 57 cm (14 5/8 × 22 7/16 in.)
Sheet: 37.9 × 58.3 cm (14 15/16 × 22 15/16 in.)
Harvard Art Museum, Fogg Art
Museum, Gray Collection of
Engravings Fund, G8856
Woll 117 iv/v c
P. 151, FIG. 164

64
Towards the Forest I, 1897
Woodcut printed from two blocks
(one sawn into three sections)
in black, blue, and brownish orange
ink on ivory Japanese paper
Image: 52.3 × 64.4 cm
(20 5/8 × 25 3/8 in.)
Sheet: 54.6 × 66 cm (21 1/2 × 26 in.)
Collection of Catherine Woodard
and Nelson Blitz, Jr.
Woll 112
P. 150, FIG. 163

65
Blossom of Pain, 1898
Woodcut printed from one block in
blue, red, and green ink on ivory laid
paper
Image: 45.9 × 32.8 cm (18 × 12 7/8 in.)
Sheet: 65 × 47.8 cm (25 5/8 × 18 7/8 in.)
Munch Museum, Oslo, MMG
586-12
Woll 130 only state
P. 62, FIG. 60

66
Melancholy II, 1898
Woodcut printed from one block
(sawn into three sections)
in black, dark green, and red ink
on cream wove paper
Image: 33 × 42.2 cm (13 × 16 5/8 in.)
Sheet: 33.5 × 54 cm (13 1/4 × 21 1/4 in.)
Epstein Family Collection
Woll 132 only state
P. 151, FIG. 167

67
Two Women on the Shore, 1898
Woodcut printed from one block
(sawn into three sections) in dark
blue, green, black, and red-brown
ink with additions in green crayon
on cream Japanese paper
Image: 45.6 × 51.4 cm (18 × 20 1/4 in.)
Sheet: 53.6 × 59.8 cm (21 1/8 × 23 1/2 in.)
The Art Institute of Chicago, Clarence
Buckingham Collection, 1963.293
Woll 133 ii/iv2b
P. 151, FIG. 166

68
Ashes II, 1899
Lithograph in black ink with
additions in brush and blue, red,
yellow, purple, and orange
watercolor on tan wove paper
Image: 35.2 × 45.2 cm (13 7/8 × 17 3/4 in.)
Sheet: 42.3 × 52.8 cm (16 5/8 × 20 3/4 in.)
Private collection
Woll 146 ii/ii 2
P. 140, FIG. 150

69
Boys Bathing, 1899
Woodcut printed from two blocks
(one sawn into two sections) in
blue, green, and light orange ink on
cream card
Image: 38 × 44.8 cm (15 × 17 5/8 in.)
Sheet: 46.5 × 60.1 cm (18 1/4 × 23 5/8 in.)
The Art Institute of Chicago, Clarence
Buckingham Collection, 1963.296
Woll 150 ii/ii
P. 173, FIG. 191

70
Man Bathing, 1899
Woodcut printed from two blocks
in blue, green, and orange ink on
a grayish ivory card
Image: 44.4 × 44.4 cm (17 1/2 × 17 1/2 in.)
Sheet: 48.7 × 66.2 cm (19 1/8 × 26 1/8 in.)
The Art Institute of Chicago, Clarence
Buckingham Collection, 1963.295
Woll 149 ii/iv
P. 173, FIG. 192

71
*Two Human Beings: The Lonely
Ones*, 1899
Woodcut printed from one block
(sawn into three sections) in
black and blue-gray ink on ivory
Japanese paper
Image: 39.3 × 54.6 cm (15 1/2 × 21 1/2 in.)
Sheet: 41.9 × 57.2 cm (16 1/2 × 22 1/2 in.)
Collection of Catherine Woodard
and Nelson Blitz, Jr.
Woll 157
P. 149, FIG. 160

72
*Woman's Head against the
Shore*, 1899
Woodcut printed from two blocks
(each sawn into two sections)
in light green, orange, blue-green,
and red-brown ink on ivory
Japanese paper
Image: 46.5 × 41.1 cm (18 1/4 × 16 1/8 in.)
Sheet: 59.5 × 47 cm (23 3/8 × 18 1/2 in.)
The Art Institute of Chicago, Clarence
Buckingham Collection, 1962.84
Woll 152 ii/ii
P. 151, FIG. 165

73
Dance of Life, 1899 / 1900
Oil on canvas
125 × 191 cm (49 1/4 × 74 3/4 in.)
The National Museum of Art,
Architecture and Design, Oslo,
NG.M.00941
EM 464
P. 158, FIG. 170

74
The Empty Cross, 1899 / 1901
Black ink with additions in brush and
red watercolor on cream wove paper
45.2 × 49.9 cm (17 3/4 × 19 5/8 in.)
Munch Museum, Oslo, MMT 2547-57
P. 165, FIG. 178

75
Golgotha, 1900
Oil on canvas
80 × 120 cm (31 1/2 × 47 1/4 in.)
Munch Museum, Oslo, MMM 36
EM 465
P. 165, FIG. 179

76
The Island, 1900/01
Oil on canvas
99 × 108 cm (39 × 42 1/2 in.)
Private collection
EM 471
P. 163, FIG. 175

77
The Dead Mother and Her Child, 1901
Etching with open bite and
drypoint in black ink on heavyweight
cream wove paper
Plate: 32.3 × 49.4 cm (12 3/4 × 19 1/2 in.)
Sheet: 42.1 × 58.6 cm (16 5/8 × 23 1/8 in.)
The Art Institute of Chicago,
the William McCallin McKee
Memorial Collection, 1944.591
Woll 163 ii/ii
P. 107, FIG. 108

78
The Kiss IV, 1902
Woodcut printed from two blocks
(one sawn into two sections) in
gray-brown and black ink on cream
Japanese paper
Image: 47.1 × 47.2 cm (18 1/2 × 18 1/2 in.)
Sheet: 52.5 × 49.4 cm (20 5/8 × 19 1/2 in.)
The Art Institute of Chicago, Clarence
Buckingham Collection, 1963.292
Woll 204 iv/iva3
P. 153, FIG. 168

79

The Kiss IV, 1902
Woodcut printed from two blocks
(one sawn into two sections) in
gray and black ink on heavyweight
cream wove paper
Image: 46.7 × 48.2 cm (18³/₈ × 19 in.)
Jim and Kay Mabie
Woll 204 iv/iva3
P. 153, FIG. 169

80

*Woman with Red Hair and Green
Eyes: The Sin*, 1902
Transfer lithograph printed from two
stones in yellow, reddish brown,
and green ink on lightweight cream
semitransparent wove paper
Image: 70 × 40.3 cm (27¹/₂ × 15⁷/₈ in.)
Sheet: 77.8 × 48.1 cm (30⁵/₈ × 18⁷/₈ in.)
The Art Institute of Chicago,
Robert A. Waller Fund, 1950.1457
Woll 198 ii/v2
P. 141, FIG. 151

81

*Trees and Garden Wall in
Åsgårdstrand*, 1902/04
Oil on canvas
99 × 103.5 cm (39³/₄ × 41⁵/₈ in.)
Musée d'Orsay, Paris, 1986, R.F.
1986-58
EM 537
P. 72, FIG. 70

82

Salome, 1903
Lithograph in black ink on light-
weight laid buff paper
Image: 39.8 × 30.5 cm (15⁵/₈ × 12¹/₈ in.)
Sheet: 59.8 × 43.5 cm (23¹/₂ × 17¹/₈ in.)
Print Collection, Miriam and Ira D.
Wallach Division of Art, Prints and
Photographs, Photography Collection,
The New York Public Library, Astor,
Lenox, and Tilden Foundations
Woll 245 only state
P. 81, FIG. 80

83

Bathing Young Men, 1904
Oil on canvas
194 × 290 cm (76³/₈ × 114¹/₈ in.)
Munch Museum, Oslo, MMM 901
EM 589
P. 175, FIG. 195

84

Bathing Boys, 1904/05
Oil on canvas
57.4 × 68.5 cm (22⁵/₈ × 27 in.)
Private collection
EM 592
P. 177, FIG. 199

85

Self-Portrait in Moonlight, 1904/06
Woodcut printed from one block
in blue and black ink on cream
wove paper
Image: 75.4 × 42.3 cm (29⁵/₈ × 16⁵/₈ in.)
Sheet: 80 × 57.1 cm (31¹/₂ × 22¹/₂ in.)
The Art Institute of Chicago,
Clarence Buckingham Collection,
1963.290
Woll 251 only state
P. 179, FIG. 200

86

Sun, 1912
Oil on canvas
123 × 176.5 cm (48³/₈ × 69¹/₂ in.)
Munch Museum, Oslo, MMM 822
EM 1019
P. 183, FIG. 205

87

Sunbathing I, 1915
Woodcut printed from two blocks
in pink, orange, red, yellow, yellow-
green, blue, green, and brown ink
on heavyweight cream wove paper
Image: 35.1 × 57.4 cm (13⁷/₈ × 22⁵/₈ in.)
Sheet: 55.2 × 73.1 cm (21³/₄ × 28³/₄ in.)
The Art Institute of Chicago, Clarence
Buckingham Collection, 1963.309
Woll 536 vi/xi
P. 185, FIG. 207

ANNA ANCHER
Danish, 1859–1935

88

A Funeral, 1891
Oil on canvas
103.5 × 124.5 cm (40³/₄ × 49 in.)
Statens Museum for Kunst,
Copenhagen, KMS 1433
P. 105, FIG. 105

HARRIET BACKER
Norwegian, 1845–1932

89

By Lamplight, 1890
Oil on canvas
64.7 × 66.5 cm (25¹/₂ × 26¹/₈ in.)
The Rasmus Meyer Collection,
The Bergen Art Museum, RMS.M.20
P. 39, FIG. 35

ALBERT BESNARD
French, 1849–1934

90

Love, c. 1886
Etching and drypoint in black ink on
cream Japanese paper
Image: 31.7 × 24.8 cm (12¹/₂ × 9³/₄ in.)
Sheet: 39.5 × 31 cm (15¹/₂ × 12¹/₄ in.)
The Art Institute of Chicago, Albert
H. Wolf Memorial Collection, 1926.164
Delteil 48 ii/iii
P. 55, FIG. 56

ARNOLD BÖCKLIN
Swiss, 1827–1901

91

In the Sea, 1883
Oil on panel
86.5 × 115 cm (34³/₈ × 45³/₄ in.)
The Art Institute of Chicago,
the Joseph Winterbotham Collection,
1990.443
Andree 376
P. 77, FIG. 76

GUSTAVE CAILLEBOTTE
French 1848–1894

92

Paris Street, Rainy Day, sketch, 1877
Oil on canvas
54 × 65 cm (21¹/₄ × 25⁵/₈ in.)
Musée Marmottan Monet, Paris, 5062
Berhaut 1994, 56
P. 43, FIG. 41

JEAN CHARLES CAZIN
French, 1841–1901

93

Ulysses after the Shipwreck, 1880/84
Oil on canvas
73.3 × 59.7 cm (28⁷/₈ × 23¹/₂ in.)
Tate: Presented by Arthur R.
Anderson, 1927, L694
P. 17, FIG. 10

PAUL CÉZANNE
French, 1839–1906

94

Bather, Seen from the Back, 1879/82
Oil on canvas
31.7 × 21.6 cm (12¹/₂ × 8¹/₂ in.)
The Art Institute of Chicago,
Brooks McCormick Estate, 2007.289
Rewald 452
P. 177, FIG. 198

95

The Bathers, 1896/98
Lithograph printed from seven
stones in black, blue, pale gray,
green, yellow, beige, orange, and
pink ink on ivory laid paper
Image: 42.2 × 52.8 cm (16⁵/₈ × 20³/₈ in.)
Sheet: 46.4 × 56.9 cm (18¹/₄ × 22³/₈ in.)
The Art Institute of Chicago,
William McCallin McKee Memorial
Fund, 1932.1297
Cherpin iii/iii
P. 177, FIG. 197

GEORGE CLAUSEN
English, 1852–1944

96

Schoolgirls, Haverstock Hill, 1880
Oil on canvas
52.1 × 77.2 cm (20¹/₂ × 30³/₈ in.)
Yale Center for British Art,
Paul Mellon Collection, B1885.10.1
P. 43, FIG. 42

HENRI DE GROUX
Belgian, 1867–1930

97

Christ among His Tormentors,
1894/98
Pastel over lithograph in black ink
with additions in crayon and
graphite on cream wove Canson
and Montgolfier paper
59.3 × 81.4 cm (23³/₈ × 32 in.)
The Art Institute of Chicago,
Mr. and Mrs. Robert Hixon Glore
Fund, 1997.414
P. 167, FIG. 182

CHARLES MARIE DULAC
French, 1865–1898

98

The Fish, 1893
Lithograph in brown ink on pale
green lightweight wove paper laid
down on tan wove paper (chine collé)
Image/sheet: 50.4 × 33.5 cm
(19⁷/₈ × 13¹/₄ in.); support: 64.5 ×
49.5 cm (25³/₈ × 19¹/₂ in.)
S. P. Avery Collection, Print Collection,
Miriam and Ira D. Wallach Division
of Art, Prints and Photographs, the
New York Public Library, Astor, Lenox
and Tilden Foundations
P. 131, FIG. 137

MAGNUS ENCKELL
Finnish, 1870–1925

99
The Awakening, 1894
Oil on canvas
113 × 85.5 cm (44¹/₂ × 33⁵/₈ in.)
Ateneum Art Museum, Finnish
National Gallery, Helsinki,
Antell Collection, A II 787
P. 87, FIG. 89

JAMES ENSOR
Belgian, 1860–1949

100
Christ Tormented, 1888
Oil on linen
55.3 × 70.2 cm (21⁷/₈ × 27⁵/₈ in.)
Mildred Lane Kemper Art
Museum, Washington University,
St. Louis, bequest of Morton J.
May, 1968, WU 4391
Tricot 277
P. 166, FIG. 180

101
Christ Tormented by Demons, 1895
Etching in black ink with additions in
brush and orange-red, blue, yellow,
and pink watercolor and pink,
orange, and blue crayon on cream
wove paper (discolored to tan)
Plate: 17.9 × 24.3 cm (7 × 9¹/₂ in.)
Sheet: 35.6 × 47.7 cm (14 × 18³/₄ in.)
The Art Institute of Chicago,
restricted gift of Dr. Eugene Solow,
1975.499
Tavernier 94 only state
P. 167, FIG. 181

102
The Intrigue, 1911
Oil on canvas
94.6 × 112.4 cm (37¹/₄ × 44¹/₄ in.)
Lent by The Minneapolis Institute of
Arts, gift of Mrs. John S. Pillsbury,
Sr., 70.38
Tricot 446
P. 57, FIG. 59

AKSELI GALLEN-KALLELA
Finnish, 1865–1931

103
Väinämöinen and Aino, 1890
Oil on canvas
117 × 117 cm (46¹/₈ × 46¹/₈ in.)
Private collection
P. 77, FIG. 78

PAUL GAUGUIN
French, 1848–1903

104
The Arlésiennes (Mistral), 1888
Oil on canvas
73 × 92 cm (28³/₄ × 36³/₁₆ in.)
The Art Institute of Chicago,
Mr. and Mrs. Lewis Larned Coburn
Memorial Collection, 1934.391
Wildenstein 1964, 300;
Wildenstein 2001, 329
P. 91, FIG. 92

105
Human Sorrow, 1889
Zincograph in reddish brown ink on
yellow wove paper
Image: 28.7 × 23.7 cm (11¹/₄ × 9³/₈ in.)
Sheet: 49.9 × 65 cm (19⁵/₈ × 25⁵/₈ in.)
The Art Institute of Chicago,
William McCallin McKee Memorial
Endowment, 1943.1028
Kornfeld 11 Ab
P. 131, FIG. 136

106
Auti te pape (Woman at the River),
1893 / 94
Woodcut printed from one block in
orange and black ink over yellow,
pink, orange, blue, and green wax-
based media on laminated cream
Japanese paper
Image/sheet: 20.3 × 35.3 cm
(8 × 13⁷/₈ in.)
The Art Institute of Chicago,
Clarence Buckingham Collection,
1948.264
Kornfeld 16 ii/ii B
P. 145, FIG. 156

VINCENT VAN GOGH
Dutch, 1853–1890

107
Weeping Woman, 1883
Black and white chalk with brush
and stumping, brush and black and
gray wash, and traces of graphite,
over a brush and brown ink under-
drawing on ivory wove paper
50.2 × 31.4 cm (19³/₄ × 12³/₈ in.)
The Art Institute of Chicago, gift
of Mrs. G. T. Langhorne and the
Mary Kirk Waller Fund in memory
of Tiffany Blake and Anonymous
Fund, 1947.23
De la Faille 368; Hulsker 325
P. 17, FIG. 8

108
The Bridge at Trinquetaille, 1888
Oil on canvas
65 × 81 cm (25¹/₂ × 31⁷/₈ in.)
Hackmey Family, Israel
De la Faille 426; Hulsker 1888
P. 91, FIG. 91

EUGÈNE GRASSET
French, 1841–1917

109
The Acid Thrower, 1894
Gillotage with hand stenciling in
blue, green, pink, orange, and
brown ink on beige wove paper
Image: 39.9 × 27.6 cm (15⁵/₈ × 10⁷/₈ in.)
Sheet: 59.7 × 43.8 cm (23¹/₂ × 17¹/₄ in.)
Jane Voorhees Zimmerli Art
Museum, Norma B. Bartman
Purchase Fund, 1988.0138
P. 127, FIG. 131

HENRI CHARLES GUÉRARD
French 1846–1897

110
The Basin at Dieppe, 1883/89
Etching and aquatint with burnishing
in black and blue-gray ink on ivory
laid paper
Image: 29.5 × 47.5 cm (11⁵/₈ × 18³/₄ in.)
Sheet: 45.5 × 62.1 cm (17⁷/₈ × 24¹/₂ in.)
The Art Institute of Chicago, Mary S.
Adams Endowment, 2003.259
P. 41, FIG. 38

VILHEM HAMMERSHØI
Danish, 1864–1916

111
Interior, Frederiksberg Allé, 1900
Oil on canvas
56 × 44.5 cm (22 × 17¹/₂ in.)
Private collection
P. 53, FIG. 52

ERICH HECKEL
German, 1883–1970

112
Two Seated Women, 1912
Woodcut in black ink over monotype
in green-blue, yellow, and pink
opaque watercolor on heavyweight
mottled gray wove paper
Image: 29.5 × 29.4 cm (11⁵/₈ × 11⁵/₈ in.)
Sheet: 39 × 43.4 cm (15³/₈ × 17¹/₈ in.)
The Art Institute of Chicago,
anonymous gift, 1948.41
Dube 240 2/3
P. 185, FIG. 206

HANS HEYERDAHL
Norwegian, 1857–1913

113
Bathing Boys, 1887
Oil on canvas
140 × 132 cm (55¹/₈ × 52 in.)
Drammens Museum, DFG 136
P. 171, FIG. 189

114
The Dying Child, 1889
Oil on canvas
24.5 × 25.5 cm (9⁵/₈ × 10 in.)
The National Museum of Art,
Architecture and Design, Oslo,
NG.M.00349
P. 31, FIG. 29

ERNST JOSEPHSON
Swedish, 1851–1906

115
The Water Spirit, 1884
Oil on canvas
146.5 × 114 cm (57⁵/₈ × 44⁷/₈ in.)
Göteborg Art Museum, F 215
P. 77, FIG. 77

MAX KLINGER
German, 1857–1920

116
Abandoned, plate 5 from the series
A Life, 1884
Etching and aquatint in dark brown
and reddish orange ink on light-
weight off-white wove paper, laid
down on heavyweight off-white wove
plate paper
Plate: 32 × 45.3 (12⁵/₈ × 17⁷/₈ in.)
Sheet: 37 × 53.3 cm (14⁵/₈ × 21 in.)
The Art Institute of Chicago, Mr. and
Mrs. Philip Heller; Jeffrey Shedd
and Prints and Drawings purchase
funds; Joseph Brooks Fair and
Everett Graff endowments; through
prior acquisitions of the Carl O.
Schniewind Collection, 1992.757
Singer 131 i/vi
P. 143, FIG. 153

117
Suffer!, plate 14 from the series
A Life, 1884
Etching, aquatint, and drypoint
in black ink on grayish ivory wove
paper, laid down on cream laid
plate paper (chine collé)
Plate: 36.8 × 26 cm (14 1/2 × 10 1/4 in.);
primary support: 35.9 × 25 cm
(14 1/8 × 10 in.); secondary support:
approx. 78.8 × 57.5 cm (31 × 22 5/8 in.)
The Art Institute of Chicago, John H.
Wrenn Memorial Endowment,
2000.419.14
Singer 140 ii/vi
P. 167, FIG. 183

118
In the Park, plate 4 from the series
A Love, 1887
Etching in black ink on cream
Japanese paper
Plate: 45.5 × 27.3 cm (17 15/16 × 10 3/4 in.)
Sheet: 60 × 44.8 cm (23 5/8 × 17 5/8 in.)
National Gallery of Art, Washington,
D.C., gift of the Epstein Family
Collection 2001, 2001.132.19
Singer 160 iv/vii
P. 55, FIG. 55

119
Dead Mother, plate 10 from the
series *On Death, Part II*, 1889
Etching in black ink on lightweight
cream wove paper, laid down on
cream wove paper (chine collé)
Plate: 45.6 × 34.7 cm (18 × 13 5/8 in.)
Sheet: 63.4 × 47.4 cm (25 × 18 5/8 in.)
The Art Institute of Chicago, Joseph
B. Fair Fund Income, 1977.303
Singer 239 iv/vi
P. 107, FIG. 107

120
Night, plate 1 from the series
On Death, Part I, 1889
Etching, aquatint, and burnishing
in black ink on ivory wove paper
Plate: 31.5 × 31.5 cm (12 3/8 × 12 3/8 in.)
Sheet: 36 × 36 cm (14 1/2 × 14 1/2 in.)
The Art Institute of Chicago,
restricted gift of Thomas Baron,
2008.148
Singer 171 iii/vi, first edition
P. 17, FIG. 11

121
The Isle of the Dead (after Arnold
Böcklin), 1890
Etching and aquatint in black ink on
heavyweight ivory wove paper, laid
down on ivory wove plate paper
(chine collé)
Plate: 61.3 × 77.4 cm (24 1/8 × 30 1/2 in.)
Sheet: 67.6 × 87.4 cm (26 5/8 × 34 3/8 in.)
The Art Institute of Chicago,
gift of Jack Daulton, 2000.111
Singer 327 ix/ix
P. 163, FIG. 176

CHRISTIAN KROHG
Norwegian, 1852–1925

122
Village Street in Grez, 1882
Oil on canvas
102 × 70 cm (40 1/8 × 27 1/2 in.)
The Rasmus Meyer Collection,
The Bergen Art Museum, RMS.M.214
P. 42, FIG. 39

WALTER LEISTIKOW
German, 1865–1908

123
Evening Mood at Schlachtensee,
c. 1895
Oil on canvas
73 × 93 cm (28 3/4 × 36 5/8 in.)
Stiftung Stadtmuseum, Berlin,
GEM 68/1
P. 67, FIG. 64

MAX LIEBERMANN
German, 1847–1935

124
Bathing Boys, 1900
Oil on canvas
113 × 152 cm (44 1/2 × 59 7/8 in.)
Stiftung Stadtmuseum, Berlin,
GEM 92/14
Eberle 1900/1
P. 171, FIG. 190

**HENRI JEAN GUILLAUME
MARTIN**
French, 1860–1943

125
Silence, 1894 / 97
Transfer lithograph printed from
three stones in light blue, golden
yellow, and black ink on grayish
ivory China paper
Image: 49.2 × 32.5 cm (19 3/8 × 12 3/4 in.)
Sheet: 57 × 43 cm (22 1/2 × 16 7/8 in.)
The Art Institute of Chicago, Print
and Drawing Fund, 2008.149
P. 85, FIG. 85

CLAUDE MONET
French, 1840–1926

126
*On the Bank of the Seine,
Bennecourt*, 1868
Oil on canvas
81.5 × 100.7 cm (32 1/16 × 39 5/8 in.)
The Art Institute of Chicago,
Potter Palmer Collection, 1922.427
Wildenstein 110
P. 15, FIG. 4

127
The Boulevard des Capucines, 1873
Oil on canvas
80.3 × 60.3 cm (31 5/8 × 23 3/4 in.)
Nelson-Atkins Museum of Art,
Kansas City, Missouri, purchase,
The Kenneth A. and Helen F.
Spencer Foundation Acquisition
Fund, F72-35
Wildenstein 293
P. 46, FIG. 46

128
*The Red Kerchief, Portrait of
Madame Monet*, 1873
Oil on canvas
99 × 79.8 cm (39 × 31 3/8 in.)
Cleveland Museum of Art,
bequest of Leonard C. Hanna, Jr.,
1958.39
Wildenstein 257
P. 53, FIG. 53

129
*Study of a Figure Outdoors
(Facing Right)*, 1886
Oil on canvas
130.5 × 89.3 cm (51 3/8 × 35 1/8 in.)
Musée d'Orsay, Paris, gift of
Michel Monet, R.F. 2620
Wildenstein 1076
P. 48, FIG. 48

EILIF PETERSSEN
Norwegian, 1852–1928

130
Summer Evening at Sandø, 1884/94
Oil on canvas
129 × 160 cm (50 3/4 × 63 in.)
Private collection, courtesy Galleri
Kaare Berntsen, Oslo
P. 15, FIG. 5

131
Afternoon at Dælivannet, 1886
Oil on canvas
64 × 91 cm (25 1/4 × 35 7/8 in.)
Private collection, courtesy Galleri
Kaare Berntsen, Oslo
P. 33, FIG. 31

132
Nocturne, 1887
Oil on canvas
81.5 × 81.5 cm (32 1/8 × 32 1/8 in.)
The National Museum of Art,
Architecture and Design, Oslo,
NG.M.00848
P. 19, FIG. 13

ODILON REDON
French, 1840–1916

133
*Death: "My Irony Surpasses All
Others,"* plate 3 from the series
To Gustave Flaubert, 1888
Transfer lithograph in black ink
on lightweight ivory wove paper, laid
down on heavyweight ivory wove
plate paper (chine collé)
Image: 26.1 × 19.7 cm (10 1/4 × 7 3/4 in.)
Sheet: 34.7 × 45.2 cm (13 5/8 × 17 3/4 in.)
The Art Institute of Chicago,
the Stickney Collection, 1920.1651
Mellerio 97 only state
P. 85, FIG. 86

JÓZSEF RIPPL-RÓNAI
Hungarian, 1861–1927

134
The Country Dance, 1896
Lithograph printed from six stones
in gray, light yellow, dark yellow,
green, blue, light orange, pink, and
purple ink on ivory Japanese paper
Image: 39.6 × 52.9 cm (15 5/8 × 20 3/4 in.)
Sheet: 43.3 × 56.4 cm (17 × 22 1/4 in.)
The Art Institute of Chicago, gift of
the Marjorie Blum-Kovler Collection
and the Harry and Maribel G. Blum
Foundation, 1995.49
P. 159, FIG. 172

AUGUSTE RODIN
French, 1840–1917

135
The Kiss, 1886
Bronze
86.4 × 34 cm (34 × 13 3/8 in.)
The Baltimore Museum of Art, the
Jacob Epstein Collection, BMA.
1951.128
P. 55, FIG. 57

FÉLICIEN ROPS
Belgian, 1833–1898

136

The Greatest Love of Don Juan,
1882 / 83
Graphite with stumping, scratching,
and eraser on off-white wove paper,
prepared with a white gouache
ground (scratchboard)
26.1 × 19 cm (10¼ × 7½ in.)
The Art Institute of Chicago,
Margaret Day Blake Collection,
1998.75
P. 87, FIG. 88

DANTE GABRIEL ROSSETTI
English, 1828–1882

137

Beata Beatrix, 1872
Oil on canvas
Main canvas: 87.5 × 69.3 cm
(34⁷/₁₆ × 27¼ in.)
Predella: 26.5 × 69.2 cm
(10³/₈ × 27¼ in.)
The Art Institute of Chicago, Charles
L. Hutchinson Collection, 1925.722
Surtees 168E, R3
P. 84, FIG. 83

AUGUST STRINDBERG
Swedish, 1849–1912

138

The Vita Märrn Seamark II, 1892
Oil on cardboard
60 × 47 cm (23⁵/₈ × 18½ in.)
Nationalmuseum, Stockholm,
NM 6980
P. 73, FIG. 71

FRANZ VON STUCK
German, 1863–1928

139

Sin, c. 1893
Oil on canvas
88 × 53.3 cm (34⁵/₈ × 21 in.)
Galerie Katharina Büttiker, Art
Nouveau-Art Deco, Zurich
P. 84, FIG. 84

FRITS THAULOW
Norwegian, 1847–1906

140

Melting Snow, 1887
Pastel on tan wove paper, laid
down on canvas and wrapped
around a strainer
54.6× 94.6 cm (21½ × 37¼ in.)
The Art Institute of Chicago,
Margaret Day Blake Collection,
2004.86
P. 19, FIG. 14

**HENRI DE TOULOUSE-
LAUTREC**
French, 1864–1901

141

Jane Avril, 1893
Lithograph printed from five stones
in olive green, yellow, orange, red,
and black ink on tan wove paper
Image: 124 × 91.5 cm (48⁷/₈ × 36 in.)
Sheet: 129 × 94 cm (50³/₄ × 37 in.)
The Art Institute of Chicago,
Mr. and Mrs. Carter H. Harrison
Collection, 1949.1004
Wittrock P6 b/c
P. 129, FIG. 134

FÉLIX VALLOTTON
Swiss, 1865–1925

142

The Funeral, 1891
Woodcut in black ink on tan
wove paper
Image: 26 × 35.2 cm (10¼ × 13⁷/₈ in.)
Sheet: 32.4 × 42.2 cm (12³/₄ × 16⁵/₈ in.)
The Art Institute of Chicago, gift of
the Print and Drawing Club, 1956.1067
Vallotton and Goerg 84 a/c
P. 132, FIG. 139

ERIK WERENSKIOLD
Norwegian, 1855–1938

143

In Familiar Surroundings, 1882
Oil on canvas
46 × 56 cm (18¼ × 22 in.)
Lillehammer Art Museum, LKM 337
P. 25, FIG. 22

JAMES MCNEILL WHISTLER
American, 1834–1903

144

Valparaiso Harbor, 1866
Oil on canvas
76.6 × 51.1 cm (30¼ × 20¼ in.)
Smithsonian American Art Museum,
gift of John Gellatly, 1926.6.159
Young 74
P. 40, FIG. 36

ANDERS LEONARD ZORN
Swedish, 1860–1920

145

Fisherman at St. Ives, 1891
Etching with burnishing in black ink
on ivory laid Van Gelder paper
Plate: 28 × 19.8 cm (11 × 7³/₄ in.)
Sheet: 47.2 × 30.7 cm (18⁵/₈ × 12¼ in.)
The Art Institute of Chicago,
Charles Deering Collection, 1927.1825
Asplund 53 ii/ii
P. 149, FIG. 161

BIBLIOGRAPHY

Behrndt, Helle, et al. 2002. *Women Painters in Scandinavia, 1880–1900*. Exh. cat. Kunstforeningen.

Berman, Patricia G. 1986. *Edvard Munch: Mirror Reflections*. Exh. cat. Norton Gallery of Art, West Palm Beach.

———1989. "Monumentality and Historicism in Edvard Munch's University of Oslo Festival Hall Painting." Ph.D. diss., New York University.

———1993a. "Body and Body Politic in Edvard Munch's *Bathing Men*." In *The Body Imaged: The Human Form and Visual Culture since the Renaissance*, edited by Kathleen Adler and Marcia Pointon, pp. 71–83. Cambridge University Press.

———1993b. "Edvard Munch's Self-Portrait with Cigarette: Smoking and the Bohemian Persona." *Art Bulletin* 75, 4 (December), pp. 627–46.

———1993c. "Norwegian Craft Theory and National Revival in the 1890s." In *Art and the National Dream: The Search for Vernacular Expression in Turn-of-the-Century Design*, edited by Nicola Gordon Bowe, pp. 159–60. Irish Academic Press.

———1994. "(Re-)reading Edvard Munch: Trends in the Current Literature." *Scandinavian Studies* 66, 1, pp. 45–67.

———2006a. "Edward Munch's 'Modern Life of the Soul.'" In McShine 2006, pp. 34–51.

———2006b. "Menssana in corpore sano: Munchs vitale cropper." In Lerheim and Ydstie 2006, pp. 45–60.

———2008a. "Dionysus with Tan Lines: Edvard Munch's Discursive Skin." In *A Fine Regard: Essays in Honor of Kirk Varnedoe*, edited by Patricia G. Berman and Gertje R. Utley, pp. 69–85. Ashgate.

———2008b. "The Urban Sublime and the Making of the Modern Artist." In Ydstie and Guleng 2008, pp. 139–56.

Berman, Patricia G., and Jane Van Nimmen. 1997. *Munch and Women: Image and Myth*. Exh. cat. Art Services International.

Bjerke, Øivind Storm. 1995. *Edvard Munch, Harald Sohlberg: Landscapes of the Mind*. Exh. cat. National Academy of Design/University Press of New England.

——— 2006a. "Edvard Munch and Félicien Rops: Two Generations of Symbolists." In idem, *Félicien Rops and Edvard Munch: Men and Women*, pp. 28–35. Transpetrol Foundation.

———2006b. "Edvard Munch, *The Sick Child*: Form as Content." In Mørstad 2006a, pp. 65–86.

———2008. "*Scream* as Part of the Art Historical Canon." In *The Scream*, edited by Ingeborg Ydstie, pp. 13–55. Vigmostad and Bjørke.

Boe, Roy Asbjön. 1971. "Edvard Munch: His Life and Work from 1880 to 1920." Ph.D. diss., New York University.

Bowen, Anne McElroy. 1988. "Munch and Agoraphobia: His Art and His Illness." *RACAR: revue d'art canadienne* 15, pp. 23–50.

Bruteig, Magne. 2005. "–Above Were the Heavenly Stars." In *Blossom of Pain: Edvard Munch*, pp. 12–91. Exh. cat. Museum for Religious Art, Lemvig.

———2008. "Unpainted Drawings." In Ydstie and Guleng 2008, pp. 63–84.

Buchhart, Dieter, ed. 2007. *Edvard Munch: Signs of Modern Art*. Exh. cat. Hatje Cantz/Fondation Beyeler.

Bøe, Alf. 1989. *Edvard Munch*. Rizzoli.

Challons-Lipton, Siulolovao. 2001. *The Scandinavian Pupils of the Atelier Bonnat, 1867–1894*. Scandinavian Studies 6. Edwin Mellen Press.

Clarke, Jay A. 1999. "The Construction of Artistic Identity in Turn-of-the-Century Berlin: The Prints of Klinger, Kollwitz, and Liebermann." Ph.D. diss., Brown University.

———2000. "Munch, Liebermann, and the Question of Etched 'Reproductions.'" *Visual Resources* 16 (June 2000), pp. 27–63.

———2002. "Neo-Idealism, Expressionism, and the Writing of Art History," *Art Institute of Chicago Museum Studies* 28, 1, pp. 25–37.

———2003. "Meier-Graefe Sells Munch: The Critic as Dealer." In *Festschrift für Eberhard W. Kornfeld zum 80. Geburtstag*, edited by Christine E. Stauffer, pp. 181–94. Kornfeld.

———2006. "Originality and Repetition in Edvard Munch's *The Sick Child*." In Mørstad 2006a, pp. 43–63.

Connelly, Frances S. 1995. *The Sleep of Reason: Primitivism in Modern European Art and Aesthetics, 1725–1907*. Pennsylvania State University Press.

Cordulack, Shelley Wood. 2002. *Edvard Munch and the Physiology of Symbolism*. Farleigh Dickinson University Press.

Eggum, Arne, et al. 1978. *Edvard Munch: Symbols and Images*. Exh. cat. National Gallery of Art, Washington, D.C.

———1979. *The Masterworks of Edvard Munch*. Exh. cat. Museum of Modern Art, New York.

———1980. "James Ensor and Edvard Munch: Mask and Reality." In *James Ensor, Edvard Munch, Emil Nolde: An Exhibition*, pp. 21–29. Exh. cat. Norman Mackenzie Art Gallery, University of Regina, Saskatchewan.

———1982. *Edvard Munch: Expressionist Paintings, 1900–1940*. Exh. cat. Elvehjem Museum of Art, University of Wisconsin–Madison.

———1989. *Munch and Photography*. Exh. cat. Yale University Press.

———1999. "Munch og Warnemünde." In Annie Bardon et al., *Munch og Warnemünde, 1907–1908*, pp. 109–17. Exh. cat. Munch Museum/ Labyrinth Press.

———2000. *Edvard Munch: The Frieze of Life from Painting to Graphic Art; Love—Angst—Death*, translated by Hal Sutcliffe and Torbjørn Støverud. Stenersen.

Eggum, Arne, Gerd Woll, and Marit Lande. 1998. *Munch at the Munch Museum, Oslo*. Scala.

Epstein, Sarah G. 1983. *The Prints of Edvard Munch, Mirror of His Life: An Exhibition of Prints from the Collection of Sarah G. and Lionel C. Epstein*. Exh. cat. Allen Memorial Art Museum, Oberlin College.

Facos, Michele. 1998. *Nationalism and the Nordic Imagination: Swedish Art of the 1890s*. University of California Press.

Glaser, Curt. 1917. *Edvard Munch*. B. Cassirer.

Gran, Henning. 1951. "Munch Seen Through the Eyes of Werenskiold." *Kunsten Idag* 17, pp. 5–21.

Greve, Eli. 1963. *Edvard Munch: Liv og verk i lys av tresnittene*. J. W. Cappelen.

Hayward Gallery. 1986. *Dreams of a Summer Night: Scandinavian Painting at the Turn of the Century*. Exh. cat. Arts Council of Great Britain.

Heller, Reinhold. 1969. "Edvard Munch's 'Life Frieze': Its Beginnings and Origins." Ph.D. diss., Indiana University.

———1973a. *Edvard Munch: The Scream*. Viking.

———1973b. "Edvard Munch's *Vision* and the Symbolist Swan." *Art Quarterly* 36, 3 (Autumn), pp. 209–49.

———1978. "Edvard Munch's 'Night,' the Aesthetics of Decadence, and the Content of Biography." *Arts Magazine* 53, pp. 80–105.

———1984. *Munch: His Life and Work*. University of Chicago Press.

———1993. "'Das schwarze Ferkel' and the Institution of an Avant-Garde in Berlin, 1892–1893." In *Künstlerischer Austausch*, vol. 3, edited by Thomas W. Gaehtgens, pp. 509–19. Akademie Verlag.

———2006. "'Could Only Have Been Painted by a Madman,' Or Could It?" In McShine 2006, pp. 16–33.

Herman, Kerry. 1999. "Modernism's Edge: Nationalism and Cultural Politics in Fin-de-Siècle Europe; Norwegian Painters, 1880–1905." Ph.D. diss., Brown University. Høifødt, Frank. 1988. "Det Tomme Kors: fin-de-siècle og endeperspektiv paa liv og kunst." M.A. thesis, University of Bergen.

———2006. "The Kristiania Bohemia Reflected in the Art of the Young Edvard Munch." In Mørstad 2006a, pp. 15–41.

———2008. *Munch's "Madonna": Dream and Vision*. Munch Museum.

Izenberg, Gerald N. 2000. *Modernism and Masculinity: Mann, Wedekind, Kandinsky through World War I*. University of Chicago Press.

Jaworska, Wladyslawa. 1974. "Edvard Munch and Stanislaw Przybyszewski." *Apollo* 100 (October), pp. 312–17.

Jayne, Kristie. 1989. "The Cultural Roots of Edvard Munch's Images of Women." *Woman's Art Journal* 10, 1, pp. 43–59.

Jensen, Robert. 1994. *Marketing Modernism in Fin-de-Siècle Europe*. Princeton University Press.

Johannesen, Ina. 2002. "Tone, Colour, Nuance: The Evocative Painting— A New Creation or a Romantic Tradition?" In Johannesen, Thomsen, and Lande 2002, pp. 106–10.

Johannesen, Ina, Ingrid Reed Thomsen, and Marit Lande. 2002. *Tunes in a Landscape: Fleskum; A Norwegian Artists' Colony*. Exh. cat. Kisterfos Museum/Royal Norwegian Ministry of Foreign Affairs.

Jumeau-Lafond, Jean-David, et al. 2006. *Painters of the Soul: Symbolism in France*. Exh. cat. Tampere Art Museum.

Kent, Neil. 2000. *The Soul of the North: A Social, Architectural, and Cultural History of the Nordic Countries, 1700–1940*. Reaktion.

Kneher, Jan. 1994. *Edvard Munch in seinen Ausstellungen zwischen 1892 and 1912*. Wernersche Verlagsgesellschaft.

Lande, Marit. 1992. "—for aldrig meer at skilles—: fra Edvard Munchs barndom og ungdom i Christiania. Universitetsforlaget.

Langaard, Ingrid. 1960. *Edvard Munch: modningsår*. Gyldendal.

Langaard, Johann H., and Reidar Revold. 1964. *Edvard Munch: Masterpieces from the Artist's Collection in the Munch Museum in Oslo*. Translated by Michael Bullock. McGraw-Hill.

Lange, Marit. 1988. "Die Neuromantik in der Norwegischen Landschaftsmalerei." In *Landschaft als Kosmos der Seele: Malerei des nordischen Symbolismus bis Munch, 1880–1910*, edited by Götz Czymmek, pp. 51–59. Exh. cat. Wallraf-Richartz-Museum/Braus.

———1994. "Max Klinger und Norwegen," *Niederdeutsche Beiträge zur Kunstgeschichte* 33, pp. 157–212.

———2002a. Marit Lange, "Between Naturalism and Neo-Romanticism: Puvis de Chavannes and the Evocative Norwegian Landscape." In *Toward Modern Art: From Puvis de Chavannes to Matisse and Picasso*, edited by Serge Lemoine, pp. 267–75. Exh. cat. Rizzoli.

———2002b. "Harriet Backer and Kitty L. Kielland at Fleskum in the Summer of 1886: International Currents and Individual Approaches." In Johannesen, Thomsen, and Lande 2002, pp. 118–26.

———2003. "Edvard Munchs 'Natt i Saint Cloud': fortolkninger og forvrengninger." In Marit Lange, Ina Johannesen, and Knut Ljøgodt, *Fra romersk barokk til norsk nyromantikk*, pp. 79–91. Ortiz.

Lathe, Carla. 1979. "Edvard Munch and the Concept of 'Psychic Naturalism.'" *Gazette des beaux-arts* 93, pp. 135–46.

Lerheim, Karen E., and Ingebjørg Ydstie, eds. 2006. *Livskraft: Vitalismen som kunstnerisk impuls 1900–1930*. Exh. cat. Munch Museum.

Lewis, Beth Irwin. 2003. *Art for All? The Collision of Modern Art and the Public in Late-Nineteenth-Century Germany*. Princeton University Press.

Lippincott, Louise. 1988. *Edvard Munch: Starry Night*. Exh. cat. J. Paul Getty Museum.

Makela, Maria. 2007. "Munch's Women: Misused and Munch-Abused." *Cantor Arts Center Journal* 5, forthcoming.

McShine, Kynaston, et al. 2006. *Edvard Munch: The Modern Life of the Soul*. Exh. cat. Museum of Modern Art, New York.

Messel, Nils. 1994. "Edvard Munch and His Critics in the 1880s." *Kunst og Kultur* 77, 4, pp. 213–27.

———2002. "Norwegian Impressions." In Torsten Gunnarsson et al. *Impressionism and the North: Late Nineteenth-Century French Avant-Garde Art in the Nordic Countries, 1870–1920*, pp. 201–25. Exh. cat. Nationalmuseum, Stockholm.

Messer, Thomas M. 1985. *Edvard Munch*. Harry N. Abrams.

Munch, Edvard. 1949. *Edvard Munchs Brev: Familien*, edited by Inger Munch. Johan Grundt Tanum.

———1954. *Edvard Munchs Brev: Fra Dr. Med. Max Linde*. Dreyer.

———2005. *The Private Journals of Edvard Munch: We Are Flames which Pour Out of the Earth*, edited and translated by J. Gill Holland. University of Wisconsin Press.

Munch, Edvard, and Gustav Schiefler. 1987. *Briefwechsel: Edvard Munch, Gustav Schiefler*. Veröffentlichungen des Vereins für Hamburgische Geschichte 30, 36. Verlag Verein für Hamburgische Geschichte.

Mørstad, Erik. 2004. "Munch og Böcklin: En komparatia nalyse." *Kunst og Kultur* 87, 3, pp. 156–74.

———ed., 2006a. *Edvard Munch: An Anthology*. Oslo Academic Press.

———2006b. "Responding to *Self-Portrait with Cigarette*: A Case History." In Mørstad 2006a, pp. 107–16.

———2008. "Edvard Munch's First School Years: Teachers and Textbooks on Drawing." In Ydstie and Guleng 2008, pp. 21–33.

Naess, Atle. 2004. *Munch: en biografi*. Gyldendal.

Nergaard, Trygve. 1975. "Emanuel Goldstein og Edvard Munch." *Louisiana Revy* 16, pp. 16–22.

———1978. "Despair." In Eggum 1978, pp. 113–41.

Prelinger, Elizabeth. 1996. *The Symbolist Prints of Edvard Munch: The Vivian and David Campbell Collection*. Exh. cat. Yale University Press.

———2000. "Music to Our Ears? Munch's *Scream* and Romantic Music Theory." In *The Arts Entwined: Music and Painting in the Nineteenth Century*, edited by Marsha Morton and Peter L. Schmunk, pp. 209–25. Garland.

———2001. *After the Scream: The Late Paintings of Edvard Munch*. Exh. cat. High Museum of Art/Yale University Press.

———2006. "Metal, Stone, and Wood: Matrices of Meaning in Munch's Graphic Work." In McShine 2006, pp. 52–63.

Przybyszewski, Stanislaw, ed. 1894. *Das Werk des Edvard Munch: Vier Beiträge*. S. Fischer.

Rapetti, Rodolphe. 1991. "Munch face à la critique française: 1893–1905." In Rapetti and Eggum 1991, pp. 16–31.

Rapetti, Rodolphe, and Arne Eggum. 1991. *Munch et la France*. Exh. cat. Réunion des Musées Nationaux.

Sato, Naoki, Anne-Brigitte Fonsmark, and Felix Krämer. 2008. *Hammershøi*. Exh. cat. Royal Academy, London.

Schiefler, Gustav. 1907. *Verzeichnis des graphischen Werks Edvard Munchs bis 1906*. B. Cassirer, 1907.

Schneede, Uwe M., and Dorothee Hansen. 1994. *Munch und Deutschland*. Exh. cat. G. Hatje.

Schröder, Klaus Albrecht, and Antonia Hoerschelmann, eds. 2003. *Edvard Munch: Theme and Variation*. Exh. cat. Graphische Sammlung Albertina/Hatje Cantz.

Sheffield, Clarence Burton, Jr. 1999. "The Lysaker Circle and the Development of Peasant Imagery in Norwegian Painting (1880–1920): From Naturalism to Modernist Expression." Ph.D. diss., Bryn Mawr College.

Sherman, Ida L. 1976. "Edvard Munchs *Pubertet* og Felicien Rops." *Kunst og Kultur* 59, 4, pp. 243–58.

Smith, John Boulton. 1983. *Frederick Delius and Edvard Munch: Their Friendship and Their Correspondence*. Triad Press.

Stabell, Waldemar. 1973. "Edvard Munch og Eva Mudocci." *Kunst og Kultur* 56, 4, pp. 209–36.

Stang, Ragna. 1979. *Edvard Munch: The Man and His Art*. Abbeville.

Steinberg, Norma S. 1995. *Munch in Color: Harvard University Art Museum Bulletin* 3, 3.

Thiis, Jens. 1933. *Edvard Munch og hans samtid; skleten livet og kunsten geniet*. Gyldendal.

———1934. *Edvard Munch*. Rembrandt Verlag.

Torjusen, Bente. 1978. "*The Mirror*." In Eggum 1978, pp. 185–227.

Tøjner, Poul Erik. 2001. *Munch in His Own Words*. Prestel.

Van Nimmen, Jane. 1997. "Loving Edvard Munch: Women Who Were His Patrons, Collectors, Admirers." In Berman and Van Nimmen 1997, pp. 43–59.

Varnedoe, Kirk. 1979. "Christian Krohg and Edvard Munch." *Arts Magazine* 53, 8, pp. 88–95.

———1982a. "Nationalism, Internationalism, and the Progress of Scandinavian Art." In Varnedoe 1982b, pp. 13–32.

———1982b. *Northern Light: Realism and Symbolism in Scandinavian Painting, 1880–1910*. Exh. cat. Brooklyn Museum.

———1988. *Northern Light: Nordic Art at the Turn of the Century*. Yale University Press.

Warick, Lawrence and Elaine. 1995. "Edvard Munch: A Study of Loss, Grief, and Creativity." In *Creativity and Madness: Psychological Studies of Art and Artists*, edited by Barry Panter, pp. 177–86. Aimed Press.

Woll, Gerd. 1978. "The Tree of Knowledge of Good and Evil." In Eggum 1978, pp. 229–47.

———1991. "Le graveur." In Rapetti and Eggum 1991, pp. 241–75.

———1993. *Edvard Munch: Monumental Projects, 1909–1930*. Exh. cat. Lillehammer Art Museum.

———1995. *Edvard Munch, 1895: First Year as a Graphic Artist*. Exh. cat. Munch Museum.

———1996. *Prints from 1896*. Exh. cat. Munch Museum.

———2001. *Edvard Munch: The Complete Graphic Works*. Munch Museum/Harry N. Abrams.

———2003. "Papier en Edvard Munchs graphischen Arbeiten." In Schröder and Hoerschelmann 2003, pp. 41–52.

———2004. "Vita brevis ars longa: Munchs selvportretter som kunstnerisk overlevelsesprosjekt." In *Portrett i Norge*, edited by Nils Messel, Anne Wichstrøm, and Janike Sverdrup Ugelstad, pp. 39–51. Labyrinth Press/Norsk Folkemuseum.

———2008a. *Edvard Munch: samlede malerier*. 4 vols. Cappelen Damm.

———2008b. "Use and Re-Use in Munch's Earliest Paintings." In Ydstie and Guleng 2008, pp. 85–103.

Wood, Mara-Helen, ed. 1992. *Edvard Munch: The Frieze of Life*. Exh. cat. National Gallery, London.

Yarborough, Tina. 1995. "Exhibition Strategies and Wartime Politics in the Art and Career of Edvard Munch." Ph.D. diss., University of Chicago.

Ydstie, Ingebjørg, and Mai Britt Guleng, eds. 2008. *Munch Becoming "Munch": Artistic Strategies, 1880–1892*. Exh. cat. Munch Museum.

Zarobell, John. 2005. "A Year in Paris: Edvard Munch's *Mermaid*." *Philadelphia Museum of Art Bulletin* 93, pp. 6–23.

INDEX OF WORKS

Numbers in **bold** refer to
pages with illustrations.

For ease of identification,
works of art by Edvard
Munch are described as:
aquatint (a)
drawing (d)
drypoint (dp)
etching (e)
lithograph (l)
oil (o)
pastel (p)
tempera (t)
watercolor (wc)
woodblock (w)
zincograph (z)

Becoming Edvard Munch: Influence, Anxiety, and Myth is published in conjunction with an exhibition of the same title on view at the Art Institute of Chicago from February 14 to April 26, 2009.

The exhibition is organized by the Art Institute of Chicago.

Bank of America is the Exclusive Corporate Sponsor.

Bank of America

Major funding is generously provided by the Harris Family Foundation in memory of Bette and Neison Harris.

The project is also supported by an award from the National Endowment for the Arts, which believes a great nation deserves great art. An indemnity for the exhibition has been granted by the Federal Council on the Arts and the Humanities.

First edition
Library of Congress Control Number: 2008936805
ISBN: 978-0-300-11950-3 (cloth)
ISBN: 978-0-86559-228-5 (paper)

Published by
The Art Institute of Chicago
111 South Michigan Avenue
Chicago, Illinois 60603-6404
www.artic.edu

Distributed by
Yale University Press
302 Temple Street
New Haven, Connecticut 06520-9040
www.yalebooks.com

Produced by the Publications Department of the Art Institute of Chicago, Susan F. Rossen, Executive Director

Edited by Gregory Nosan, Associate Editor

Production by Carolyn Heidrich Ziebarth, Production Coordinator, and Kate Kotan, Production Assistant

Photography research by Joseph Mohan, Photography Editor

Designed and typeset by Daphne Geismar, New Haven, Connecticut

Separations by Professional Graphics, Rockford, Illinois

Printing and binding by Conti Tipocolor, Florence, Italy

This book was produced using FSC-certified paper.

Front cover: *Anxiety*, 1894 (detail, p. 90, fig. 90)

Back cover: *The Girl by the Window*, 1893 (detail, p. 52, fig. 50)

Frontispiece: *Madonna*, 1895 (detail, p. 127, fig. 128)